# THE BOOK OF COLOR PHOTOGRAPHY

## ADRIAN BAILEY & ADRIAN HOLLOWAY

ALFRED A KNOPF
NEW YORK 1984

Managing editor **Joss Pearson**
Art editor **Christopher Meehan**
Assistant art editor **Denise Brown**
Designers **Jill Leman, Marnie Searchwell**
Editors **David Lamb, Lucy Lidell, John Smallwood**
Assistant editor **Judith More**
Staff photographer **Andrew de Lory**
Picture research **Elly Beintema**
Technical consultant **Michael Langford**
Editorial director **Christopher Davis**

**This is a Borzoi Book
published by Alfred A. Knopf, Inc.**

The Book of Color Photography
was conceived, edited and designed by
Dorling Kindersley Limited
9 Henrietta Street. London WC2.

Copyright © 1979 and 1984 by
Dorling Kindersley Limited, London.

All rights reserved under International and
Pan-American Copyright Conventions.
Published in the United States by
Alfred A. Knopf, Inc., New York, and
simultaneously in Canada by Random House of
Canada Limited, Toronto.
Distributed by Random House, Inc., New York.

Library of Congress Cataloging in Publication Data
Bailey, Adrian, 1928 –
    The book of color photography.
        Includes index.
1. Color photography. I. Holloway, Adrian.
II Title.
TR510.B23     1984       778.6       83-49190
ISBN 0-394-72467-4

Manufactured in Spain by Grijelmo S.A.

## How to use this book

The book is divided into seven main sections, as shown in the Contents list opposite. Even if you are a fairly experienced photographer, you should look at sections 2 to 4 before turning to section 5, The Subject, as it draws on the information and terminology introduced earlier in the book. When approaching a particular subject in this section, make full use of the additional material to which you are cross-referred, as well as the glossary of technical terms.

In the Color Language and Subject sections, each photograph has a picture-taking guide, as shown right. These are designed as guides to the essential requirements for taking a similar picture, rather than as exact descriptions of how the picture was taken.

## How to use the picture-taking symbols

**Camera type**
This symbol is always given with one of the terms on the right or mention of any special camera. If the metering or aperture/shutter symbols are present, use a camera with manual exposure control.

**Term used**
*Reflex* SLR or TLR with interchangeable lenses
*Viewfinder* Direct viewfinder, fixed lens camera
*Rangefinder* Viewfinder camera with rangefinder focusing and few interchangeable lenses

**Lens type**
The lens symbol is given if a non-standard lens is required. Unusual lenses are mentioned by name. You will find the basic set of lenses on pages 36–7 and 88–9, and unusual lenses on pages 188–9.

(35 mm format)
*Standard* 50–55 mm
*Medium wide-angle* 35 mm
*Wide-angle* 21–28 mm
*Extreme wide-angle* 18–21 mm
*Medium long* 80 mm
*Long* 135–250 mm
*Extra long* 500 mm or more

**Lens filter**
If no symbol is given, no filter is required (except perhaps a skylight filter). See pages 190–1.

Filters are named. (Check the makers recommended filter factor if your camera does not have a TTL meter.)

**Film type**
This symbol is given unless the film required is medium speed daylight film. See pages 40–53 for the types of film available, and pages 98–9 for manipulating film speed by uprating.

*Type B* 3200 K tungsten
*Daylight* Daylight or flash
*Infra-red* Ektachrome IE
*Ultrafast* 400 ASA or faster
*Fast* 160–200 ASA
*Medium* 60–125 ASA
*Slow* 15–50 ASA

**Lighting**
This symbol is given if the lighting required is not standard daylight (bright, but diffuse sunlight, front lighting). See pages 100–5.

**Term used**
The type – daylight, flash, tungsten or other artificial source – is named, and lighting quality and direction are given where relevant.

**Metering**
This symbol occurs where a particular exposure or metering technique is required. See Exposure, pages 92–9 and Flash, page 102. Where no symbol occurs, you can rely on an overall TTL reading.

Specific metering techniques are stated, using the definitions given in the Exposure section of the book.

**Aperture and shutter**
Where this symbol occurs, aperture and shutter combinations are classified as shown right. If there is no symbol, you can use medium aperture and shutter settings, or automatic exposure controls. Use a tripod or camera support below 1/30 sec shutter speed. See pages 86–91.

*Full aperture* maximum
*Wide aperture* maximum–f4
*Medium aperture* f5.6–f8
*Small aperture* f11–f22
*Very fast shutter* 1/1000 sec +
*Fast shutter* 1/250–1/500 sec
*Medium shutter* 1/60–1/125 sec
*Slow shutter* 1/15–1/30 sec
*Very slow shutter* 1 sec–1/8 sec
*Time exposure* over 1 sec
*Tripod* support camera

# CONTENTS

# INTRODUCTION

Color photography today is characterized by explosive growth and rapid development of new technology and ideas. Each year more than six billion pictures are now taken in color, and a bewildering array of new films, cameras and devices floods on to the market. In the past decade, miniaturized electronics and computer-assisted design have brought both sophisticated automation and professional quality within the reach of amateurs.

This book is designed to help you find your way in this complex field – to choose the right equipment for your needs, learn how to use it effectively, and acquire the practical and creative skills that will allow you to pursue your own interests and develop a personal style. These introductory pages are illustrated with the work of four leading color photographers, each of whom has developed a strongly individual style and an expressive use of color.

One of the great attractions of photography is the ease with which you can master its basic skills. Unlike some of the older arts, where it takes many years of training even to produce an acceptable image, you can learn the practical craft of photography quite fast. You don't need elaborate equipment either – today even quite simple cameras are likely to give acceptable results, and can cover a fair range of subjects so long as the controls are not wholly automatic.

But this very ease with which a camera reproduces reality is deceptive, and often the cause of ill-considered, disappointing pictures. Good photography depends not on recording reality, but on interpreting it. Ultimately, it is the individual eye of the photographer that makes a picture memorable. Every shot you take should have a clear purpose. With practice, you can learn to control all the elements in your pictures, so that they powerfully express this purpose, and your own point of view and style.

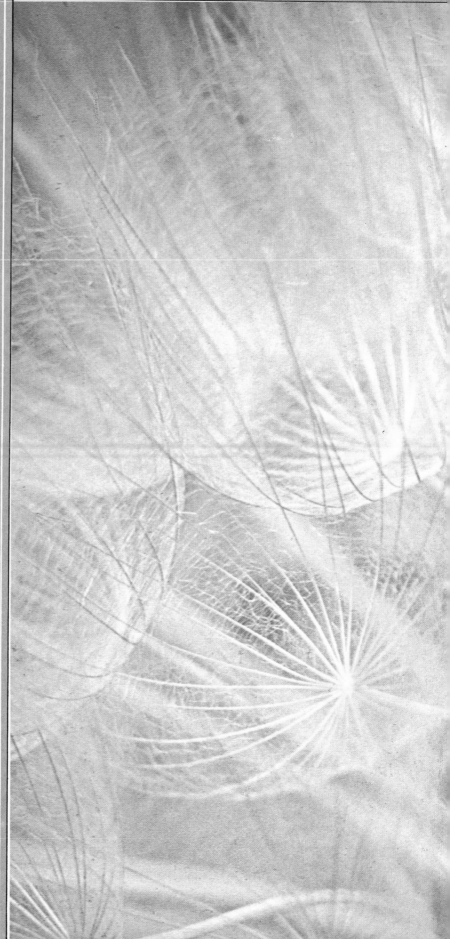

**Ernst Haas**

In this delicate study of seed heads, Haas has made soft harmonious color the subject of his picture. By using an extreme close-up lens, he has produced a filigree pattern of color and line. The repetition of curving fan shapes across the picture adds rhythm to the composition.

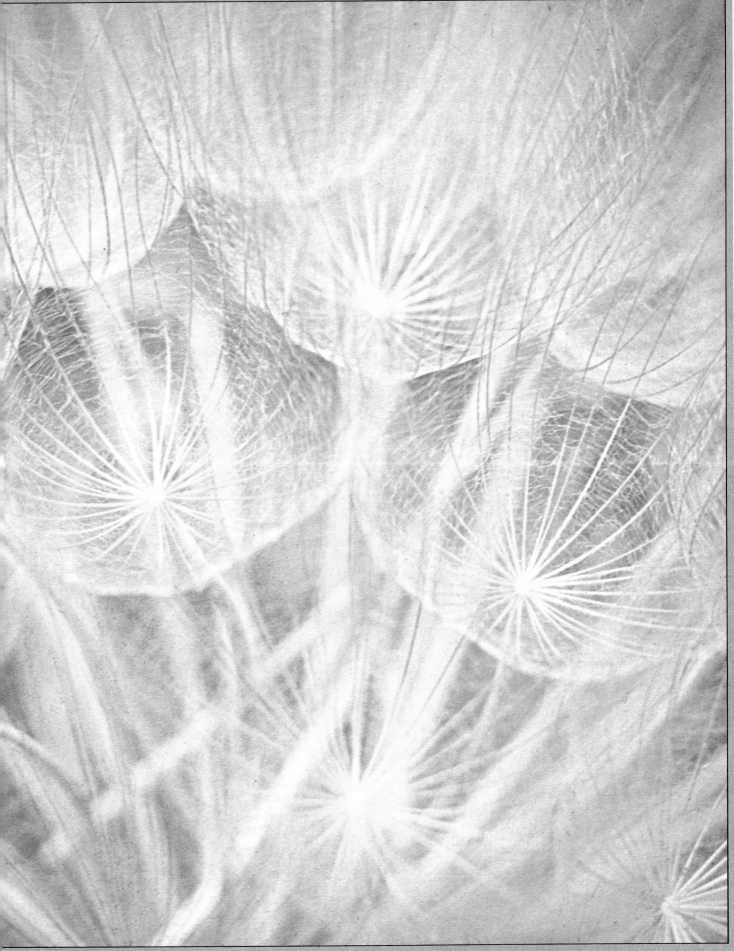

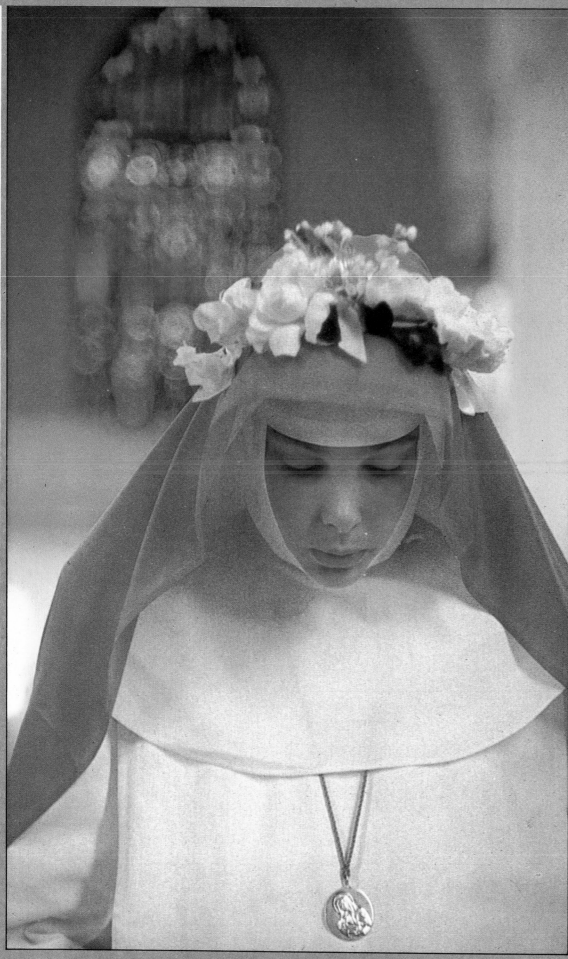

**Eve Arnold** *left*
Eve Arnold has used color for its emotional symbolism in this intimate portrait of a young nun taking her vows. The warm amber tones of the background lift the picture's mood as well as providing a contrasting frame for the figure. Defocusing the background into a shimmering blur of color (see p. 90) concentrates attention on the subject, while the use of a relatively high viewpoint emphasizes the devoutness and humility of the bowed head.

**Ernst Haas** *right*
A limited color range with accents of light against a dark frame gives this picture vitality as well as simplicity. One of the main problems of strong color is its tendency to flatten form and overwhelm shape—here Haas has used the dense blue background to provide depth and offset the dominant reds and yellow. Tight framing draws attention to the unusual shape of the flower.

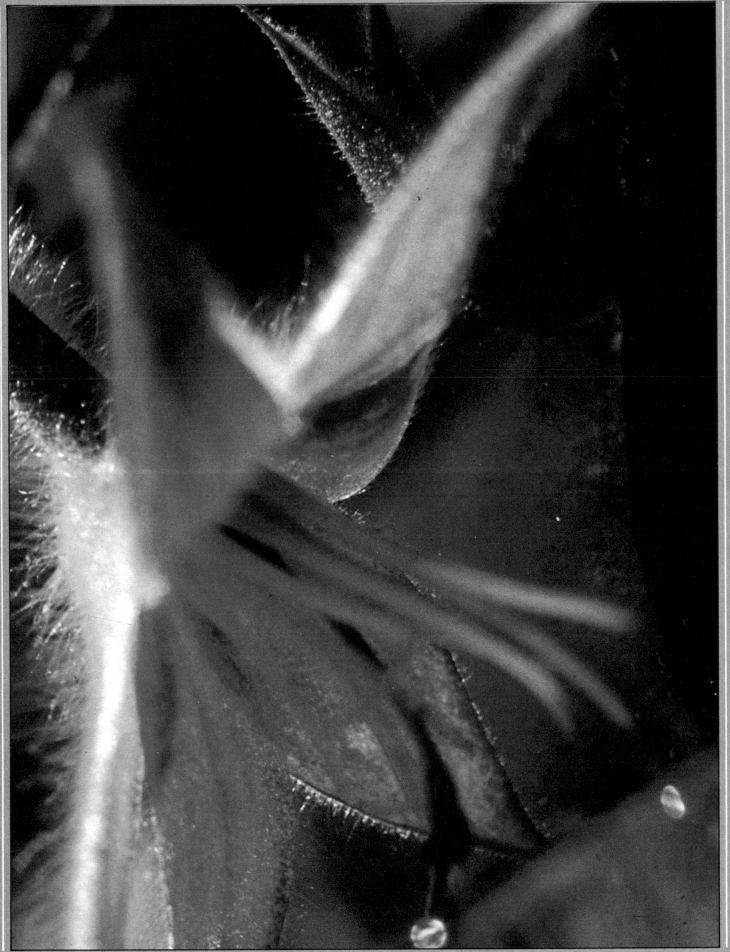

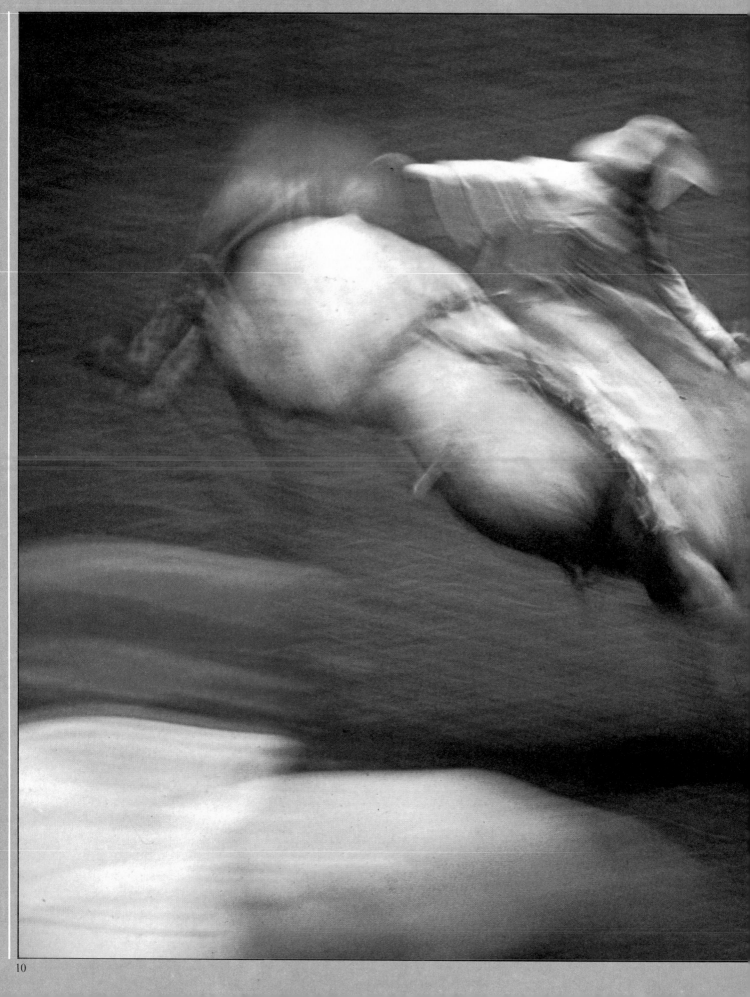

The main sections of this book on The Language of Color, Picture Taking, and The Subject concentrate entirely on the skills which will enable you to develop this interpretive strength in your pictures – the handling of color, the camera's control of the image, and the effects of light; the more abstract elements of balance, shape and line, repetition and emphasis; and the more concrete ones of the individual qualities of different subjects, and the expression of movement and space.

Color affects every element of photography, to a greater or lesser degree. In the early days, color was used merely to record reality; later it was treated as an extra dimension, grafted on to a basically black and white conception. But the two require quite different skills. In this book, every practical technique is considered in terms of color – from the effect of focusing or altering shutter speed, through the use of exposure and lighting, to the impact of color on composition, and so on. The information is illustrated with the work of many contemporary photographers, showing the widely differing ways color is used.

The problem with color is that it is overpowering. Color can flatten form, destroy shape, and confuse line, and the more colors you add, the more weaker elements are suppressed. The appeal of bright colors is also so strong that we often pursue them while ignoring the important matters of content and style – producing pictures that lack any further interest once the immediate impact of the color has passed. And whereas a black and white picture is by its nature an interpretation of reality, color by its realism tempts us to try to record the "true" colors of a scene.

**Ernst Haas**

Haas has conveyed all the excitement and tension of a rodeo in this impressionistic interpretation. By using a slow shutter speed with the camera held still, he has blurred color and line to convey a feeling of movement. The subject remains recognizable, and the warm colors are mingled without losing strength.

**Pete Turner** *over left*

In this picture, Turner has simplified and manipulated the tonal range to bring out shape and line, by means of special darkroom effects (see pp. 182–7). The flat areas of strong color and the simple graphic shapes are somewhat reminiscent of a poster.

**George Gerster** *over right*

Gerster's spectacular aerial view has reduced this ski marathon to an abstraction of colored lines and patterns.

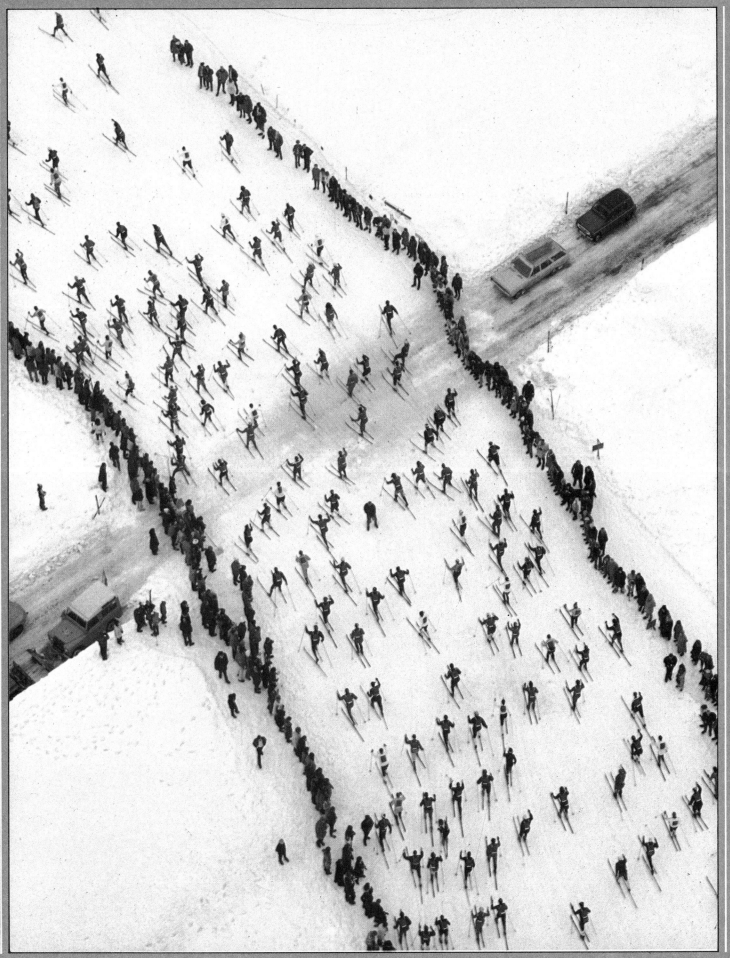

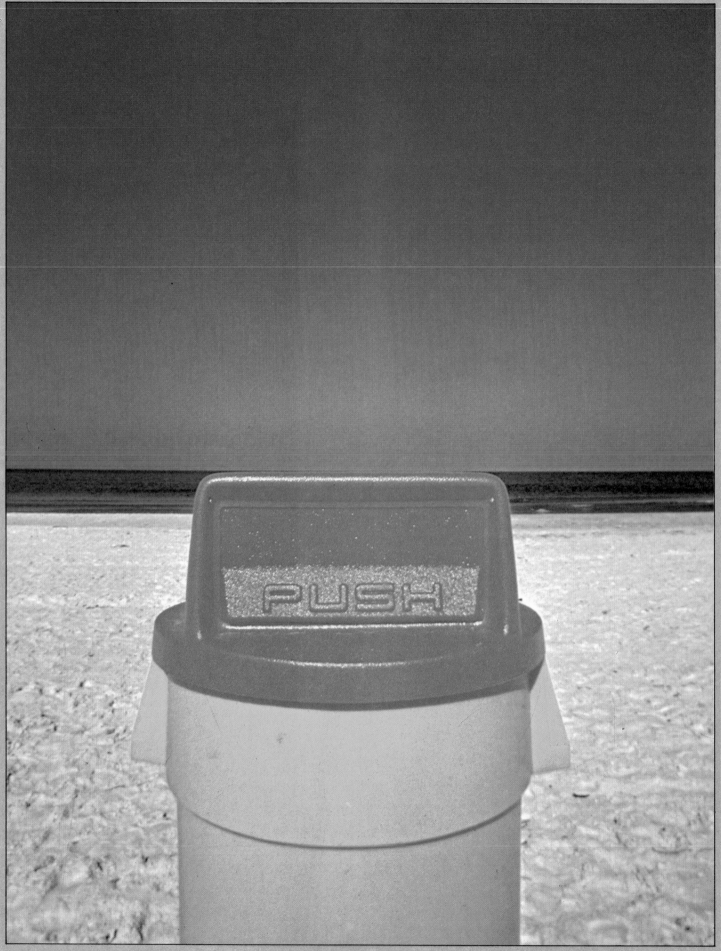

**Pete Turner** *left*
This picture is remarkable for its striking color contrast and its stark composition. Turner has used a low viewpoint and a neutral background to make the trash can stand out boldly in the foreground. Even the most ordinary object can provide an interesting subject for photography, if treated with skill and imagination.

**Ernst Haas** *below and over*
The semi-abstract landscape below shows how powerful a limited color range can be. Haas took his exposure reading from the sky only (see p. 96), eliminating detail and throwing the canyon walls into sharp silhouette.

In the cluttered street scene overleaf, by contrast, he uses numerous accents of bright color, set against neutral tones and the stormy dark background, to produce a jazzy, vibrant effect. A long lens compresses space, emphasizing the feeling of overcrowding.

But this very search for realism produces another difficulty – the colors of a scene alter radically with the changing effects of light, a fact we seldom notice. And every control on the camera will subtly affect the colors too – while color films will record each nuance and cast of light, each touch of color in shadow or reflection. For these reasons, results are often quite unexpected.

The true creative advantage of color is not realism, but eloquence. Color is passionate and sensual, appealing directly to our emotions. Its beauty can be a subject in itself, and it can convey different moods, or command attention. But it is never neutral – every time we see a color image it arouses in us some emotional response. To use color well, you must understand this emotional language, and apply it consciously.

The acknowledged master of color, Ernst Haas has said: "There are no color theories, and no color formulas. If you arrive at a formula, go against it". For Haas, this means employing color almost as a painter uses it, experimenting with a rich palette of effects. He will use slow exposures to blur action, so that colors are spread in mingled abstract forms across the print, or reduce a subject to stark color contrasts, or soft pastel whorls and spirals. Peter Turner takes the subjective use of color even further, however, exploring the borderline between reality and fantasy.

The photographs shown here draw on every area of interpretive skill, but they all have one important element in common – the simplicity of their images. Simplicity is essential to good color photography. You must strip your subject down to its barest essentials, using very few colors and bold images, so that the emotional, almost surreal qualities of color can dominate the picture without destroying it. The strongest color photographs are those in which you see the color first, and then the image, not the other way around.

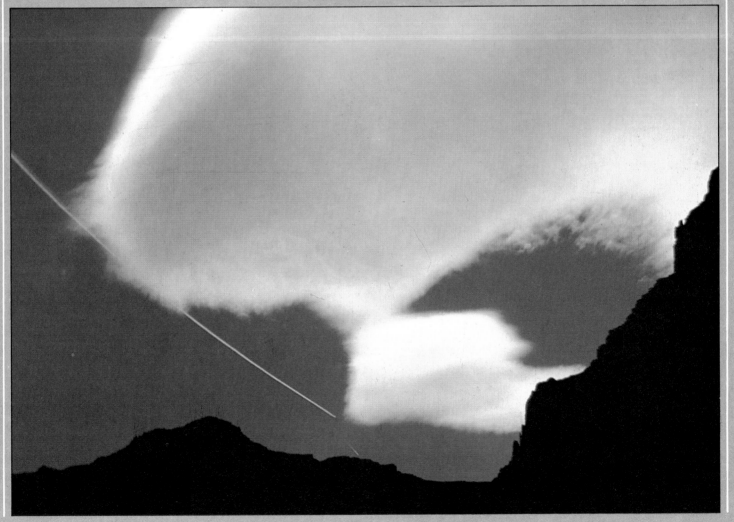

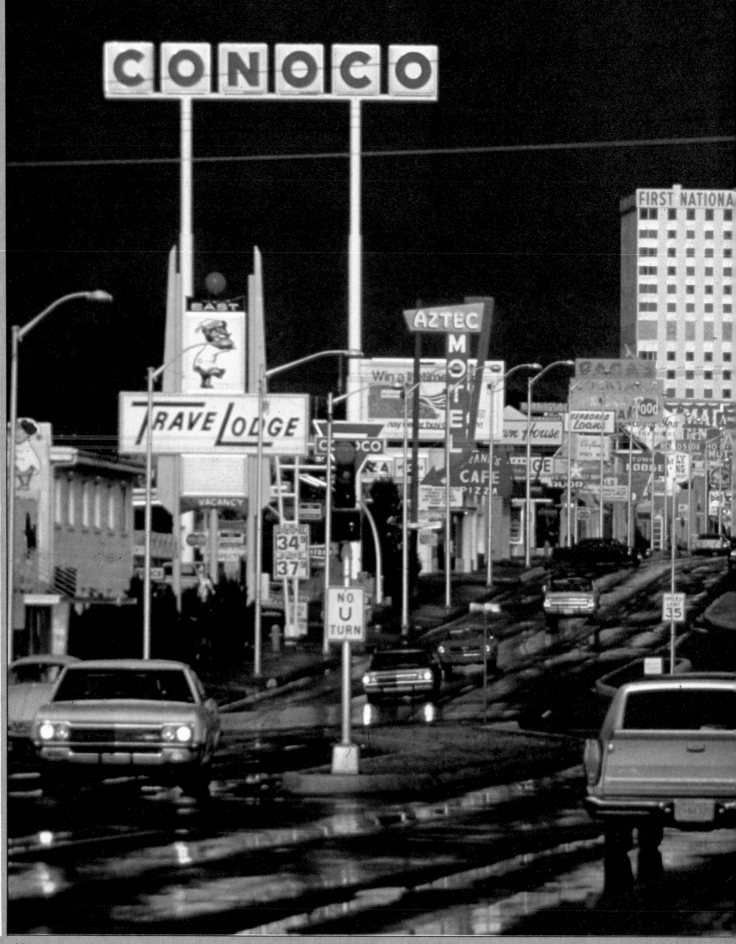

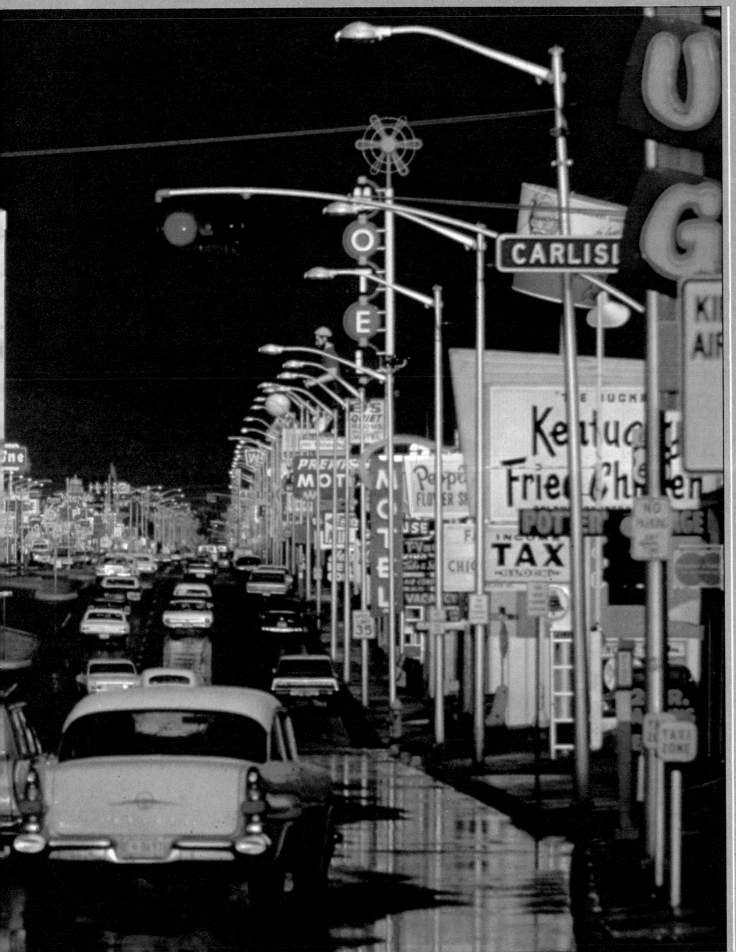

# 1 THE SEARCH FOR COLOR

To the pioneers of photography, the black and white image was merely a means to an end. Color was their aim, and color remained the incentive that was to sustain them through half a century of experiment. The search for color in photography evolved in two stages: first, the analysis and understanding of light; and second, the chemical and physical recording of light waves. Both involved great discoveries, bitter rivalries, and costly failures and led to the fulfillment of a prophecy. In 1907 the American photographer Alfred Stieglitz wrote: "Soon the world will be color mad". In 1977, more than six billion photographs were taken in color.

Color as a science began in 1666, when Isaac Newton conducted an experiment that proved to be "the most considerable detection which has hitherto been made in the operation of nature". This "detection" was the discovery of the solar spectrum – and the realization that all colors are present in light. In 1801, the scientist Thomas Young took color theory a step further. He suggested that light travels in waves, each wavelength value representing a specific color.

Young proposed that the eye interprets colors on a trichromatic principle, with three groups of nerve fibers. Each acts as a receptor for one of the primary colors, red, blue or green, and partially accepts the influence of the remaining two. Young also decided that the retina of the eye responds to light waves, the sensation of color depending on the frequency and length of each wave.

Much of Young's reasoning was speculative, and his published work lay forgotten for 50 years until discovered by the German scientist Hermann von Helmholz, in 1852. After rigorous experiment, Helmholz published the Young-Helmholz theory of color vision in 1888.

The basic principles of color theory were established by the mid nineteenth century. It was found that the three primary colors, red, green and blue, combine to make white light. Combining any two primaries gives a third color – red and green for example make yellow. This third color (yellow) is complementary to the remaining primary (blue)

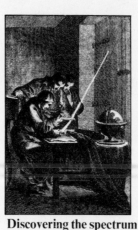

**Discovering the spectrum**

This contemporary copper engraving shows Isaac Newton's crucial experiment of 1666. Newton discovered that a beam of sunlight (white light) passed through a glass prism splits into seven component colors – the solar spectrum; and that the colored "rays", as he called them, could be directed through a second prism to recombine again into white light. His experiment proved that the colors come from the light itself, not from the prism.

**The first photograph**

Joseph Nicephore Niépce produced the world's first black and white photograph, at Châlon-sur-Saône, in 1827 – using an 8 hour exposure on pewter coated with bitumen and silver salts. Yet in 1816 he wrote: "I need to arrive at some way of fixing the color, that is what is concerning me at the moment, and it is the thing which is the most difficult. Without that it would not be worth anything." For the photographic pioneers the black and white picture was always a staging post on the road to color.

because together they make white light. Colored objects absorb or reflect different wavelengths according to their nature.

Important though these theories were, the progress of photography, in black and white or color, depended on a single element – silver. Were silver salts without that peculiar property of turning black when exposed to light, there would be no photography. In 1777, a Swedish chemist, Carl Scheele, found that silver chloride (a silver halide) responded selectively to light waves, being particularly sensitive to the violet end of the spectrum.

The first monochrome photograph was taken in 1827. By the mid nineteenth century, several scientists had succeeded in obtaining limited color images on hydrous silver chloride, by exposure to light through a prism. But none of them could fix the image permanently. Abel Niépce de St Victor and Edmond Bequerel, however, had some success: St Victor stabilized his color images with a varnish; Bequerel silvered plates by electrolysis.

An army of Saturday photographers stained their fingers in makeshift darkrooms, after a London sculptor, Frederick Scott Archer, perfected the fast, wet collodion plate for monochrome photographs, in 1851. Collodion was a by-product of gun-cotton, spread on a glass plate, dipped in silver nitrate solution and exposed while still wet. The collodion plate was a useful basis for color experiments.

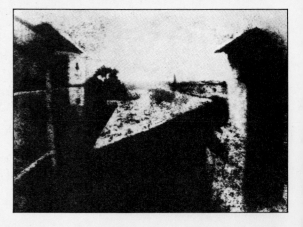

The first true color photograph passed almost unnoticed. It was made, not by a photographer, but by a Scottish scientist, James Clerk Maxwell. In 1861, Maxwell used the young medium of photography to demonstrate a physical principle – that all colors could be made by mixing the primary colors. This principle became known as additive synthesis.

Maxwell and his assistant, Thomas Sutton, chose a subject containing the right colors – a tartan ribbon – and Sutton photographed it on three collodion plates, exposing each through a different primary filter. In the lecture theater of the Royal Institution, London, they set up three projectors, each carrying a positive plate made from one negative, and a color filter, and all aligned so that the images reached a screen in register. The result was a crude but recognizable color picture of the ribbon.

In the years that followed, photographers began to wonder if Maxwell guarded some secret formula: how had he managed to obtain a three-color image, when collodion was insensitive to red and green? Tests by Kodak researchers in 1961 suggest that the red dye in the ribbon was fluorescent, and recorded on the plate by infra-red waves, while the blue-sensitive plate passed some green light.

In 1869, Charles Cros, a French poet, and Louis Ducos du Hauron, a French pianist, simultaneously announced a "subtractive" system of photography. So, apparently, did Frederick Ives of Philadelphia, who invented half-tone printing. Cros and du Hauron outlined the additive synthesis of primary lights, and proposed a new principle – that *pigments* gave color not by addition, but by *subtraction*, that is by absorbing (subtracting) from white light all

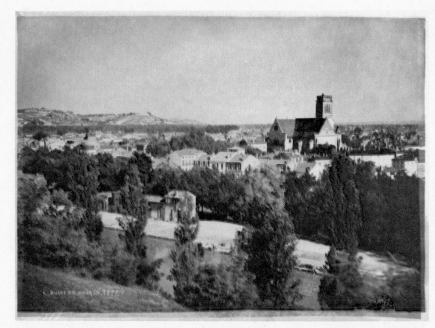

wavelengths save their own color. By superimposing pigments so they progressively subtracted colors, a color image could be reproduced. For this subtraction, primary colors would not work – the three layers had to be in complementary colors.

Du Hauron published the theory, with others, in *Les Couleurs en Photographie, Solution du Problème*. He also introduced his carbon process in which three negatives, separated through primary filters, were turned to positives on gels containing carbon pigments in complementary colors; these were overlaid to give a subtractive color print.

**Ducos du Hauron's early subtractive landscape**

This photograph was taken by du Hauron in 1877, using his carbon process. He made three exposures, through primary orange/red, green, and blue/violet filters, and produced complementary positives on gels dyed light blue, red and yellow, which he then superimposed. The long exposures required limited du Hauron's subjects to still life, landscape, or persons asleep.

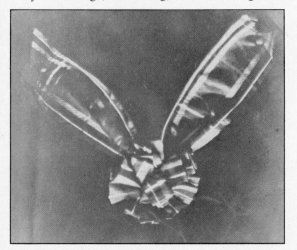

**Maxwell's first color photograph**

The Scottish scientist James Clerk Maxwell chose a national symbol, a tartan ribbon featuring the three primaries, to be the subject of the world's first true color photograph. He made three separate positive transparencies on collodion plates. Then he placed these positives together with three color filters in three carefully aligned projectors to produce this historic picture. The additive process Maxwell demonstrated in 1861 dominated color photography until the arrival of the simple subtractive tripack in 1935.

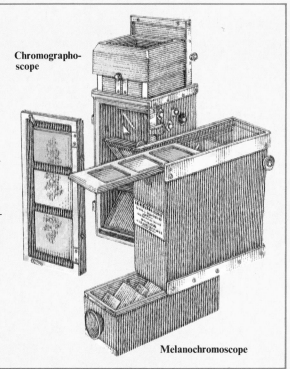

**Ducos du Hauron's early cameras**

The two cameras in this photograph were both invented by the subtractive theorist, Louis Ducos du Hauron.

The Chromographoscope, top, was patented in 1874 and first built in 1879. The camera takes three separation negatives on a single plate. A series of mirrors transmit the picture through the filters on to a photographic plate. The camera can also be used as a viewer for the color transparencies it produces.

The Melanochromoscope, bottom, patented in 1899, expanded on Frederick Ives' Kromskop process of 1892. Mirrors reflect light upward through blue, yellow and red filters to produce a color photograph from the black and white negatives.

**Chromographoscope**

**Melanochromoscope**

By 1870 there were two distinct directions in the search for color – additive synthesis, and the subtractive theory. Each had different applications. The additive principle only applies to mixing colored lights – since it is the combination of two wavelengths that creates the sensation of a third color: red and green make yellow, red and blue make magenta, and blue and green make cyan.

These new colors are the subtractive primaries – like additive primaries, two of them will combine to make a new color. But subtractive primaries do this by superimposition. Place a yellow and magenta filter so they overlap, and you have three colors, see right. You cannot do this with additive colors. Where a red and green filter overlap, the red filter blocks blue and green, and the green one blocks red and blue, so they cancel each other out, and you get black. So the additive primaries cannot be sandwiched together to make a color image.

Subtractive colors, on the other hand, can be overlaid to create a colored image, because each absorbs or "subtracts" only one color from light, allowing the other two to pass. The subtractive principle, however, was discovered far in advance of any viable practical application in photography. Until the invention of the subtractive tripack in 1935, additive synthesis remained the basis of all the widely used, practical forms of color photography.

Color photography had begun, but there were still many problems to be overcome, in particular the insensitivity of collodion to all colors other than blue. 1873 proved to be a vintage year when Dr Hermann Vogel showed that sensitivity to green could be obtained by adding dyes to the emulsion. In the same year John Burgess swept aside the messy, wet collodion process and launched the dry, gelatin plate on the market. This new plate was very fast, and a good base for dye experiments. Over the next decade Dr Vogel and others improved their "orthochromatic" plate, using the newly developed aniline dyes that could sensitize emulsions to wavelengths from violet, through green, and as far along the spectrum as orange.

Toward the end of the century color picture techniques arrived at a fast pace. In 1891 Gabriel Lippman, a professor of physics at the Sorbonne, invented his "Interference" process which created some of the most perfect and accurate color photographs ever made. The Lippman plate consisted of an extremely fine-grained emulsion spread on glass. The emulsion was in contact with a mirror surface of mercury, which was removed after exposure. Lippman's method employed the phenomena of "standing" waves of light: these are produced when the light waves returning from a reflecting surface (the mercury) collide with the arriving, direct light waves, thus causing the waves to stand still at the meeting point.

If standing waves are created in a photographic emulsion, the silver halides (salts) are exposed (and

## Additive synthesis

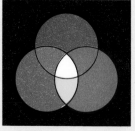

Primary colored lights, projected separately, can combine to form any color. All three together make white light. Mixed in pairs they make three new colors – cyan (blue/green), magenta (blue/red) and yellow (red/green). Additive primaries cannot be overlaid to form colors – they must be separated in a screen.

## Subtractive filters

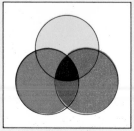

Cyan, magenta and yellow are also subtractive primaries. They can be overlaid as filters to form a colored image. All three give black, subtracting all light. Two give a new color – cyan and magenta, for example, give blue (cyan subtracts red, magenta subtracts green, but both transmit blue).

darkened) wherever wavecrests or troughs occur. Since wave frequencies vary according to color, a physical record of the color is established in the emulsion, as a multi-layered silver image, which can be developed and fixed. The plate must be viewed by white light, which is reflected back to the viewer from the silver layers, each layer transmitting the color wavelength of the original exposure. Lippman's process was, however, never practical, as emulsions were extremely slow, and you had to view the picture from a direct frontal position to catch the reflection – the effect is the same as that seen in mother of pearl.

It seemed that Maxwell's additive synthesis held the most promise for the future of color photography. In America, Frederick Ives designed a camera, the Kromskop, that took three negatives on one plate, using color filters and a reflex system of prisms and mirrors. Ives' combined plate, the "Kromogram", never became commercially viable, however. The search for a color process as convenient as black and white photography now led to a promising newcomer – the screen plate.

In *Les Couleurs en Photographie*, the inventive Ducos du Hauron suggested arranging additive color filters across the surface of a glass plate in such a way that they could pass wavelengths of light on to an emulsion. This would allow a single, compact color plate to be used in a conventional camera. The first screen plates were produced by a Dublin professor, John Joly. In 1894 he showed screen plates bearing a network of fine lines of orange-red, blue and blue-green inks. The screen was coupled to an orthochromatic plate and exposed in the camera. This gave Joly a black and white negative, from which he obtained a positive black and white transparency by contact printing on glass. The positive and a second screen inked red, green and blue-violet were fitted together in exact register, to be viewed against the light or projected.

## McDonough's additive screen and photograph

The early additive photograph, left, was taken by an American, James McDonough, in 1894, using the regular ruled screen shown ×50, below. In the original picture, the tomatoes were orange-red; but the screen has shifted and this color cannot be reproduced.

Joly's results, though acceptable, had the drawback of limited color, owing to the lack of a satisfactory emulsion sensitive to the entire visible spectrum. What photographers now wanted to see was red! A Kodak manual of this time urged that "as much red should be recorded as possible". Again, help arrived from Germany, where such firms as Agfa led the world dye industry. Dr Benno Homolka, a chemist at Farbewerke Hoechst, found a new dye, Pinacyanol, that proved an excellent red sensitizer. Homolka also made another discovery which had considerable significance for the future of photography – that some chemicals could be converted to dyes during photographic development.

Pinacyanol was first used by the small firm of Wratten and Wainwright in London, who were noted for the quality of their dry plates – they were produced in Mrs Wratten's kitchen, where she made the emulsions in a teapot and poured the gelatin through the spout on to the glass. The plates were bathed in Pinacyanol, and Wratten's (where nobody cared for the tea!) finally marketed their new "panchromatic" plates.

The twentieth century got off to an encouraging start when the Lumière brothers, using the new panchromatic emulsion, patented their Autochrome screen plate, in 1904. Three years later, Auguste and Louis launched the new plates to an enthusiastic response. The photographer Alfred Stieglitz wrote to the editor of *Photography*, in London: "the pictures are so startlingly true that they surpass anyone's keenest expectations".

The Autochrome plate was a mosaic of microscopic, transparent grains of potato starch, about four million to the square inch, dyed orange-red, green and blue-violet. These acted as color filters, scattered on to adhesive on a glass plate, and compressed to a single layer, the gaps being filled with carbon black. The surface was varnished, and the screen coated with a panchromatic emulsion. After exposure through the screen base, the picture was developed, and re-exposed to make a positive.

Lumière's screen plate marked the birth of color photography as a popular medium. Stieglitz' prediction that the world would go "color mad" was not far wrong. The screen plate also began the development of color photography as a creative art. Auguste and Louis were themselves keen photographers, and pioneers of the cinema. In their Autochromes, the handling of color, imagery and mood bears comparison with many modern pictures, within the limits of the technique. They were soon followed by others – among them Stieglitz himself, and another American, Edward Steichen.

Other screen plates of varied designs appeared. Some screens were "random", like Autochromes, with scattered grains of starch or gelatin. Others were "regular", variations of Joly's screen of 1894, the geometric designs being printed by machine. Screen and plate could be separable, or combined.

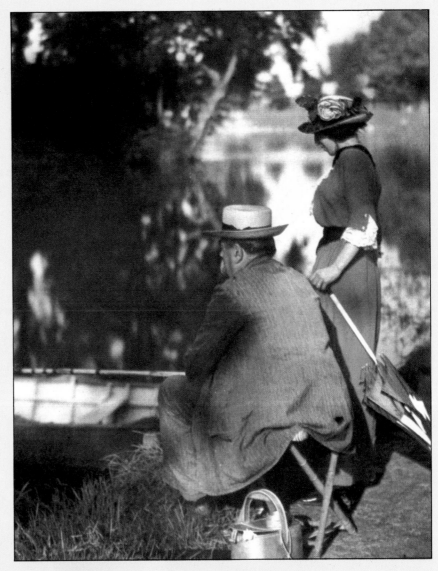

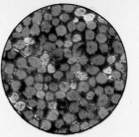

### Lumière Autochrome

This lake scene was taken by one of the Lumière brothers on an Autochrome plate. The screen is shown magnified × approximately 60, left, and a plate pack is shown below. By 1913, Auguste and Louis were manufacturing 6000 plates a day. The Autochrome saw the birth of color photography as a popular medium.

### Jougla's plate pack *below*

This pack was used to market an additive screen plate made by Jougla. It was a combined plate, with the emulsion surface bound permanently in contact with the screen.

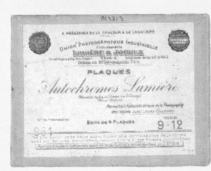

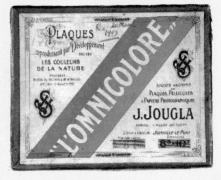

Although the new screens were a great improvement on previous color techniques, they shared several problems: low sensitivity, lack of contrast, and too much density. Photographers found, for example, that the carbon and starch grains of Autochrome plates absorbed much of the light. But the generally muted, low key color gave very soft, beautiful pictures.

Additive screen photography flourished in the early twentieth century – in fact Autochromes remained in production until 1932, Excellent subtractive plates had been produced from the 1900's onward – color was strong, as no filters were needed. But commercial development was a long way off.

Early subtractive photographs depended on the use of bichromated gelatin. It was Fox Talbot who discovered (in the mid nineteenth century) that gelatin treated with potassium bichromate would harden if exposed to light. If it was exposed to a negative, and the unhardened areas washed away, a positive image remained, in relief. Ducos du Hauron had used gelatin in his carbon process.

### Autochromes by Stieglitz and Galsworthy

Alfred Stieglitz took the portrait of his daughter Kitty, below, on an Autochrome screen plate. The muted color of the Autochrome enhances the pensive, romantic mood. Portraiture was a very popular subject for early color photographers.

The Autochrome process was used for this portrait of a soldier, taken by Olive Edith Galsworthy, a professional portrait photographer in the early 1900's. The soldier's vivid uniform shows the quality of red obtained with the new Pinacyanol dye.

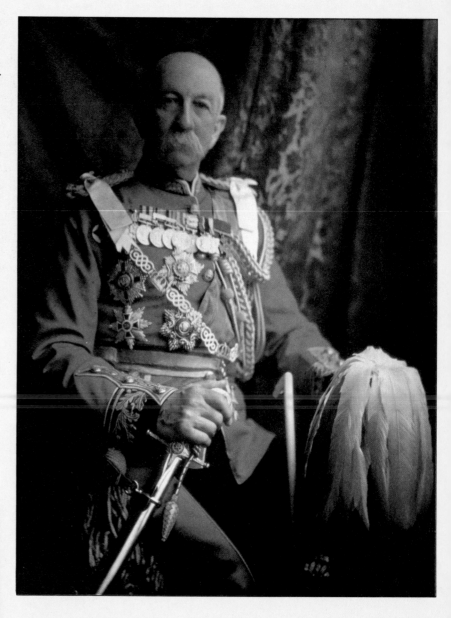

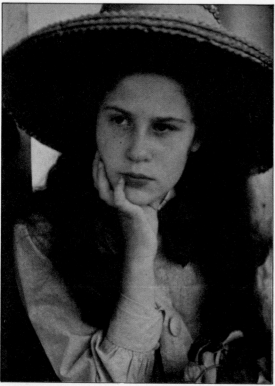

### The Graphostereochrome

This French camera, invented by the Abbé Tauleigne, was able to take either a 4 × 6 ins color photograph or stereoscopic pairs. Autochrome, Dioptichrome or Omnicolore plates could be used.

### Dufay's Dioptichrome

Louis Dufay's Dioptichrome plate pack, produced in 1910, was a geometrical screen plate. The Dioptichrome was not as dense as the Autochrome, and therefore color saturation was better.

### Fenske's Aurora

The additive screen shown magnified ×50, above, is Fenske's Aurora, a random screen like Lumière's Autochrome. Fenske's process never became commercial, since it used a separate negative plate, which led to registration problems with the screen.

### Agfacolor random screen

This Agfacolor screen, shown magnified ×50, is also a random additive screen like Lumière's Autochrome and Fenske's Aurora. The Agfacolor process left no gaps between the starch grains; the effect was a finer and richer color than the Autochrome.

Experiments with these bichromated gelatin tissues led to the invention of the Pinatype, or "imbibition" print. In this process, the dyed gelatin was used to transfer the dye images on to paper to form a print: the density of the dye depended on the relative hardness of the gelatin. Pinatype prints were a by-product of du Hauron's carbon process.

So too was Thomas Manly's "Ozobrome" or "carbro" process, introduced in 1905. Manly's technique was based on the discovery, by Howard Farmer, that gelatin hardened when placed in contact with silver bromide, and in proportion to the density of the silver. Gelatin tissue could therefore be presented to a bromide negative, pressed in contact, the silver then bleached away, and the resulting relief positive image dyed. Bleaching a silver image, and forming an image by bleaching away a proportion of dye, were fundamental to the evolution of subtractive photography.

The Lumière brothers, while perfecting their Autochrome plate, turned their attention to this form of color photography. In England, E. Sanger-Shephard made an early subtractive transparency with gelatin tissues containing silver bromide. These were exposed to separation negatives before being dyed. The tissues were bound in register between glass, giving a fine quality transparency.

Lumière's subtractive plate took some ten hours to assemble, however, whereas the additive screen could be mass-produced. Since screen plates were widely available, a color paper which could make a contact print from one seemed a promising idea. In 1909, Dr J. H. Smith introduced Utocolor paper – a carbon tissue treated with dyes that would turn the color to which they were exposed. Unfortunately, the paper had to be bleached by long exposure to sunlight, which also bleached the screen.

### Paget color plates

The photograph, above, was taken with Paget's separable regular screen plate, shown magnified ×50 right. The Paget plate pack in the picture below was first marketed in 1913. In comparison to Autochrome screens, much shorter exposures were possible with Paget's plates, but the colors were not so rich.

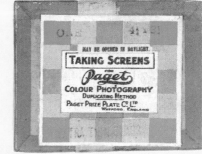

### Jos-Pe camera

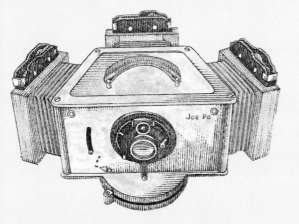

To meet the need for a compact camera for additive color photography, this three-color camera was produced in 1925. The Jos-Pe was named after its German inventor, Jos P. Welker. A beam-splitting system using prisms behind the lens, directed light on to three plates through color filters. A single focusing control moved all three plates simultaneously. Three color separation negatives could be produced in one exposure by this process.

### Sanger and Jumeaux subtractive pictures

The early subtractive photograph below was produced by the Sanger-Shephard process of 1899. Like Lumière's imbibition prints, the Sanger-Shephard process used bicromated gelatin film. As you can see, the gelatin has since shrunk and split, showing the three dye layers clearly.

The subtractive photograph below, was made by Jumeaux in 1904. Color saturation is stronger than in contemporary additive photographs, because of the absence of a viewing screen. Still life was a good subject for early subtractive photography because of the long exposures required.

In the first decade of the 1900's, the opening moves that led to the supremacy of subtractive tripack films were being played out. While on a visit to England, George Eastman, the head of Kodak, was shown the progress being made at Wratten and Wainwright on panchromatic plates and color filters. The tour was conducted by Wratten's brilliant research chemist, Kenneth Mees. Eastman was very impressed, and promptly absorbed Wratten and Wainwright into the Kodak empire, sending Mees to America to organize the Kodak research laboratory. Mees was later to aid and encourage Mannes and Godowsky, the inventors of the first successful tripack color film.

Research into the tripack began in 1905, when it occurred to a German chemist, Karl Schnitzel, that a solution to the practical problem of color film might be to add the three subtractive colors to three superimposed emulsion layers on one base, each layer being sensitized to one color of light. The dyes would be linked in some way to the three silver halide images, which could then be bleached out along with unwanted areas of dye.

At first, bleaching proved impracticable. But the tripack idea was furthered in 1912 by Rudolph Fischer, who hit upon the notion of color "couplers" that would link dye molecules to the developed halides. Fischer found that a substance called paraphenyenediamine oxidized while reducing silver halides to metallic silver. He also found that if certain reagents were then introduced to the now reactive paraphenyenediamine, they at once formed insoluble dye molecules. An even more encouraging fact emerged – the dyes formed only where the halides were converted to black silver. It proved to be simple to bleach out the silver image, so that only the subtractive dye image remained: the main difficulty lay in the fact that the dye molecules

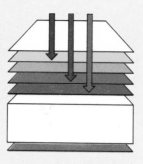

### The tripack principle

Modern color films are based on the tripack principle. Three layers of silver halide emulsions are sandwiched on a base. The top layer responds to blue light and receives yellow dye in processing; beneath it a yellow filter prevents blue light penetrating further. The second layer responds to green light and receives magenta dye; the bottom layer responds to red light and receives cyan.

### Leica III, 1933

This satin-chromed, focal plane 35 mm Leica could give slow shutter speeds (1 second, 1/2, 1/4 and 1/8) in addition to the normal 1/20. Speeds were selected on the button to the left of the lens. This camera was developed for 35 mm black and white film, but it was readily adapted to the new color film with some lens improvements.

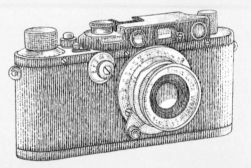

tended to wander from layer to layer through the film "sandwich". Fischer abandoned his research at this stage, unable to find the answer.

During World War I the movie industry experimented with Leon Gaumont's additive projection system, but results were poor. The challenge to perfect a color movie system was met by two Americans, Leopold Mannes and Leopold Godowsky. Mannes and Godowsky were professional musicians, pursuing their passion for photography and movies in their spare time. In 1933, aided by C. Kenneth Mees and Kodak laboratory technicians, Mannes and Godowsky produced an excellent two layer, two color subtractive film for the amateur home movie market, even though processing involved 28 steps. Their aim – a three color, three layer subtractive tripack – was almost within their reach, but they shared Fischer's vexing problem of the wandering dye couplers. The only way around the dilemma seemed to be to control the rate at which the couplers added during development diffused through the emulsion.

Whether or not the two great rival companies, Agfa and Kodak, were aware of a race to market the tripack film is arguable. But, by a bare six months, Kodak was the first to introduce tripack "reversal"

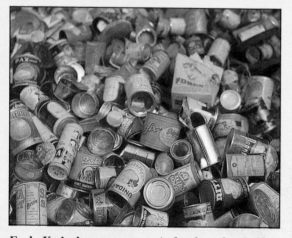

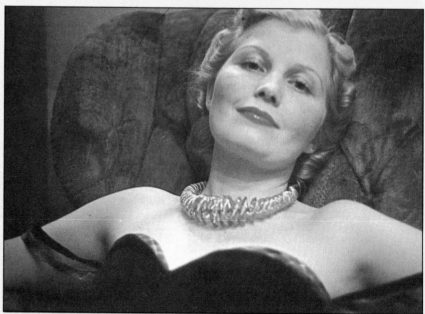

### Early Kodachrome snap

This snapshot of a garbage dump was taken on early Kodachrome tripack film in the late 1930's. Chosen for the wide color range, the subject was unusual for the period.

### Agfacolor tripack film

The newly available Agfacolor was used by Hitler's personal photographer, Hugo Jaeger, who took this shot, right. He achieved good results at speeds of 7 DIN.

film – so called because the silver image was reversed during development to form a positive, to which the dyes were coupled. The Kodak process required a complex operation after the film had been exposed and returned to the manufacturers, involving a controlled diffusion bleach and addition of dye-formers to the developing solution. Nevertheless, Kodak considered it practical enough to market. And so in April 1935, Kodak introduced a reversal color film in 16mm motion picture format, calling it Kodachrome after the now obsolete two-color film.

Meanwhile, at Agfa, a team of chemists anchored Fischer's roving dye-formers, or couplers, by a "ball and chain" of large molecules which arrested their freedom in the gelatin. The result was Agfa's "integral" tripack reversal film – with dye couplers built into the emulsion layers. The outcome was quite literally a photo finish, since both Kodak and Agfa launched reversal color film for 35mm still cameras (thoughtfully provided by Leica) in 1936. Agfa also announced a color negative process, but its release was delayed until 1950. The Agfa reversal tripack was also released in America in 1941, by Ansco, an associated company. Anscolor was used widely in World War II by the U.S. military.

Kodak and Agfa had met the needs of the amateur photographer for a simple, compact, color roll film to supersede the screen plate and cumbersome plate camera. Kodak users found nothing unusual in returning their exposed film to the makers for processing – most had done so ever since the early days of the box Brownie camera, prompted by the famous slogan of 1888: "You press the button and we do the rest". Agfacolor, with the ball-and-chain couplers that enabled dyes to be included in the emulsion, could be user-processed.

Revolutionary though the new films may have been at the time, no one cares to remember how slow they were. With an exposure rating of around 7 or 8 ASA, these first Agfa and Kodak tripacks were only marginally faster than the screen plates they superseded. Throughout the 1940s, however, film speeds steadily increased.

Although Kodak and Agfa were marketing slide films, the amateur photographer wanted color prints. Kodak researchers worked out a formula

**Tripack film cartons**

These small packs were used to market early tripack film. Each pack contained enough film for several exposures; they were much easier to

carry and use than the bulky additive screen plates. Kodak packs still bear the same symbol today.

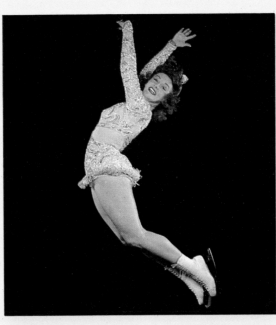

**Early flash color photo**

By the end of the 1940s, tripacks were more sensitive; so for the first time color photography could be used to freeze action. In this picture, an early form of flash was used to freeze the skater in mid-jump.

**Margaret Bourke White portrait**

This Kodak studio shot, taken in the 1940s, is typical of the period. The Kodak studios took many color portraits of famous people. Formal studio portraits were a legacy of art techniques. As films became faster, the formal shots gave way to informal portraits. The subject, Margaret Bourke White, was herself a well-known photographer.

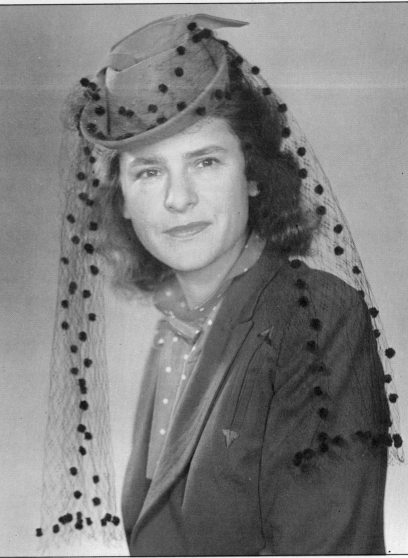

and special paper for making prints from Kodachrome slide film, which they named Kotavachrome. Even though it added 15 stages to the existing 18 stages inherent in Kodachrome development, Kotavachrome was about to be launched when the research team came up with a new negative/positive film – Kodacolor. It used a process similar to Agfa's: the errant dye couplers were imprisoned in organic, oily droplets in the emulsion. The technique produced Kodacolor in negative form, and Ektachrome in reversal.

Soon the big commercial users of screen plates switched to tripack film. Reportage work in color began during World War II, although film speeds remained slow. Fashion and advertising color photography exploded in the fifties, as the color era began.

The idea that film might be processed *instantly* to give a print was first suggested in 1940, by the young daughter of a prominent inventor and physicist, Dr

Edwin Land. Land, who had just founded the Polaroid Corporation for his research into polarized light, thought the idea worthy of fresh research. He took a close look at the chemistry of the silver image, and began a period of experiment that blossomed into a great and simple idea – as inventive in its way as Lippman's interference or today's holography.

Land produced a black and white film containing a pod of reagent. After exposure, pulling a tab broke the pod, and the reagent developed the silver negative. It also both dissolved and developed the *unexposed* halides. These "migrated" up to a receiving layer to form a black and white positive print. The revolutionary principle of image migration, producing instant photography, appeared almost miraculous when Land introduced it in 1947 to Boston, Massachusetts. It all seemed closer to sorcery than chemistry.

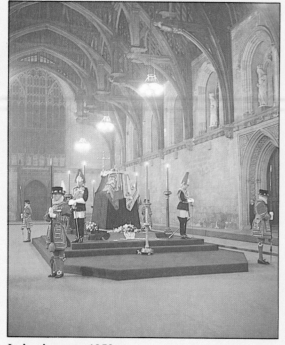

**Lying in state, 1952**
Tripack film was used for this photograph of the lying in state of King George VI of Britain in 1952. Notice how the long exposure needed on the rather slow film has produced slight color shift. High speed color films, capable of recording dimly lit interior scenes without excessively long exposures, have only become available very recently.

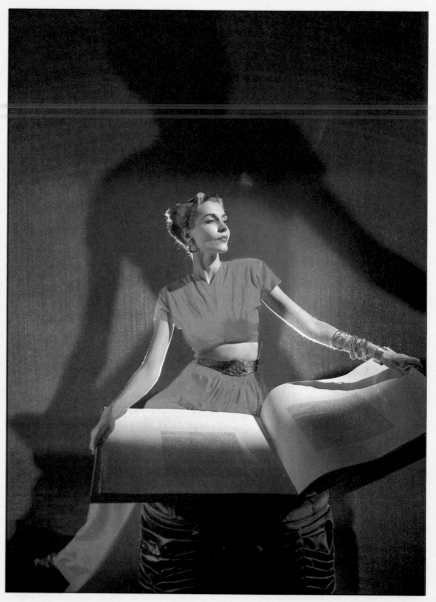

**Beaton portrait**
This large format photograph was taken in 1945, by the grand master of fashion photography and portraiture, Cecil Beaton. Fashion photography often took the lead in creative use of the new color film. Notice the stylized use of color and light, and the shadow echoing the models pose.

In 1963, further marvels were revealed when Land marketed a subtractive color dye transfer process, where dyes migrated through the layers to an image receiving base – Niépce would have loved it. The color film had red, green and blue sensitive layers (the basic tripack principle) represented by black and white image layers in contact with their respective color dyes, yellow, magenta and cyan. The developing reagents were again built in. Exposure and release of the reagents stabilized the silver negative and adjacent dyes. It also liberated dyes adjacent to the *unexposed* halides into solution, these dyes migrating through the pack to an image receiving layer, to form a positive image. The new films needed their own camera – the Land camera, which was an immediate success.

The last two decades have realized a huge market for color photography, and innovations have arrived thick and fast. Since the 1950's, chemists have made great progress on the speed of emulsions. Today we have superfast color films, at 400 ASA.

In 1963, Kodak provided amateur photographers with the Instamatic range, where films sealed in cartridges could be conveniently loaded into compact, inexpensive cameras. The 35 mm camera was greatly improved when computer-design of lenses made the inclusion of highly color-corrected lenses in medium priced models economic. The introduction of aspheric lenses, which correct color fringing, was a particular example. Perfection of injection-moulding, to produce precision plastic resin lenses for low-cost cameras, followed. The general direction of research is now toward lighter, more compact cameras, with more automatic features, and sophisticated electronic "fail safe" devices.

Kodak and Polaroid both have a range of instant picture cameras and films – Polaroid's SX-70 film, and Kodak's PR 10, are both complex, "one-step" instant color films. Polaroid has introduced sonar focusing, which uses ultrasonic pulses bounced off the subject to adjust focus automatically, and even an instant color movie film – Polavision.

### SX-70 model

This prototype of Polaroid's one-step instant picture camera was made in 1965.

### Instant color experiment

This early attempt was taken in 1955 during Land's trials. It was a three-color dye developer print from a negative constructed in stripes.

### Early and modern instant color pictures

Land's early attempts at instant color photography were mainly experimental dye images, like the 1951 picture, right. The full color picture above was taken by E. Catalano in 1977, using large-format Polacolor film. Note the rich, natural color and extreme sharpness obtained on today's film. The camera produces joined negative and positive sheets which are separated after 60 seconds. The Polacolor print is then ready.

The next obvious goal for photoscience is the three-dimensional image. The most promising 3D invention, holography, is in the tradition of Lippman's interference method, rather than the tripack. Holography, invented in 1948 by Denis Gabor, means the "whole" three-dimensional image, created by light. It depends on the pure, "coherent" monochromatic light of a laser beam.

The object to be recorded is illuminated by a laser beam split into two shafts – the "object beam", and the "reference beam". The object beam is transmitted via a deflecting mirror, through a lens and pinhole, to illuminate the object. The reference beam is directed by a mirror, lens and pinhole to meet the object beam in front of a photographic plate. The plate is coated with a special silver bromide – still the life blood of photographic processes. The overlapping beams set up an interference wavefront, which is recorded on the emulsion. The plate is then processed to obtain a reversal image, and the silver bleached out, leaving an image of transparent bromide crystals on the plate. When illuminated by laser or certain other forms of light, the crystal image produces an interference pattern of light, in three dimensions.

Russian scientists have already produced acceptable color holograms. Following the Russians' work, some researchers in Europe and the U.S. are combining the Lippman interference process with Gabor's theories, to produce a full color hologram that can be viewed in ordinary, incoherent white light.

Color photography will certainly undergo radical changes in the future – the tripack may give way to more direct means of registering an image. In the past decade, color photography has been applied to all the realms of science, producing many new techniques: sonography, the recording of sound waves; thermography, the recording of heat; infra-red film, which is also much used for creative imagery; color photography inside the body, or through the microscope and electron scanner or in outer space—like the computer-enhanced images opposite. With each discovery by photoscience, the search for color moves into new realms.

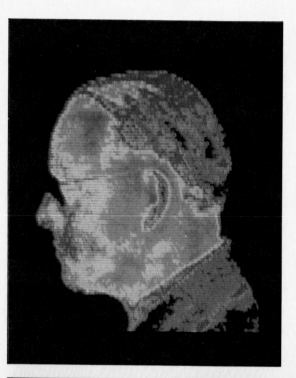

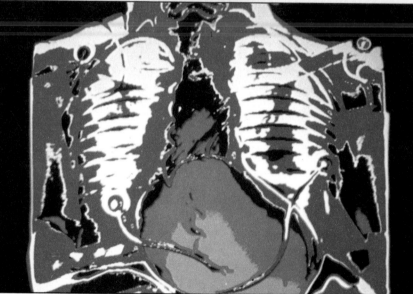

### Thermography and sonography

If an object is scanned with infra-red radiation, higher temperatures on its surface reflect more infra-red. This information can be displayed electronically on a video screen and then photographed on normal color film. The result is a false color image showing the heat contours of the object. With a face, the image is often recognizable, as in this thermograph by Howard Sochurek. But other subjects may not be recognizable.

Sonography is a similar technique: the object is scanned with ultrasonic sound, and the intensities of reflected sound are recorded as a computer-generated display on a video screen, which can be photographed. The false colors merely make the image clearer, as in the sonograph of human lungs by Howard Sochurek, below. Thermography and sonography are both used in medicine and industry.

### Holograms

These two photographs of a hologram in an exhibition were taken from different angles, to show the three-dimensional effect. Notice how you can see different parts of the subject in each shot, just as if the photographs were of a solid object, rather than a light image. The holograph plate is illuminated by laser light, or by mercury vapor or tungsten halogen; this reproduces the original object with an interference pattern of light, in three dimensions. As yet, holography cannot capture movement — subject movement destroys the interference image. But multiple holograms may simulate movement when you view them from different positions.

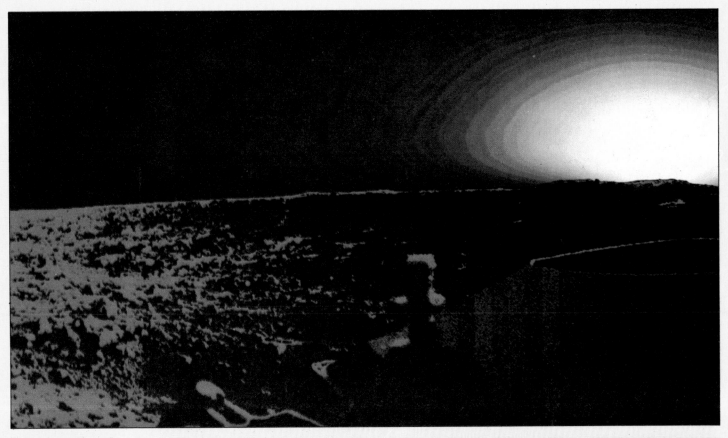

## Computer enhanced views of Mars

Computerized image-processing methods can be used to exaggerate subtle color differences among such things as clouds, atmospheric haze, frosts and rock materials. The picture above, taken by Viking I, is a Martian sunset over Chryse Planitia. The sky appears white near the sun position due to overexposure. The blue to red color variation is explained by a combination of scattering and absorption of sunlight by atmospheric particles. Darker materials, such as the earth and the rocks in the foreground, are represented by deep reds and blues. The most prominent feature in the foreground is a silhouette of the top of one of the Viking's power system covers, far right. In the picture, right, the violet background is an artifact representing black space and the Martian night. Bright materials, atmospheric hazes, surface frosts and bright deserts are represented by turquoise, whites and yellows. The giant Martian volcanoes, seen as dark red, are redder and darker than the yellow-orange plains materials which fill their floors and surround them.

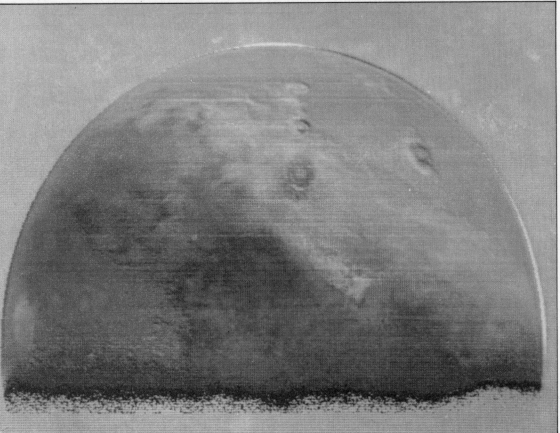

# 2 CAMERAS & FILMS

This section is designed to help you choose the equipment best suited to your photography. It defines the main types of camera, looks at single lens reflex, direct viewfinder, and instant picture cameras in more detail, and gives advice on building up your accessories to form a flexible system that will cope with a wide range of subjects. The second half of the section looks at modern color films – the different characteristics of prints, slides and instant pictures, and the choice of film speed, light balance, and brand to suit your subject.

A camera is an expensive item. Before buying one, always try out a similar model first if you can, checking each control for its ease of use, and flexibility. Make sure the camera suits the type of photography you expect from it, and buy the best quality you can afford. With experience, you will be able to judge what type of camera you prefer.

When you take a photograph, you are causing light reflected from your subject to form an image, which acts on sensitive chemicals in the film. The camera controls this action in many ways. The function of each control, and the various forms it may take, are presented simply here.

*Understanding the camera*

A modern camera must compactly house a shutter mechanism, lens and aperture, and perhaps include a light meter linked for automatic exposure, while allowing enough space for a viewing system and the film itself.

Camera size is related to the size, or *format* of the film accepted, and size in turn affects the kind of photography the camera is designed for. Pocket cameras are mostly intended for quick simple shots, large format cameras for studio work; while 35 mm cameras (the most widely used size) are light and compact, and offer the greatest versatility.

Camera design is also affected by the viewing system, which shows the area of view encompassed by the lens, and within the frame of your film. The two main types, direct (often with a rangefinder) and reflex or "through the lens", are discussed, with the cameras which use them, on pages 34–5.

**Light, camera and film**

Light reflected from the subject enters the camera through the lens, which converges the rays to pass through the open shutter, and the aperture ring (or *diaphragm*) which controls brightness, and form an upside-down, reversed image on the film. Light-sensitive chemicals in the film respond to different colors and intensities of light in the image, forming a latent image which can be developed to give the final color picture. The camera also has a viewing system to enable you to frame the subject.

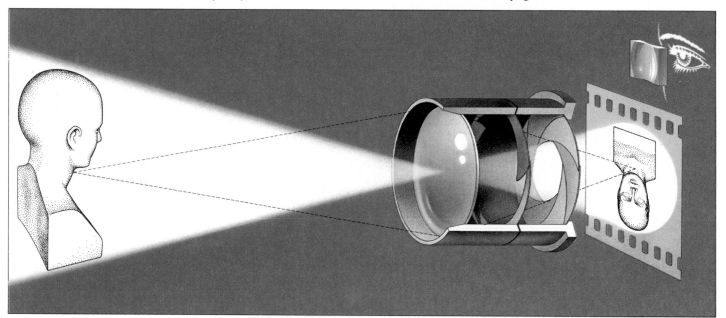

## Shutter types

The shutter controls the duration of the film's exposure to light. Today's mechanical or electronic shutters are capable of "speeds" (exposure times) of from several seconds to 1/1000 sec or less. Shutter speed affects both exposure (when combined with the aperture setting), and the way movement is recorded – sharp or blurred.

There are two main types of shutter: the *leaf shutter*, usually built in with the lens; and the *focal plane shutter*, located at the back of the camera just in front of the film, at the focal plane (see below). You will find leaf shutters on most simple cameras, while the focal plane shutter is an intrinsic part of the single lens reflex (p. 34). Between exposures, it seals the film against light so that you can remove the lens and replace it with another type, thus allowing a flexible interchangeable lens system.

## Lens function

Light waves reflected from your subject enter the camera through the lens, and its companion aperture. The aperture controls the amount or "intensity" of light entering, with a variable diaphragm that works like the iris of your eye. It is calibrated in f numbers, or "stops" (p. 86).

Modern color lenses are usually compound – constructed from a number of glass elements that together bend the light waves to meet at a specified point behind the lens, so forming a sharp image.

When a lens is set at infinity, light waves from all distant subjects converge to meet at the *focal point*. The plane on which the image comes into focus is the *focal plane*. In a camera, this plane is constant and the film is placed across it, to receive the image. The distance between the center of the lens and the focal point, measured in millimeters, constitutes the *focal length* of that lens.

## Focusing

Light waves from closer subjects converge into focus further behind the lens, at the *image plane*. For a sharp picture, this image plane must be brought to coincide with the focal plane, where the film lies – i.e. the camera must be focused. In focusing, the lens itself is moved to bring the image

## Shutter mechanisms

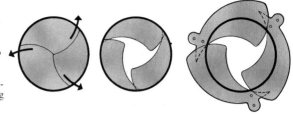

A metal leaf shutter, built into the lens body, operates as shown right. A focal plane shutter, below, consists of two traveling blinds. The frame-size aperture of the first blind is partly covered by the following blind, to form a slit moving across the film – the narrower the slit, the briefer the exposure. The whole frame is only uncovered at speeds below 1/60 (or 1/125) sec.

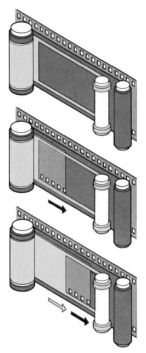

## Lens focus

A lens set at infinity brings light from distant subjects (rays traveling parallel, below) to focus at the focal plane. Light from nearer subjects arrives at the lens obliquely, and is brought to focus further behind it, at the image plane. To focus near subjects, the lens is brought forward until the image plane coincides with the focal plane, where the film lies.

plane for your chosen subject into line with the focal plane. You can easily observe this lens movement if you turn the focusing ring on a camera – the lens moves outward for closer subjects.

## Types of camera focusing

There are three main camera focusing types: fixed focus, fixed lens with variable focus, and interchangeable lens. Fixed focus cameras are the cheapest simplest type: the lens is immovable, and the aperture limited or fixed. This produces sharp focus from the horizon to a few feet away.

The great majority of cameras have a normal lens, with a variable focus ring, fixed into the camera body. Coupled with variable aperture, this allows selective focus and depth of field (pp. 87–91). The greatest flexibility is given by interchangeable lens cameras, such as the single lens reflex, which allows a choice of focal length.

## Focal length of lenses

The focal length of a lens determines its field of view and the size it shows an image in your frame. A *standard lens* gives an image size and field of view similar to what you see. A lens of shorter focal length covers a wider field of view – it is a *wide-angle lens* – but reduces image size in the frame. A *long focus* or *telephoto lens* enlarges distant objects, within a narrower field of view. The actual focal lengths concerned depend on the camera format. On a 35 mm camera, a standard lens is 50/55 mm, a wide-angle one from 18 to 35 mm, and a long focus one from 75 to 1000 mm or more. On a 110 camera, a standard lens is around 24 mm, and on a $2\frac{1}{4}$ ins$^2$ rollfilm camera, around 80 mm.

## Camera exposure systems

Most modern cameras have an exposure meter, either on the camera body to read subject brightness (electric eye), or inside the camera to read the image (TTL or integral meter). In either case, the meter may be linked to the exposure controls – aperture and shutter – and may display exposure information in the viewfinder, with a moving needle, or "LEDs" (Light Emitting Diodes). It may even program the exposure automatically.

Automatic systems are inflexible – you cannot choose settings to suit your subject. Aperture and/ or shutter "preferred" systems allow you to choose one setting. Manual operation (or automatic with manual override) is the most flexible.

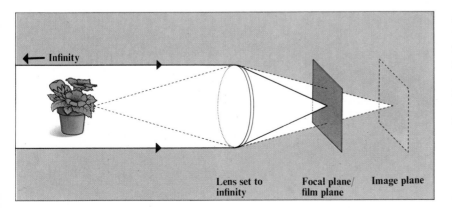

Infinity

Lens set to infinity

Focal plane/ film plane

Image plane

# CAMERAS FOR COLOR

Your choice of a camera for color photography depends, first of all, on how involved you want to become with the picture-taking process–whether you are satisfied with a "point and press" camera, for example, or enjoy the participation and creative judgment involved in SLR photography.

Four main factors vary in camera design: format, viewing system, cost, and flexibility of control. In this chart, cameras for color are divided by format and viewing system into five main ranges, the sixth being the instant picture cameras. Within each range, representative cameras are considered for cost and flexibility, and other makes suggested.

Whatever type of camera you choose, for good color pictures you must have a good lens. This is largely a matter of price: although higher quality generally goes with larger format, even the tiny 110 cameras give good results at the top of the range.

## Viewing and format

There are two main types of viewing systems in general use, reflex and direct viewfinder. SLR (single lens reflex) cameras (p. 34) view through the taking lens, showing you the image the camera "sees", while viewfinder cameras (p. 35) use instead a separate window to give you a bright view of the scene.

The size of the camera is determined by the format of the film, the most popular ones being 110 (16 mm) for pocket cameras, disc (15 frames per disc), 35 mm (135) for a wide range of viewfinder and SLR cameras, and $2\frac{1}{4}$ ins$^2$ (120 or 220) for expensive, high quality SLRs and the rarer TLR (twin lens reflex). The general trend today is toward lighter, more compact cameras, such as recent 35 mm SLR models, and the rapidly growing range of sophisticated 110 and disc cameras.

## Cost and flexibility

Inexpensive 110 or 126 cameras, such as Vivitar's 603 and Agfa's 2008, will give acceptable color pictures but offer little flexibility, as most have fixed focus and shutter speed. Medium priced models may include automatic exposure, integral metering, LED display (p. 93) coupled rangefinder (p. 35), and perhaps extra telephoto or close-up lens elements. Medium priced fixed-lens 35 mm viewfinder cameras, such as the compact Rollei 35S, offer similar advantages, with fully variable focusing.

The SLRs add greater flexibility and choice of focal length. Medium priced models include the 35 mm SLRs with their range of lenses and accessories, and the more limited newly introduced 110 SLRs. Highest in price and quality come certain $2\frac{1}{4}$ ins$^2$ rollfilm cameras, such as the SLR Hasselblad and TLR Mamiya C330f, and the Leica interchangeable lens 35 mm rangefinders.

Instant picture cameras offer immediacy and acceptable color quality. But film costs are still high, and flexibility is limited.

| Camera types | Construction | Uses and cost |
|---|---|---|
| **110**<br> | **Minolta 110 Zoom SLR** Pocket-size SLR, TTL viewing and metering. Automatic controls giving good color. Size: $2\frac{1}{8} \times 2\frac{3}{8} \times 4\frac{1}{8}$ ins ($55 \times 61 \times 105$ mm). **Agfamatic 2008** Lightweight viewfinder camera. Acceptable color. Size: $1\frac{1}{16} \times 2\frac{1}{16} \times 4\frac{7}{16}$ ins ($27 \times 53 \times 112$ mm). **Vivitar Tele 603** Integral flash and telephoto lens. Direct viewfinder. Acceptable color quality. Size: $1\frac{3}{16} \times 2\frac{1}{4} \times 6\frac{1}{2}$ ins ($30 \times 57 \times 165$ mm). | **Minolta** Versatile, multi-purpose camera. Accurate framing through a range of focal lengths. Medium price. **Agfa** Point-and-shoot pocket camera with very limited exposure control. Low price. **Vivitar** Point-and-shoot pocket camera with limited exposure control. Use of "tele" lens and built-in flash adds versatility. Low price. |
| **Kodak Disc 4000**<br> | **Disc** Slimline, bright viewfinder camera. Has autowinder, automatic exposure, and built-in automatic flash. Accepts easy-loading disc film. Size: $1\frac{1}{8} \times 3\frac{1}{8} \times 4\frac{11}{16}$ ins ($28 \times 80 \times 119$ mm). | **Disc** Extremely versatile low-price camera. Can handle virtually any lighting conditions due to automatic exposure and flash control. |
| **35 mm direct viewfinder**<br> | **Leica M4-2** 35 mm rangefinder camera with interchangeable lenses and a wide range of controls with optional TTL exposure metering. Excellent color quality. Size: $3 \times 1\frac{1}{4} \times 4\frac{3}{4}$ ins ($76 \times 32 \times 121$ mm). **Rollei 35S** Compact 35 mm viewfinder camera with a fixed, retractable lens. Built-in, coupled metering. Good color quality. Size: $2\frac{1}{2} \times 1\frac{5}{8} \times 4$ ins ($63 \times 41 \times 102$ mm). | **Leica** Unobtrusive, versatile, high performance camera. Accepts a range of different focal length lenses. Wide ranging controls. Expensive. **Rollei** Very small, able to handle a wide range of lighting conditions and easy to use. Medium price. No interchangeable lens facility. |
| **35 mm SLR**<br> | **Pentax MX** 35 mm SLR. Relatively small body with full range of controls. Interchangeable lens, viewing screen and camera back for data back or 250 exposure magazine. Excellent color quality. Size: $3\frac{1}{4} \times 2 \times 5\frac{5}{16}$ ins ($83 \times 50 \times 135$ mm). | **Pentax** Compact 35 mm SLR that offers great flexibility, and with its system of additional equipment, almost limitless scope. TTL metering coupled to very wide ranging controls give accurate results in most lighting conditions. Medium price/expensive. |
| **$2\frac{1}{4}$ ins$^2$**<br> | **Mamiya C330f** $2\frac{1}{4}$ ins$^2$ TLR. Rapid film crank and shutter cocking mechanism. Interchangeable lenses, viewing screen and camera back. Excellent color. Size: $6\frac{3}{4} \times 7 \times 4\frac{3}{8}$ ins ($172 \times 177 \times 111$ mm). **Hasselblad 2000 FC** $2\frac{1}{4}$ ins$^2$ SLR. Rapid film crank. Interchangeable lens, viewing screen and film back. Excellent color quality. Size $4\frac{1}{4} \times 7 \times 4\frac{3}{4}$ ins ($108 \times 177 \times 111$ mm). | **Mamiya** Popular among professionals, $2\frac{1}{4}$ ins$^2$ format gives fine definition. Obtrusive and not easy to use, but versatile and designed to minimize the inherent faults of TLR's. Expensive. **Hasselblad** Advantages of $2\frac{1}{4}$ ins$^2$ format with SLR viewing and sophisticated attachments giving top quality results in any photographic situation. Very expensive. |
| **Instant picture**<br> | **Kodak EK200** Instant picture viewfinder camera. Automatic exposure and picture ejection. Fair color quality. Size: $6\frac{3}{8} \times 4\frac{3}{4} \times 5$ ins ($162 \times 121 \times 127$ mm). **Polaroid SX70 Alpha I** Folding instant picture SLR camera. Automatic exposure and picture ejection. Fair color quality. Size: $5\frac{1}{4} \times 4 \times 7$ ins ($133 \times 102 \times 178$ mm) open. | **Kodak and Polaroid** Both cameras produce color prints in minutes–useful for trouble free "snaps", and for making tests before using sophisticated equipment on a special shot. Film packs are expensive, but the cameras are medium price. |

| Film | Focus control | Exposure control | Accessories | Other brands |
|---|---|---|---|---|
| All take 110 (16 mm) cartridge loading film. Both color print and color slide film are available. For prints (12 or 20 exposures), you have a choice of 80 or 100 ASA (and 400 ASA in USA), for slides there is only 64 ASA (20 exposures). | **Minolta** Fixed 25–50 mm f4/4.5 zoom lens. Focuses from just over 3 ft (1 m) to infinity. A switch-in macro lens element allows close-up focusing to 8¼ ins (21 cm). **Agfa** Fixed 26 mm f9.5 lens. Fixed focus giving acceptable sharpness from approx 4 ft (1.2 m) to infinity. **Vivitar** Fixed 24 mm f7 lens with optional 36 mm focal length (lens elements regrouped). | **Minolta** Aperture preferred TTL (CdS) automatic exposure control, giving some manual over-ride. Coupled to aperture range of f4.5 to f16 and an electronic, behind-the-lens shutter (1/10 to 1/1000 sec). **Agfa** Two manual exposure settings with aperture fixed at f9.5 and a choice of two shutter speed settings – 1/50, 1/110 sec. **Vivitar** One fixed exposure setting. Aperture f7, shutter speed 1/125 sec. | **Minolta** "Auto Electroflash 25" flash unit. Rubber lens hood. Filters. Eyepiece correction lenses. Cable release. Soft case and wrist strap. **Agfa** "Topflash" bar of eight flash bulbs, or screw-on Lux 234 electronic flash unit. Natarix Agfamatic close-up attachment kit. Case and wrist strap. **Vivitar** Wrist strap. | Canon 110ED Fujica 350 zoom Kodak Ektra (handle) range Minolta 250 Minox 110S Voigtlander V110 Asahi Pentax Auto 110 |
| Takes disc cartridge-loading film. Disc-type cameras and film are now made by several manufacturers. Kodak supply VR disc film for color prints 200 ASA/24 DIN. | **Disc** 12.5 mm f 2.8, 4 element glass lens, fixed focus. Provides good sharp pictures from 4 ft (1.2 m) to infinity. Flash will cover from 1.2 to 5.5 m (4 to 18 ft) in low lighting conditions. | **Disc** Automatic exposure control with electronically controlled shutter. Exposure ranges from 1/200 sec at f6 to 1/100 sec at f2.8. Flash automatically fires in low lighting conditions. | **Disc** Model 2 has a camera case. | Kodak Disc cameras 3500, 6000, 8000 Minolta Disc cameras |
| Both cameras take 35 mm cassette loading film for prints or for slides. A complete range of color cassette film from 25 to 400 ASA is readily available. | **Leica** Interchangeable 50 mm f1.4 lens which focuses from 2¾ ft (0.83 m) to infinity. Uses double image rangefinder with split image aid and parallax compensation. **Rollei** Fixed 40 mm f2.8 lens which focuses from 3 ft (0.9 m) to infinity. Incorporated viewfinder parallax correction. | **Leica** Aperture – f1.4–f16 (50 mm standard lens), shutter speeds from 1 to 1/1000 sec. Optional leicameter attachment for aimed exposure measurement. **Rollei** Automatic CdS exposure control with a choice of aperture or shutter preferred. Coupled to f2.8–f22 aperture (⅓ stop increments) and leaf shutter with speeds from ½ sec to 1/500 sec. | **Leica** All Leica M lenses. MR metering attachment. Electronic flash system. Lens hoods and filters. Supplementary finders. Tripods. Soft case, wrist strap. **Rollei** Lens attachments to vary focal length. Range of electronic or bulbflash units. Lens hood. Range of filters. Tripods. Neck strap and carrying case. | Canon A35F Cosina 35S Konica C35AF Olympus Trip 35, XA Ricoh 35EF Yashica "Auto Focus" |
| Takes 35 mm cassette loading film for prints or for slides. A complete range of color cassette film from 25 to 400 ASA is readily available. | **Pentax** Choice of interchangeable standard lenses – 40 mm f2.8, 50 mm f1.4 and 50 mm f1.7. These have closest focusing at 2 ft (0.6 m), 1½ ft (0.45 m) and again 1½ ft (0.45 m) respectively. Focus is judged through the taking lens itself. | **Pentax** TTL metering (GPD cells) coupled to apertures from f2.8 to f22 (40 mm standard lens) and focal plane shutter with speeds from 1 sec to 1/1000 sec. | **Pentax** Wide range of interchangeable lenses and accessories available for all types of photography. Check manufacturer's literature for details. | Canon F-I, AE-I Fujica ST 801 Konica T4 Leicaflex SL2 Minolta XG-2 Nikkormat FM Nikon F2, F2AS Olympus OM-1 Yashica FR |
| Both cameras are designed to take 620 or 120 roll film giving negatives or slides 2¼ × 2¼ ins (6 × 6 cm), or, by changing film backs, 6 × 7 cm. The Hasselblad also takes an instant picture film back. | **Mamiya** Interchangeable 80 mm f2.8 twin lens panel. Focuses from 7 ins (17.8 cm) to infinity using a rack and pinion mechanism. The standard waist-level screen can be changed for an eye-level viewer that corrects the reversed image. **Hasselblad** Interchangeable 80 mm f2.8 lens which focuses from 2 ft (0.6 m) to infinity. Eye level viewing attachment. | **Mamiya** Manual setting. Aperture – f2.8 to f32 (standard lens). Between-the-lens shutter has speeds from 1 sec to 1/500 sec. **Hasselblad** Manual setting. Patent diaphragm giving apertures from f2.8 to f22 (standard lens). Electronic focal plane shutter, speeds from 1 sec to 1/2000 sec. | Both cameras have a very wide range of interchangeable lenses and accessories for all types of photography. Check the manufacturer's literature for details. | Bronica ETR Mamiya RB-67S Rolleicord Rolleiflex SLX, T |
| **Kodak** Uses pr10 150 ASA film packs, giving ten 3 9/16 × 2¾ ins (9 × 7 cm) prints. These are both dry process films. Peelapart films available are: polacolor 88 (8 square prints) and polacolor 108 (8 rectangular prints). Both are 75 ASA. **Polaroid** Uses SX70 125 ASA film packs, giving ten 3¼ × 3¼ ins (8 × 8 cm) prints. | **Kodak** Fixed 200 mm f11 lens that focuses from 3½ ft (1 m) to infinity. An additional focusing slide is linked to a finder circle in the viewfinder. **Polaroid** Fixed 116 mm f4 lens that focuses from 10 in (25.4 cm) to infinity. Focus is changed on a dial and is judged through the taking lens. There is a split image aid. | **Kodak** Automatic exposure (CdS) sets exposure combination from apertures f11 or f16 and shutter speeds from 1/20 sec to 1/300 sec. Darken and lighten control. **Polaroid** Silicon cell automatic exposure linked to fixed f8 aperture and an electronic leaf shutter (infinitely variable between 14 secs and 1/180 sec). Darken and lighten control. | **Kodak** Electronic flash unit or flash bar. Tripod. Wrist strap. Carrying case with shoulder strap. **Polaroid** Close-up lens attachment. Snap-on lens attachment to give 175 mm focal length. Flash bar and diffuser or electronic flash unit. Tripod mount. Cable shutter release and self timer. | Kodak EK2, EK8, EK300 Polaroid Instant range Polaroid EE 100 |

# SINGLE LENS REFLEX CAMERAS

The unique design of the single lens reflex, the SLR, allows you to see on the viewing screen the image of your subject, exactly as it is projected toward the film by the lens. An SLR camera uses an angled mirror behind the lens to reflect (hence the term "reflex") the image up, through a pentaprism which corrects it to read the right way around, on to a small eye-level focusing and viewing screen. The mirror moves out of the way for exposure.

SLRs are the most versatile modern cameras for color photography. The reflex system allows you to anticipate results with considerable accuracy, observing in advance the effects of variable aperture, focus, and depth of field, and of color filters, and lenses of different focal length. Fast and precise focal plane shutters, accurate "through-the-lens"

## Color key

| | |
|---|---|
| ▨ | Viewing system |
| ▨ | Metering system |
| ▨ | Shutter system |
| ▨ | Aperture system |
| ▨ | Focusing system |

### 110 mm SLR camera

The popularity of the 110 mm format has encouraged the first 110 mm SLR designs. The pocket style Minolta, below right, has a fixed zoom lens with a "macro" setting and TTL exposure metering. The miniature Pentax, below, also has TTL metering, but has interchangeable lenses.

(TTL) exposure metering, and the system of high quality interchangeable lenses and accessories, give SLRs great accuracy and wide application.

The great majority of SLRs are in the 35 mm format. The larger $2\frac{1}{4}$ ins² rollfilm models give fine quality and have their own range of lenses; the new 110 models offer neat but limited systems; but the 35 mm models combine quality and compactness with the widest system of lenses and accessories.

The general trend in 35 mm SLRs is toward lighter cameras with more automatic features, but there is considerable variation. Exposure control and display systems differ, and so do focusing screens and lens mounts. Most recent models have an automatic diaphragm, with full aperture focusing for brighter and easier viewing.

## Pentaprism optics

When image-forming light rays have passed through the taking lens, **6**, they are reflected off the mirror, **5**, to the focusing screen, **2**. The silvered sides of the pentaprism, **1**, correct the image we see through the eyepiece, **3**. As the shutter is released, the mirror lifts, allowing the image to reach the film, **4**. This temporarily blocks the light to the eyepiece.

## Digital computerized automatic SLR

The Canon A1 has five auto-exposure (AE) modes: manual-shutter priority AE, aperture priority AE, programmed AE, stopped-down AE, and AE with electronic flash. The A1 can be fitted with the following accessories: motordrive/power winder, external battery pack, and a data pack.

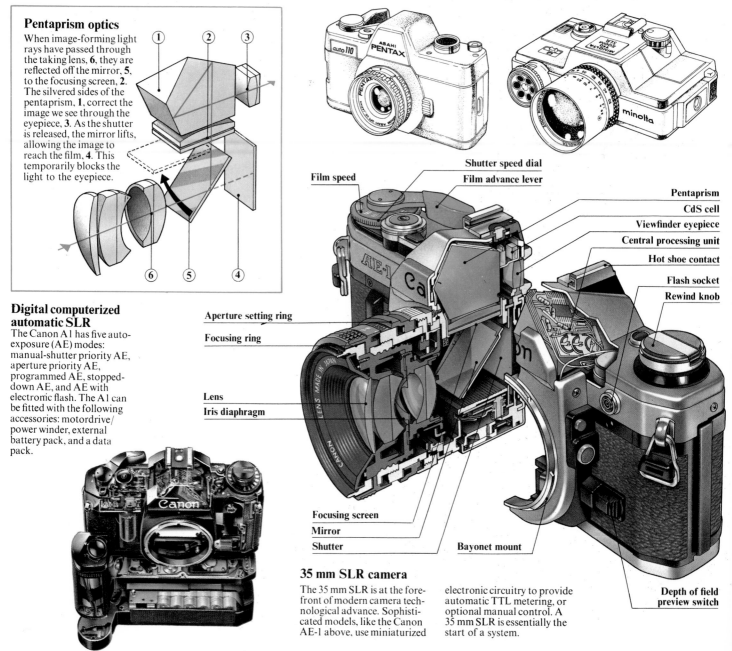

Film speed · Shutter speed dial · Film advance lever

Pentaprism · CdS cell · Viewfinder eyepiece · Central processing unit · Hot shoe contact · Flash socket · Rewind knob

Aperture setting ring

Focusing ring

Lens

Iris diaphragm

Focusing screen · Mirror · Shutter

Bayonet mount

Depth of field preview switch

## 35 mm SLR camera

The 35 mm SLR is at the fore-front of modern camera technological advance. Sophisticated models, like the Canon AE-1 above, use miniaturized electronic circuitry to provide automatic TTL metering, or optional manual control. A 35 mm SLR is essentially the start of a system.

# VIEWFINDER CAMERAS

Look through the eyepiece of a viewfinder camera and you will see a clear bright view of the subject, even in poor light conditions. Since you cannot view the scene exactly as the camera sees it through the lens, better viewfinder cameras incorporate a coupled rangefinder, shown below, for fine focusing. Inexpensive cameras merely have a focusing ring or slide on the lens, marked with distances or symbols; the very cheapest are fixed-focus, giving a sharp image from about 6 ft to the horizon.

Fixed-lens 35 mm viewfinders in the medium price bracket include many excellent compact rangefinder cameras. Most of these have integral meters and automatic exposure, and some models now have automatic focusing. Lighter, cheaper, and simpler than SLRs, such cameras have many

### 35 mm rangefinder camera

The new 35 mm rangefinder cameras, such as the Canon below, are completely automatic and include features such as auto-film loading, auto-film drive and rewind, auto-exposure and focus control, as well as auto-flash for low light conditions. The infrared auto-focus system (which will work in the dark) activates a motordrive on the fixed lens, focusing on a subject in the center of the viewfinder. A lens shield acts as a lens cap and turns off the camera when not in use.

advantages. The bright viewed image is not lost during exposure, so action shots are easy to view. Rangefinder focusing is clear and accurate, and the quiet shutters help wildlife photography. The expensive Leicas, with interchangeable lenses, offer high quality with flexibility to match SLRs.

The neat cartridge-loading instamatics range from the low-priced fixed-focus 126 models to the sophisticated cameras at the top of the growing 110 range. Such cameras may include coupled rangefinder, integral meter, automatic exposure, and supplementary lens elements to alter focal length, giving considerable versatility. The lightweight instamatics need to be held rock steady – camera shake effects are minimized on some models by a "sensor" (light-touch) shutter.

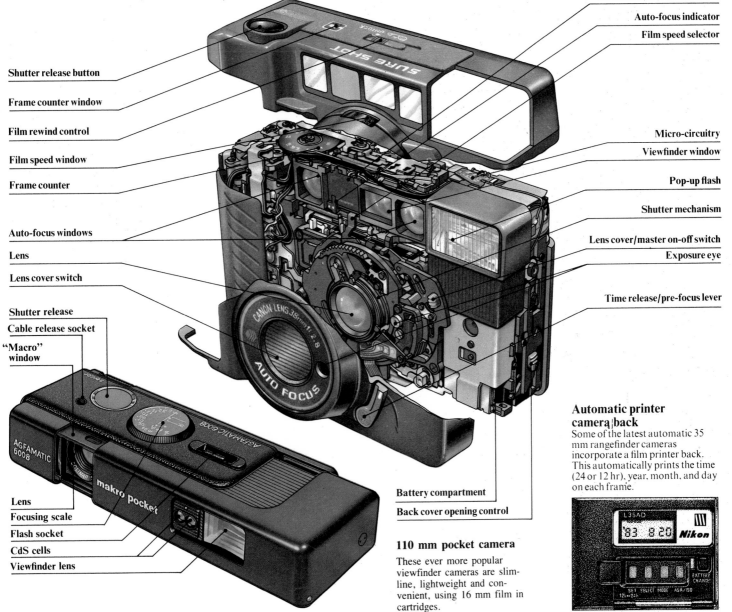

Shutter release button

Frame counter window

Film rewind control

Film speed window

Frame counter

Auto-focus windows

Lens

Lens cover switch

Shutter release

Cable release socket

"Macro" window

Lens

Focusing scale

Flash socket

CdS cells

Viewfinder lens

Parallax frame for viewfinder

Auto-focus indicator

Film speed selector

Micro-circuitry

Viewfinder window

Pop-up flash

Shutter mechanism

Lens cover/master on-off switch

Exposure eye

Time release/pre-focus lever

Battery compartment

Back cover opening control

### 110 mm pocket camera

These ever more popular viewfinder cameras are slimline, lightweight and convenient, using 16 mm film in cartridges.

### Automatic printer camera back

Some of the latest automatic 35 mm rangefinder cameras incorporate a film printer back. This automatically prints the time (24 or 12 hr), year, month, and day on each frame.

# BUILDING A CAMERA SYSTEM

When you buy a camera, it usually comes with a standard lens, giving you an image similar to your eye's view of a scene, and perhaps a lens cap and soft carrying case. How much of a camera system you build up around this depends on the camera you choose, and the style of photography you develop. With an interchangeable lens camera, you can add different focal lengths. With any good camera you can add tripod, lighting, and most of the other equipment shown opposite. The items shown here are all for 35 mm cameras.

*Buying additional lenses*

You can cover the majority of photographic situations by adding two lenses – one shorter, and one longer than your standard lens of 50 or 55 mm focal length. Choose these lenses carefully, so your set of three focal lengths offers a wide enough choice of images (see Using Different Lenses, pp. 88–9). In the equipment recipes that follow many of the pictures in this book, the most commonly used non-standard lenses are either a 28 mm wide-angle, or a 135 mm medium long lens. These focal lengths allow you to vary the image without the drawbacks of extremely wide or long lenses – distortion, camera shake, or limited apertures.

Everyone's choice of lens combinations will be different – you may decide to add a more extreme lens, or to dispense with a normal lens. Another alternative is to replace two focal lengths with one zoom lens covering the same range.

Lens quality is vital for picture sharpness and good color reproduction. A lens should undergo a process called "blooming" – the coating of a metallic fluoride on all air-to-glass surfaces. This increases the transmission of light and reduces flare (see pp. 148–9) caused by reflected light scattering through the lens elements. If your camera is of a popular make, you have the choice of buying lenses of the same make, that will match the quality of your camera, or buying them from an independent lens manufacturer. In this case, state the make and type of your camera so that the right lens mount – screw or bayonet – is supplied. Non-proprietary lenses are usually cheaper, but can be of poorer quality. You can also use lenses designed for other makes, but only if adaptor mounts are available.

A new lens is supplied with lens caps, for both the front element and rear mount, to protect it against dust and damp. (If your camera body is to be left without a lens for any period it is best to fit a cap for the empty mount too.) At the front of the lens you will notice a screw thread, of a marked size, that takes colored and clear filters, lens attachments, or a lens hood. Hoods also help to eliminate flare and they protect the front element of the lens. Each focal length lens has a different-shaped hood for increased or decreased field of view. The rear of the lens will accept extension rings (shown right) or bellows attachments for close-up work.

## Lenses and lens attachments

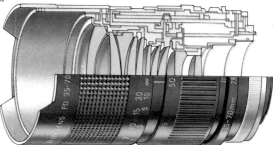

**Wide-angle lens** *above*
The popular wide-angle focal lengths are 28 and 35 mm. They give an increased angle of view over the standard lens, dramatizing linear perspective (see p. 108) and giving greater depth of field (see pp. 88–9) throughout their range of apertures. You can focus down to about 1 ft (0.3 m), and fill the frame with a small object. But images diminish in size with distance from the camera more rapidly than with a standard lens.

**Maximum focal length**

**Minimum focal length**

**Zoom lens** *above and left*
The zoom lens, above, has infinitely variable focal length between 35 and 70 mm. At any focal length between these limits, you can turn the focus ring on the lens barrel to give a sharp image. To change the focal length you operate the zooming mechanism, so sliding the primary groups of lens elements apart or together. The maximum and minimum settings are shown left. Once you have focused on a particular subject distance, it remains in focus throughout the zoom.

**Telephoto lens** *right*
Long lenses give a closer view of a limited area of distant subject. They reduce linear perspective and compress different subject planes. The longer the focal length of a lens, the shallower will be depth of field through its range of apertures. Modern telephoto design allows lenses of long focal length to be more compact, though still bulky.

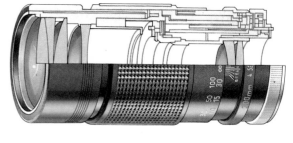

**Lens and body caps** *left*
Protective caps of the right size keep dust and moisture away from lenses, and from the camera lens opening.

**Filters** *right*
Filters (see pp. 190–1) are bought in mounts that are threaded to fit in front of the lens.

**Lens hoods** *left*
Lens hoods of the appropriate shape are used to keep strong sunlight from striking the front of the glass obliquely. They also protect against rain, airborn grit and accidental knocks. Some long lenses have integral lens hoods.

**Extension rings** *left*
Extension rings fit between the lens and the camera body to allow close-up pictures.

**Adaptor mounts** *right*
To fit a lens of different make to your camera, you can use an adaptor mount behind the lens.

## Choosing useful accessories

No matter how wide your camera control range, and how fast your lenses, difficult lighting may require additional equipment. A reliable, hand-held light meter that you can use to take incident light readings (see p. 95) will be invaluable. For long exposures, which could cause camera shake, you will need a tripod. It should have a pan and tilt head and a light but firm construction. Clip release extending legs are quicker to use than thread lock types, but clips wear more quickly. A cable release will be necessary so that you can release the shutter without touching the mounted camera.

Artificial light sources provide another way of overcoming awkward available lighting. The most convenient form is electronic flash – today's power-ful units are very compact and light. They fit into a shoe on top of the camera itself, as shown right, or to one side on an extension arm that separates the flash angle from the camera lens view. This avoids red eye and gives better modeling on the subject (see Working with Flash pp. 102–3). When you buy a flash unit, consider its power, versatility, battery life, and the recycling time between firings.

The SLR camera, shown right, is fitted with an autowinder. A small electric motor, engaged with the film take-up spool, automatically winds on to a new frame of film after you have pressed the shutter release. You can use it to take a series of exposures (up to three and a half frames a second), as long as the shutter release is depressed. If you plan to use an autowinder in conjunction with flash, make sure the recycling time of the flash equals the autowinder frames-per-second rate.

To keep expensive, precision equipment in good order you must clean it carefully and regularly. Always use a soft puffer brush to dust lenses and camera bodies first; then you can wipe lenses and eyepieces carefully with an anti-static lens cloth.

Lens cases are made to cushion against knocks, and you can carry two or three strapped over your shoulder. If you want to transport all your camera system, you should have an equipment case with rigid sides, and padded partitions. Between trips, such a case makes a good dust-free store.

## Useful accessories

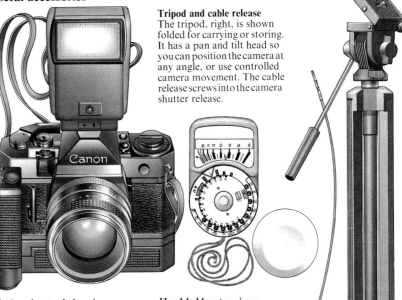

**Tripod and cable release**
The tripod, right, is shown folded for carrying or storing. It has a pan and tilt head so you can position the camera at any angle, or use controlled camera movement. The cable release screws into the camera shutter release.

**Flash and autowinder** *above*
Electronic flash and autowinder units now closely match the specification of their 35 mm SLR cameras, so that recycling time equals film advance rate.

**Hand-held meter** *above*
The selenium cell light meter, above has two scales for strong and weak lighting. To convert it for incident readings (p. 95), you move the diffuser, above right, over the cell.

**Cases and cleaning equipment**
Clean lenses and visible mechanisms carefully before use. Only wipe lens surfaces after removing dust with the brush, left. Use individual equipment cases on location; or a larger stiff-sided gadget bag with partitions, when you want to store or carry all your equipment.

---

### 110 camera accessories

Some 110 cameras have their own, scaled down accessories. The high quality model shown here has a wrist strap and hard carrying case. You can also buy flash attachments, a small tripod and a cable release.

**Strap and case**
A carrying strap and additional case protect the camera in use and store.

**Flash lighting** *left*
The battery flash unit, far left, clips on the end of the camera away from the lens axis. Alternatively, you can fit a flash cube or flip flash on top.

**Mini-tripod and release** *right*
The stand, right, is pocket size and suitable for table top or similar use. The cable release connects next to the shutter button.

# INSTANT PICTURE CAMERAS

Instant picture cameras use special films (pp. 46–7) and built-in processing systems. You press the shutter and almost immediately the camera delivers the exposed material. Seconds later the positive color image appears while you wait.

Because you can see the result straight away, you can correct faults immediately if it proves disappointing, before taking further shots. You can even use a good quality instant picture camera to make trial exposures, before photographing a subject with your regular camera (allowing for any difference in film speed between the instant picture material and your regular film).

Developments such as automatic focusing (with a sonic beam) zoom lenses, and reflex printing from original prints, promise a good future. But there are still disadvantages: the reasonably priced popular cameras have limited flexibility, films are expensive, print size is restricted to the camera format, and color films have rather low speeds.

### Peel-apart and dry print systems

Inexpensive Polaroid cameras (and special backs for large format cameras) take peel-apart film. After exposure you pull a sandwich of negative and positive material out of the camera, wait 60 seconds, and peel away the print, a messy process which may not always give good results.

Polaroid cameras using SX-70 or 600 film reverse the image in the camera. With Kodak cameras the image appears on the reverse side of the film. Dry print cameras have a motor to eject the print. Recent developments in instant picture cameras include infrared and ultrasonic focusing control.

**Kodak Champ** *above*
At the lower end of the range this model from Kodak, the "Champ", offers automatic exposure control and a fixed-focus lens.

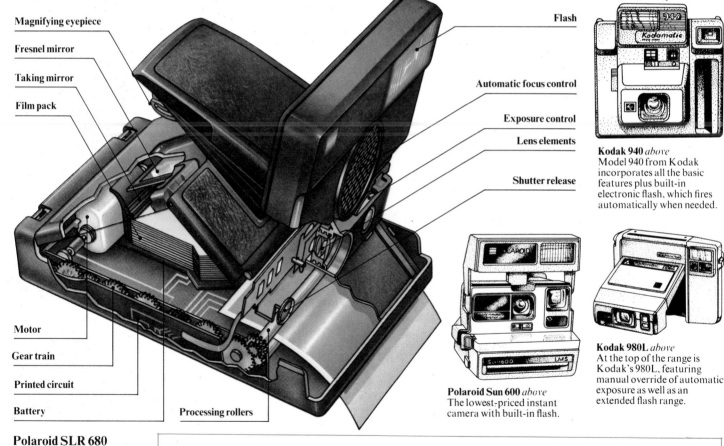

Magnifying eyepiece
Fresnel mirror
Taking mirror
Film pack
Motor
Gear train
Printed circuit
Battery
Processing rollers
Flash
Automatic focus control
Exposure control
Lens elements
Shutter release

**Kodak 940** *above*
Model 940 from Kodak incorporates all the basic features plus built-in electronic flash, which fires automatically when needed.

**Kodak 980L** *above*
At the top of the range is Kodak's 980L, featuring manual override of automatic exposure as well as an extended flash range.

**Polaroid Sun 600** *above*
The lowest-priced instant camera with built-in flash.

### Polaroid SLR 680
This is a reflex instant picture camera with automatic focus and flash. Exposure is automatic with ambient light exposure controlled by a center-weighted, scene-averaging silicon photo-diode. Flash exposure establishes the correct aperture for a measured subject distance at constant electronic flash output. The camera uses high-speed 600 ASA/29 DIN film with 10 exposures per pack.

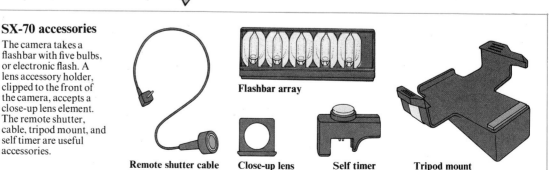

### SX-70 accessories
The camera takes a flashbar with five bulbs, or electronic flash. A lens accessory holder, clipped to the front of the camera, accepts a close-up lens element. The remote shutter, cable, tripod mount, and self timer are useful accessories.

Flashbar array

Remote shutter cable    Close-up lens    Self timer    Tripod mount

# DISC CAMERAS

"Disc" photography is the latest of the many custom-designed film/camera systems on the market. The camera itself is designed around the neat, flat film cartridge, which contains a magazine of fifteen tiny frames arranged in a disc. It looks a very simple camera, but it is extremely sophisticated electronically, having fully or semi-automatic exposure, built-in flash, and automatic film advance.

The disc film, with its own C41-compatible process, is available in color negative, and in several brands, and is generally sharper and lower in granularity than most films, having a higher resolution. It is rated at 200 ASA/24 DIN.

The short focal length lens of 12.5 mm (f2.8) is incorporated in the slim camera body and it has a depth of field suitable for fixed-focus photography.

The lens is reasonably sharp for the film format and the maximum print size of 10 × 8 ins. The focusing is fixed from 1.2 m to 5.5 m using the built-in flash, and from 1.2 m to infinity in daylight.

One of the most novel features of the disc photography system is that it has been designed to be a totally efficient consumer operation, which incorporates the camera, the disc film cartridge module with a coding facility, photo finishing (auto-processing), and printing. Eventually it will be possible to slot the processed disc into a video display unit, which will turn the negative film image into a positive video display. Instructions for making enlargements and selecting an image area for enlarging and printing will then be encoded on to the film via the unit — the film core itself giving instructions to print machines for reprints.

**The disc** *below*
The disc film is a color negative emulsion type (200 ASA/24 DIN) arranged in a flat disc with 15 exposures per disc. It has a binary bar coding form which is used for identifying frames for enlargement.

**The cartridge** *below*
The film is sealed between a core and a ring to form a disc film assembly (cartridge).

**Loading** *below*
To load the disc cartridge you simply open the camera back and slot in the disc cartridge.

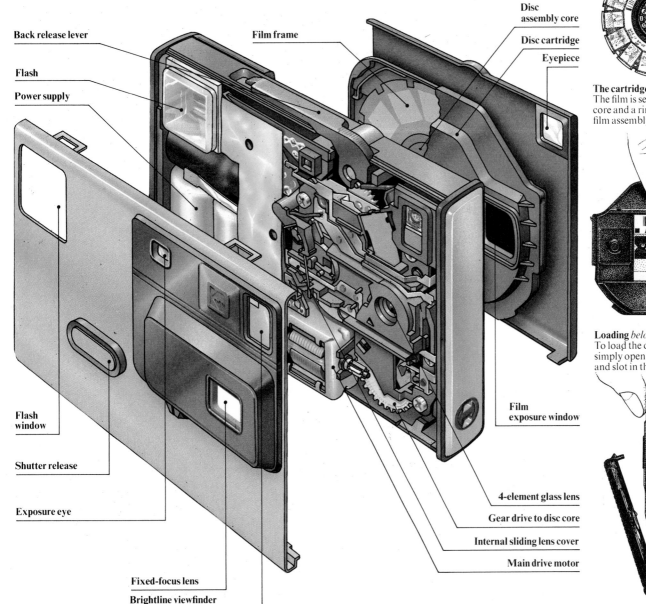

Back release lever

Flash

Power supply

Film frame

Disc assembly core

Disc cartridge

Eyepiece

Flash window

Shutter release

Exposure eye

Fixed-focus lens

Brightline viewfinder

Film exposure window

4-element glass lens

Gear drive to disc core

Internal sliding lens cover

Main drive motor

# COLOR FILM

Color film is a triple-layered sandwich of light-sensitive silver halide emulsions and linked dyes. Each layer responds to one primary color of light—the top layer to blue, the middle to green, the bottom to red. When you take a picture, the layers record a triple latent image, from which the subject's color range is recreated in processing.

### Prints, slides and instant pictures

Print film (pp. 44–5) produces a *negative* (complementary colors, reversed tones) from which you can obtain unlimited *positive* (correct color and tone values) prints and enlargements. Instant picture film (pp. 46–7) gives you a positive print made directly in the camera. Transparency or "reversal" film (pp. 42–3) gives you a positive image on the film itself, resulting in a color slide for projection.

Instant pictures, with only 8 or 12 shots per pack, are the most expensive. Slides give the most brilliant color and are the cheapest per shot. Prints are very popular for their ease of viewing and duplication.

### Speed, brand and color response

Color film is less adaptable than human vision, so choosing a film of the right sensitivity and balance for your subject is important (see pp. 48–53). Films differ in their sensitivity to light—in *speed*. A hypersensitive "fast" film records better in poor light than a "slow" film, but also shows more "grain" in enlargements. Sensitivity is rated in speed number codes—ASA, ISO, DIN or GOST (see p. 48).

You should choose a film balanced for the type of light you will be using—daylight and flash, studio lamps ("tungsten" light), or both. Try out the characteristics of different brands too—each has particular color qualities (pp. 52–3).

### Color film packs

Most cameras accept only one pack type and size. Shown below, left to right, are: cartridges for 110 and 126 cameras, 12 or 30 exposures; cassette for 35 mm camera, 20 or 36 exposures; rollfilm for 2¼ ins² camera; Kodak instant picture pack, 10 exposures; Polaroid instant picture pack, 10 exposures, and batteries.

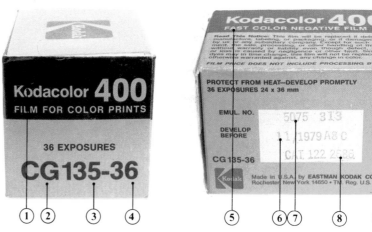

### Buying your film

When you go to buy your film, it will help to understand the information printed on the pack (see above). The type of film is usually encoded in the brand name—Kodacolor and Agfacolor for prints, Kodachrome and Agfachrome for slides. The code on the end flap of the pack indicates the type of emulsion, film format (size and packing), and number of exposures. Thus "Kodacolor 400" is coded CG 135–36: a color film with a general emulsion, in 35 mm format, with 36 exposures. It is a high-speed color negative film (400 ASA).

You will find the film's speed, type (print or slide), and light balance printed separately on the pack too. Check the expiry date. Most films have a built-in safety factor beyond this of about six months. Check whether the price includes processing, and make a note of the emulsion number (useful for complaining). If you intend doing your own processing, note the processing details, if given.

### Decoding the pack

1 Brand name
2 Type. CG means color film with a general emulsion
3 Format and container type
4 Number of exposures
5 Prints or slides
6 Expiry date
7 Emulsion number
8 Kodak catalog number
9 Whether price includes processing
10 ASA/DIN speed

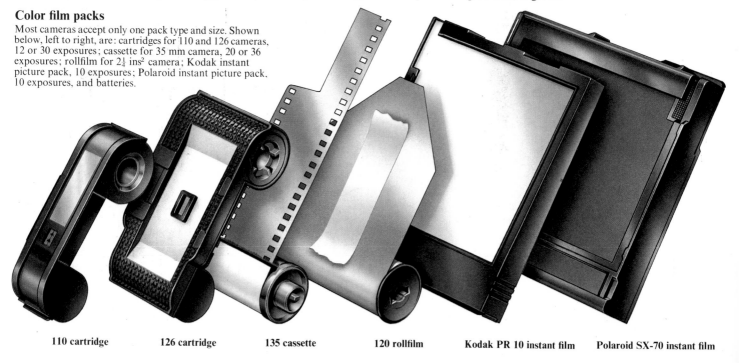

**110 cartridge**    **126 cartridge**    **135 cassette**    **120 rollfilm**    **Kodak PR 10 instant film**    **Polaroid SX-70 instant film**

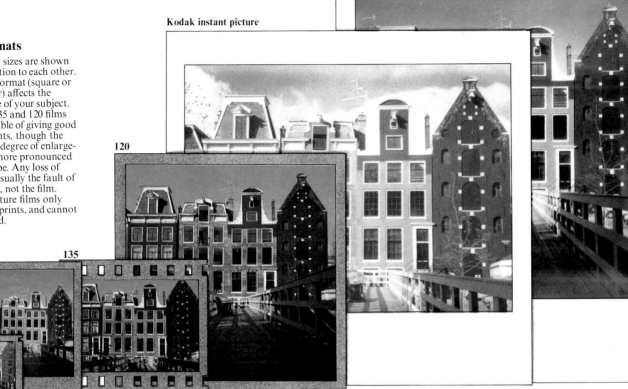

Polaroid instant picture

Kodak instant picture

120

126    135

110

## Film formats

Actual film sizes are shown here in relation to each other. Note how format (square or rectangular) affects the appearance of your subject. 110, 126, 135 and 120 films are all capable of giving good enlargements, though the greater the degree of enlargement, the more pronounced faults will be. Any loss of quality is usually the fault of the camera, not the film. Instant picture films only give single prints, and cannot be enlarged.

### Film packs and loading

Color film is packed in cartridges, cassettes, rolls, instant packs, or as sheet film. *Cartridges* have a built-in take-up spool; when a film is finished, you simply remove the cartridge. *Cassettes* have a single spool protected by a metal jacket; the take-up spool is in the camera. After the last exposure you must rewind the film into the cassette before removing it. *Rollfilms* are paper-backed, on a spool identical to the camera take-up spool. After exposure, the film is wound forward, fully on to the take-up spool, before you remove it. *Instant packs* contain 8–12 sheets which are emitted individually, after each shot. Cassettes and rollfilms are not entirely light-tight, so for safety you should load them in the shade or indoors.

### Format and color quality

Film/camera formats are sometimes quoted in film widths–16 mm, 35 mm, $2\frac{1}{4}$ ins and larger, and sometimes in code numbers–110, 126, 135, and so on. The code numbers indicate the shape of the frame and type of pack as well as the width.

The most popular is 35 mm in cassettes (135), which is used by many SLRs and viewfinders. The sprocket holes along the edges betray its origins as motion picture film. 110 (16 mm cartridge) and 126 (35 mm cartridge) formats are used in simple cameras. 120 and 220 rollfilms are for $2\frac{1}{4}$ cameras.

Format affects color quality. Obviously, an original image $2\frac{1}{4}$ ins square will give finer enlargements than a tiny 110 image. But larger format cameras also tend to have better lenses, rendering color tones more subtly and accurately, and with greater saturation.

## How to load your camera

**Loading a cartridge**
Cartridges are accepted by 110 and 126 cameras. They are light-sealed. Each has its own take-up spool to receive exposed film. So after the last exposure, you need not rewind the film–you simply remove the cartridge. To load the camera, open the back and drop the cartridge in place, right way up. Make sure it is firmly engaged, and close the camera back.

Wind on the film with the push tab (or lever) until the first exposure number appears in the counter window, and the advance lever locks.

**Loading a 35 mm cassette**
In low light, open the camera back. Lift up the spool receiving shaft in the empty left-hand chamber, slot in the cassette, and push the shaft down. Draw the film tongue across the pressure plate and slot or clip it to the take-up spool on the right. Advance the film slightly with the film wind lever, so it winds clockwise on the spool. Check the film perforations engage firmly on the sprocket teeth and the film is taut and running straight. Close the camera back. (You can check if the film is firmly engaged by turning the rewind crank gently clockwise until you feel slight resistance.)

Now advance the film wind lever (usually three times) until the first number appears in the counter window. Depress the shutter each time.

After the last exposure, the film advance lever will lock. To rewind the film, depress the release button, usually under the camera and turn the rewind crank until it frees. Then remove the cassette in dim light.

# USING SLIDE FILM

Color slides, or transparencies, are positive color images produced on reversal film. They possess a brilliant, jewel-like quality, giving a sharpness, color strength, and sense of depth that prints often lack. But because the image is contained on the film base itself, it is too small and dark to see until lit up and enlarged in a hand viewer, or better still a projector. So you will have to buy extra equipment – a projector and folding screen.

However, once you have invested in the projector, slides are considerably cheaper per shot than prints, and you can project your pictures as large as you like, recreating the subjects with impressive realism and vitality and admirable color reproduction.

### Projectors

Slide film can now be bought in all formats. Most projectors are for the 35 mm format, the slides being fed from a circular carousel or magazine. 126 slides can also be shown with 35 mm equipment, but 110 slides either have their own projectors, or need special mounts to fit 35 mm magazines. Larger format transparencies require cumbersome projectors with hand-operated push-pull frames. Setting up projection equipment and loading slides into magazines can take some time. Take care to load slides correctly, so that they are not projected upside down or the wrong way around. (Place them in the projector upside down, but the right way around.)

### Processing, copying and storing slides

Reversal films are easier to process than negative films because no printing is involved. Most can be home processed, without the use of a darkroom (pp. 168–9). But some must be returned to the manufacturer, in which case the cost of processing is usually included in the film price. Commercial bulk processing is generally good, and all manufacturers cut your strip of film into single transparencies and mount them in cardboard or plastic frames unless otherwise requested. If your film requires any special processing you can send it to an independent laboratory, in which case you should specify which mounts you would prefer.

Transparencies must be handled carefully as they are irreplaceable. Cardboard mounts are cheap but they will not protect your transparencies from scratches or finger marks and they tend to buckle when loaded into the projector. Plastic frames with glasses are preferable as they last longer and offer more protection to the transparencies.

Slides are sometimes less convenient than prints. You can get the best of both systems by making copies of slides (p. 200), or by making prints via an internegative (p. 179). You can also make prints directly from transparencies, by color reversal printing with a special paper such as Cibachrome A (pp. 178–9).

### How dye layers create subject color

The top layer records a negative image of blue parts of the subject. Unexposed parts of the layer form a positive image of areas that were *not* blue. These positive areas are dyed yellow. Similarly, parts that were *not* green are shown magenta in the middle layer; parts *not* red appear cyan in the bottom layer. A full color range arises from superimposition of the three layers of yellow, magenta and cyan dye.

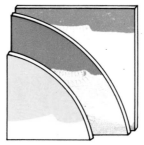

**Simplified cutaway slide showing yellow, magenta and cyan dye layers.**

**Complete slide**

### Idealized curves for slide film

The curves represent the response of the three dyes to changes in exposure. As exposure decreases, the density of dyes produced increases.

Acceptable exposure falls on the steep straight slope of the graph. Here the three layers respond in balance, and changing density gives an adequate tonal range.

Color balance is lost at the extreme top of the curves – they are no longer aligned. See also reciprocity failure, on page 93.

### How reversal film works

Reversal film is so called because it "reverses" the familiar negative image-forming process. Like color negative film, during exposure and initial development each layer records one of the primary color ranges in the subject – reds, greens, or blues – as a black silver negative image. But in color reversal processing the remaining *unexposed* halides then give a corresponding black silver positive, with linked dyes to give the color positive. The dyes are deposited in proportion to the density (darkness) of the intermediary black silver positive, and the silver is then bleached away, leaving the color image.

As shown left, the finished slide reproduces the subject color range with three superimposed dye layers. The top layer has formed yellow dye, the middle layer magenta (purplish red) dye, the bottom layer cyan (blue-green) dye. These complementary (p. 56) colors are used in most color printing.

### Exposure range and tolerance

You can see how reversal film responds to exposure on the opposite page. This can also be expressed as a "characteristic curve" on a graph (below). The curve shows how dye density alters with exposure. Overexposure gives you a weak pale slide, underexposure gives a dark slide.

Any subject you photograph will have a range of bright and dark areas. On the steep part of the graph below, every slight change in subject brightness produces a corresponding change in dye density, so your subject is reproduced with an acceptable range of tones. But on the outer, flattened parts of the graph differences in density are too slight to show adequate tonal detail.

For a scene of "average" brightness, slide film will give acceptable results about one stop either side of an "ideal" exposure. Beyond this you will notice a loss of color saturation (p. 56), and of detail in shadows or highlights. Slight underexposure may improve color saturation. But overexposure produces a thin positive with highlights "burning out", so exposure should be read for the highlights (using an invercone, p. 95).

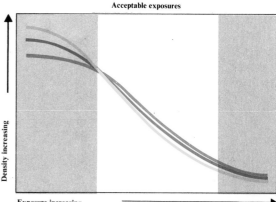

**Acceptable exposures**

Density increasing

Exposure increasing

## How slide film responds to exposure

This sequence of photographs shows the effect of different exposures on Kodachrome 64 ASA reversal film, through the full range of camera shutter speeds from 1/2000 sec to 1/2 sec. The aperture was kept constant at f16. The camera TTL meter read 1/60 sec for this subject – a rather high contrast scene with strong reds and a brilliant specular highlight. The top row of exposures is largely unacceptable, since underexposure has left them too dense. But the top right exposure has created a dramatic "day into night" effect (see p. 44). The middle row of exposures are all acceptable, but differ in the way they render shadow and highlight detail, and in color saturation. The bottom row is overexposed, and probably unacceptable, giving pastel shades and large areas of white.

**Grossly underexposed 1/2000 sec**
Only a bright specular highlight on the knife blade has recorded – the rest of the positive is black, as the negative was empty. Always take readings from general highlight areas, not random specular highlights.

**Few colors recorded well 1/1000 sec**
Even the highlights are very dark, although the knife blade now shows fine detail. The yellow dye is the strongest because it was the brightest lit color in the original scene.

**Day into night 1/500 sec**
Underexposure is still causing a weak negative at the primary stage leaving a dense positive of oversaturated dyes in the emulsion. This has created a twilight effect which gives highlights of maximum detail against black shadows.

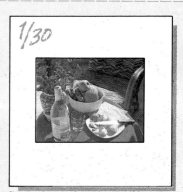

**Highlights dominate 1/250 sec**
This would be the probable result if you took a reading from general highlights only. The knife blade shows detail; color is strong but contains too much black, and shadows are too dark and lack detail. Cyan and magenta are still weak, but yellow is bolder.

**Highlights show full detail 1/125 sec**
At one stop below "normal", reds are rich but colors are generally too dark and shadows too dense. The chair and flowers begin to appear, but the knife highlight still dominates. Good textural effects are achieved.

**"Ideal" exposure for subject 1/60 sec**
TTL meter reads "normal" for this subject giving an ideal overall exposure to balance shadows with highlights. Color is fully saturated and highlights are good, but with this exposure shadows still lack full detail, which may be unacceptable.

**Good color result achieved 1/30 sec**
At one stop above normal, the part of the color curve used gives good color balance and saturation. Shadows are lightening, but highlights still dominate, though they are losing detail.

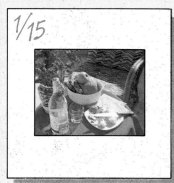
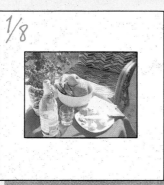
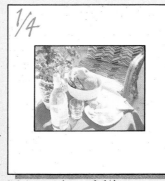

**Highlights empty of detail 1/15 sec**
At two stops above "normal", this subject shows maximum detail in the shadows but the highlights are too bright. Yellow, magenta and cyan are all losing strength.

**Shadow detail just visible 1/8 sec**
Cyan, magenta and yellow are still performing in balance. Shadows become paler, showing some detail, but highlight detail is lost. Color is still almost acceptable at this exposure.

**Color saturation weak 1/4 sec**
Detail and tonal range are disappearing, yellow is very weak, reds are off balance. Shadows are light and weak, with white, burned-out, highlights dominating as colors become more muted and saturation decreases.

**Image grossly overexposed 1/2 sec**
The subject appears as a light, almost abstract image, with some weak red showing. Highlights, and mid-tone areas of color are completely lost, leaving large areas of white. Shadows are cold and empty, showing no color strength, nor gradation of tonal values.

# USING PRINT FILM

Color negative film, from which unlimited prints can be made, is used by over 80 per cent of camera owners. The chief virtue of prints is convenience – you can keep them in albums, send copies to friends, or display enlargements in frames, while slides need a projector. Another advantage is that less-than-perfect negatives can usually be corrected in printing, while results with slides are fixed.

The main problem with prints is color quality, particularly if you use mass processing. Compare a print and a slide of the same subject and you will see that the slide has more brilliance, and registers color more subtly, with greater saturation. This is largely because print paper absorbs some of the light – and therefore the color.

### How negative film works

Like reversal film, color negative film is a tripack of silver halide emulsions linked to potential dye molecules – yellow, magenta and cyan. When you shoot a picture, a latent black silver image is created in each layer. But during color negative development, the full black silver image and the dye image are formed simultaneously, to give a complementary-colored negative, after bleaching. The positive is produced by printing through the negative on to color printing paper, which reverses the tones and colors back to those in the original subject. As you can see, opposite, the developed negative shows an orange cast. This results from an orange masking layer that is necessary to maintain accurate color reproduction in each layer.

### Exposure response

Negative film has a wider acceptable exposure range than reversal film, largely because some correction of density is possible in printing. As you can see opposite, overexposure produces a dense, darker negative and a lighter finished print; under-exposure gives a weak, paler negative and a dark, flat print. You should read exposure for negative film from mid-tone areas as a general rule, to avoid a weak thin negative, with a flat print as a result.

### Processing and printing

If you return your film to the manufacturer it will be bulk processed, and you will receive a strip of negatives and a set of standard prints. Bulk processing can cause faults in the prints – spots, scratches, blur, weak color, or strong red or blue casts. Enlargements receive more care, and seldom show such faults.

Independent laboratories charge more, but they will carry out correction, and are quicker. They give you a contact strip for selection. The small prints, opposite, show the extent of correction possible. The top and bottom prints are extreme examples – manufacturers would not recommend such correction, and even independent processors would be unwilling to do it. If you do your own darkroom work, however, you will find it possible to achieve such results.

You can process your own negatives quite simply (p. 168), but for printing you require a darkroom and some skill (see pp. 170–181). Color negative processing and printing techniques allow you fine control of results – color balance, density, and contrast can be altered. You can manipulate the image in the darkroom for unusual effects or even create a wholly new image. This flexibility of print film, arising from the two-stage process of negative and print, is its main creative appeal.

see pp. 170–181

### How exposure affects print film *right*

The pictures on the opposite page shows the response of Sakuracolor 100 ASA print film, at "normal" exposure, and at two and four stops either side of normal. The first column shows the negative; the second the maker's uncorrected enprint; the third the result obtained by an independent color processing laboratory.

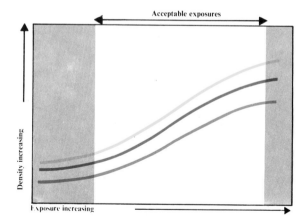

### Idealized curves for negative film

The dye layer performance curves for negative film, left, go in the opposite direction from those for slide film (p. 42). Density and color saturation *increase* with increasing subject brightness and exposure. With under-exposure shadows and mid-tones fall at the extreme left of the graph, producing thin areas on the negative. Over-exposure moves subject brightness to the right.

## Exposure for effect

Contrasting tones can be dramatically emphasized by varying exposure. Overexposure at 1/8 sec gives a soft romantic atmosphere to the landscape on the right. At 1/125 sec, "normal", the sun-lit house is sharply defined against the background, and at 1/1000 sec, underexposed, the scene appears as if lit by moonlight. For successful use of such effects you require high contrast subjects with bright highlights.

**Overexposed**

**Normal**          **Underexposed**

| Negative | Normal print | Specially corrected print |
|---|---|---|

**Grossly underexposed (4 stops)**
A very thin negative gives a dark enprint. The corrected print (far right) is flat with little contrast, and a color cast. The paper had to be underexposed, well short of the recommended time, with the enlarger lens at f16.

1/1000

**Shadow detail emerging (2 stops)**
The negative is stronger, with much more detail. The enprint has bold highlights and some shadow detail, with reasonable color balance, but is too dark and flat overall. In the corrected print, there is a marked improvement in contrast, although a slight color cast remains. This is due, as in the above example, to the thinness of the negative. The exposure in the enlarger was 4 seconds at f11.

1/250

**Normal exposure for subject**
The meter reading for a "normal" exposure for this subject was 1/60 sec at f16. In the negative, the brightest highlights and darkest shadows all show detail, and color balance is good. The enprint and corrected print both show good contrast, response to color, and detail in the shadow areas, well balanced by the highlights. The enlarger exposure for the corrected print was 4 seconds at f5.6.

1/60

**Highlights burned out (2 stops)**
The negative at two stops overexposed appears very dark. This is partly due to the orange mask. In the uncorrected version shadows are light, highlights burned out, and contrast excessive. The corrected print slightly varies in color and detail from the normal. The enlarger exposure for the corrected print was 10 seconds at f5.6, twice the recommended time for the paper.

1/15

**Grossly overexposed (4 stops)**
An extremely dense negative has produced a very weak image with large areas of white and unbalanced color. The correction is remarkable, and gives an acceptable print with good color rendering and contrast, although there is a slight loss of shadow detail. Filters were used to prevent a strong color cast through reciprocity failure of the paper, since a long enlarger exposure of 20 seconds at f5.6 was required.

1/4

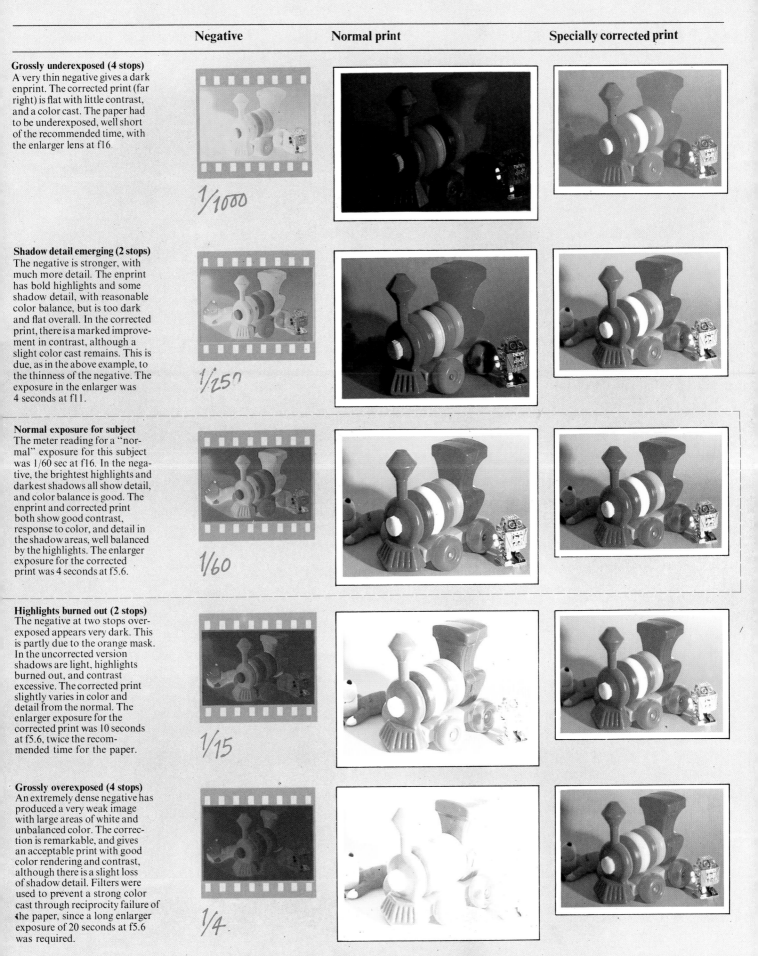

# USING INSTANT PICTURE FILM

There are two main types of instant color film — peel-apart and integral. Peel-apart film must be kept reasonably warm for a timed interval (60 secs) and you then discard the negative backing. Integral films develop while you watch. Each film is designed for specific cameras: Polacolor (peel-apart) for Polaroid's EE range and special backs on ordinary cameras; SX-70 and Polaroid 600 for SX-70 and SLR 680 cameras; Kodak's Trimprint H144 film (integral) for Kodak instant cameras.

Instant color films are basically tripacks with built-in processing. SX-70 film, right, uses a system where the exposed halides are developed to a black silver negative. Where dyes meet this silver they are halted; the rest to pass to form a color positive. Kodak's PR 10 also uses a reversal system, but here the *unexposed* halides are developed, and this development activates dyes to form the positive.

In a good camera, all the films will render colors well – except for greens, which are often poor, making landscapes rather dull. Flesh tones are good. Colors are best with sunlight or flash, for which the films are balanced. PR 10 and Polacolor may show casts in extreme temperatures. Above 30°C, set the camera lighten/darken control to "darker"; below 15°C, to "lighter". Clean your camera rollers regularly to remove any dirt or chemicals that may mar prints.

Exposure can be adjusted slightly with the lighten/darken control, but the film's response throughout the exposure range can only be seen on a conventional camera. Long exposure and development of Polacolor gives deep, muted colors.

## How SX-70 film works

**1 Exposure and activation**
Halides record the red, blue and green content of the subject. A pod of reagent in the film breaks as it leaves the camera.

Opaque timing layer
Image receiving layer
Reagent collecting layer
Blue-sensitive layer
Corresponding dye layer (yellow)
Green-sensitive layer
Corresponding dye layer (magenta)
Red-sensitive layer
Corresponding dye layer (cyan)

**2 Dyes and developers seep up**
The exposed halides are developed and the underlying dyes seep up into each layer. Where they meet developed silver, they become immobile forming a black-silver-and-dye negative in each sensitive layer, plus unfixed dyes.

**3 The final image forms**
Where dye is free, it seeps up into the image receiving layer, gradually forming a full color image.

In Kodak film, below, the dyes move in the reverse direction.

Development of Kodak PR 10

**Exposure and development of Polaroid SX-70 film**

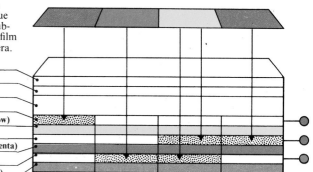

1 Film exposed; dyes and developers activated

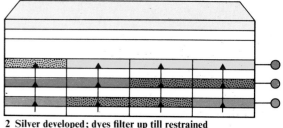

2 Silver developed; dyes filter up till restrained

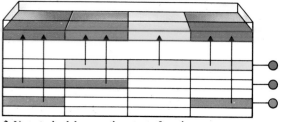

3 Unrestrained dyes continue up to form image

## Comparison of brand color variations

**Kodak Instant Color film H144 (Trimprint) (in 980L)**
Reds and blues are good, and color contrast acceptable, but weak green loses some background color.

**Polaroid SX-70 film (in SX-70)**
Color contrast is good and dyes are well balanced, with magenta less dominant. Reds, blues and skin tones are accurate, and yellow is stronger; green is weak.

**Polacolor 88 P2 film (in EE 100)**
This peel-apart film shows acceptable color contrast and skin tones. Cyan dye is dominant, giving lighter, greener blues and a slight green cast.

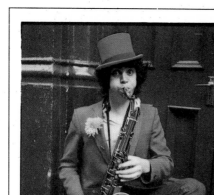

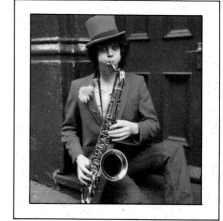

## Using the lighten/darken control

**Dark subject, light scene**
If your main subject is darker than the rest of the scene, you may underexpose it. With the lighten/darken control at normal, below, the subject's face is too dark, red is weak, and detail is unclear in the clothes. With the control at "lighten", right, the subject is correctly exposed and color is stronger.

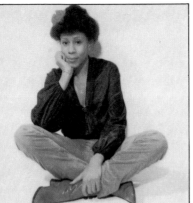

**Set to "lighten"**
Moving the dial to the right lightens the image, in $\frac{1}{2}$ stop stages.

**Light subject, dark scene**
If your main subject is lighter than the background, it may be overexposed. With the control set at normal, below, the white suit, face and hands are overexposed, and blue is weak. With the control turned to "darken", right, the subject is correctly exposed, showing detail and texture, while blue is stronger.

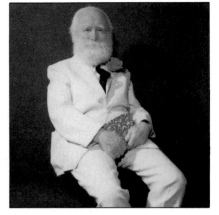

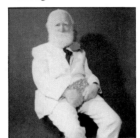

**Set to "darken"**
Moving the dial to the left darkens the image, in $\frac{1}{2}$ stop stages.

---

## How instant color film responds to exposure

**f16/ 2 stops under**
This series shows Polacolor 108 PE used on a Hasselblad back (below), at 1/125 sec. At two stops underexposed, dyes are fully saturated but the shadow areas are solid black.

**f11/ 1 stop under**
Shadows are still too black but the stripes of the parasol and the edge of the jug are beginning to emerge. The highlights are cleaner, and texture begins to show.

**f8/ normal reading**
Highlights and shadows are well balanced. Full detail shows in the hat and flower, and the parasol stripes are clearer, while the highlight on the jug is sharp.

**f5.6/ 1 stop over**
Highlights begin to dominate. The red hat and rose are weakened by desaturation and the jug is overexposed. Cyan is weak, and yellow losing strength.

**f4/ 2 stops over**
Patches of white appear on the hat and rose. The jug is grossly overexposed, but the parasol colors are clear. Dyes are weak, with cyan almost lost, but magenta holding on.

---

## Long exposure and development with peel-apart film

Polacolor film is available in special backs for use on conventional cameras, in various formats. This system allows you to use the full range of camera controls, and also exploit the effects of altered development time. The picture, right, was taken on a Hasselblad with Polacolor 108 P2 film, given a correct 1 sec exposure and an increased development time, of 100 sec. The low light, long exposure, and increased development have produced muted color and a rich tonal range.

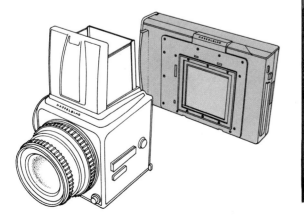

# FILM SPEED & GRAIN

Film emulsion consists of silver salts (halides) suspended in gelatin. When you expose film to light it takes only a fraction of a second to create minute changes in the silver halides and establish a latent image. The larger the halide particles dispersed in the emulsion, the quicker the film will respond to light: this is the film's "speed".

A slow film has a thin, even deposit of small silver halide crystals; a fast film has concentrations of larger crystals. Chemical development converts the exposed halides to grains of black metallic silver. The dye molecules, linked to the halides, form in direct proportion to the size of the silver grains. The pattern of minute dye particles forms the photographic image, in much the same way as a tapestry is made up of tiny, individual stitches. This is the film's "grain".

The faster the film, the coarser and more pronounced is the grain. The pictures right show a small area of a subject enlarged ×100 to emphasize grain on print and slide films of different speeds. Speed is rated in standard code numbers, see opposite: higher numbers denote faster films.

Grain is kept down in all ratings of color film, because coarse grain reduces color saturation, and gives poor definition. On the other hand, fast films can produce some very effective, grainy results when uprated and overdeveloped (see pp. 98–9).

*Color latitude*

The amount exposure can be varied either side of "normal", yet still give an acceptable result, is referred to as a film's "latitude". For example, Kodacolor 400 has a latitude of about 1½–2 stops for average subjects (latitude is reduced with high contrast subjects).

Latitude increases with film sensitivity and with the flexibility of the development process. The latitude of black and white film is generous, because you can vary the processing and printing, and still produce a picture of acceptable tonal values. But color film latitude is limited, because processing must be confined to a strict standard to maintain the correct colors. With color negative film, some exposure adjustments can be made in printing.

## Grain on color prints

Harsh grain structure causes a loss of picture quality because it breaks up the image colors, reducing saturation and color contrast. This makes pictures appear less sharp, and less brilliant. Loss of brilliance is particularly noticeable on prints, which normally show rather less color saturation than slides. With most standard prints from 35 mm negatives, magnification is not great enough to produce evidence of grain. With smaller negatives, especially if they have been overexposed and given compensatory printing, grain may become apparent on the print.

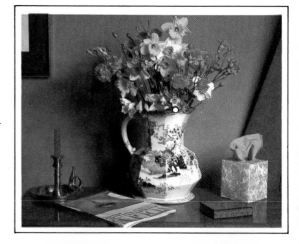

**100 ASA Fujicolor**
Grain is starting to become apparent, but the good color contrast maintains overall image quality.

**400 ASA Kodacolor**
Grain is coarse, and molecules of dye visible. But this film retains its color contrast.

## Grain on color slides

Since slides are usually projected, they are subject to considerable magnification. Increase of grain occurs in the same way as with prints, but because of the contrast and brilliance of the projected slide image, the effect of grain is rarely noticeable except in large areas of flat color. Copied slides show increase of grain from the original, and therefore slightly poorer quality.

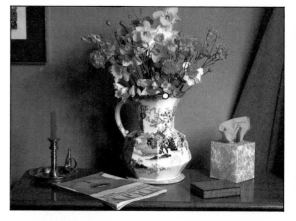

**25 ASA Kodachrome**
Even at 100 × magnification, this slow film has barely perceptible grain. Saturation and color contrast are both excellent.

**64 ASA Ektachrome**
Grain is still barely perceptible and color contrast is excellent, showing sharp detail.

**100 ASA Fujichrome**
With the increase in speed, grain is noticeable on this film, with slight loss of color contrast and apparent sharpness.

**200 ASA Ektachrome**
Fast film shows a noticeable increase in grain. Sharpness deteriorates; but on this film the larger dye molecules offset this by good color contrast.

# CHOOSING FILM SPEED

Since latitude varies little between color films, your choice of film speed depends only on particular subject and light conditions, and the quality of grain you want in the final picture. What type of subject will you be photographing? Will the light be bright, diffused or very limited? Will you be shooting action, or a posed portrait?

Some films are suitable for a variety of subjects and conditions. A medium rated film, with a speed of 64–125 ASA, gives acceptable color within an average range of light conditions. Grain size is minimal, and good definition possible. For a fine definition picture more or less free of grain, and shot in average or bright light, you would choose a film with a slow rating, say 25–64 ASA.

In less flexible conditions, where light is limited, you will need a film of high sensitivity. For example, an ultrafast film, 1000 ASA (perhaps uprated even higher, pp. 98—9) will help you compensate for weak light, and is especially useful if you also have to use a fast shutter speed to capture action.

*Fast films*

Fast color films (200—1000 ASA) are suitable for most types of photography, because their sensitivity to light means you can always choose a fast shutter speed, if you wish. This helps to avoid camera shake. You can also use smaller apertures to give greater depth of field (see p. 87). However, in very bright light, a fast film may be too sensitive, forcing you to stop down and use fast shutter speeds when a slow shutter or a wide aperture would suit your subject better.

Bear in mind that fast films may be unsuitable for use with some older 110 and 126 cameras–they may have been designed to give best results with slow to medium speed films. Newer models of the Canon, Fujica, Kodak, Minolta and Rollei ranges adjust automatically for 400 ASA film.

## Setting the ASA

Films of different speed ratings are not available for many simple 110 and 126 cameras, but some new, simple cameras are designed to set different exposure ranges for a choice of perhaps two film speeds. This is done as the film cartridge itself is inserted. If you have a camera with a full range of controls (usually 35 mm and larger formats) you must carefully note the speed of your film so you can set your exposure meter accordingly. Always match the film speed dial to the speed of the film unless you mean to uprate the film you are using (see pp. 98–9).

**Camera**
If your camera has a built-in exposure meter you must set the speed rating on the camera –usually on the shutter speed dial (above).

**Hand-held exposure meter**
On a hand-held meter, set the speed in the window on the calculator dial, to suit the film you are using. Check the setting does not slip.

## Film speed ratings

There are several systems for rating film speed: the American ASA and new international ISO use the same scale, in which a doubling of speed is shown by a doubling of rating number. The German DIN denotes doubling of speed by a rating increase of 3; the Russian GOST uses a scale like ASA. The table below shows the new ASA/DIN ratings of slow to fast transparency films.

| Speed (color slide film) | | ASA | DIN |
|---|---|---|---|
| Slow | (daylight) | 16 | 15 |
| | (daylight) | 25 | 15 |
| | (daylight) | 32 | 16 |
| | (tungsten) | 50 | 18 |
| Medium | (tungsten) | 64 | 19 |
| | (daylight) | 80 | 20 |
| | (daylight) | 100 | 21 |
| | (daylight) | 125 | 22 |
| | (daylight) | 160 | 23 |
| Fast | (daylight) | 200 | 24 |
| | (daylight) | 400 | 27 |
| Ultrafast | (tungsten) | 640 | 29 |
| | (daylight) | 1000 | 31 |

### Infra-red color film

Infra-red is radiated as wavelengths below the red end of the visible spectrum. These can be recorded on infra-red color film – its three layers respond to the green, red and infra-red areas of the spectrum. In addition all three layers are sensitive to blue light so a predominant magenta cast will result unless a yellow filter is used, see below. IR film can be used in daylight, artificial light and in total darkness to record invisible infra-red waves.

You can also photograph scenes in the far distance more clearly using IR film, as the long infra-red waves penetrate haze and mist. The chlorophyll used for photosynthesis by plants reflects infra-red waves, making foliage shot with IR film appear in bizarre colors – the colors vary according to the type, health and age of the leaves.

**Normal film** *left*
The normal film on the left has accurately recorded the green foliage and cacti. The distance is obscured by haze.

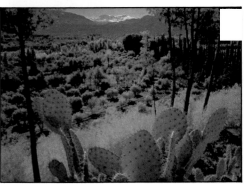

**IR film without filter** *above*
The same scene photographed on infra-red Ektachrome without any filter shows an overall magenta cast. To avoid this cast, the film is normally used with a yellow filter, see below.

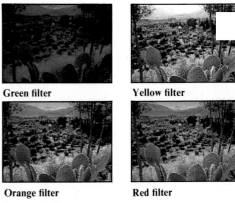

| **Green filter** | **Yellow filter** |
|---|---|
| **Orange filter** | **Red filter** |

**IR film with filters** *above*
Results with filters depend on the subject. In this case the green filter shows little change, merely emphasizing magenta. The yellow, orange and red filters remove the magenta cast. Each filter provides a new set of colors from the same scene.

# MATCHING FILM & LIGHT

The sun, our singular source of daylight, radiates "white" light–a continuous spectrum of all the visible wavelengths produced by elements burning on the sun's surface. When these wavelengths are separated out by reflection and absorption in the world around us, we see them as color–longer wavelengths as red, shorter ones as blue, and all the hues between.

Though we think of it as "white", daylight usually has some color content, slowly shifting between a predominance of red and a predominance of blue, as the sun's position and the effects of the atmosphere change through the day and year. Artificial light too is seldom truly white. But our eyes usually fail to notice this subtle bias in the everyday scene, unless it is very pronounced–like the blue of morning mist, or the red of sunset.

## Color response of film

The response of color film is less accommodating. The emulsion will record both the entire range of subject colors, and any extraneous color influence from the light. Tungsten artificial light, for instance, has a strong red/yellow content; winter daylight is rather blue; light cast through a green shade or leaves will dominate other colors in the picture, and so may light reflected from colored walls.

Because color film will record, but not interpret, the content and quality of light, emulsions must be chemically balanced to provide "normal" color in a given type of light. The color content of light is referred to as the "color temperature", expressed on a scale that ranges from black through glowing red, yellow, and white, to blue. Different color films are balanced to match particular parts of the scale–daylight, tungsten artificial light, and general purpose (daylight and artificial).

You can get exciting and unusual color results by bending the rules of color temperature–by shooting for example with daylight film in artificial light and vice versa. However, if color accuracy is important, use the correct film for the light source, or correct the light itself by filtering.

## Changing colors of light

Both the intensity and the color temperature of light vary according to season, time of day and local weather. These variations cause color casts that can be attractive.

**Blue cast in winter**
An overall blue color cast is caused when the short, blue wavelengths of light are scattered and reflected by minute particles of water vapor. This color effect can emphasize a wintry, industrial atmosphere, as in the picture, right.

**Green cast at dawn**
The faint oblique rays of early dawn, filtered through mist and haze, produce an ethereal green cast (right). The wavelengths of green light, which predominate under such conditions, are intermediate between short blue and long red wavelengths in the color spectrum (p. 56). The green cast here may be strengthened by particles of soot in the atmosphere.

**Red cast at the end of day**
The yellow and red glow of sunset is caused, not by water vapor, but by the absorption of blue wavelengths during the light's passage through the atmosphere. When the sun is low, the light travels a longer path through the atmosphere, so only red/yellow waves penetrate it. Sometimes, shorter wavelengths are included, and the sky takes on a faint, green cast. The extreme ends of the day often offer the most dramatic landscape effects, as in the picture, right.

## Matching light source and film

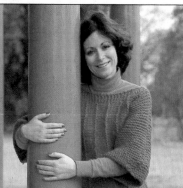

**Outdoors**
In daylight, tungsten film gives a blue cast and false colors, as you can see above. Daylight film, right, maintains the color range of the original scene.

**Indoors**
In artificial lighting, daylight film gives a yellow cast, above. Type B tungsten balanced film maintains the color balance and gives good flesh tones, right.

# COLOR TEMPERATURE

The color temperature of a light source is measured in Kelvins. A candle is found to be around 1930K; a household lamp bulb is 2400K–2800K; the average for daylight is between 5000K and 6000K; blue sky is from 12000K to 18000K. The Kelvin scale is shown below, parallel to its red/blue content, with the corresponding type of light source and appropriate film (and filter if necessary). The scale also shows mireds (*mi*cro *re*ciprocal *de*grees), which may be used on some filters and meters rather than Kelvins.

## Daylight and flash

You will see that outdoor lighting has a predominantly blue content. The midpoint of this blue area of the chart (5500K) can be taken as average daylight at around midday. Daylight films are designed to give most faithful color results between 5200K and 5800K. When you take pictures early in the morning or at sunset, lighting will be lower than 5200K, so color casts will occur.

**Color temperature meter**
This meter is used mainly by professional photographers needing extremely accurate readings in studio lighting conditions. It analyzes the color content of the lighting, showing whether the film should be used with or without a correction filter.

The newer fast color print film such as Kodacolor 400 (coded CG) are general purpose films. They are principally balanced for daylight. But as color correction filters are introduced at the printing stage, it is possible to use them in most forms of lighting without using filters on the camera.

Flash lighting has a color temperature equivalent to bright sunlight, and so requires daylight or general purpose film. When shooting with flash it is better to turn off any tungsten illumination.

## Tungsten lighting and using filters

The lower area of the chart shows the red content of artificial lighting. Tungsten type B film is the most easily obtained artificial light film. It is balanced for 3200K, so if you use tungsten illumination of a different color temperature you must use filters to maintain color balance. Indeed, you can alter the balance of any color film by using filters, but remember to increase the exposure by the filter factor.

## Color temperature chart

| K | Mireds | Outdoor source | Indoor source | Film and filter | Result |
|---|---|---|---|---|---|
| 18 000 | 56 | Snow, water blue sky | | | |
| 6000 | 167 | Large shadows, blue sky | | Daylight + 81A + ½ stop | |
| 5800 | 172 | Average day light, central | Electronic flash | | |
| 5600 | 179 | latitudes | | Daylight film optimum Type B + 85B + 2/3 stops | |
| 5400 | 185 | Noon sunlight | Blue bulb, cube flash | | |
| 5200 | 192 | | | | |
| 5000 | 200 | Average daylight Northern | | | |
| 4800 | 208 | hemisphere | Fluorescent "daylight" tubes* | GP film optimum *Daylight + 82C + 1 stop | |
| 4600 | 217 | | | | |
| 4400 | 227 | | | | |
| 4200 | 238 | Early morning late afternoon, and evening sunlight | | Daylight + 82C + 82A + 1 stop | |
| 4000 | 250 | | Fluorescent "warm white" tubes | | |
| 3800 | 263 | | | | |
| 3600 | 278 | | Clear flash bulbs | Type B + 81A + ½ stop | |
| 3400 | 294 | | Photofloods | Daylight + 80B + 1 stop | |
| 3200 | 312 | | Photolamps (pearls, argophot) | Type B optimum | |
| 3000 | 333 | | | | |
| 2800 | 357 | | Projector lamp Household 150/200W | Type B + 82C + 1 stop | |
| 2600 | 385 | | Household 60/40W | Type B + 82C + 82A + 1 stop | |
| 2400 | 417 | | Household 25W | Type B + 82C + 82C + 1½ stop | |
| 2200 | 455 | | | | |
| 1930 | 518 | | Candlelight | | |

Daylight

General purpose

Type B

Types B + 82C filter

**Daylight and flash film**
The emulsion of film balanced for daylight and flash will accept quite a wide range of color temperatures, accomodating blue flash (cube and electronic) and most daylight hours. The optimum range is from 5200–5800K but you will often find the most exciting lighting conditions outside these limits.

**General purpose print film**
Fast print films can handle a greater range of color temperatures than slide or slower print films. The optimum range is from 4500–5000K, but the films will give acceptable results from all forms of lighting (apart from fluorescent lighting, which requires a filter).

**Tungsten type B film**
Tungsten type B film is the only readily available film which is balanced for tungsten lighting. It is balanced for 3200K (250–500 watt photolamps or spots). Lighting of above or below this color temperature will produce progessively bluer or yellower results respectively with type B film.

**Type B film and filters**
For accurate color reproduction with type B film with tungsten lighting other than 3200K, you must use an appropriate filter. If you want to use, say a 150 watt domestic desk lamp (2800K), your result will be yellow ("warm") unless you use an 82C filter in front of the lens. Remember to increase exposure.

# CHOOSING FILM BRANDS

Modern tripack emulsions give very accurate color reproduction, but the patented dyes used by each manufacturer do produce color variations between brands. These can be quite distinctive – reds, blues and greens vary considerably, and films may show an overall warm (red/yellow) or cool (blue) color bias. Brands also differ, to a lesser extent, in saturation and in sharpness (effect of grain and contrast). These differences are important in color photography. For consistent results, it is best to keep to one brand for most of your photography, only changing it to get a particular result. Take care not to change brands during a sequence of shots.

Variations in color rendering are more evident in slides than in prints – the natural luminosity of a slide readily shows up differences in hue and tone. In addition, a degree of color bias in a negative can be corrected during printing (pp. 174–5).

Brand differences are most apparent when prints or slides are closely compared, using a neutral gray card as a key, as shown in the composite pictures on these pages. An exact rendering of the gray does not necessarily recommend a film for all-purpose photography – skin tones are more important.

The charts below and opposite are designed to help you choose the brand, speed and light-type of print or slide films, according to your subject and lighting, or the color rendering you want. The films shown are all available in 35 mm cassettes. (Instant picture films are compared on pp. 46–7.)

## Slide films

### A bluish-gray cast
Most slide films give fully saturated colors in bright light. However, you must use a daylight, U/V, or a red filter to compensate for bluish grays.

### A red bias
Color slide film is most susceptible to the effects of unsuitable storage conditions, which may produce a red bias like this. Keep your films in a freezer until a few hours before you need them.

### Too much yellow
Unsuitable storage conditions may also cause one emulsion to slow down. In this case the blue-sensitive layer on reversal produces too much yellow dye (grays become yellow).

### A magenta bias
Try to buy film in bulk and all in one batch. In this case you may need to use a 10G color correction filter to compensate for the strong magenta bias which produces casts on flesh tones and degraded greens.

### Cool colors
Because you cannot compensate for color casts after shooting on slide film, test several brands and select one which gives a good neutral response, as here.

## Chart of recommended slide films

The chart below suggests films appropriate to different subjects in differing lighting situations. The columns cover all-purpose films, and films for specific subject types. Film speed numbers are shown as ASA/DIN ratings, but some films such as Kodacolor VR 1000 also denote their film speeds in their titles. Films suggested for tungsten light are balanced to 3200K and may require correction in other artificial lighting conditions.

| K | Kodachrome | | |
|---|---|---|---|
| A | Agfachrome | B | 100 |
| I | Ilfachrome | C | 135 |
| E | Ektachrome | D | 120 |
| F | Fujichrome | E | Sheet |

| | General | Landscape | Portraits | Action | Close-up | Nature | Still life |
|---|---|---|---|---|---|---|---|
| **Bright sun** | K 25 (25/15) C<br>A 50S<br>Prof (50/18) C, D, E<br>I 100 (100/21) C | K 64<br>(64/19) B, C<br>E 64 (64/19) C, D<br>A 200 (200/24) C | K 25 (25/15) C<br>E 64<br>Prof (64/19) C, D, E<br>E 160 Prof<br>(160/23) C, D, E | K 64 (64/19) B, C<br>A 100 Prof<br>(100/21) C<br>3M color slide<br>1000 (1000/31) C | K 64 (64/19) B, C<br>A 100 Prof<br>(100/21) C<br>E 400 (400/27) C, D | K 64 (64/19) B, C<br>A 100S<br>Prof (100/21) C, D, E<br>F 100 Prof<br>Type D (100/21) C, D, E | K 25 (25/15) C<br>A 100S<br>Prof (100/21) C, D, E<br>F 100 Prof<br>Type D (100/21) C, D, F |
| **Shade** | K 64 (64/19) B, C<br>F 100 Prof<br>(100/21) D, E<br>E 200 Prof<br>(200/24) C, D, E | E 160<br>Prof (160/23) C, D, E<br>F 400 (400/27) C<br>A R100S<br>Prof (100/21) D, E | E 160<br>Prof (160/23) C, D, E<br>F 400 (400/27) C<br>A R100S<br>Prof (100/21) D, E | E 400 (400/27) C, D<br>3M color slide<br>(400/27) C<br>3M color slide<br>1000 (1000/31) C | E 400 (400/27) C, D<br>3M color slide<br>(400/27) C<br>3M color slide<br>1000 (1000/31) C | E 400 (400/27) C, D<br>3M color slide<br>(400/27) C<br>3M color slide<br>1000 (1000/31) C | E 400 (400/27) C, D<br>K 64 (64/19) B, C<br>A 50S Prof (50/18)<br>C, D, E |
| **Flash** | K 25 (25/15) C<br>F 100<br>Prof Type D<br>(100/21) C, D, E<br>A R100 S Prof<br>(100/21) D, E | | K 25 (25/15) C<br>F 64<br>Prof (64/19) C, D, E<br>A 50 "S"<br>Prof (50/18) C, D, E | I 100 (100/21) C<br>F 400 (400/27) C<br>3M color slide<br>1000 (1000/31) C | E 200 Prof<br>(200/24) C, D, E<br>F 400 (400/27) C<br>3M color slide<br>1000 (1000/31) C | K 64 (64/18) B, C<br>F 50 Prof Type<br>D (50/18) C, D, E<br>A 50 S Prof<br>(50/18) C, D, E | K 25 (25/15) C<br>E 64 Prof (64/19)<br>C, D, E<br>A 50 S Prof<br>(50/18) C, D, E |
| **Tungsten*** | K 40<br>Type A (40/17) C<br>A 50 L<br>Prof (50/18) C, D, E<br>3M color slide<br>6407 (640/29) C | | K 40<br>Type A (40/17) C<br>F 64<br>Prof (64/19) C, D, E | E 160 Prof<br>(160/23) C, D, E<br>3M color slide<br>640 T (640/29) C | 3M color slide<br>640T C<br>E 160 Prof<br>(160/23) C, D, E | K 40 Type A<br>(40/17) C<br>A 50 L Prof<br>(50/18) C, D, E | K 40 Type A<br>(40/17) C<br>E Prof Type 6118<br>(32/16) E<br>A 50L Prof<br>(50/18) C, D, E |

\* Kodachrome 40 Type – balanced for normal 3400 °K (all other tungstens 3200 °K)

## Brand and film speed

Each brand offers films in a range of speeds. In general, slower films are inclined to give greater saturation, while faster films can record subtler variations of tone and hue in low lighting. For example, Kodachrome 64 gives good results with strong colored subjects, while Ektachrome 400 is at its best with muted scenes, but these effects also vary with brand. It is worth trying several in order to achieve the effects you like. Slower films tend to have lower grain and better color contrast, so appearing sharper. Kodacolor VR films have a new "T grain" structure which means faster emulsion while retaining sharpness and definition.

## Brand and lighting conditions

Brands also vary in their color performance under different lighting conditions. Most films give good saturation in a variety of daylight conditions. Kodachrome 64 or Kodacolor VR200 retain strong color in overcast daylight or deep shade, but faster films lose saturation more quickly. Some color negative films are balanced for tungsten light, notably Fujicolor 80 Professional L (80 ASA/20 DIN), Vericolor II Professional Type L (80 ASA/20 DIN), and Fujicolor 8518 (250 ASA/25 DIN). The fastest color negative films presently available are rated at 1000 ASA/31 DIN. Some films, such as Kodachrome 64, must be returned to the manufacturer for processing.

## Colour negative films

### Slow or medium speeds
Color negative films with a speed of around 100 ASA give good highlight and shadow detail, neutral grays and good color saturation in standard lighting conditions.

### Harsh lighting
Lighting conditions which are hard (direct flash) will result in good shadow detail but loss of highlight detail if exposed for the shadows. Colors will be rendered accurately but will be rather bright.

### Color casts
Color negative film is likely to produce color casts if you use an incorrect light source and exposure for the film. This means, for example, that you will get green shadows and red highlights which are impossible to correct at the printing stage.

### Correcting a green cast
This color test shows a single green color cast. This is simple to correct by reducing magenta in the filter pack. The background will shift to gray, and the red, yellow and magenta will "clean up" and become more vibrant.

Ⓐ Agfacolor
Ⓕ Fujicolor     A Disc
Ⓚ Kodacolor     B 110
Ⓥ Vericolor     C 135
ⓀⒸ Konicacolor     D 120
Ⓘ Ilfacolor     E Sheet

## Chart of recommended color negative films

This chart suggests films for prints, covering the same range of subjects and lighting as are shown for slides, opposite. Each brand has its film speed indicated, plus its format availability. You can either use the films specifically designed for tungsten light (see chart) or you can correct daylight film for tungsten as required with suitable color correction filters.

| | General | Landscape | Portraits | Action | Close-up | Nature | Still life |
|---|---|---|---|---|---|---|---|
| **Bright sun** | Ⓚ VR Disc 200/24 A<br>Ⓥ III Prof<br>Type S (160/23) D, E<br>Ⓐ N100S<br>Prof (100/21) D, E | Ⓚ VR Disc 200/24 A<br>Ⓥ III Prof<br>Type S (160/23) D, E<br>Ⓐ N100S<br>Prof (100/21) D, E | Ⓚ VR Disc 200/24 A<br>Ⓥ III Prof<br>Type S (160/23) D, E<br>Ⓐ N100S<br>Prof (100/21) D, E | Ⓚ VR Disc 200/24 A<br>Ⓥ III Prof<br>Type S (160/23) D, E<br>Ⓐ N100S<br>Prof (100/21) D, E | Ⓚ VR Disc 200/24 A<br>Ⓥ III Prof<br>Type S (160/23) D, E<br>Ⓐ N100S<br>Prof (100/21) D, E | Ⓚ VR Disc 200/24 A<br>Ⓥ III Prof<br>Type S (160/23) D, E<br>Ⓐ N100S<br>Prof (100/21) D, E | Ⓚ VR Disc 200/24 A<br>Ⓥ III Prof<br>Type S (160/23) D, E<br>Ⓐ N100S<br>Prof (100/21) D, E |
| **Shade** | ③Ⓜ color disc film<br>(200/24) A<br>ⓀⒸ SR<br>Prof Type S (100/21) D, E<br>Ⓚ VR 400<br>(400/27) B, C, D | ③Ⓜ color disc film<br>(200/24) A<br>ⓀⒸ SR<br>Prof Type S (100/21) D, E<br>Ⓚ VR 400<br>(400/27) B, C, D | ③Ⓜ color disc film<br>(200/24) A<br>ⓀⒸ SR<br>Prof Type S (100/21) D, E<br>Ⓚ VR 400<br>(400/27) B, C, D | ③Ⓜ color disc film<br>(200/24) A<br>Ⓚ VR 1000<br>(1000/31) C<br>Ⓐ 400<br>(400/27) B, C | ③Ⓜ color disc film<br>(200/24) A<br>Ⓚ VR 1000<br>(1000/31) C<br>Ⓐ 400<br>(400/27) B, C | Ⓐ N100S<br>Prof (100/21) D, E<br>ⓀⒸ 400<br>(400/27) B, C, D | ③Ⓜ color disc film<br>(200/24) A<br>Ⓐ N100S<br>Prof (100/21) D, E |
| **Flash** | Ⓚ VR<br>Disc 200/24 A<br>Ⓚ VR 100<br>(100/21) B, C, D<br>Ⓥ III Prof<br>Type S (160/23) D, E | | Ⓚ VR<br>Disc 200/24 A<br>Ⓚ VR 100<br>(100/21) B, C, D<br>Ⓘ 100 (100/21) B, C | Ⓚ VR<br>Disc 200/24 A<br>Ⓚ VR 400<br>(400/27) B, C, D<br>Ⓘ 400<br>(400/27) C | Ⓚ VR<br>Disc 200/24 A<br>Ⓚ VR 1000<br>(1000/31) C<br>Ⓘ 400<br>(400/27) C | Ⓚ VR<br>Disc 200/24 A<br>③Ⓜ color print II<br>120 RP (100/21) D<br>Ⓘ 100 (100/21) B, C | Ⓚ VR<br>Disc 200/24 A |
| **Tungsten** | Ⓥ II Prof<br>Type L (80/20) D, E<br>Ⓐ N80L<br>Prof (80/20) D, E<br>Ⓕ 80 Prof L<br>(80/20) D, E | | Ⓥ II Prof<br>Type L (80/20) D, E<br>Ⓐ N80L<br>Prof (80/20) D, E<br>Ⓕ 80 Prof L<br>(80/20) D, E | Ⓥ II Prof<br>Type L (80/20) D, E<br>Ⓐ N80L<br>Prof (80/20) D, E<br>Ⓕ 8518<br>(250/25) C | Ⓥ II Prof<br>Type L (80/20) D, E<br>Ⓐ N80L<br>Prof (80/20) D, E<br>Ⓕ 8518<br>(250/25) C | Ⓥ II Prof<br>Type L (80/20) D, E<br>Ⓐ N80L<br>Prof (80/20) D, E<br>Ⓕ 80 Prof L<br>(80/20) D, E | Ⓥ II Prof<br>Type L (80/20) D, E<br>Ⓐ N80L<br>Prof (80/20) D, E<br>Ⓕ 80 Prof L<br>(80/20) D, E |

# 3 THE LANGUAGE OF COLOR

Color is a powerful language. It helps define what we see and communicates mood or emotion, as well as delighting our eyes. To use this language consciously in your pictures, you must discard your assumptions about color and begin to see with a fresh eye – recognizing the way light affects colors, and how the colors your film records will differ from what you see.

## Light, vision and color film

All color comes from light. We see by detecting different wavelengths of light, just as we hear by detecting different wavelengths of sound. When all visible wavelengths are present, we see white, or daylight; when none, we see black, or darkness. But when only some are present, we see color.

Objects appear colored mainly because their surface pigments absorb some wavelengths but reflect others. A green leaf, for instance, is reflecting green wavelengths and absorbing the rest. In white light, the leaf appears green – the denser the pigments and the stronger the light, the more intense (saturated) the color becomes.

If the leaf is shiny, it reflects some white light toward you, weakening the color; if it is in shade, or dim light, the color is muted because there is less light to reflect. In red light, it turns black, because there is no green light to reflect. While if the pigments are interspersed with areas that absorb light (black) or reflect it all (white) the color will be more muted in any light.

Oil on water, and the grooves of an LP disk, diffract light (produce interference) so that you see colors from some angles: a prism refracts it (bends light of different wavelengths differentially) to produce spectral colors. Various combinations of absorption, reflection, refraction and scattering affect light as it passes through the atmosphere, often producing color casts. Sky light, for example, is often blue, giving a blue cast in shadows.

Our color vision becomes weaker in dim light, when we see more in black and white. But color film records any color present, however faint. Pictures taken in dim light often show surprising color strength. In addition, we notice strong colors more readily than muted hues – particularly if these are distant from us. But in photographs, the subtler shades of color are recorded clearly.

The colors we see are also conditioned by what we expect, and limited by our attention. We think of grass as green, stone as gray, and objects outside our attention as neutral, while largely ignoring the effects of light. But your film records whatever color wavelengths it receives – showing grass black and stone pink in a red sunset, or background objects in obtrusive bright colors.

## Using the language of color

An unusual or striking color effect can itself be the subject of a picture, as opposite. More often, color is an essential part of your picture's structure. It defines shapes, patterns and textures, and conveys distance – the further an object is away, the paler it appears. It also directs attention – strong colors stand out, while weaker ones recede. Some colors blend gently, producing harmony; others contrast, emphasizing shapes and creating impact. The overall influence of one color can determine mood; while small patches of color attract the eye.

Colors also evoke an emotional response – strong colors suggest vigor, muted colors are more romantic. Red and yellow are dynamic and warm; blue and green are passive and cool.

In this chapter we have divided color effects into ten categories: strong color, muted color, high key (pale) color, low key (dark) color, contrast, harmony, predominant color, isolated color, and false color. You will find these overlap in practice, and you may develop other categories of your own; but learning to recognize particular effects will develop your color awareness, and help you to exploit the language of color in your pictures. There are many ways you can select or strengthen color effects in your photographs – with viewpoint, framing and choice of lens; with focus and exposure; with color filters and darkroom effects; and most of all, by taking advantage of the influence of light.

**Learning to see color**
Bare winter woodlands are generally associated with dull, muted colors. So strong is this association, that the powerful color in this picture seems almost surreal. Even though it was in partial shade, the photographer was struck by the subtle green of the tree bole, covered in moss and lichen, and its contrast with the blue sky beyond. Notice how careful framing isolates and emphasizes the color effect. As you develop greater awareness of color, you will yourself begin to notice the abundance of striking color subjects in your environment.

# UNDERSTANDING COLOR RELATIONSHIPS

Many systems have been devised to categorize all the shades of color we see around us. Although terminology may differ, most agree in defining color by three qualities – *hue* (the actual color wavelength), *saturation* (intensity or chroma), and *brightness* (luminance or value). Saturation and brightness produce different tones of a hue.

In general, colors which differ greatly in hue, saturation or brightness provoke contrast when placed together, while those that are similar produce harmony. Pictures limited in tonal range or hue can be very effective – as in high or low key subjects, or predominant or isolated color scenes. False or unusual colors can suggest unreality.

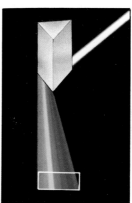

## Color circle

Color relationships can be shown simply on a color circle. A conventional circle is formed by bending the spectrum band, above, so the red and violet ends meet. The circle shown right is stylized, and limited to six hues – primaries (red, blue, green), and complementaries (cyan, yellow, magenta). The center of the circle represents white light.

### Contrast and harmony

The circle contains only pure saturated hues, giving strong color, below. As you can see, the circle has a warm half (red, yellow, magenta) and a cool half (blue, green, cyan). Colors from opposite halves of the circle produce color contrast when placed together, far right. A primary and its complementary, lying opposite each other on the circle, give the strongest contrast. Colors from the same segment of the circle produce harmony, below right.

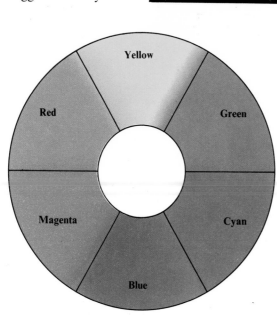

### The range of hues

The visible spectrum contains seven hues, but these can all be produced by mixing light of three colors – red, green and blue. These are the primary colors of light. Added two at a time they produce three new hues – the complementary colors, magenta, cyan and yellow. Cyan, for example, contains green and blue and is complementary to (forms white light with) red. Red, blue and green only serve as primaries when mixing lights. To mix pigments, red, blue and yellow are used; while the complementary colors, called subtractive primaries, are used in most color printing and films. The major hues can be arranged in a color circle

### Primary colors

Red, blue and green are primary colors. By adding lights of these colors you can make any hue – they are additive primaries. All three together make white light. Tripack color films, and our eyes, analyze color by its primary content.

### Complementary colors

Magenta (red/blue), cyan (green/blue) and yellow (red/green) are complementary colors, each made of two primaries and complementary to a third. Complementary dyes (subtractive primaries) form the image in tripack color films.

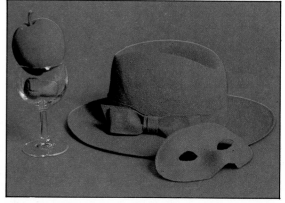

**Color contrast**

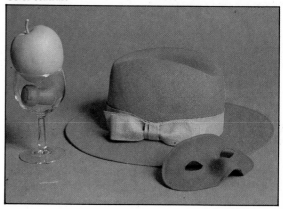

**Color harmony**

**Strong color**

where adjacent hues are closest in wavelength. The circle shows how hues interact – which provide harmony, which contrast, which are warm or cold.

*Saturation and brightness*

The pure hues of the color circle are fully saturated (undiluted). Each hue can also appear in a range of tones, which can be shown as a triangle projected from the circle. The hue is desaturated (diluted) as it moves down the triangle, and changes in brightness across the triangle. The more desaturated a hue becomes, the more black (shadow or pigment), white (light or pigment), or gray is intermingled with it.

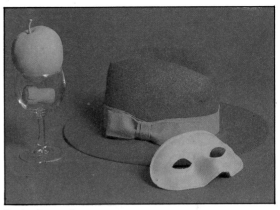

**Predominant color**

## Tonal triangle

The tonal range of a single hue from the color circle can be displayed as a triangle, with saturation changing vertically and brightness changing horizontally. The hue is progressively desaturated as it moves down the triangle, from strong color at the top, through muted color, to absence of hue. Moving across the triangle, the tones increase in brightness from left to right, going from black (no light) to white (maximum light).

## Defining hue and tonal range

Color effects can be defined by their range of hue or tone. Predominant color images are dominated by a single hue. Isolated color images are small, saturated color areas on a muted background. High key images use only pale, bright tones from the right half of the triangle; low key only deep, dark tones from the left side. Muted color scenes use only the desaturated hues in the lower part of the triangle.

**Low key color**

**Muted color**

**High key color**

## False color

A subject which appears in hues different from its original coloring is said to show false color. Such effects can arise naturally in lighting with a strong color cast, or be induced deliberately. The objects below were originally a red apple, a green hat and a blue mask. The false colors arose from using infrared slide film, given negative processing.

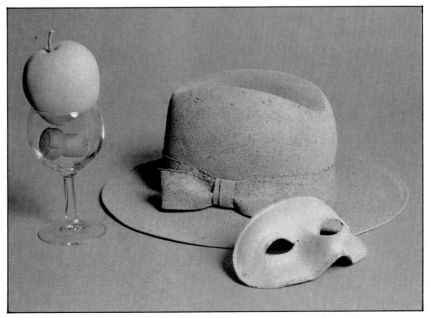

**Isolated color**

# STRONG COLOR—CARNIVAL MOOD, BRIGHT LIGHT

Pure strong colors hold the eye and create bold, vital effects. You can use them to command and direct attention, or exploit their carnival mood, as shown here. But you must handle them with care. Strong colors dominate all others in a picture. They can overwhelm shape and detail, or unbalance a composition. Primary colors are the most powerful, particularly red—a small area of red distracts attention from the rest of a scene. So make sure that areas of strong color support the main interest in your pictures.

Many strong colors together result in a struggle for power. This gaudy clash of colors suits some subjects. But generally strong color pictures are more effective if you limit the range of hues and include areas of neutral contrast.

Color is strongest when fully saturated—undiluted by black or gray (shadow or tone) or white (light or tone). So you need strong direct lighting. Bright flat daylight without strong shadows or highlights is ideal—particularly when the air is clear after rain. Or you can use a shaft of intense light to pinpoint a color on a dark background. But you will not get strong color in dim or diffused light, nor where haze or distance desaturate color.

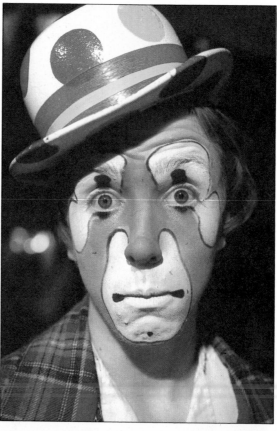

## Using neutral contrast
*left and right*

Strong light and bold colored shapes, contrasted with black or white make these fairground pictures very effective. The expressive clown's face was lit by a powerful studio flood in a dim interior. The prancing carousel horse, right, was picked out by brilliant sunlight against a shadowed background.

**To take the picture** *left*
- 📷 reflex or rangefinder
- ○ skylight
- fast type B, uprated two stops
- studio flood
- wide aperture, slow shutter; tripod or carefully hand-held

**To take the picture** *right*
- 📷 reflex or rangefinder
- standard or medium wide-angle
- read from highlights
- wide aperture, fast shutter

## Strident carnival colors

Flat daylight gave intense color saturation in this quick shot of a moving carnival float. With little neutral relief, and many competing colors, the effect is vital and gaudy.

**To take the picture**
- 📷 reflex or viewfinder
- pre-set exposure and bracket
- medium aperture, fast shutter

# STRONG COLOR—DETAIL & DESIGN

Since the invention of synthetic dyes and pigments in the nineteenth century and the progress in color photography, our modern environment has developed an unprecedented range of colors. You will find a wealth of strong colored subjects around you, particularly in the details of urban environments – painted buildings, illuminated signs and traffic signals, vehicles, clothes in store windows. In the natural world, too, close detail provides the strongest colors – flowers, fruit, bright insects and the plumage of birds.

Strong color is color for color's sake – its very intensity is the main point of the picture. Strong colors need strong simple design. Bold graphic images can be more effective than a riot of colors, particularly in close up. Take care with the proportions of different colors in your pictures – warm colors are more dominant, so a small area of saturated red or yellow may effectively balance a larger area of blue or green. There are many ways you can strengthen the color in your photographs – by working close up to eliminate desaturated colors, by using strong light, and by positioning your camera or using a polarizing filter to reduce specular reflections and glare. Backlighting through colored glass, curtains or flowers gives strong color, as do matching light casts – yellow appears stronger in tungsten light, blue under blue sky light, green in light shining through green leaves.

If you are shooting with print film, remember that the print paper will absorb a proportion of the color – slides are more brilliant. Strengthen color in prints by using neutral contrast, particularly black, and by close framing; try slightly overexposing, for a denser negative, with compensation in printing. With slides, try under-exposing by, say, one stop, in order to increase the color saturation.

## Strong color subjects

Both in human society and in the natural world, strong colors are used to attract attention and as signals. Man use red for danger, green as an all-clear signal and patterns of bold colors as identifiable symbols – flags, military uniforms, packaging, etc. Birds, insects and fish use color patterns for identification; flowers use it to attract pollinating insects. Remember that close framing and attention to design help to enhance strong color.

*Top row, left to right*
Painted bicycle frame and lock, shot after rain for strong color saturation; pyramid of circus tumblers in brilliant costumes, shot on uprated film (p. 98–9); wall in Arab quarter of a city; backlit stained glass detail; North African bazaar scene in strong sunlight, balanced against a warm neutral background.

*Middle row, left to right*
Drive-in restaurant chairs and tables in bold colors and shapes; pair of brightly colored parrots close-framed against neutral background; painted house, sky and cloud shapes framed for graphic effect.

*Bottom row, left to right*
Sunflower framed close up against white contrasting background; close-up of wall tapestry displayed in market; Las Vegas neon signs, shot through a prism (p. 190) to produce multiple images on a black sky; zipped tent entrance taken from inside to produce a strong abstract design; detail of children's painted mural; close-framed military uniform in a store.

## Intensifying color

### Working close up

Moving in close to your subject helps to strengthen color. It eliminates distracting weaker color elements, fills the frame with color, and also minimizes the desaturating effect of scattered light. But take care to avoid camera shake, as this is more noticeable in close-ups.

### Using a polarizing filter

If you have a reflex camera, a gray polarizing filter is very useful for improving color saturation. It removes the polarized wavelengths of light that create glare while leaving other subject colors unaffected. Polarized light is reflected from bright skies and smooth (non-metallic) reflective surfaces – glass, water. Place the filter in front of your lens and rotate it until optimum color saturation is observed.

**Without filter**          **With filter**

# MUTED COLOR—EXPRESSIVE LIGHT & TONE

Whereas strong color impresses us with its vitality, muted color is evocative and expressive. You can use it to convey many different moods – industrial bleakness, rural tranquillity, romantic portraits, and dramatic stormy landscapes. You will find muted colors in most natural landscapes; in worn, aged and weathered surfaces; in gray urban scenes, and in winter.

Color is muted by the addition of black, gray or white–whether through the effects of lighting and exposure, or through desaturated tones in the subject. Low lighting reduces saturation. The delicate colors produced by failing evening light or by available light indoors (p. 118) can be captured on fast film. Shadows add black and gray, while reflection, flare and scattering of light desaturate color by introducing white. Shooting into the light also mutes color, often increasing tonal contrast. You can use exposure selectively to emphasize such light effects: overexposure adds white; underexposure deepens color and adds black. And finally, with a long lens, you can select an area of distant muted color to produce a pale unreal effect.

### Colors muted by effects of light *left and below*

Muted color most commonly arises from the effects of scattered light. In the portrait of the miner, left, a dusty atmosphere and a dim single light source have softened and desaturated colors. Flesh tones are stressed by the directional light and deep cast shadows. The mood is dramatic and rather bleak. The evening seascape, below left, has a gray-blue cast produced by distance, weak light, and scattering of blue wavelengths. Color was further reduced by shooting into the light, exposing for highlights, and using a long mirror lens (p. 189), which produced the circular highlights. Foreground detail is eliminated, and the figure reduced to a silhouette, creating an ethereal effect.

**To take the picture** *left*
- reflex or viewfinder
- fast
- read from face
- wide aperture, slow shutter

**To take the picture** *below*
- reflex
- 500 mm mirror or 500 mm telephoto with black dot marked over center
- fast
- TTL, read from highlights; bracket 1 or 2 stops down
- full aperture, fast shutter

### Muted subject colors

The gray of weathered stone allows the faded splashes of yellow and blue to stand out, giving a range of gentle muted colors and strong textural effects. The picture was shot in shade, using a wide-angle lens and close viewpoint. Notice how this affects perspective, exaggerating the three-dimensional qualities of the steps and doorway.

**To take the picture**
- reflex or viewfinder
- medium wide-angle
- read from mid-tones

# MUTED COLOR—DIFFUSION & SOFT FOCUS

When mist drifts across a landscape, or it is obscured by rain, light is scattered and colors softened and muted. Dust, smoke and pollution also mute color by obscuring the transmission of light waves. Smog may give a yellow or green cast to light; smoke usually mutes colors to a dusky blue; rain renders everything in shades of gray.

Colors in distant scenes are muted by atmospheric scattering of light, so that tones appear progressively paler as landscapes recede from the eye. This is known as aerial perspective (p. 109).

The minute droplets of water vapor in winter fog and mist can act like millions of tiny mirrors, reflecting light in all directions. Sometimes the effect is a brilliant white light that desaturates the most strident colors. More often it is that familiar soft blue, reinforced by the inherent blue sensitivity of color film, as in the park scene opposite.

*Techniques that mute color*

You can deliberately mute colors in many ways. They can be softened by creating soft focus: vaseline smeared on a filter, a haze filter, an old stocking over the lens, shooting through dust or condensation on a window, deliberate defocusing (p. 91), or moving the camera while the shutter is open, all produce softening effects. Moving subjects given a long exposure produce transparent, ghostlike images; shorter exposures partially blur the subject producing streaks of color. You can find such techniques in the section on Action Photography.

**Colors muted by diffusion** *left*
The combination of diffused light, smoke and dust effectively mutes colors in this shot of a blacksmith in his forge. Notice how the tones decrease progressively in strength toward the background.
**To take the picture**
📷 reflex or viewfinder
⬛ standard or medium long

**Shooting with a soft focus lens** *below*
Vaseline smeared on a filter blurs the image and mutes colors by obscuring the transmission of light waves. Shooting into the light and exposing for shadows create pale, desaturated tones, accentuated by flare.
**To take the picture**
📷 reflex
⬛ long
○ vaseline on glass
▸ fast
◉ read from shadows

### Shooting through a dusty window

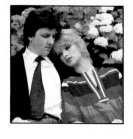

In the photograph above, dust on a window pane has effectively obscured the light waves and produced a soft, muted image, creating a romantic mood in keeping with the subject. With the window open, right, stronger colors and detail destroy the mood.

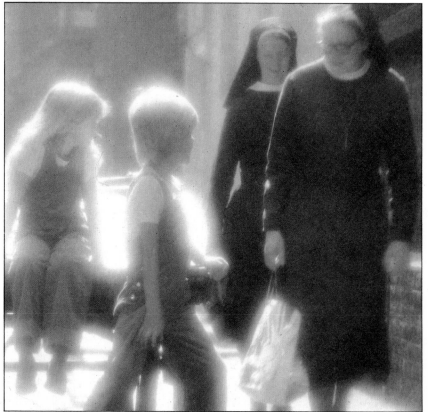

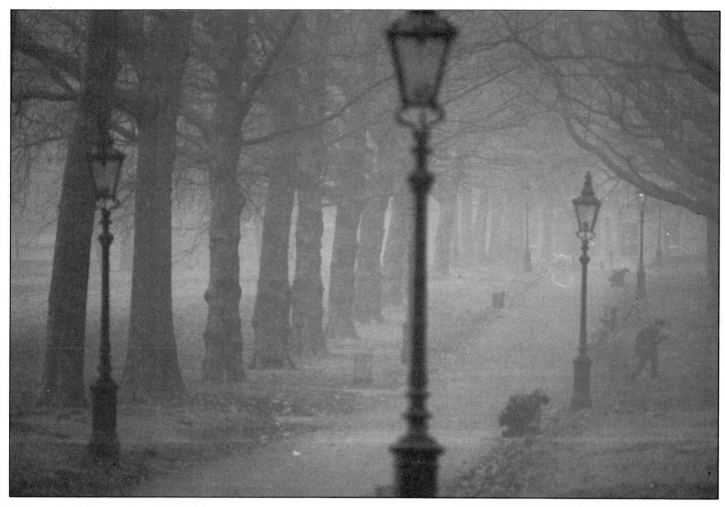

## Colors muted by weather and distance

In the foggy park scene above and in the rainy street scene below, the moist winter atmosphere has scattered the light waves in all directions, producing an overall soft blue cast and a romantic mood. The landscape on the right shows how colors fade as distance and atmospheric interference increase, especially at dawn or by evening

light. Here this atmospheric perspective creates a delicate picture of soft pinks and blues.

**To take the picture** *above*
- reflex
- medium long
- fast

**To take the picture** *below*
- reflex or direct viewfinder
- standard or medium wide-angle
- fast
- medium aperture, slow shutter

**To take the picture** *right*
- reflex
- long
- fast
- small aperture, medium shutter

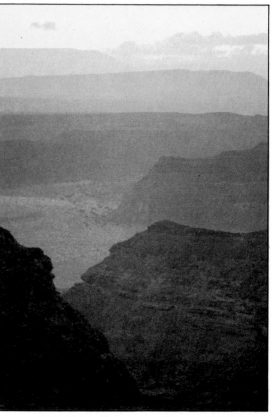

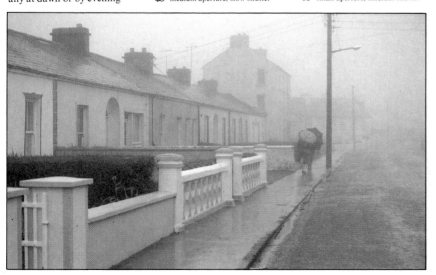

# HIGH KEY COLOR

When a scene is dominated by reflected white light, the pictorial effect is called high key. High key pictures contain large areas of light, desaturated colors with few mid-tones and shadows. Like low key pictures, they are defined by limited contrast, being composed of fairly uniform, desaturated shades.

Subjects for high key pictures may exist naturally or be deliberately created. A high key tonal range is usually caused by atmospheric conditions – by scattered reflected light in fog and mist and by powerfully reflective surfaces such as snow, sand and water. Under these conditions, you are bound to get a high key picture unless you underexpose.

Deliberate overexposure (exposing for shadows) will create a high key effect while slight overexposure will intensify the effect of a potentially high key subject, burning out highlights, reducing contrast and desaturating color. A high key effect may also be produced by shooting into the light (coupled with overexposure), by introducing additional lighting, and, at the processing stage, by overdevelopment (see pp. 164–9).

High key pictures tend to suggest lightness, heat, delicacy and happiness. Potential subjects include sand dunes, seascapes, snowscapes, and portraits.

## Using high key for a romantic portrait

Slight overexposure of a naturally high key subject, combined with soft lighting, enhances the romantic mood of this delicate, golden portrait. Exposure was bracketed one stop either side of the "normal" reading – the picture shown right was exposed at one stop above normal.

**To take the picture**
- reflex or viewfinder
- medium long
- electronic studio flash, bounced
- flash meter or guide numbers; bracket 2 stops

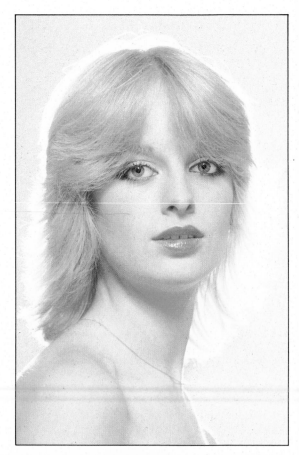

## Natural high key

The landing of a military helicopter has created a dust cloud that completely filters out any color, save for a predominant grayish brown. The high key effect has been produced by the combined influences of dust and bright sunlight, reducing the contrast.

**To take the picture**
- reflex
- medium long
- small aperture, medium shutter

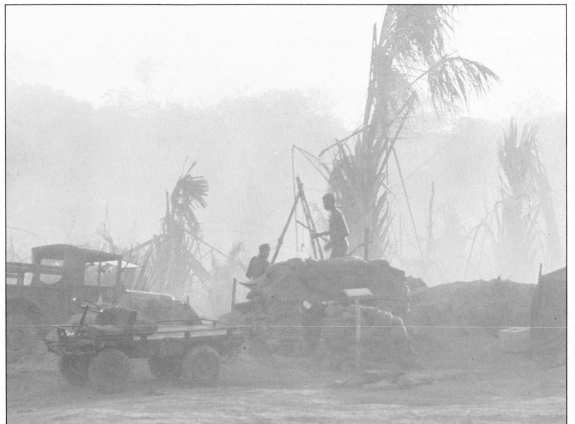

# LOW KEY COLOR

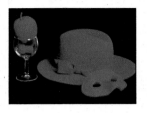

A low key effect is created when light is weak and the scene is dominated by shadows. Low key pictures tend to have predominantly dark, degraded colors, generous areas of shadow and few highlights, though they may also contain colors which appear fairly bold and rich, due to the dark, shadowed background. A low key effect is produced by selecting naturally dark subject colors such as violet, or black or gray. A blue color cast due to weak light, fog or mist will lower the tonal range. Low key shots can also be induced by exposing for highlights.

A low key tonal range is frequently used for nudes, portraits and stormy landscapes; the mood it evokes is mysterious, dramatic, dark or sensuous.

**Dramatic low key** *above and left*

The dramatic low key mood is established in these two shots by a combination of lighting quality and location. The portrait above was taken in a meadow in low sunlight, creating dramatic rim lighting on the face. The low key effect was enhanced by exposing for highlights, using a fast shutter speed. In the picture on the left, the clown's head and the balloons are obscuring the light source, limiting the contrast. The dark, shadowed background makes the colors appear richer.

**To take the picture** *above*
- reflex
- medium long
- medium aperture, fast shutter

**To take the picture** *left*
- reflex or viewfinder
- fast type B, uprated 2 stops

**Low key through exposure** *above*

Exposing for sunlight and bracketing one stop below normal have produced a dark, mysterious image. Without deliberate underexposure, flare from the sun would have overwhelmed detail. A starburst filter was used to counterpoint the shadow.

**To take the picture**
- reflex or viewfinder
- starburst
- read from sunlight; bracket one stop down
- small aperture, medium shutter

# COLOR CONTRAST—DYNAMIC EFFECT

Colors with opposite characteristics interact strongly when placed together, creating a dynamic effect. Each color offsets and exaggerates the qualities of the other, so that the color images stand out boldly from your picture. This color contrast is strengthened if you support it with the contrast of mass against detail—a solitary bright red flower pinned to a bright green hat or coat is a good example.

Warm and cold colors nearly always contrast—the warm color advances while the cold one recedes. Dark colors contrast against light ones—notice how the deep blue of the sky throws light subjects into sharp prominence, especially if you underexpose in favor of the highlights. A weak color will boldly offset an adjacent strong one, too. Even quite soft colors provide contrast if widely separated on the color circle.

*Using color contrast*

Color contrast is a powerful picture-building element, just as tonal contrast is in black and white photography. You can divide up your frame in terms of areas of contrasting color; emphasize or isolate a subject by placing it on a contrasting background; create patterns and designs by choice of viewpoint and framing, or provide visual balance between opposing colors. You can produce a sense of movement by juxtaposing active and passive colors, or of tension by placing active colors in conflict. Simple contrast of a few colors in large masses is often very effective. Complex multi-colored contrast requires careful handling—the subject may be confused by the dazzling array of colors—but results can be quite striking, as in the picture at the bottom of the opposite page.

## Strong primary contrast *left*

Almost fully saturated red on green in this picture demonstrates the powerful contrast between these two primary colors. The photographer used a bold simple composition to emphasize the effect, and shot in bright direct daylight with little shadow, for good saturation. Kodachrome 25 ASA reversal film gave fine detail and vivid color with strong reds (p. 53). The exposures were bracketed (p. 97); ½ stop below the normal reading produced the best result.

**To take the picture**
- reflex or viewfinder
- slow
- bracket 1 stop
- small aperture, fast shutter

## Complementary contrast *above*

This picture of fairground tents relies for its effect on the contrast of primary blue with its complementary color, yellow. The photographer used a wide-angle lens and chose a high viewpoint, to emphasize the contrasting segments of color, in flat strong light. High viewpoints will often reveal such unexpected patterns.

**To take the picture**
- reflex or viewfinder
- medium wide-angle
- small aperture, medium shutter

## Strong contrast

Which colors contrast most strongly, and whether you like the results, is largely a matter of personal preference and interpretation. Strong colors placed opposite or nearly so on the color circle usually give the greatest contrast. Of primary colors, red and green give the strongest effect, and you will often find this combination in nature – red poppies in green grass, for example. Red and blue also contrast strongly, but blue and green are usually harmonious. Primary and complementary colors together also give differing contrast effects. Yellow and blue, for example, combine to emphasize warm/cold contrast, but red and cyan or magenta and green appear discordant to some people.

A saturated color set against a neutral back-ground will always contrast strongly and appear bolder and more intense. Saturated red against passive black, for example, will sing out with gem-like brilliance. You can change your viewpoint and framing to isolate a strong color and take advantage of this, for example by using a low view-point to set a strong colored subject against an overcast sky.

## Discordant color

Don't ignore the chance to shoot strident, dis-cordant contrasts. Strongly saturated colors and restless jazzy patterns are often used to catch the eye, particularly in commercial art. You can also produce discordant effects using false color (pp. 78–9) – given by special films, filters, colored lights.

### Neutral contrast

Underexposure, caused by taking a reading from the highlight on the umbrella alone, created simple dark and light con-trast for this picture. The background is reduced to passive black, pro-viding a sharp contrast to the pale yellow. Backlighting gives a luminous quality to the umbrella. The photo-grapher used a wide aperture to create shal-low depth of field.

### Active and passive colors *above*

The contrast of active red and passive blue is supported by powerful composition in this picture of a swingboat. The blue recedes and the red advances, so that the swing appears almost to leap for-ward out of the picture. Diagonal lines in the picture add to the sense of move-ment (see Composition pp. 108–9). A fast shutter and head-on viewpoint helped to freeze motion (see Action pp. 130–1).

**To take the picture**
📷 reflex or viewfinder
⫴ standard or medium long
○ polarizing
📠 fast
◉ read from mid-tones, not sky
⫴⬤ medium aperture, fast shutter

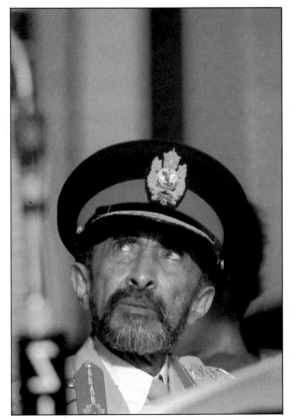

### Multi-colored contrast

Complex contrast requires careful handling, especially if you use it to support a main subject rather than as a subject in itself. In this portrait of Haile Selassie the photographer has exploited the repetition of the national colors of Ethiopia in the background flag and the cap. National flags often use con-trasting primary colors because they are visually compelling and easily remembered. Here the back-ground color is softened by selective focus (p. 90) to emphasize the main subject, using a long lens with shallow depth of field. The interplay of colors offsets the expressive strength of Selassie's face, to create a bold study of mili-tarism and national pride.

**To take the picture**
📷 reflex
⫴ long
📠 fast
⫴⬤ medium aperture, very fast shutter

# COLOR HARMONY IN NATURE

You can see color harmony at work in any quarter section of the color circle–the adjacent hues are more or less matched in mood and tone, giving a pleasing balance of colors. But much depends on the individual colors: cool blue and violet are side by side on the color circle and so technically in harmony, but the effect is dull. However orange next to harmonic yellow is a lively, even overpowering combination.

Cool colors are more restful than warm ones, and tend to harmonize more readily. The blues and greens of the natural world will provide you with many subjects. Color harmony is likely to be more successful in your pictures if the colors are slightly muted. Color harmony and muted color (pp. 62–5) have many similarities and are mutually beneficial,

whereas strong saturated colors may provoke contrast, even if close on the color circle.

A single color theme running through a picture, or a variety of similar colors, ranging from partially saturated to the gentlest tints, create a harmonizing tonal range: the muted tones of brown linking autumnal reds and yellows, the pale blue-gray of mist linking blues and greens. Sometimes cool harmony is helped if you include a warm, but muted, complementary color–the gold of a wheat field offsets the blue sky and green hills.

## Harmony and composition

Harmony is strengthened if the linked colors are repeated and interwoven across your picture. Repeated shapes and patterns can also emphasize harmony–such as a pattern of leaves and shadows or the boundaries of fields. Cool harmony works well with static horizontal lines and symmetrical forms, which strengthen its calm mood.

### Cool harmony and symmetry *right*

Cool colors convey tranquillity and harmonize even when quite fully saturated. In this landscape the harmony is strengthened by repetition of color in the reflection. The restful mood is matched by the symmetry of the balanced shapes, the stillness of the water, and strong horizontal line in the composition.

**To take the picture**
- reflex
- long
- fast
- small aperture, medium shutter

### Warm harmony–landscape and detail

Late season colors harmonize well. Faded yellows and reds, burnt browns and dusty greens are linked by muted tone and softened by diffused light. In the landscape, left, the repeating shapes of the trees echo the rich color harmony. You can find many harmonious color combinations if you seek out details, as in the picture above. Here the rusty colors of Virginia creeper harmonize with almost neutral background tones. Again, composition and repeating shape strengthen the effect. Careful framing has excluded any colors that might destroy the delicate interplay of related tones.

**To take the picture** *left*
- reflex
- medium long
- small aperture, medium shutter

**To take the picture** *above*
- reflex or viewfinder
- macro, focused at 10 ins (25 cm)

# COLOR HARMONY TECHNIQUES

While color harmony is often found in landscape, you will have to be more selective in urban surroundings and adjust viewpoint and framing carefully to encompass harmonizing colors. In many towns the effects of color harmony are quite deliberate, although the same is true of color contrast – people may paint their houses and stores to blend with a street color scheme, as shown right, or to emphasize their individuality.

When you are taking portraits, still life, or other controlled subjects you can build harmonious color schemes into your picture to express different moods. Even in less controlled situations, you can often enhance color harmony by exploiting the chance introduction of a harmonizing color.

*Adding other harmonious elements*

You can strengthen color harmony by using weak matching filters over the lens or by exploiting a natural light cast, or increase the effect by composing your picture to incorporate repeated patterns and balanced shapes. Compositional elements are of prime importance in color harmony. You can be fairly sure of harmonious color rendering when tones are subdued and light is soft and diffused. Even quite strong different colors can be harmonized by the presence of neutral areas or a linking tone.

Contrasting colors in a scene can also be in harmony if the colored objects have certain qualities in common – tone, texture, symmetrical or repeating shapes or patterns.

**Urban colors in harmony** *left*
Pastel colors combine with neutral gray-brown tones to complete a street scene of varied but harmonious colors. Flat lighting helps to give an even tonal range.

**To take the picture**
- reflex or viewfinder
- standard or medium wide-angle
- small aperture, medium shutter

**Harmony in portraiture**
Both background and props have been carefully chosen to harmonize with the girl's dress. Soft directional lighting helps to subdue the contrasting reds and blues and, combined with the use of a horizontal format and mirror image, contributes to the romantic, tranquil mood of the portrait.

**To take the picture**
- reflex or viewfinder
- fast
- wide aperture, slow shutter

### Harmony through tone and shape *above*

Although the actual colors in this shot – red, green and blue – are not especially harmonious, the neutral browns, early morning shadows and repetitive pattern of conical shapes all combine to achieve an effect of stillness and harmony.

**To take the picture**
- reflex
- long
- fast

### Harmony using a pale color filter *left*

The potential harmony of gold and yellow is enhanced by the use of a pale amber filter. A starburst filter scatters the light and, combined with the symmetrical composition, contributes to the harmonious effect.

**To take the picture**
- reflex
- long
- pale amber and starburst
- read from mid-tones
- wide aperture, medium shutter

### Harmony in still life

Still lifes are ideal subjects for exploring color harmony – you can select and position each element within the composition and control lighting and viewpoint to enhance the harmony. In this still life the photographer used an unusual viewpoint to set the simple, harmonious shapes against a uniform background. Browns and reds predominate, creating warm harmony. The picture was taken in diffused lighting which brought out a range of subtle colors.

73

# PREDOMINANT COLOR—DICTATING MOOD

Colors are called predominant when they effectively render neighboring colors subordinate by their boldness and saturation, or when they strongly influence a whole scene. Even a soft color can predominate if it takes up all or most of the picture area. A scene where a single color dictates the mood of the moment can be used to considerable pictorial effect. Each color has its own special qualities: yellow is optimistic, blue reflective and green suggests tranquillity.

When your attention is captured by the atmospheric color of the light, or by the very greenness of a scene, take advantage of the predominant color by using it as your main subject. At sunset, when the entire landscape is dominated by golden light, you can use a long lens to fill your frame with color. Later in the evening you can use fast film to capture the indigo mood of the fading light waves.

In spring, when the fresh green of new foliage dominates the landscape, strengthen the effect with a green filter, or wait for the chance arrival of another green element—a green car, or a figure wearing green—to echo and enhance the color. Or work close up, to frame a single color boldly.

### Predominant effects of sunlight *left*

As the sun sinks towards the horizon, longer wavelengths—reds and yellows—predominate. A summer night in the Shetland Isles, where daylight hours are prolonged, shows a yellow cast due to the sun's position in the sky, and the reflection of light from cloud and water.

**To take the picture**
- reflex or viewfinder
- standard or medium long
- slow

### Filling the frame *right*

Tight framing of the dominant green of this leaf has eliminated other colors, making the greenness itself the subject of the picture. Single color shots are helped by relieving detail and strong composition. Here, the photographer has used line, pattern, and highlights to offset the symmetry.

**To take the picture**
- reflex or viewfinder
- slow
- slow shutter; tripod or carefully hand-held

## Predominant color and design

Certain colors tend to predominate by their very strength. When warm red or yellow images are predominant in a scene, all other colors are forced into weak supporting roles. You will find many opportunities to shoot predominant colors in urban environments. Compose your pictures for strong simple design. For the best results, work close up, use strong direct lighting, and remember that film brands vary in color reproduction (see pp. 52–53).

**Dominant frame** *below*
Framed by the orange train, the group of commuters adds touches of other colors but orange still dominates.

**Dominant shape** *right*
Red predominance is strengthened by the subject's bold design, aided by a wide-angle lens and close viewpoint.

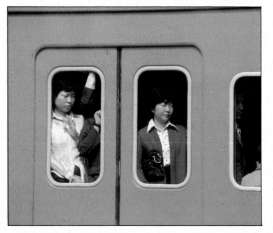

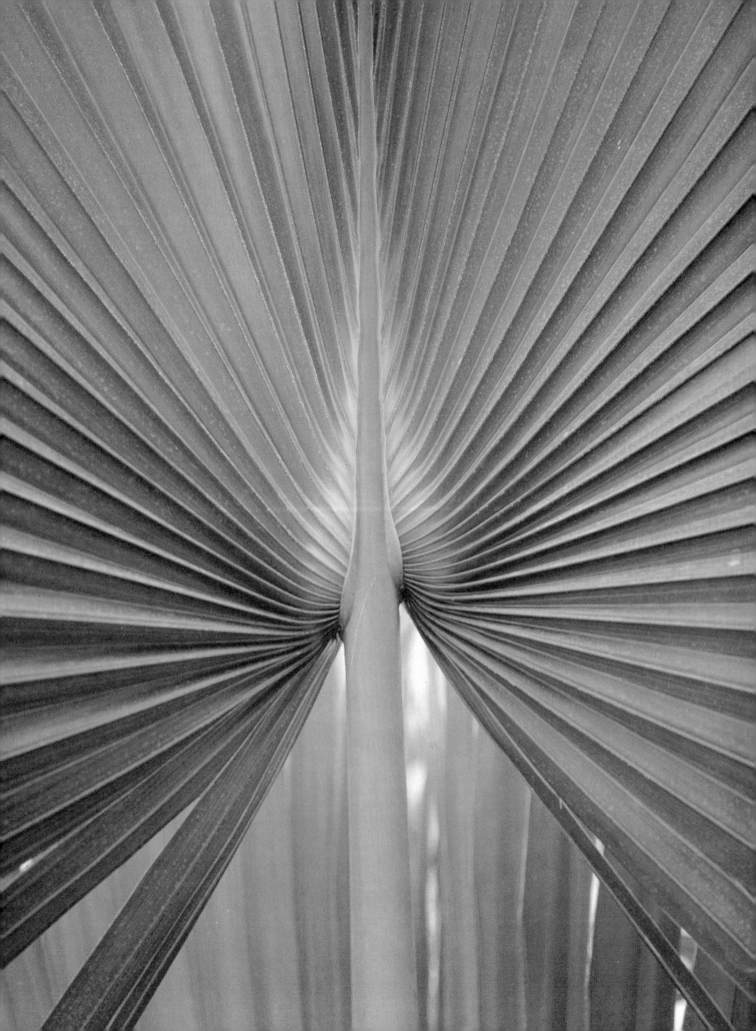

# PREDOMINANT COLOR TECHNIQUES

A filter or a piece of colored cellophane over your lens, a color cast reflected from an adjacent surface, shooting through a colored window–these are all predominant color techniques. You can use weak filters to emphasize existing color moods, adding warmth or coldness to a scene (below). But strong color filters can add an entirely new color dominance, and should be used with care.

You can obtain predominant color effects too by shooting with tungsten film in daylight or vice versa (p. 50), by using infra-red reversal film (p. 49), or by special effects in the darkroom (see pp. 182–3). You may even use reciprocity failure (p. 93), where the film's color response is distorted to magenta/violet by long exposure, usually an unintentional effect. The simplest predominant color techniques, however, are to fill your frame with subject color, or exploit natural color casts.

### Using a color cast

In this portrait the strong yellow of the background has produced a predominant yellow cast over the whole frame. This is strengthened by warm lighting. The effect is a blaze of sunshine.

**To take the picture**
- reflex
- long
- medium aperture, fast shutter

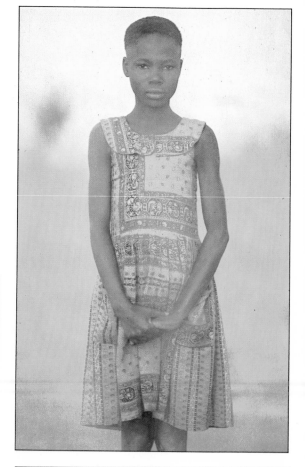

### Warm and cold color filters

Weak color filters (p. 190) can emphasize warmth or coldness. In the picture, right, a blue chromo filter has added a chilly blue-gray color. The picture below right uses a pale magenta filter to enhance the delicate pastel warmth of a desert scene. Without a filter, below left, the emphasis is lost.

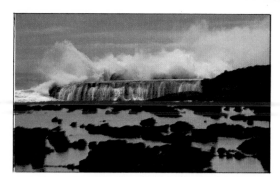

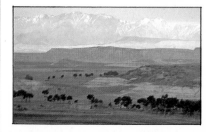 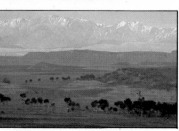

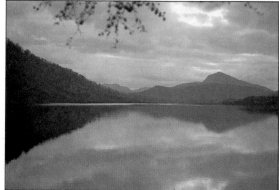

### Strong filter *left*

Strong filters override all other colors in a scene and are best used with bold, high contrast subjects. This beach scene has been rendered almost abstract by use of a red filter over a 500 mm long focus lens. Underexposure, read for highlights, has created a black silhouette dominated by saturated red.

**To take the picture**
- reflex
- long, defocused
- red
- TTL meter; read from highlights

### Low light *above*

The blueness of this landscape is helped by the natural blue cast of failing light, by aerial perspective, and by slight reciprocity failure from long exposure, producing a purplish cast. The predominant color gives a cold mood.

**To take the picture**
- reflex or viewfinder
- slow
- small aperture; time exposure ¼–1 sec; tripod or carefully hand-held

# ISOLATED COLOR–CATCHING THE MOMENT

The added dimension that color brings to photography is evident from every picture of isolated color. In drab surroundings or city streets, during a storm, or beside an expanse of water under overcast skies when everything is uniformly gray–then is the time to be alert to the chance shots of isolated color. Suddenly, the sun is reflected in a window, creating an accent of gold; a red boat comes into view on the water; or a colorful figure dashes across the street.

All at once, the scene becomes a color picture, inviting a statement about the power and vitality or fresh beauty of a solitary example of color. Because an isolated color irresistibly draws the eye, it will become the center of interest, indeed the main subject. It need not be the *only* color around, but it is isolated by its very individuality.

Often, isolated color is momentary and transient –like the figure dashing across the street–so that you will need to anticipate events to capture the occasion on film. You must be in the right place at the right time, with your camera already focused and set to the correct exposure.

An accent of color may well be pronounced because of its isolation in a monochromatic setting. Accuracy of exposure is important–taking a reading of the background will throw a solitary color into greater prominence. While a long focus lens can enlarge a distant patch of color to fill the frame, you may need a normal lens, or a wide-angle lens, to encompass the neutral background that offsets a small area of isolated color.

**Accent of light** *right*

The vapor trail of an aircraft catches the last rays of sunset. Against a dark sky, this passing streak of gold is the central, focused point, framed within the abstract angles formed by the girders of a bridge. The camera was supported against another girder for a slow hand-held exposure. The light-reading was taken from the sky.

**To take the picture**
- reflex or viewfinder
- TTL, read from sky
- small aperture, very slow shutter; tripod or support

**Isolated red on gray**

Gray stormy skies and featureless gray water often provide an ideal setting for isolated color. For this picture, the photographer read the exposure from the gray-green sea, and pre-set the camera. Then he observed the movement of different boats, until this striking group of red sails, aligned to the prevailing wind, formed itself on the water. Notice how the red leaps out from the background.

**To take the picture**
- reflex or viewfinder
- standard or medium long
- fast
- TTL, read from background

# FALSE COLOR—DRAMATIC & BIZARRE

False or synthetic color is color that is not normally associated with an object – blue hair, red grass, green sky, for instance. Such bizarre, distorted colors create a powerful, at times disturbing effect, a kind of photographic surrealism. False color can be created by changing the nature of the light received by the film or by changing the film structure or its processing.

You can achieve unreal color effects by mismatching film and light source (see pp. 50–51) or by using a "false color" film, such as infra-red Ektachrome. Remember that IR film tends to turn all colors magenta, unless you use a filter (p. 49).

Filters used in front of the lens are one of the simplest false color techniques and they need not be expensive. All but the most elaborate can be made out of any transparent colored material, such as gelatin or cellophane (see p. 190). Mixed colored lighting also gives bizarre color effects, as shown by the picture of the fortune-teller opposite. Spotlights concentrate a beam of light on your subject; floods give a more diffused effect.

In the darkroom, the easiest way of achieving false color is by processing slide film – normal or infra-red – as a negative. Processing print film by the reversal method, however, gives unacceptable results. Other darkroom techniques which yield striking false color effects include solarization, posterization, manipulated printing and slide-copying (see pp. 182–7 and 200).

**Natural colors**
This portrait shows the true colors of the subject below, shot on Kodachrome 25 film.

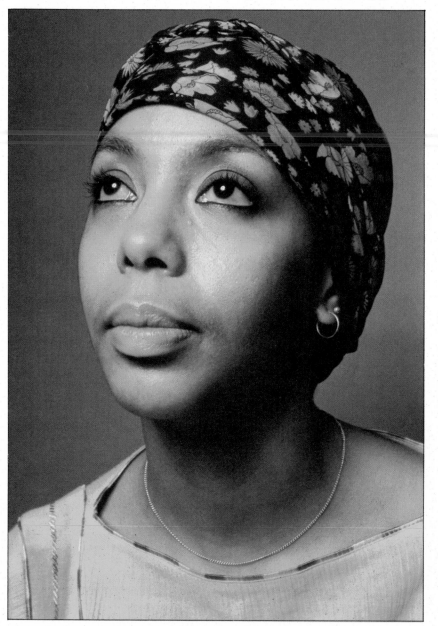

### Using infra-red film for dramatic effect

The original colors of both these portraits are shown at the top of the page – red lips and dress, blue background, pink and orange flowers on a navy blue scarf. Both were shot on IR film but in the portrait above no filter was used, resulting in a predominant magenta cast. A deep green filter was used for the portrait left, changing reds to orange, skin tones to yellow and the whites of the eyes to green. When using IR film, bracket exposures at least 2 stops either side of normal.

**To take the picture** *above*
- reflex or viewfinder
- infra-red
- electronic flash
- bracket 2 stops either side

**To take the picture** *left*
- reflex or viewfinder
- green 61
- infra-red
- electronic flash
- bracket 2 stops either side

## Processing infra-red film as negative film

It is often difficult to find a laboratory willing to process slide film as a negative so you may have to process your film yourself. The process you use must be compatible with your film. For example, Kodak IR film requires C22 negative process. If you intend to process IR film as a negative, you will have to double the normal ASA rating. On negative-processed IR film, green leaves appear green, but all other colors are distorted.

**To take the picture**
- reflex or viewfinder
- infra-red, double rated process as negative

## Processing slide film as negative film

The effect of processing slide film as a negative is to increase contrast, and produce a yellow cast, especially in skin tones and neutrals. When shooting, uprate your film by about half a stop and develop the film in a compatible negative process. Here C41 was used (see p. 169).

**To take the picture**
- reflex or viewfinder
- medium, 64 ASA, uprated to 80 process as negative

## Using colored gels on studio lights

Three studio floods were used to light this picture, filtered by deep magenta, green and blue gels to suggest a supernatural atmosphere. The light reading was taken just in front of the subject's face and a wide-angle lens was used to exaggerate the strange effect of mixed colored lighting. Don't allow colored gels to get too close to the light source. They are only heat-resistant up to a point and in time will buckle and smoulder.

**To take the picture**
- reflex or viewfinder
- wide-angle (28 mm)
- deep magenta, green, blue
- type B, 160 ASA
- three studio floods
- read from face

## Using special color filters

One of the most striking ways of creating false color is to use a filter. Deep color filters give a strong overall effect; more unusual results can be obtained with dual color or spot filters, as shown below. Remember to alter the exposure according to the filter factor recommended by the manufacturer; with dual color filters, each half is usually designed to give the same factor. Other special filters include diffraction and chromo filters (see pp. 190–1).

**Using a dual color filter**
A wide aperture or a long focus lens will soften the sharp color division of a dual color filter. Here a violet/yellow filter was used over a 300 mm lens.

**Using a spot filter**
Commercial filters are graduated in density from edges to center; home-made spot filters may give a hard-edged effect, unless a wide aperture is used.

# 4 PICTURE TAKING

Every time you take a photograph, you are making a selective judgment – choosing to record a particular subject, viewpoint, and moment in time out of a moving, changing world. This very choice means that your photograph is making a statement – about the interest or beauty of the subject, and your own perception, pictorial sense, and ideas.

Taking successful, striking pictures involves extending this selectivity, so that you consciously control every element in your photograph to produce a clearer, more powerful statement. A good photograph can distill into a single image the whole essence of a subject or event, while still conveying the individual vision of the photographer.

*Seeing as the camera sees*
Creative photography depends first and foremost on being able to see as your camera sees. Although the camera is essentially a recording device, a photograph does not reproduce a scene quite as you see and experience it. The camera isolates a small part of a larger scene, reduces it to two dimensions, freezes it into stillness, and sets it in a frame. It does not record the sequence of events with time, nor your own emotional response to the scene.

More important still, the camera does not discriminate – when you look at a scene, your selective vision shows you only the important elements, and ignores the rest, but the camera will record every detail. This is why photographs are often disappointing. Backgrounds are cluttered with objects you do not remember seeing; subjects are smaller in the frame, or less striking, than you recall them; and the whole scene lacks emphasis and life.

By developing your picture taking skills, you can learn to suggest the elements that photographs lack – movement and life, three dimensional depth and form, and the selective emphasis of your attention – and to recreate the emotional impact of the original scene. Get used to looking all around the viewfinder frame with a critical eye, considering how each element will record, and the part it plays in the whole composition. Make yourself thoroughly familiar with what your own camera can do – how

manipulating each of its controls will alter the image, and how you can exploit these changes from different viewpoints, and in different lighting.

You can suggest movement by using blurred or multiple images, or lines of direction, or by freezing the action at a position impossible in a static subject. You can convey depth through perspective, or the overlapping of objects at different distances. You can suggest form with light and shadow, or oblique viewpoints. You can give your pictures selective emphasis by filling your whole frame with the subject – this is particularly important to portraits – or by making sure the main subject is in stronger color, different tone, or sharper focus than the rest. You can also emphasize a main subject with many compositional techniques.

The camera can also produce images your eyes never see. With a very fast shutter speed it can freeze the motion of a humming bird's wings; with a long exposure it can turn moving people into phantom shapes. From certain viewpoints, and with non-standard lenses, it can radically alter linear perspective and change the relation of foreground and background. At a wide aperture it can show different zones in and out of focus in the same picture; by underexposure it can turn day into night.

*Exploring the camera's range*
The picture taking skills covered in this chapter fall into four distinct categories: controlling the image, using exposure, working with light, and composition. As you explore the different techniques, be prepared to experiment with your camera, using some time and some film to try out the effects, and looking at your results carefully to see if they match expectations. Having expensive, elaborate equipment can extend your range, but it is no substitute for skill with a camera. Some of the best known color photographers still work with quite simple equipment. With experience, and knowledge of your equipment, you will begin to "think through your camera", without conscious effort, so that you are free to concentrate on lighting and composition, and the qualities of the subject.

**Images from a scene**
All these pictures were taken around the same dockland location in a single morning, with a 35 mm SLR camera and a set of three lenses.

*Top row, left to right*
The whole location is encompassed with a wide-angle lens from a tall building; whereas the red boat is shot from a low, close viewpoint, emphasizing the foreground. The boatman coiling a rope is picked out with a long lens, and given emphasis by selective focus, at a wide aperture.

*Second row, left to right*
Moored boats, shot from a distance with a long lens, appear crowded closely together. The swing of an axe is expressed by a partially blurred image, produced by a slow shutter speed. In the far picture, attention is directed to the boats by the converging lines of the ropes, emphasized by a low viewpoint.

*Third row, left to right*
Close framing centers attention on the bold color and design of a detail of a painted boat. In the far picture, exposure read for highlights gives a dramatic day-into-night shot.

*Bottom row, left to right*
A cluttered scene is simplified by shooting through an existing frame, which suggests the setting. Pointing the camera toward the light, and up, reduces complex sail shapes to bold silhouette. In the far shot, rhythmic shapes and lines center attention on the figure.

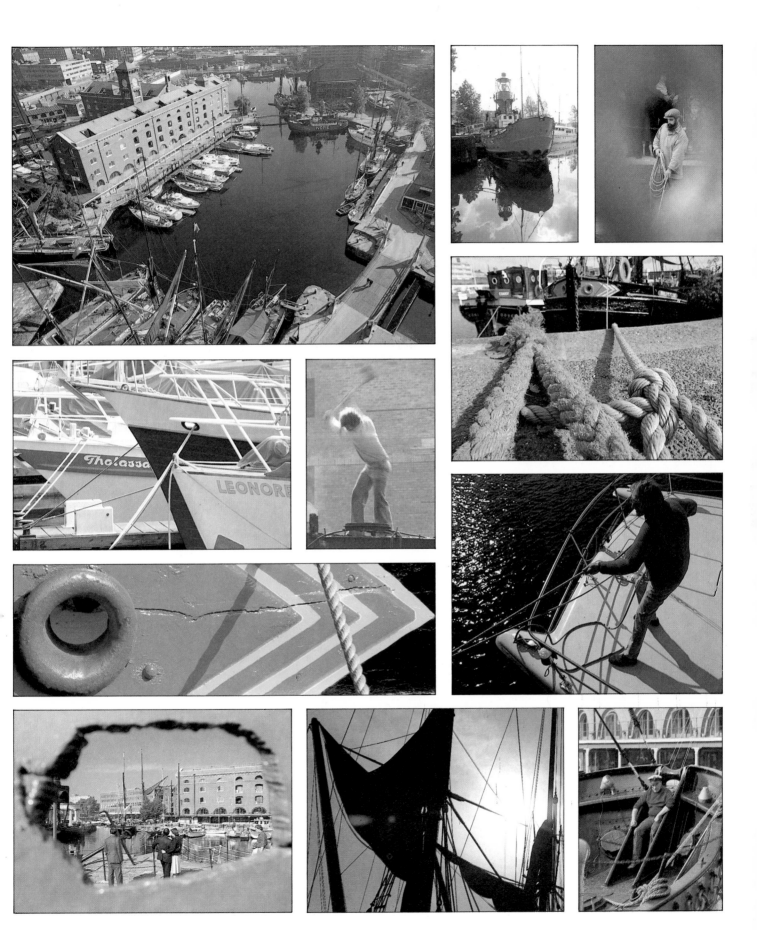

# POSITIONING & STEADYING THE CAMERA

The way you hold your camera, and the viewpoint you select, are as important to good pictures as your choice of subject and exposure.

Before you begin using a new camera, familiarize yourself with the controls. On a 35 mm camera, you will probably use your left hand for focus and aperture, your right for shutter and film wind. Practice bringing the camera up to viewing level, focusing, selecting speed and aperture, depressing the shutter, and winding on, until you become used to operating it.

To avoid camera shake, hold the camera steady when shooting, using your whole body as a firm support. If you can, lean against a wall, or rest your camera on a firm surface. Take extra care if using a small format camera, or a long lens, or

"panning" with a moving subject (p. 132). Use the fastest shutter speed you can (p. 86), and a tripod when working close-up or at slow speeds.

Standing with the camera at eye-level will give you a "normal" view. But a less obvious angle may produce a more dynamic picture. The scope of a crowd scene demands a high viewpoint, while children and animals are often best photographed from a low camera position. Shooting from above foreshortens the subject, and reveals unexpected patterns and shapes. Shooting at ground level or upward from low viewpoints exaggerates perspective, producing bold images. Try varying focal length as well—wide-angle from low viewpoints, or long focus from high ones—to increase the effects of perspective or foreshortening.

### Standing, camera vertical or horizontal

Keep your feet well apart and use your body as a support for the camera. Use your left hand to support the lens, focus, and alter aperture, and your right to control the shutter.

For vertical shots, right, press the camera to your forehead, supporting it with your left hand. For horizontal shots, far right, press the camera to your cheek, supporting the camera with both hands.

### Using a support

A good way of keeping the camera steady while shooting is to lean your body against a wall or other firm support, such as a tree or lamp-post. If you want to use a slow shutter speed and do not have a tripod, try holding your camera vertically against the side of a wall, below left, or resting it on the top of a wall, below. You can use a soft cloth or bean bag as a cushion between the lens barrel and a hard surface.

### Using a tripod *left*

For really sharp close-up shots or for long exposures you must rule out the possibility of camera shake. So use a tripod and a cable shutter release, and avoid contact with the camera during the exposure. If you have no tripod, support the camera on a wall, table, floor, pile of books or other firm surface.

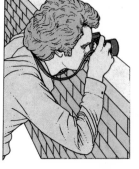

### Supporting a heavy long lens *right*

Long focus lenses are bulky and heavy to hold, making them difficult to keep steady. The likelihood of camera shake increases in direct proportion to the focal length of the lens. A tripod is the most effective camera support for long lenses. If you don't want to carry a tripod, a pistol grip with a built-in cable release, right, allows you to support the camera and shoot with your right hand, leaving your left hand free to focus, adjust controls, and support the lens barrel.

### Shooting on the move

Promising scenes often flash past train, bus or automobile windows.

When shooting from a moving vehicle, avoid touching any vibrating surface—you can get camera shake even at fast shutter speeds. Aim the camera forward, in the direction you are moving. This reduces apparent movement and blur in the subject. Use the fastest shutter speed possible. You can take very effective shots from low flying aeroplanes, as shown right.

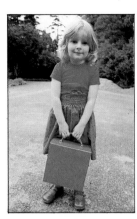

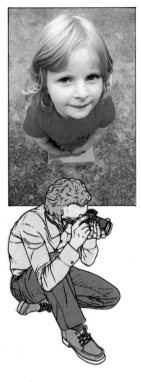

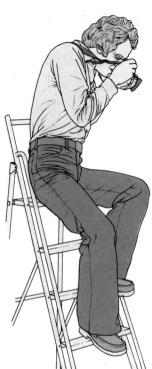

## Kneeling position

Children, small animals, flowers and any subject shorter than you will be less distorted if you crouch down to their level. Kneel on one knee, and let the soft part of your arm rest on the other knee. Make sure you are balanced and steady and use the fastest shutter speed you can.

## Using a high viewpoint *below*

High windows, balconies and rooftops give unusual views of scenes. Shooting from above foreshortens the subject, emphasizing horizontal groupings and patterns like those formed by the sunshade and figure on the rug below. For high viewpoints you can sometimes use a ladder. Sit on the step, steadying your body by pressing your feet on a lower tread. Tuck in your arms and hold the camera tight against your cheek. Alternatively, try shooting down a stair or flight of steps for a similar effect.

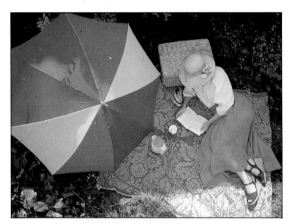

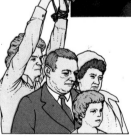

## Shooting over a crowd

In crowds when you cannot get a clear view, you can raise the camera, steadying it with the strap, to shoot over people's heads. If you have a $2\frac{1}{4}$ ins$^2$ camera, or a waist-level viewing attachment, hold the camera upside down to see the screen.

## Shooting at ground level *above*

If your camera has a waist-level focusing screen, you can rest the camera itself on the ground and view the screen from above. Shooting at ground level steepens perspective and tends to isolate a subject from its background, thus producing a strong bold image. Notice how shapes nearest the camera are exaggerated. A wide-angle lens used close up will increase these effects.

## Shooting lying down

Shooting from a low viewpoint can dramatically alter perspective and subject appearance. For low viewpoint shots, lie with feet apart and body supported on elbows, leaving hands free for camera. If you want a vertical picture you will have to support yourself and the camera with your left elbow and hand, leaving the right arm free for the controls. Shoot across the ground, or upward. If tilting the camera up, double your shutter speed and increase aperture by one stop.

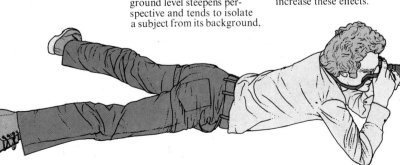

# USING THE VIEWFINDER & FOCUSING

Accurate framing and focusing are essential for good pictures, and modern cameras have many devices to help you achieve this. With most cameras you hold the viewfinder to one eye. This viewfinder consists of a lens that should give you a bright clear view of the part of the subject that will appear in your picture. Reflex systems show you exactly what the lens sees, through a mirror arrangement. Direct viewfinder systems give you a separate view of the subject, approximating to the view of the lens, through a window on the camera body. This system sometimes introduces a framing error that you should be aware of when composing pictures (see parallax error, below).

Some reflex cameras (mostly $2\frac{1}{4}$ ins² format) are designed for waist-level viewing. You look down on a screen on the top of the camera, where the subject appears reversed left to right. These cameras include a sportsfinder, for viewing moving subjects, and a magnifier, for fine focusing.

The viewfinder frame is your main control of picture composition. The various shapes are shown

**Vertical format**

**Horizontal format**

actual size below. With rectangular frames you can compose your subject horizontally or vertically, holding the camera as shown left. With square frames, fill the picture area as generously as you can. Look around your frame carefully, and avoid distracting details or colors in the background. Take care to align vertical lines and horizons with the edges of the frame, and come in close enough to fill the picture frame with the subject, especially when you are photographing people.

*Focusing systems*

The simplest, fixed focus cameras always give a sharp picture as long as your subject is not closer than about 6 ft (2 m). Some variable focus cameras now have autofocusing systems. But most must be focused, using a distance scale or symbols. Reflex cameras show changing focus in the viewfinder, and often include a split image or microprism circle which only becomes sharp when focus is correct. Direct viewfinders may incorporate a rangefinder system, for fine focusing, see opposite.

## What you see through the viewfinder

**110 format**
This is the view through the viewfinder of a sophisticated 110 camera with variable focus and a rangefinder system. The small center rectangular area gives a double image when the subject is out of focus. To aid composition, the viewfinder is larger than the actual picture area, which is shown by the inner frame lines. Note the rectangular frame shape.

**126 format**
The view through the direct viewfinder of a simple 126 camera shows the square frame of this format. Again, inner frame lines show the actual picture area that will result.

**35 mm format**
A typical 35 mm SLR viewfinder shows exactly the same image as will record on the film. Note the rectangular frame shape. The central area contains a split screen (see opposite) which unites as focus is found, with a microprism collar that remains blurred until, again, focus is correct.

**$2\frac{1}{4}$ ins² format**
The viewfinder shows a square image. Grid lines may be present to assist composition. The scene is reversed left to right.

**Viewing with a $2\frac{1}{4}$ ins² camera**
Hold the camera at waist-level, cradling the body in your left hand while operating the controls with your right hand. As you view and frame your subject, the viewfinder image moves in the opposite direction to the way you move the camera. To check focus accurately, flip up the focus magnifier and bring the camera up to your eye level, see below.

## Parallax error

On most simple direct viewfinder cameras, the viewfinder is set to one side of the lens, and sometimes slightly above it. So your view of the subject differs from that of the lens, see right. For distant subjects, this difference is not noticeable. But if your subject is closer than about ten feet (3 m), you see more of one side and less of the other than will record through the lens.

This parallax error can result in pictures with part of the subject cut off, or symmetrical framing spoiled. If the viewfinder is above the lens, you may also find you have cut off part of the subject's head in your picture, or an important area of sky.

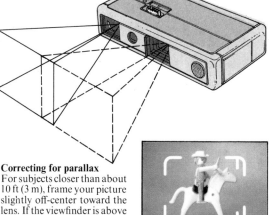

**Correcting for parallax**
For subjects closer than about 10 ft (3 m), frame your picture slightly off-center toward the lens. If the viewfinder is above the lens, frame slightly high as well. Some cameras have correction marks, shown right.

**Parallax correction lines**

**Waist-level viewing**     **Using a focus magnifier**

## Focusing systems

### Symbols for distance
Simple cameras often have a few fixed focus settings, marked by symbols around the lens. The camera, right, has settings, below, for portraits, head-and-shoulders, figures and landscape.

### Feet and meter distance scales
Most cameras with focus control have continuously variable focus from a minimum distance to infinity. You turn the lens and read the in-focus subject distance off a scale marked on it in feet or meters, shown below.

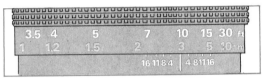

## Viewing and focusing aids for reflex cameras

### 35 mm interchangeable heads
The 35 mm SLR, right, has optional viewfinders and focusing screens to suit many different requirements. The standard pentaprism viewfinder is shown in the center flanked by a waist level finder on the left, and a pentaprism viewfinder with automatic exposure mechanism on the right. The interchangeable focusing screens have different focusing aids to suit individual preferences. These include a microprism screen, a split image screen, an overall ground-glass screen and a screen with incorporated grid lines.

### Split image screen
A central split image screen in your viewfinder helps you to focus. Lines across the center join as you find focus.

**In focus**    **Out of focus**

$2\frac{1}{4}$ ins$^2$ viewing aids *right*
For action shots, you may find a sportsfinder attachment helpful to view the movement. Replacing the waist-level finder with a pentaprism gives you eye-level, corrected SLR viewing.

**Sportsfinder viewing**       **Pentaprism attachment**

### Rangefinder focusing
Direct vision cameras may have a rangefinder to aid focusing. A separate window and a mirror system give a second image of the subject in the viewfinder. Usually you see the double image in a small central area; when the correct focus is found, the two images coincide into a single sharp image, as shown in the two pictures below.

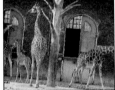

**In focus**

**Out of focus**

### How autofocus cameras work
Most autofocus cameras use the same principle as a rangefinder. They assess image distance by comparing the contrast brightness of two images, reflected from a fixed and a movable mirror. An electronic brain converts the information to impulses which trigger a motor, to move the lens to the point of sharp focus.

The subject must be centered in the viewfinder. Sharp focus occurs almost immediately, as the two light impressions are matched at their optimum contrast and brightness. On some cameras you can hold focus to reframe the subject.

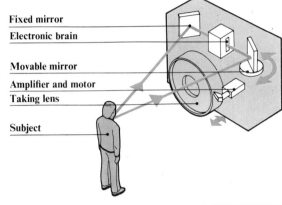

Fixed mirror
Electronic brain
Movable mirror
Amplifier and motor
Taking lens
Subject

## Six basic errors in picture taking

**Sloping verticals**
Strong vertical lines call for careful framing so that they remain parallel to the edges of the frame and thus appear to be upright.

**Sloping horizon**
Horizontal lines, such as the waterfront, above, or horizons should be framed to run parallel to the top of your viewfinder frame.

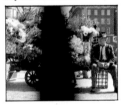

**Head cut off**
For a full frame portrait, look beyond the subject's eyes and make sure all the head fits in the frame, and is not cut off as above.

**Object obscuring lens**
Take care your camera strap or finger does not obscure the lens, especially on non-reflex cameras where you cannot see this in the frame.

**Confusing background**
A distracting background can ruin a portrait. Move your subject, change viewpoint, or use shallow focus.

**Subject too close**
With a fixed-focus camera, do not take subjects closer than the minimum focus distance, about 6 ft (2 m).

# APERTURE & SHUTTER

After focus, aperture and shutter are the two most important controls on a camera. Together they determine the exposure – the aperture controls the amount of light admitted; the shutter speed controls the length of time that the light is admitted.

In addition to exposure, the aperture and shutter speed also affect the way that the subject records. The size of the aperture affects the depth of field, as explained on the opposite page. The shutter speed controls the way that movement records.

The size of the aperture is controlled by an iris diaphragm in the lens barrel. Each aperture setting is given an "f number", or "stop", which is calculated by dividing the aperture diameter into the focal length of the lens. Increasing the aperture by one stop doubles the light admitted.

Shutter settings are calibrated on the camera in a standard series of fractions of a second. Each setting doubles or halves the speed, just as each f stop doubles or halves the light admitted by the aperture. Thus you can combine aperture and shutter in a number of ways yet still maintain the same exposure, as explained below.

If you or your subject move while the shutter is open, the subject will record blurred on the film (see Action pp. 130–7). So at very slow shutter speeds camera shake will become visible in the image. As a rough guide, do not use shutter speeds slower than the focal length of your lens; for example, a minimum hand-held shutter speed of 1/60 sec for a 50 mm lens.

Cameras with an unspecified fixed shutter speed usually work at a speed of around 1/75 sec. Electronic shutter automatic exposure cameras use speeds ranging from 1 sec to 1/500 sec. Automatic systems will give you accurate exposures but you cannot select your exposure to suit your subject.

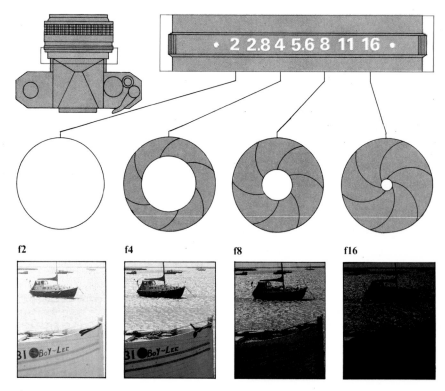

f2     f4     f8     f16

### Aperture control and exposure

The aperture control ring is positioned on the lens barrel. The series of f numbers, shown on the scale above, is universal; but the range varies according to the lens type.

Doubling the aperture diameter quadruples the exposure, as the pictures above show. Most lenses include intermediate stops, which double the light admitted (thereby matching the doubling shutter speed series).

Although wide-angle lenses give brighter images than long lenses, the f scale gives constant exposure even when you change lens, because each f number is calculated as a proportion of the focal length

### Selecting shutter speed

The shutter speed dial is either on the top of the camera or on the lens barrel. It usually includes a "B" setting which keeps the shutter open for as long as the release is depressed.

The shutter speed affects the way that subject movement records. At very slow speeds most movement will blur. As the speed is increased (with the aperture altered to keep exposure constant) movement is "frozen", see below.

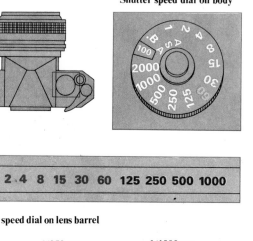

**Shutter speed dial on body**

B 1 2 4 8 15 30 60 125 250 500 1000

**Shutter speed dial on lens barrel**

### Combining aperture and shutter speed

Because the aperture and shutter speed follow a similar series, you can choose from several permutations of the two controls for any one exposure reading, to change your subject image. If, for example, you increase the aperture by one stop and decrease the shutter speed by one setting the exposure remains constant, as shown below.

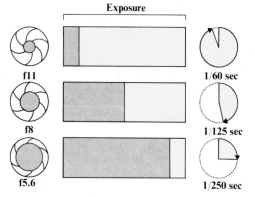

**Exposure**

f11    1/60 sec

f8    1/125 sec

f5.6    1/250 sec

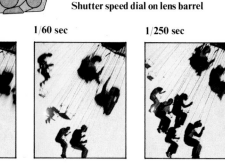

1/15 sec    1/60 sec    1/250 sec    1/1000 sec

# DEPTH OF FIELD

The amount either side of your focused subject that is sharp in your pictures is known as the depth of field. Simple cameras without variable apertures will produce pictures that are sharp up to about 6 ft (2 m) away, but on other cameras you can vary the depth of field by three factors: the size of the aperture, the camera-to-subject distance, and the focal length of the lens. Altering the depth of field enables you to produce quite different pictures from the same scene–emphasizing some elements and leaving others unsharp (see p. 90), suggesting a sense of depth, and so on.

When the lens is stopped down (at its smallest aperture) the depth of field is at its maximum. As you increase the aperture this zone of sharpness around the focused subject is reduced.

Camera-to-subject distance also affects depth of field–the closer you are to your subject the shallower your depth of field becomes, and vice versa.

The third control over depth of field is the focal length of your lens (see p. 89). The shorter the focal length of the lens, the greater the depth of field–even at its minimum aperture, a long lens gives comparatively shallow depth of field.

Most variable aperture cameras have a depth of field scale on the lens, such as shown right. This enables you to judge the extent of the depth of field at any one focus and aperture setting. Single lens reflex cameras will show you the effect of altering the depth of field in the viewfinder itself. Sometimes the viewfinder image alters as you adjust the aperture, but on many SLRs you must press the special preview button to see the depth of field in your image. This is because the camera only changes to the set aperture at the moment of exposure, keeping to the maximum aperture, and therefore the brightest image, for focusing.

### Hyperfocal distance

At any given aperture you can maximize the depth of field in your picture by focusing on the hyperfocal point. This is the nearest point of sharpness shown against your f number on the depth of field scale when the lens is focused at infinity. By altering the focus to this distance, you will increase the zone in front of the subject that is sharp, while the horizon, or "infinity", will remain the furthest sharp point in your image.

You can determine the hyperfocal distance at any aperture from the depth of field scale. In the example above, the aperture is set at f16. With the lens focused at infinity, the nearest sharp point is 16½ ft (5 m) away. After the focus is set to this near point, sharp detail extends down to 10 ft (3 m) away.

### Depth of field scale

The special scale, right, shows depth of field at each aperture. The relevant two f numbers mark off the nearer and further limits of sharp detail either side of the focused subject.

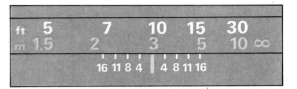

### Aperture and depth of field

The series of pictures below show that stopping down (reducing the aperture) progressively increases the depth of field in your pictures. The focus was set for the background figure in all three shots, but reducing the aperture made the foreground figure and the background sharper.

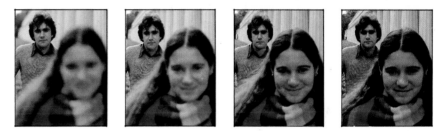

### Camera-to-subject distance

The pictures below show how as you move away from your subject your depth of field will increase rapidly. It will be maximized when the focus is set at the hyperfocal distance.

At subject distance over 3½ ft (1 m), depth of field extends about one third in front and two thirds behind the focused subject; under this, the ratio becomes almost half and half.

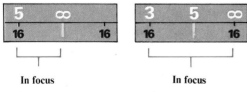

**Subject 3 ft away**  **Subject 7 ft away**  **Subject 15 ft away**

# USING DIFFERENT LENSES

On page 36 you saw how by adding only two other focal length lenses to your normal 50 mm lens, you could build a camera system to cope with most photographic situations. Now you can see how using a full range of lenses can help your results.

There are two occasions for changing lenses. The first is when your viewpoint is relatively fixed. Imagine you are on the cliff-top at the camera position for the series of four pictures shown right. To get a broader view, including the surrounding foreground, you cannot move your camera position back because the cove itself would be lost behind the cliff edge. A wide-angle lens used from the same viewpoint is the answer, as shown top. To get a close-framed shot of the cliff face on the other side of the cove, or even a detail of the waves breaking at its foot, you obviously cannot move close enough for your standard lens. You have to use a longer focal length to bring the distant sections of the scene to you, as in the bottom two pictures.

The other time you will want to change lens occurs when the characteristic optical features of a lens will enhance your subject. This depends on your being able to change camera position backward and forward, so you can always fill the frame with the subject, whatever focal length lens you choose (see opposite). Using a long lens reduces depth of field (see p. 87) through the range of apertures, makes the effects of linear perspective less dramatic, and decreases the apparent distance between different planes of the subject, from the camera to the horizon. No distortion of image shape occurs, so it is good for portraits. Using a wide-angle lens has the opposite effect, increasing depth of field, exaggerating linear perspective and increasing the apparent distance between foreground and background. Image distortion becomes increasingly severe with decreasing focal length, down to the extreme fisheye, below.

## Angle of view and image size

The diagram, below, shows the different angles of view you can expect from a range of different focal length lenses. The shorter the focal length of a lens, the wider the angle of view through the viewfinder and the further away a subject will appear from a fixed viewpoint. The longer the focal length of a lens the more narrow the angle of view will be and the closer a subject will appear from that fixed viewpoint.

The four photographs, right, show the effects of using different lenses from the same viewpoint. At the top, a 24 mm wide-angle lens shows foreground, bay, distant cliffs and nearly a half-frame of sky. The view becomes increasingly selective as you switch to a standard, a long (135 mm), and finally a very long (500 mm) lens.

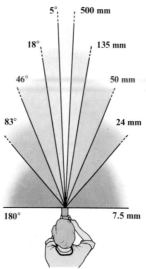

5°    500 mm
18°    135 mm
46°    50 mm
83°    24 mm
180°    7.5 mm

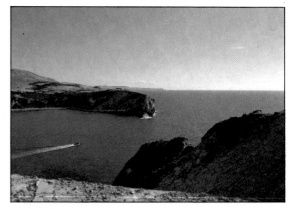

**24 mm wide angle**

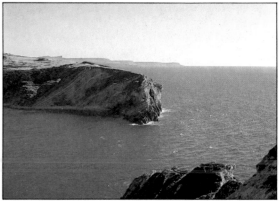

**50 mm standard**

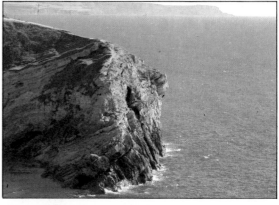

**135 mm long focus**

**500 mm very long focus**

## Fisheye lenses

The focal length of the fisheye lens (see p. 189) used for the picture, right, was 7.5 mm. This gives an extremely wide view, of 180°; but the image shows "barrel distortion" – both horizontal and vertical lines bow considerably toward the circular frame. Least distortion occurs in the center of the frame, so the main subject is best placed there. The scene will appear to rush away to the edges.

The extreme depth of field with a fisheye lens makes it unnecessary to focus it – sharpness extends from foreground to infinity. The front of the lens is too wide to accept filters, so built-in filters are common.

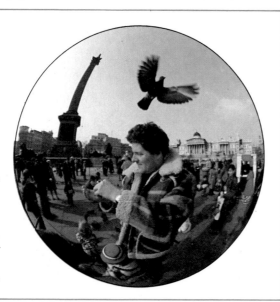

## Changing lens and viewpoint

Although the sculpted figures in the three photographs, right, occupy roughly the same amount of space in the frame, each picture has its own character. The diagram, right, shows the different lenses and camera positions adopted.

The wide-angle shot, top, gives the most dramatic impression of the landscape as a whole, with increased linear perspective making the figures appear to look away over the water. Depth of field is so good that we see detail in the cloud formations and the distant hills. The normal lens shot, middle, reduces these effects. The telephoto shot isolates the figures completely from their surroundings. There is no sense of space because the longer focal length has flattened perspective, making the distant subject planes seem closer. Depth of field is shallow, leaving only the figures in sharp focus.

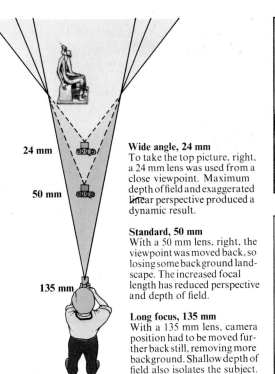

**24 mm**

**50 mm**

**135 mm**

**Wide angle, 24 mm**
To take the top picture, right, a 24 mm lens was used from a close viewpoint. Maximum depth of field and exaggerated linear perspective produced a dynamic result.

**Standard, 50 mm**
With a 50 mm lens, right, the viewpoint was moved back, so losing some background landscape. The increased focal length has reduced perspective and depth of field.

**Long focus, 135 mm**
With a 135 mm lens, camera position had to be moved further back still, removing more background. Shallow depth of field also isolates the subject.

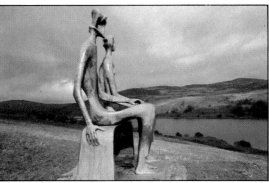

**24 mm wide-angle**

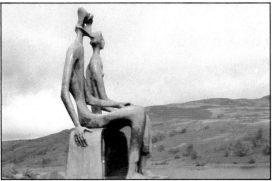

**50 mm standard**

## 110 camera telephoto option

Some 110 pocket cameras offer the option of bringing a distant subject closer, as shown right. This type of 110 camera has a switch that either brings an additional lens element up in front of the normal lens group, or rearranges the lens elements internally to give increased focal length. Some 110 cameras now offer zoom lenses or even interchangeable lenses.

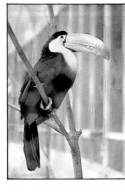

**135 mm long focus**

## Changing lens for maximum and minimum depth of field

**Large aperture, long lens**
If you fit a long lens, to pick out a distant subject with close framing, you can also select a large aperture, using the character of the lens to give minimum depth of field. This further isolates the subject, as shown right. With a 200 mm lens at f4, sharp focus only reaches from just under to just over fifteen feet as shown on the lens barrel depth of field scale, below.

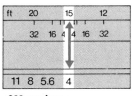

**200 mm lens**

**Small aperture, wide-angle lens**
For a picture like the one, right, where a wide-angle lens was used to dramatize both foreground and background, you will want to exploit the extended depth of field inherent with short focal length lenses. Using the smallest aperture possible will maximize the effect. At f22, a 24 mm lens gives sharp focus from under two feet to infinity, as shown on the lens barrel depth of field scale, below.

**24 mm lens**

# FOCUSING FOR EFFECT

Controlling which areas will be sharp in your pictures is an important compositional technique. You can use it to produce a range of pictures from the same camera position and scene – alter emphasis, soften shapes or colors and create a sense of depth.

There are several methods of altering the amount that is sharp in your pictures – selective focusing, defocusing, diffusing the light entering the lens and so on. In order to assess the effects of these techniques on your image you need a camera with a reflex viewing system and through-the-lens metering. With other viewing and metering systems you will have to estimate the effects and any adjustments in exposure from experience.

*Selective focusing*

Once you have set the focus, widening the aperture will progressively reduce the amount in front of, and behind the subject that is sharp (p. 87). This produces selective focusing, which can be used to bring out your main subject by making the remaining areas of the picture unsharp. This is particularly useful when, for example, your main subject is relatively small or when the background is full of distracting details or colors. You will find that the out-of-focus foreground and background will act as a frame to further emphasize the sharp subject.

Long lenses are particularly suitable for selective focusing because of their wider real apertures. Wide-angle lenses are unsuitable because of the great depth of field that they give at most apertures. Camera-to-subject distance is also a means of controlling selective focus. Depth of field decreases as you move closer to your subject, so that by working close-up at a wide aperture you can minimize the amount that appears sharp in your pictures.

If you are working under very bright lighting, you can still use a wide aperture for selective focusing by fitting a neutral density filter (see pp. 190–1) over the lens. This clear gray filter reduces the amount of light entering the lens, enabling you to increase exposure, without altering subject colors or affecting saturation.

### Using selective focus

Conventionally the main subject in a picture is placed centrally in the foreground. But this can lead to very unexciting pictures that lack a context and fail to hold the eye. In the picture above the sharp area of interest has been placed off-center in the middle background. Far from distracting attention, the larger out-of-focus driver's helmet in the foreground directs the eye and adds to the atmosphere. The long focus lens used has added to the sense of congestion at the beginning of the race. But the shallow depth of field given by the lens has enabled the photographer to pick out one car and driver strongly from the confusion.

In the picture, right, convention suggested focusing on the face, but a more humorous atmospheric picture has been created by using strong selective focus to give only an impression of the reclining figure.

### Using selective focus to direct interest

The three pictures, right, show the way that selective focus can be used to pick out different elements from the same scene. Only the focus was changed for each of the shots – from the foreground, near right, to the middle ground, center, and finally to the background, far right. The aperture on the 300mm lens was set at its widest, producing strong selective focus in each picture.

The nearest picture shows the importance of selective focus most clearly. If the small shapes of the bee and flower had not been so strongly separated (by leaving the rest of the picture unsharp) they would have been overwhelmed by the more dominant background detail.

**Foreground sharp, midground and background unsharp.**

**Midground sharp, foreground and background unsharp.**

**Background sharp, foreground and midground unsharp.**

## Framing

Rather than detracting from your main subject, surrounding elements can give it a context and emphasis by creating a frame. This is especially true if you keep only the main subject sharp, and make the surrounding elements out of focus, though still clear enough to provide a recognizable context. In the picture, right, the blurred foliage acts as a frame to the sharp subject, emphasizing the shy figure in the concealing undergrowth. If the picture had been sharp throughout, the emphasis would have been lost and the figure would have merged with the surroundings.

## Defocusing

Deliberately making the whole of your picture out of focus can add great atmosphere to a scene. Defocusing softens shapes and desaturates colors producing a more impressionistic effect that is particularly useful when fine detail is not required, such as in the picture above. If your main subject has a simple shape which is different in tone or color from its surroundings it will remain distinct when it is out of focus. At its most extreme, defocusing produces very abstract effects, such as shown by the color highlights, right. With a normal lens, out-of-focus highlight points become bright disks. The bright ring shapes in the picture above were formed because it was taken with a mirror lens.

## Diffusing the image

Shooting through a semi-transparent material will diffuse the light, softening shapes and desaturating subject colors. Such techniques cannot be used very selectively, but they can be done with any camera.

A reflex camera with through-the-lens metering will show you the change in the image and adjust the exposure accordingly. With other cameras you have to estimate the effect and you should bracket your exposures (see p. 97).

Three effects are shown below, but there are numerous other possibilities. You should never put grease or any other substance directly on the lens surface – use a clear filter to protect the lens.

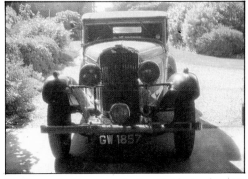

**Putting a stocking over the lens** Subject colors are desaturated and flattened, highlights suppressed, and shapes softened.

**Smearing grease on a clear filter over the lens** Colors are diffused, shapes softened and merged, and highlights spread and emphasized.

**Breathing on the lens** Colors and shapes are softened; strong highlights create rainbow effects.

# UNDERSTANDING EXPOSURE

When you vary the aperture and shutter settings on your camera, you are altering the brightness of the image and the duration it acts on the film, so that the film's response falls within constant, defined limits. When the exposure is correct, the brightest parts of your subject (the highlights) will give neither too much response, resulting in bleached white patches on your slide or print, nor too little, resulting in muddy highlights. The dimmest areas (shadows) will give enough response for some variation of tone and color to show; while the mid-tones will give fine variation of response, to show full detail, and balanced, saturated color.

In bright light, you will have to use smaller apertures and briefer exposures, and in dim conditions wider apertures and longer exposures, to maintain a similar response in the film. So the first thing you must do is determine the overall brightness of the light. Since color film has little latitude, most modern cameras now incorporate meters to read the light. But a meter will only prevent exposure errors if you know how and where to take your readings. This depends on three further factors: the range of tones in the subject; the main subject interest; and the distribution of tones.

### Brightness and tonal range

Generally, the brighter and harsher the light, the wider will be the range of subject tones, and the more care you must take with exposure readings. In dim, diffuse light on overcast days, colors will be muted, shadows weak, and highlights only slightly paler than mid-tones. Wherever you point your meter, readings may range within 3 stops.

In average bright daylight, colors will be stronger, shadows darker, and highlights quite bright – from pale or white surfaces to bright skies. Readings from different areas may cover 7 stops, and you must take care to read in the right place. If your meter is in direct light, and your subject is not, for example, you will underexpose the subject.

Brilliant direct sunshine produces strong color and high contrast conditions – black shadows, very bright highlights, and additional extreme specular reflections off water, glass and metal. The subject may cover the full 12 stop range, stretching the film's response to the limit, or beyond. You may decide to use incident readings (p. 95), for correct highlights, or expose for full detail in one part of the brightness range only (p. 96).

### Subject interest

The simplest and safest rule for exposure is: always read exposure directly from the main subject interest. Thus for a general scene, like a landscape, an overall reading from the camera position may serve. But for portraits, or any picture with a relatively small center of interest, you should go up to the subject to take the reading, before you return to the position where you will take the shot.

## Exposing for subject brightness range

**3-stop exposure range**
In weak even light, tonal range is only about 3 stops. A single overall reading will probably place exposure correctly on the film's performance curve, below, so highlights are clean.

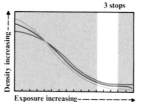

**7-stop exposure range**
In bright daylight, the range is around 7 stops. You must consider subject interest, and the distribution of tones, in deciding what exposure readings to take.

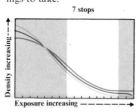

**12-stop exposure range**
In brilliant sun, with black shadows, the range can be at least 12 stops. Such contrasty conditions require careful readings, and perhaps selective exposure techniques (pp. 96–7).

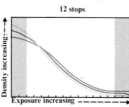

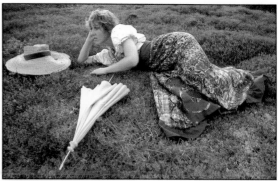

## Exposing for subject interest

**Reading for a general scene**
For general scenes like this landscape, with a fairly even distribution of tone, you can often take an overall reading from the camera position.

**Reading for a portrait**
When you take a close-up portrait, make sure your meter reads directly off the subject's face. You can often do this from your camera position.

**Reading a portrait in setting**
The face is still all-important, in a portrait with a setting. Go up to the subject, read the exposure from the face, and then go back to take the picture.

## Distribution of tones

If a subject contains large areas of dark or light tone, these could bias a single exposure reading. For a general scene, you can balance the exposure by averaging two readings, as shown below right. If the difference is large, however, averaging may result in too little detail in either area. With a portrait or other main subject which is much lighter or darker than the background, you should not average exposure, as this will reduce detail in the main subject. Instead, either let the background go, or use lighting techniques to reduce the contrast (see p. 97 and Working with Light).

## Reading and setting exposure

There are two main ways of reading exposure; you can read the light reflected from the subject, or the light falling on it ("incident" light, p. 95). Camera meters read reflected light, and convert the readings to exposure information which is shown in the viewfinder using various quite sophisticated displays including pointers, scales, and warning lights or LED's (light-emitting diodes).

Either you adjust the controls yourself, until the displays indicate exposure is correct; or the meter sets one or both controls for you, in which case the displays are used to warn you of any further action you should take. For selective or incident readings, or dim light, a hand meter is best (p. 95).

### Time exposures

Most cameras have a "B" setting, at which the shutter stays open while the release is pressed, for long exposures in dim light or at night, as below. Exposures over 5 sec (or under 1/1000 sec) however, can cause evident "reciprocity failure" – dye strengths become imbalanced, giving unpredictable color casts, depending on the film type.

**Subjects in very low light**
This floodlit building was taken at late dusk, using a small aperture for maximum depth of field. This meant a long exposure, of 3 sec. There is no evident reciprocity failure. The unusual colors are caused by mixed light temperatures – common in night shots.

## Viewfinder displays

The top screens are from automatic 35 mm viewfinder cameras. In the near one, the red arrow warns of overexposure, the yellow of low speeds. In the far one, a bar scale shows the automatic settings, and a red light warns of underexposure. The lower screens are from 35 mm manual SLRs. The pointer on the near one centers between the + (overexposure) and − (underexposure) signs, as you adjust the controls. The Nikon screen displays shutter speed on the left edge, aperture at the top, and correct or over/under exposure with 3 red LEDs.

**Yashica Electro 35 GX**

**Rollei XF 35**

**Olympus OM 1**

**Nikon FM**

## Averaging exposure

Some scenes have large areas of very different tone. Common examples are landscapes with bright skies, as shown below, or with areas of sand, snow, water or pale buildings. To show a balance of detail in the light and dark zones, you must take a reading from each, and work out an average, compromise exposure. You should not average more than a 5–6 stop range – the result will be to lose both highlight and shadow detail.

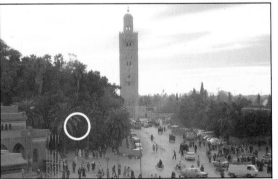

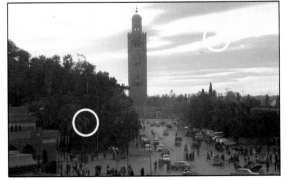

**Reading for the sky**
This scene in Morocco showed interesting foreground detail and a dramatic sky. A hand meter scale (p. 95) showed 13, when pointed at the sky. With 64 ASA film, this gave an exposure of f11 at 1/125 sec, which rendered the sky well, but lost all foreground detail.

**Reading for the ground**
For the picture left, the hand meter was pointed down, to read the foreground. The scale showed 9, giving an exposure of f4 at 1/125 sec. Detail and color have now appeared in the street scene. but the dramatic clouds are bleached out through overexposure.

**Averaging sky and ground**
This shot shows some detail in both areas; the meter scale was turned to 11, giving an averaged exposure of f5.6/18 at 1/125 sec. You can also calculate an average with a TTL meter: point the camera at each area and halve the stop difference between readings.

# CAMERA METERING

Practically all 35 mm SLRs, and many other cameras, now incorporate through-the-lens (TTL) metering systems, which measure reflected light from the subject after it has passed the lens and any lens attachments, using internally positioned light-sensitive cells. Simpler cameras may have an electric eye positioned on the outside of the camera, which reads light reflected from the general direction of the subject.

*Alternative TTL systems*

There are various types of cell used in TTL systems: cadmium sulfide (CdS); the faster-reacting silicon (Si) type; and in a few cameras, the super-sensitive gallium arsenic phosphorus (GAP) cell, which is unaffected by infra-red radiation. The cells are powered by tiny silver oxide or mercury batteries, giving constant power for up to 50 hours; spent batteries fail suddenly, rather than gradually.

One light-sensitive cell cannot read light evenly across the whole frame, so two or more are usual; their positions determine what kind of metering bias you can expect. Some systems place cells in the pentaprism housing; these read mostly from the center of the frame, with diminishing sensitivity toward the edges – a center-weighted system. Some systems place cells along the focal plane itself; these will usually read from the center of the frame only – spot metering. A third type of system uses two or more cells to measure light from different areas of the frame – an averaging system.

The very number of different TTL systems shows that no one is infallible – unusual light conditions in your frame can still "fool" the meter. Most obviously, a system reading from specific areas of the frame will give a false reading if your main subject is placed away from the metered areas, in very different local lighting. It is important, therefore, to know what system your camera uses.

*Automatic metering systems*

Some simpler TTL systems on direct viewfinder and rangefinder cameras, and most "electric eye" systems, are fully automatic, without any override – they set aperture and shutter for you, leaving you no control over exposure, depth of field, or freezing action. What you can do, however, is take care with your framing, so the meter is not fooled – avoid placing areas of very contrasting tone in the frame, or dominating light or dark backgrounds.

Many 35 mm SLRs now also have an optional "automatic" setting, coupled to the TTL meter, in addition to full manual control. In most cases, switching to automatic means the camera sets the second control, after you have chosen the first. "Aperture preferred" systems allow you to choose the aperture, but set the shutter for you; "shutter preferred" systems do the reverse. These semi-automatic systems are useful in rapidly changing light conditions, or demanding photographic situations.

## Through-the-lens metering systems

### Center-weighted system

The TTL metering system, right, has the light-sensitive cell positioned to the rear of the pentaprism. Its effect, far right, is to give the center of the frame priority for metering. Sensitivity decreases toward the bottom, and even more toward the top.

Metering on Canon AE1

### Overall system

In the system, right, cells read image light from the whole frame, reflected off the random patterned shutter curtain, far right. This gives slight bias to the frame center. At low light levels, light reflected from the film itself is read, giving an overall reading.

Metering on Olympus OM2

### Averaging system

The popular system, right, has two light-sensitive cells in the pentaprism to cover different areas of the frame. The two readings are combined to give an averaged reading that is based on the areas of the frame shown far right.

Metering on Minolta SR-T 101

### "Spot" system

The system, right, reads image light from a small rectangular area in the center of the frame. You must point this area (marked in the frame) at important lighting sections in your subject, and perhaps average the results yourself, before framing for the shot.

Metering on Canon F1

### Avoiding false TTL readings

Through-the-lens metering is not infallible. You must always consider which part of the frame will chiefly affect your meter. The composition of the picture, right, leaves the subject to one side of the frame in shadow, while strong lighting from the window dominates the center. Center-weighted or spot systems will give a false exposure, shown in the picture, top right, unless you first point the center of the frame toward the subject to judge correct exposure, as below, before framing the shot.

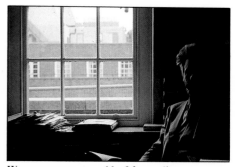

Wrong exposure caused by false reading

Exposure corrected by reading off subject

# USING HAND-HELD METERS

A hand-held light meter is very useful, even if your camera has built-in metering. You can see on the opposite page how through-the-lens meters can give false readings under certain lighting conditions. With a good hand-held light meter you can overcome any metering problem by using a number of techniques. You can take several readings from areas of both highlight and deep shadow in the subject, so you can average them for the optimum exposure (p. 93). You can deliberately read from highlight or shadow areas only to give low and high key effects (p. 96). You also have the option of taking an incident light reading, pointing the meter at the light source rather than at the subject. To do this you have to fit a light diffusing attachment to your meter, or take a reading from a gray card facing the light source. Regular hand meters are designed to read an area the same size as covered by a standard lens.

There are two kinds of hand meter, the selenium cell type or the cadmium sulfide (CdS) cell type. The selenium cell needs no battery, as it generates a small electric current in proportion to the intensity of light falling on it, so deflecting the gauge. The Weston meter, below, is a rugged and accurate selenium cell hand meter. CdS hand meters, like the Gossen, and Minolta spot meter, below, require batteries to provide a flow of current through the cell. The light creates a resistance to the flow, proportionally deflecting the gauge. CdS hand meters are accurate in very dim lighting where selenium cell types lose their sensitivity.

## Using an invercone

To read incident light with a hand meter, you must clip on or slide over a light-diffusing dome or disk. This will diffuse light entering the cell. With the Weston meter, below, the diffuser (called an invercone) is shaped to broaden the meter's angle of view to 180°, mixing the light striking it from all angles, as well as any strong directional light at which it is pointed. Where strong incident light will falsify TTL reflected readings, by flaring into the camera, you can *carefully* hold an invercone in front of your lens, so the TTL meter can read incident light.

## Operating a CdS meter

The Gossen Lunasix 3 is a good CdS meter. To take a reflected light reading, set your film speed in the window, **6**, point the uncovered cell aperture toward your subject, and flip the operating switch, **5**, with your thumb. Light intensity is first read as a number, **3**. There are two scales, for high, **4**, and low, **2**, readings. You flip the switch up to read light values 1–12, and down for 12–22. By turning the calculator dial, **7**, you convert the light value number into a range of correct f stop and shutter speed combinations. To take an incident reading, slide the diffusing dome, **1**, over the CdS cell, as illustrated, and point it at the light source.

## Selenium meters

A similar system applies for the Weston Euro-master, shown left. In normal daylight the baffle remains up, below left, and the scale 10–16 is used. In low light you fold the baffle down, below right, and use the 1–10 scale.

## Spot metering *left*

A hand-held spot meter is valuable for reading light off small, selected parts of your subject. The small angle of view gives accuracy even over long distances, so spot meters are useful with long lenses. Some standard CdS hand-held meters accept a "tele" attachment for spot readings, below left. A viewfinder allows you to sight on the chosen area.

The sophisticated spot meter, shown left, uses a silicon light-sensitive cell with a one degree angle of acceptance. You dial in the film speed, and then SLR viewing allows you to sight accurately. Exposure values are displayed on the meter when you pull the trigger.

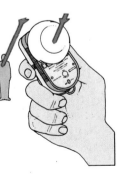

## Light readings with a hand-held meter

Using the full potential of a hand meter will enable you to overcome awkward light-reading problems. For reflected light readings you hold the meter with its cell pointing at the subject. Where it is difficult to approach close enough to a person to take a reading for a portrait shot, use the back of your hand, in the same lighting level, as a substitute. For incident readings, fit a light-diffusing dome and point the covered cell at the light source so that the meter is under the same lighting as the subject. Alternatively, take a reading of the incident light reflected from a piece of gray cardboard.

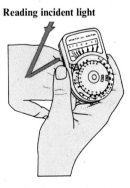

**Reading incident light**

**Reading reflected light**       **Reading off gray card**       **Reading from your hand**

# EXPOSURE TECHNIQUES

An exposure meter is simply a measuring device – it is up to you to decide what readings to take, and from where. Your decision will largely determine which parts of the subject record in the strongest color and fullest detail, and which are reduced to plainer supporting areas of pale highlights, dark shadow, or black silhouette. It will also affect the overall mood – high key, low key or balanced. Thus exposure is a creative tool in photography.

Slides and prints require slightly different exposure decisions. With slides the end result is final, and accurate key tones and highlights are essential, so incident readings are generally recommended. Negatives, however, must have sufficient detail in shadows to allow good printing, so reflected readings from midtones are safer.

Your choice of readings, however, depends mainly on the subject and lighting conditions you are working with. In most situations, reflected readings with your TTL meter will work quite well, which is convenient since you can adjust exposure as you frame the subject. Once you know what kind of metering bias your own TTL system has, you can make sure the metered area of your frame is reading from the most important key tones in your subject, and also use your TTL meter to take averages (p. 93), or selective readings from shadow areas or highlights. Overall reflected readings are accurate so long as the subject has an average tonal range (no large pale or dark areas) and is lit frontally (light source behind camera) or evenly (diffused or reflected light) at average brightness.

Subjects with unbalanced tone may bias reflected readings. Large light areas of snow, sand or white walls for example may cause a metering bias

## Exposing for highlights or shadows only

If your subject is unevenly lit, exposing for highlights or shadows only may be more effective than seeking a balance. When choosing whether to expose for bright or dark areas, consider which has the most detail and color.

This balcony scene shows most color and interest in the dark area. So the highlight reading, near right, gives a dull result – the dark frame surrounds an area lacking in interest. The shadow reading, far right, is more effective.

## Duplex incident readings

The duplex technique is useful when your light source is high or oblique. Subject planes facing the camera are then dimmer than those facing the source, and an incident source reading alone will underexpose them. So you take a second reading, with the meter and attachment pointed toward your camera (along a line from the subject), and then average the readings.

The extreme case is high back lighting, shown right. The source reading (14 on the scale) will expose highlights on top of the subject correctly, leaving the rest dark. The camera-directed reading (10) will be correct for parts facing the camera, but will overexpose the highlights. The midway point (12) will create an effective balance.

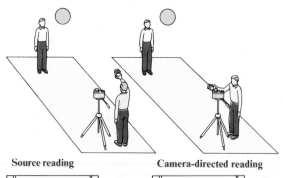

Source reading          Camera-directed reading

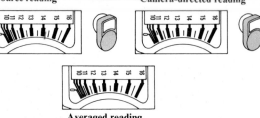

Averaged reading

## Handling scenes with extreme highlights

If your subject has extreme specular (mirror-like) reflections and glare from water, snow or metal, neither a reflected nor an incident reading will suggest a correct exposure alone. The reflected reading will be biased by the extreme highlights, even if you shield the meter from the sun and direct it downward to exclude the sky. The result will be underexposed, as near right.

The incident reading will take no account of extreme reflected highlights, and these will cause flare and apparent overexposure of highlit areas as shown center. For a balanced result, you should take both readings and choose the midway point, far right.

For this subject, the reflected reading showed 14 on a Weston meter scale, giving an exposure of f16 at 1/250 sec for 60 ASA film. The incident reading was 12, giving f5.6 at 1/250 sec, and the balanced result was taken from 13, giving f8/f11 at 1/250 sec.

Reflected reading f16 at 1/250 sec          Incident reading f5.6 at 1/250 sec          Balanced exposure f8/f11 at 1/250 sec

toward underexposure; dark areas may cause overexposure. But an incident reading will still be accurate. It suggests correct exposure for any normal tonal range lit directly by the source, and is unaffected by tonal imbalance in the subject.

The greatest exposure problems arise when the lighting is unusual. Generally, the more oblique or uneven the lighting, the more care you will have to take – the extreme cases being backlighting with specular reflection and glare, or very uneven lighting with large shadows, as through windows or doorways indoors, or between tall buildings. All these situations cause metering problems, and also have high contrast – the range of tones is wider than the film's scope, and you must choose which part of the range to get correct, and how to do this.

You may get the most effective result by exposing for one or other end of the tonal range – highlights or shadows – rather than attempting a balance. Which end you choose depends on which has the main subject interest, color and detail, and the effect you want. Shadow readings give a high key, rather romantic effect, with muted color and fine detail in darker areas offset by bleached highlights. If your main subject is in shadow, or has large shadow areas, take a reflected reading from the most important shadowed area (such as the face of a portrait) to set the exposure.

Highlight readings are suited to very high contrast subjects. They have a low key, dramatic effect with color and detail in bright areas, shadows reduced to dark frames, and backlit shapes in silhouette. Take care your reflected readings are from the main highlight, or use an incident reading which will have a highlight effect in very high contrast or backlit subjects.

If you want to balance exposure in high contrast situations, you will have to use the special techniques shown here: the duplex method (devised by J. F. Dunn), or combined incident/reflected readings, or supplementary lighting to reduce contrast.

Finally, if you are uncertain of a reading, use bracketing as a back-up. Even a half stop change may radically alter color results. So if you suspect a metering bias, or a finely balanced exposure is critical, take additional exposures ranging closely around the original one (at half stop intervals if your camera will do this), to allow yourself a choice.

## Exposing indoor/outdoor subjects

Subjects with outdoor areas framed through windows or doorways show high contrast, and are difficult to handle. In this case, a highlight reading from the window area, **1** (see diagram), gave a reasonable result, right, with the main interest placed in a dark frame; but the face is underexposed. A reading from the dark interior, **2**, gave the unacceptable result below, with color in the interior but the main interest lost. An average of both readings, **3**, gave the result below right – detail is weak in both areas, because the stop difference was too great. The photographer then used diffused flash, **4**, to lighten the interior. The flash was placed to match the strength of the daylight, so that color and detail are equally strong inside and out. The flash distance was calculated as explained below (see also Working with Flash).

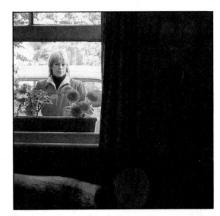

**Exposing for outside**

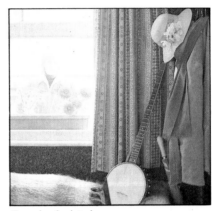

**Exposing for interior**

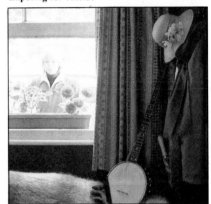

**Averaging the exposure**

**Filling in with flash** *right*
At 1/60 sec, the bright window required an aperture of f11 for correct exposure. The flash guide number was 110, so the flash distance had to be 10 ft ($110 \div 11 = 10$), to match the strength of the daylight.

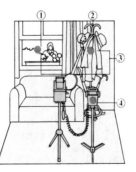

### Bracketing
This subject needs both strong color in the sky and enough detail in the shadow. The photographer took a TTL reading under the arch (third right), and then bracketed in ½ stops around this. The best balance between sky and arch was achieved at ½ stop under (second right).

# UPRATING COLOR FILM

Setting your film speed dial to the correct ASA or DIN rating of your film, and returning the exposed film for standard processing, establishes the optimum relationship between exposure and development for color accuracy with that film. But you can alter this relationship, within limits, and still get results. By setting a higher rating than the true one, and giving longer development to compensate, you can effectively increase the speed of your film–and also exploit the altered grain, contrast and color caused by overdevelopment. This is known as uprating or "pushing" your film.

Uprating is most useful when you find yourself with a film too slow for lighting conditions (where flash is not available, or a long tripod exposure is not possible). If your film is rated at, say, 100 ASA, your meter will give an impractical exposure, perhaps 1/15 sec at f2.8–a very wide aperture with too slow a shutter speed. To give a more manageable combination, you can set your film speed dial to 400 ASA, doubling the given film speed twice, and therefore uprating the film by two stops: this will allow you to shoot at 1/60 sec at f2.8. You are, in fact, underexposing the film to a consistent factor that can be compensated for during processing. You must, therefore, uprate the whole film; or use several blank frames to divide the uprated pictures from the rest, to allow separate processing.

At a concert or a circus, lighting may be strong enough for a hand-held exposure; but even with fast color film the possible shutter speeds will be too slow to freeze action. Uprating will allow you to use faster shutter speeds, as shown right. In very low light with a still subject, uprating gives you fast enough shutter speeds to prevent camera shake, and smaller apertures to increase depth of field.

The effect of overdevelopment on color film depends on the degree of uprating, the film brand, and the original speed rating. Both reversal and negative films give increased grain and more muted colors, increased contrast and loss of shadow detail. However, uprating negative films more than one stop is inadvisable, as first development is color linked, and extending it may give unacceptable results. The examples here are all on slide film.

Before increasing film speeds, you must find out whether your regular processor provides an uprating service. Film manufacturers are mostly reluctant to upset the balance of their films, though some provide a limited service. Independent color laboratories will usually process uprated film to your instructions–as a rule you have only to tell them by how many stops the film has been uprated.

If you do your own processing (pp. 164–9), you can develop uprated film yourself. With E6 slide processing, extend the normal first development time by one third for one stop uprating, and by one third again for two stops, and so on. With C41 negative processing, increase normal first development time by 40% for one stop uprating.

## Increasing shutter speed

In lighting conditions where a standard exposure requires a slow shutter speed, you will not be able to freeze motion and so get good subject detail. To have the option of faster shutter speeds, you can set the film speed dial at double the given film speed rating, to uprate the film by one stop; or double again for two stops, and so on. This allows you to expose the film as if it were more sensitive.

The violinist, right, was photographed on 160 ASA tungsten film. TTL metering gave a combination of 1/30 sec at f2.8 under the low stage lighting, producing the top picture, right. The slow shutter speed has created movement blur. The photographer wanted to remove this so he uprated the film 3 stops, by turning the film speed dial to just over 1200 ASA. to allow a 1/250 sec shutter speed, giving the bottom picture, right. Blur is removed and the yellow cast adds atmosphere.

## Avoiding camera shake

The doll, right, was illuminated by very weak daylight, and the photographer was caught with only 64 ASA film, and no tripod. At this rating, the lighting required a 1/8 sec shutter speed. The hand-held result at this shutter speed is shown near right. Camera shake has given an unacceptable image. The answer was to push the film 2½ stops, to 400 ASA, so that a 1/60 sec shutter speed could be used, giving the sharp result, far right. In this case, the photographer uprated a section of film only. He fired the shutter three times without removing the lens cap, both before and after the pushed section, and made a note of the frame numbers.

## Enlarging grain size

The deterioration in film performance caused by uprating produces effects that you can use creatively. Increased grain size softens image detail and improves the sense of atmosphere, if you can judge the color changes. The picture of swans, above, is a prime subject for extreme uprating for effect. On 200 ASA color film, normal exposure (1/250 sec) gives a realistic representation, as shown above left, with cool contrast between green water and pure white bird. If you can handle the processing, uprating the film by 4 stops will give the result shown above right. The effect is more romantic, with a surreal, grainy image of the bird in a sepia surround. The film speed had to be set at approximately 2400 ASA, which meant shooting at 1/1000 sec.

## Improving contrast

When you are confronted with a low contrast scene or detail, as shown right, you can use uprating to improve contrast. The left side of the picture shows the original contrast on the leaves under weak, diffuse daylight. The right side shows the result of pushing the film 3½ stops, from 64 to 800 ASA. Color saturation and contrast are improved, and the color imbalance that would result from pushing film with a high contrast subject is not present.

## Using color casts

You can use the color casts produced by uprating for atmosphere, as shown right. The picture of the skull and candlestick was set up under tungsten lighting. It was planned to use type B slide film, rated at its normal 160 ASA, to give the result, near right. But to achieve a yellow cast that suggests age and decay, far right, the film was uprated two stops to 650 ASA. Print film would have given a magenta cast.

## Uprating to extremes

Extreme uprating may be required for a result at any cost (perhaps when your film speed dial has slipped to a very high number) or for a special, stylized effect. The two small photographs, below, show 160 ASA slide film: normally exposed and developed, left, and uprated two stops, right. A slight increase in contrast is the only difference. The result of pushing the film four stops, below, is a more noticeable increase in contrast and grain and an obvious color shift toward yellow. At six stops, these effects are merely amplified but at eight stops, the extreme underexposure has flattened contrast beyond possible correction.

**Normal**  **Uprated 2 stops**

**Uprated 4 stops**

**Uprated 6 stops**

**Uprated 8 stops**

# WORKING WITH LIGHT OUTDOORS

In photography, you are working with light, just as an artist works with brushes and oils. Its color content, direction and quality largely determine how your subject appears. In a studio, with constant artificial sources, you can control these three effects precisely. But most of your pictures will be taken in daylight, outdoors. Daylight is not a constant source – it changes hour by hour, and with weather, season and latitude, radically altering the shapes, colors, and forms in a scene. Think of the outdoors as a natural studio – sometimes you can alter the lighting by changing your viewpoint, but more often you must wait for the light to change.

Daylight changes color most rapidly at the extreme ends of the day, when it may move from yellow, through orange and red, to deep blue at dusk. Strong color casts also occur during storms, or on blue wintry days, or in haze or mist. Lighting color casts can give dramatic landscapes, but they may overbear subtle colors, such as skin tones.

The direction of natural light changes as the sun moves across the sky. Shadows alter their shape and position, and the different angles of light greatly affect a subject's appearance, even from a constant viewpoint. Front lighting reveals detail and color, but reduces the sense of depth and form. Oblique and side lighting reveal texture and form. Finally, backlighting can emphasize shape, or produce a silhouette.

Lighting quality depends on its strength, and directness. Strong, direct light is hard – it produces black, sharp-edged shadows and brilliant, compact highlights, with strong modeling of form. Light is hardest on clear summer days, at noon, at high altitudes, or near the equator. Hard light weakens pale colors, but makes strong colors more brilliant.

**Natural light and time of day** *below*
The series of pictures below illustrate the variety of changing natural light on one day. In the first hour, after a dramatic sunrise at 5 am, the light changes color rapidly and becomes less diffuse. By 9 am the sun is higher, bringing out color, form and texture in the rocks. At 2 pm the light is stronger and bluer; contrast is high, and the sky and sea are very intense in color. The lower and softer lighting between 5 and 6 pm reveal detail and texture in the rocks and sea, colors are less saturated. At 7 pm, as the sun is setting, the whole subject is tinted by the pinkish color of the light. The low diffused light brings out maximum detail in the rocks.

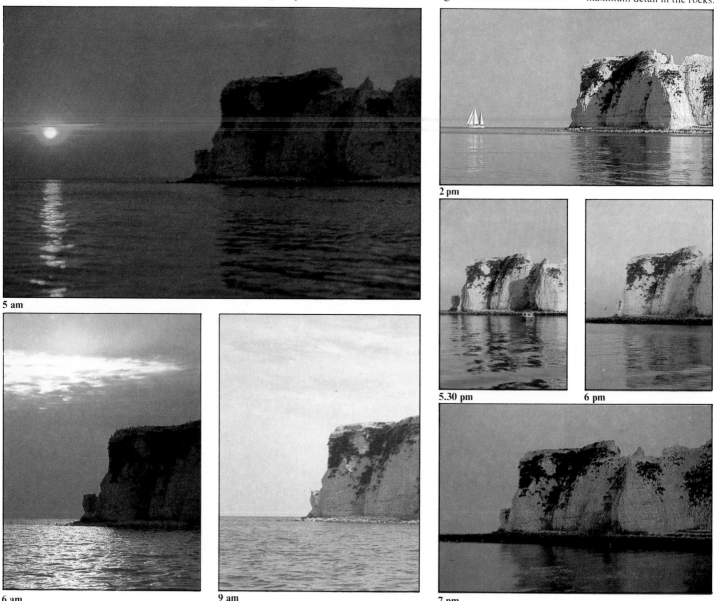

5 am

2 pm

5.30 pm

6 pm

6 am

9 am

7 pm

Reflected or diffuse light is softer. It gives weak, soft-edged shadows and dim, spread highlights – or no dark shadows or specular highlights at all. Light is diffused by haze, mist, water vapor or pollution in the atmosphere. Diffuse sunlight may still be directional. Reflected daylight is usually directionless – in open shade, or under overcast skies, the only illumination is light reflected from clouds, sky or light surfaces near by.

Directionless, even lighting is often called flat lighting – it reveals fine detail but flattens form. If it is weak, color will be muted. But strong flat light, particularly after rain, may produce vibrant, saturated colors. Toward the end of the day, or when daylight falls through a small window, light can be weak but directional – colors will be muted, shadows soft and large, and there may be extreme contrast between highlights and shadows.

## Quality of natural light

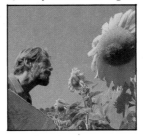 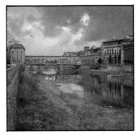 

**Hard sunlight**
The uncompromising quality of bright sunlight on a clear day makes it unsuitable for subtle effects. Its starkness emphasizes bold shapes and colors. You should be careful in strong sunlight that hard shadows do not obscure the subject, or destroy shapes.

**Soft daylight**
Diffuse and reflected light on overcast days reveals a wide range of subtle tones, colors and shapes. Soft light with small, weak shadows will show fine detail and texture, and give muted colors delicacy and depth. Bright, flat lighting gives strong colors richness.

**Scattered light**
Bright light filtered through leaves is diffused and scattered, giving a soft light, with weak shadows, which can be used to model the features of a portrait, as here. The dappled pattern of light and shadow creates a cool, restful mood, without breaking up shapes.

## Direction of light

**Texture**
Generally, oblique lighting will reveal texture, because the short shadows formed define different surface levels. The finer the texture, the smaller and weaker the shadows must be to reveal it.

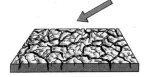

**Form**
Hard side lighting from the sun will create strong contrast between light and dark surfaces in a subject. This helps to define different planes, bringing out form.

**Shape and silhouette**
Backlighting throws the outlines of solid forms into sharp relief against the bright background. Shapes are simplified or reduced to silhouette. Colors are lost in the subject, further emphasizing shape.

## Using flash to supplement daylight

You can use flash as a form of supplementary lighting in daylight, either to soften or remove shadows, or to highlight your main subject against darker surroundings. The flash must not overwhelm the natural light – to calculate its position, and the correct exposure, see Working with Flash (p. 103).

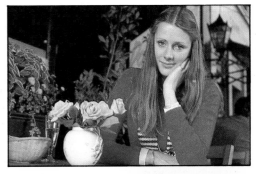

**Flash in sunlight**
Hard light from one side produced ugly shadows in the portrait, right. Adding flash from the other side removed the shadows, above, retaining the sunlit effect.

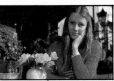

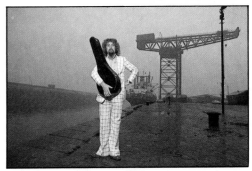

**Flash in gray, overcast conditions**
On gray, overcast days, the even light and tone may cause your main subject to lack emphasis. Using flash to brighten the subject picks it out from the darker background.

# WORKING WITH FLASH

Good flash equipment is essential if you want to work with a variety of subjects. Since it is color balanced to match daylight film, it effectively gives you a portable source of daylight, so you can take pictures in poor light without long exposures, and can alter existing lighting by filling shadows and so on.

Electronic flash is the most versatile. It is synchronized with the shutter via the X socket on your camera (with focal plane shutters there is a top limit to the shutter speed you can use: 1/60 or 1/125 sec depending on your camera). Bulb flash (in cubes or bars) is limited in use, and requires different synchronization. Modern electronic flash units are small and powerful, with fast recycling times and built-in batteries. You can fit them in the hot shoe of your camera, or use an extension synchronization cable to place them where you choose.

Since flash is a discontinuous source, you cannot usually read the exposure, but must calculate it from the flash power and the subject distance. Every flash unit has a guide number indicating its power (based on using 100 ASA film). The flash intensity decreases with the distance it travels, according to the inverse square law, below. Since shutter speed is usually fixed by X synch, to adjust exposure for subject distance you must change the aperture, using the guide number, as shown below.

Many flash units now have a subject distance/aperture scale. Some, such as the one shown right, have a sensor that controls the flash duration to suit subject distance, taking into account your chosen aperture and film speed. To use this type off the camera, you must attach a remote sensor device to the camera, to measure subject to camera distance.

### Electronic flash system
The flash unit below has four power settings and distance scales, and allows you to dial reduced power for fill-in flash, and use a remote sensor. The adjustable head alters the flash direction and also accepts filters, and reflectors to alter the angle of illumination to match longer focal length lenses on your camera (from 70 mm to 300 mm on a 35 mm camera).

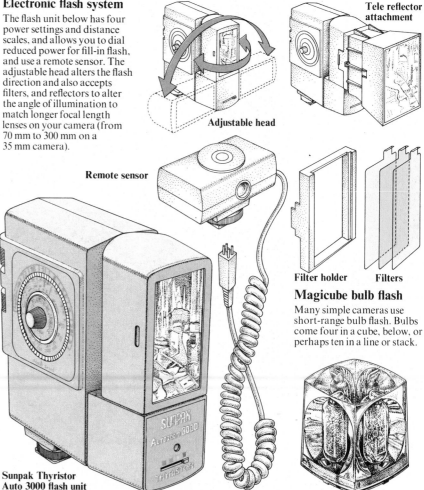

**Tele reflector attachment**

**Adjustable head**

**Remote sensor**

**Filter holder** **Filters**

**Sunpak Thyristor Auto 3000 flash unit**

### Magicube bulb flash
Many simple cameras use short-range bulb flash. Bulbs come four in a cube, below, or perhaps ten in a line or stack.

---

### Understanding flash exposure

#### Distance and aperture
With fixed-duration flash, you can adjust the exposure to suit different subject distances by changing the camera aperture. To find the correct f number, divide the flash guide number (allowing for film speed) by the subject distance. If the guide number is, say, 110, the aperture for a subject at 15 ft (4½ m) is f8 (with 100 ASA film); at 10 ft (3 m) it is f11, at 5 ft (1½ m) f22. The more powerful the flash, the smaller the apertures you can use.

**15 ft**
**10 ft**
**5 ft**

**f22** **f11** **f8**

#### Inverse square law
The intensity of illumination from any single, isolated light source decreases with distance according to the inverse square law; each time the distance the light has traveled from the source is doubled, its intensity is quartered. To compensate for this difference you must increase exposure by two stops. For example, if you move your subject from 5 ft (1½ m) to 10 ft (3 m) away, you must increase the aperture by two f settings.

#### Calculating flash fill-in
When you are using flash to relieve dark shadows, reduce contrast, or simulate sunlight, you will most often want to retain the general effect of the existing light rather than overwhelm it. You will usually get the best results by calculating the flash exposure at half strength, and the daylight exposure correctly, so the daylight to flash ratio is 2 : 1.

There are two ways you can do this. You can double the flash guide number, divide this by the subject distance to get the aperture, and then take a highlight reading of the subject to find the shutter speed that will give correct daylight exposure at that aperture (this shutter speed must not exceed the maximum X synch speed of your camera).

Alternatively, set the X synch speed, take a subject highlight reading to find the correct aperture for the daylight exposure, and then double the flash guide number and divide it by this f number to find the correct flash *distance* for the fill-in. This method is useful if your camera has a fixed (or automatic) X synch shutter speed.

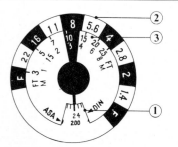

#### Flash exposure aids *above*
The dial above shows a typical flash unit scale for working out the correct aperture for different subject distances. You set the speed of your film, **1**, and simply read off the aperture required, **2**, against the subject distance, **3**. If your unit has various power options, you can then choose instead a wider aperture at lower power, or a smaller aperture at higher power.

With a computer-type flash, you can switch to "auto", after first estimating the subject distance and setting the appropriate aperture. The sensor then measures the exact subject distance as you fire the shutter, and cuts off the flash once the subject has received enough light.

## Using flash

Flash is a strongly directional, basically hard light source. Used on camera it gives harsh lighting and may create ugly shadows, or red eye in portraits (p. 121). Used well, however, flash is just as flexible as studio tungsten lighting and much more convenient. You can bounce or diffuse it, alter its angle of illumination, and so on. You can also use flash to create special effects – to turn day into night, for example, or freeze fast motion (since the brief flash determines the duration of the exposure). Flash is greatly used in many specialist subject areas such as sport or wildlife photography, photomicrography and macro work, and in most studio work.

## Altering flash quality

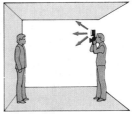

**Bounced flash**
Bouncing the flash off a white wall or ceiling to light the subject indirectly gives a soft modeling effect. Increase exposure 2 stops, or set it to auto.

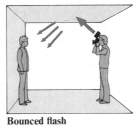

**Using a diffuser**
Adding a diffuser in front of the flash head softens the light. You can use tissue or tracing paper. (Again, increase the exposure 2 stops, or set it to auto.)

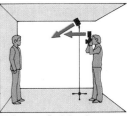

**Using two flash heads**
With advanced units you can use two flash sources to give good modeling – one as key light, the other as fill-in. A slave unit triggers the second flash.

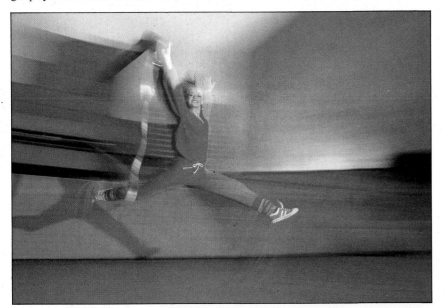

### Flash faults

The pictures below illustrate some common faults to avoid when you use flash. If you set a focal plane shutter to a faster speed than the X synch speed of your camera, part of your frame may be unexposed. Firing flash directly at subjects behind glass may produce ugly reflections (diffusing the flash may avoid this). Using a lens of wider angle than the flash may leave unexposed areas at the picture edges.

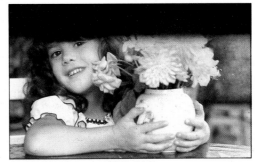

**Focal plane shutter speed too high**

**Flash reflected by glass**

**Lens angle too wide for flash**

## Experimenting with flash effects *above and right*

As flash is designed to approximate daylight, it is the ideal illumination to mix with available light for a variety of effects. You have seen how to calculate fill-in flash for a balanced effect between the flash and the natural lighting. When you have become more familiar with your flash equipment, you can experiment with altering the balance between flash and available light.

The picture above is basically an available light shot. A long time exposure was given, during which the subject jumped into the viewed area, causing blurred action. A separate flash fired at the end of the time exposure froze the figure as the shutter closed.

In the picture right, fill-in flash has deliberately been used at greater strength than the daylight, so that the background appears like night, even though there was plenty of light. This is a useful technique for obscuring confusing settings.

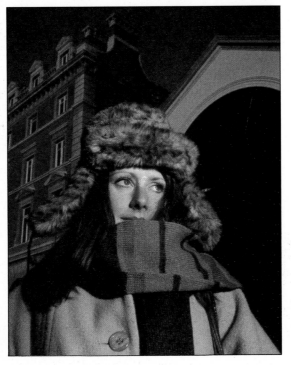

# WORKING WITH LIGHT INDOORS

Artificial lighting, used under the controlled conditions of the studio (p. 193), gives you the greatest influence over the quality, direction and effect of subject lighting. But partly because of this greater freedom, you must use studio lighting with care.

For color photography, make sure your film is the correct color balance for your lighting, and add correction filters (p. 51) if necessary. Two or more light sources of different color temperatures used together will give a color cast in your pictures. So unless you want this effect, keep your lighting balanced to one color temperature. If you are using tungsten spots or floods, exclude daylight from the studio and switch off room lights (which have a lower temperature) during exposure.

Use a single, key light as the basis for your lighting arrangement. This creates the most natural effects, since natural light is produced by one source

only – the sun. Add any further lights one at a time, for a specific purpose – to bring out detail, reduce contrast, and so on – keeping them subsidiary to your main source. Working in this way helps you to keep close control over the lighting.

The most commonly used tungsten lamps for studio photography are floods – either the short-life photofloods (or "over-run" lamps) balanced to 3400K, or the more expensive, longer life photolamps balanced to 3200K. Floods give a fairly soft, even light over a wide arc (around 60°).

The pictures on this page show the effect of lighting direction on a subject, using a single flood from varying angles. The opposite page shows how you can control the quality of lighting, making it harder or softer to suit the subject. These effects of direction and quality apply to all forms of lighting – floods, spots, flash or daylight.

## Modeling with light

The seven different lighting positions, right, change the form of the castle noticeably. Rim lighting, **1,** has caught the top edges of the castle; everywhere else is reduced to a flat silhouette. More detail is revealed by side lighting, **2, 3,** and the strong shadows give the castle greater solidity and form. Low front lighting, **4,** produces an unreal dramatic effect (daylight never shines upward in this way). The even spread of front lighting, **5,** brings out maximum detail, but the result is flat. By lighting the background alone, **6,** the castle is simplified to a silhouette. Finally, top lighting, **7,** has produced strong modeling with no significant loss of detail.

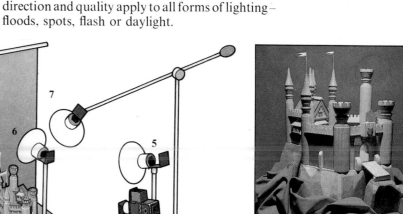

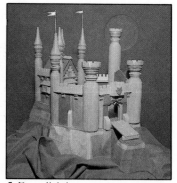

**7** Top lighting

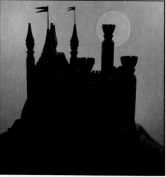

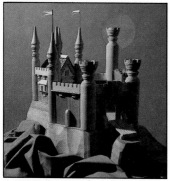

**1** Rim lighting

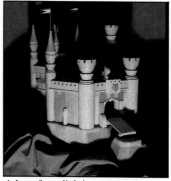

**6** Background lighting

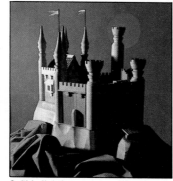

**2** Side lighting, above subject

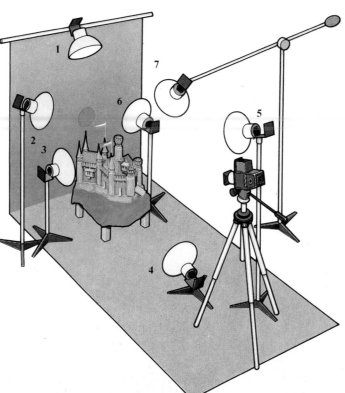

**3** Side lighting

**4** Low front lighting

**5** Front lighting

## Controlling lighting quality

You can modify the quality of your subject lighting by adding diffusers or reflectors, or a second lamp, or by using a hard spotlight rather than a flood.

Diffusers and reflectors both reduce lighting contrast, softening or eliminating shadows and highlights. You can make a diffuser out of tracing paper or a similar translucent material, mounted on a separate stand so it can be moved. Placed between your main source and the subject, its effect will vary with its distance from the lamp, as shown below.

Reflectors should be at least 3 ft² (0.9 m²) in area, and white or gray to avoid color casts. Mat surfaces soften light more than shiny ones. A single reflector is usually placed to one side of the subject, opposite the main source, to return soft light into the shadows. Or you can "bounce" your main light off the reflector on to the subject, for soft but directional light. With more than one reflector you can bounce light from several directions, creating soft even lighting for subjects with fine detail or highly reflective surfaces. (See also Still Life, pp. 128–9.)

A spotlight gives a harder, more direct light than a flood. You can vary its beam from about 1 ft (0.3 m) wide, to an arc approximating to flood lighting. Because of its controlled, directional nature, a spot is often used as a secondary lamp, to fill shadows, light the background, or pick out detail. When adding a second light source, make sure it does not compete with your main light, or create unnatural double shadows.

### Using a reflector
Placing a reflector on the opposite side of the subject to a photoflood reduces contrast. Shadows cast from the main lamp have been softened, revealing detail, but are still strong enough to model forms. The even lighting has given good color saturation.

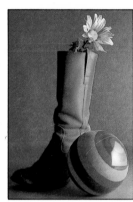

### Bouncing the light
Bouncing the light off a reflector quite close to the subject gives soft but directional key lighting. Deep shadows have been formed opposite the reflector but shadow edges are soft and the highlight on the ball is spread. The tonal variation gives a sense of depth.

### Using a spotlight
The narrow directional light of a spotlight can produce moody, high contrast pictures, as shown below. Although much detail is lost in dense shadows, highlit shapes, such as the delicate form of the flower, are brought out and color saturation is increased.

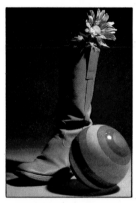

## Positioning the diffuser

### Close to the subject
Placing the diffuser near the subject, far from the lamp, maximizes its effect, shown by the spread highlight on the ball and soft shadows.

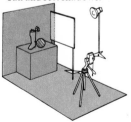

### Close to the lamp
When the diffuser is moved close to the lamp, away from the subject, its effect is reduced, as shown by the hard shadow and intense lighting.

## Using more than one light

### Fill-in lighting
A second lamp is most often used to relieve shadows formed by the main source, and reveal detail in particular subject areas. For the picture, right, a spotlight was used as the main subject lighting and a photoflood was added as a secondary, softer fill-in light. Some double shadows have been formed, but shapes are clearly definable. In the highlight areas colors are saturated.

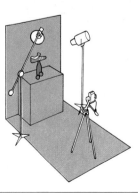

### Background lighting
The photoflood was moved to light the background for the picture, far right. As a result more of the subject is in shadow, but the tones are more graduated. The paler background throws all the objects into stronger relief. Color saturation has been reduced. Using a secondary light to reveal the background detail is a technique particularly useful in still life work, and portraiture.

# COMPOSITION-BALANCE & EMPHASIS

Good pictures seldom arise by chance. To make the most of any subject you must understand the basic principles of composition–how to arrange a scene within your frame to please the eye, arrest attention, or make a clear statement. It is often hard to analyze what goes to make a good photograph. However, knowing some simple rules for placing your subject elements effectively can be a good starting point. Viewpoint and framing are your main ways of altering composition.

Images that show order, balance, and rhythm give us pleasure, and the "classic" rules of composition aim to produce this effect. You can create visual balance and emphasis by arranging mass, detail, shape, and color, as shown here. You can also structure your pictures with line, perspective, and repeating elements, as shown on the following pages. A simple composition is usually the most effective–keep to one main subject, exclude distracting elements, and control other features to support your theme. Once you know the rules of order and harmony, you can break them deliberately. This provokes tension, which can itself give your pictures strong impact.

## Achieving balance

Start by considering where to place your main subject in the frame. A central position will give it emphasis, but may be dull. A more dynamic off-center position will require balancing with another feature. This should contrast, but not compete, with the main subject. You can balance small detail, strong color, or human interest against larger plain or weak-colored areas.

### Off-center balance

The silhouetted boat and figures are the main interest in this shot. The photographer has placed them well to the right, off-set by a greater area of space and light on the left. The boat and mast form a linking "V" shape, whose point of balance is off-center. The height and slope of the mast balance the weight of the group.

The exposure was read from the bright sky so that the boat and figures were simplified.

### Balancing shapes

Visual balance often depends on how you arrange shapes in your pictures. Two shapes of equal size balanced symmetrically across the frame may lack interest in themselves, as no emphasis is created. Unequal balance of shapes is more dynamic, as the eye is then drawn from one to the other.

The picture above uses the two foreground boats to provide balance, and to lead-in to the background group where there is sufficient detail to hold attention. Individual differences in color, tone and

texture between the boats provide variety. A low viewpoint emphasizes depth.

In contrast the picture, left, uses unequal but similar shapes to deflect the eye from the foreground hut to the lighter, more detailed scene beyond. Notice how color contrast helps the picture.

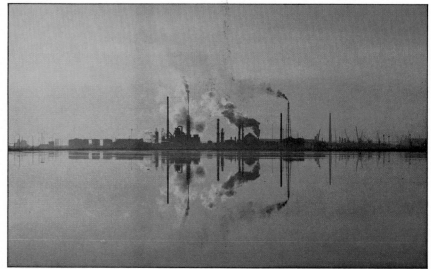

### Using reflections to create symmetry

Reflections in water or in windows offer obvious opportunities to balance shapes in your pictures. If the shapes are interesting to begin with, the exact symmetry produced can be very striking. Often the subject appears to merge with its mirror image into a single, complex new shape. For the shot above, the horizon was placed in the center of the picture frame to emphasize the perfect symmetry of the skyline and its reflection.

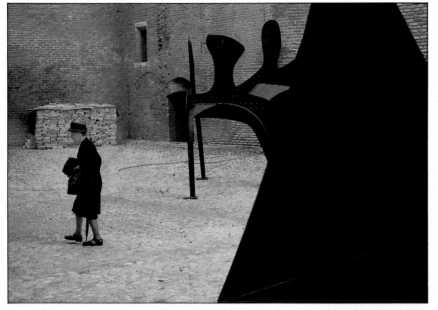

## Detail and mass *above*

A small detailed shape can be balanced by a much larger plain mass, especially if the small detail is a human figure. The position of the two elements is critical, however.

In the picture above, the large plain foreground mass of the sculpture is truncated by the picture frame, and occupies only about one third of the picture. Had it been complete, used more of the frame, or been placed closer to the figure, it would have overwhelmed her. Notice how the silhouetted shape echoes the bent figure of the women.

## Balance and tone *right*

Strong tonal contrast will emphasize shapes. Placing a dark shape against a light background, or light against dark, is a useful way of simplifying your pictures and creating visual balance. For such high contrast shots you must take extra care when measuring the exposure (see p. 97).

In the top picture, strong rhythmic arch shapes in a modern sculpture have been outlined against a pale sky. For the bottom picture a polarizing filter was used, to intensify the blue of the sky behind the white arch.

## Using frames

You can balance and emphasize your main subject by placing it in a frame. Use existing frames such as doorways, arches and windows or shoot between trees, buildings, and so on. Take care with exposure – read for main subject brightness, not the frame area.

You can also use shapes, tonal or color contrast, or areas of defocused color as frames. Foreground frames add depth to a picture, as shown above. Background frames serve to isolate the subject, as shown right.

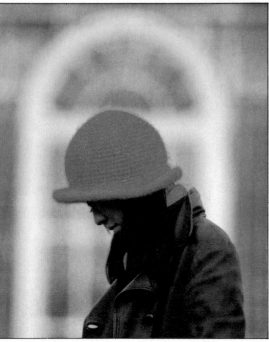

## Dividing up your picture frame

The most pleasing balance often occurs when you divide up your frame unequally. A simple "rule of thirds" is a helpful guide to positioning areas of color and points of interest. Use it to explore the frame adventurously, placing different emphasis on foreground, midground, horizon or sky.

Using a high horizon has produced a plain foreground color mass in the picture below. The middle scene is divided in half by the figures; but this is offset by the unequal division of background color. Both shots were taken with a long lens – the flattened perspective emphasizes the division of the frame. Placing the horizon in the lower third has almost filled the bottom picture with dramatic sky, while the off-center house provides balance and scale. A wide-angle lens increased the sense of space.

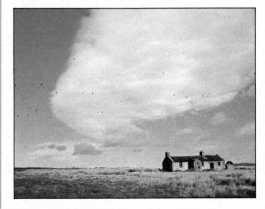

# USING LINE & PERSPECTIVE

Line is a powerful element in composition. The eye tends to follow lines, whether they are formed simply by linear features such as roads, fences, rows of crops, and telegraph poles, or more indirectly by the outlines of shapes, tones, and colors. So you can use line, with careful framing, to direct attention to a subject, link different areas of a scene, or suggest depth or movement. Vertical, diagonal and horizontal compositions create quite different moods, as shown right. Curved lines can give a rhythmic flow to images, see opposite.

Linear perspective causes receding parallel lines and planes to appear to be converging sharply in a picture. This effect allows you to create the illusion of three-dimensional depth within the two-dimensional frame. You can make the perspective steeper or shallower by varying camera viewpoint. A close-up shot exaggerates perspective – try it with a wide-angle lens for dramatic results like the parade of soldiers below. A subject placed in the path of the converging lines stops the eye and is boldly emphasized, as in the picture below right. A sense of depth can also arise in your pictures from aerial perspective. This is the progressive paling of colors with distance, as shown opposite.

Choosing your viewpoint and framing to give a dominant linear composition simplifies an image or scene. It often clarifies an otherwise complicated structure, and nearly always produces arresting, attractive pictures.

### Linear structure and mood

The mood of a subject is strongly influenced by the overall linear direction you choose for the composition. Dominant vertical lines emphasize solidity and strength. They are often used to suggest an immovable barrier, closing off the frame, as in the picture of trees, above. The urban environment offers many subjects where you can exploit this effect. A telephoto lens will help you remove unwanted detail and bring lines and shapes into closer conjunction. Horizontal lines and planes are associated with a passive, serene mood, as in the picture of a sunset sky, above right. Using horizontal line makes a scene appear more open, particularly if you are photographing landscape; but it can be rather dull if unrelieved.

Diagonal line is dynamic and can produce a sense of movement or restlessness. The pictures right and below show how strong diagonal lines lead the eye.

## Perspective and depth

The pictures right and far right were both shot from low viewpoints with a wide-angle lens, to exaggerate linear perspective effects. But they use the resulting lines in quite different ways.

The soldiers were framed to give bold diagonals traveling across the frame, as shown below. The vanishing point is so distant that the parade seems endless. The great depth of field given by the wide-angle lens adds to the almost unreal sense of depth. Harsh light and color add to the satirical comment on military precision and regularity.

## Stopping the eye

The shot of the train, above, was framed so that the linear perspective serves to emphasize the size, speed and power of the train. The converging lines are placed centrally, and are broken by the train, which stops the eye, see right. The ground-level viewpoint exaggerates the lines and the size of the train.

## Using aerial perspective

Atmospheric scattering of light causes colors to appear progressively paler with distance. The receding planes of color found in hilly or mountainous landscapes are particularly striking, as you can see above. But the gradual color changes caused by distance are often very evident in urban scenes, too, especially where atmospheric pollution is present to scatter the light. You can sometimes strengthen aerial perspective to emphasize depth in your photographs. Including some darker foreground colors as contrast is helpful, and you can further increase the sense of depth by combining aerial with linear perspective. Or you can frame your picture so that overlapping lines of hills lead the eye to the horizon. The diagram above analyzes the movement in the landscape, above left.

## Direction and rhythm

The eye quite naturally follows the line of this waterside fence into the village street beyond, see the diagram above. Linear perspective and pictorial depth are the main subjects of the photograph. The gentle curve of the fence and shoreline create rhythm in the composition, while the repeated upright lines add strength. Note how color and tonal contrast emphasize the line.

## Line to suggest movement

Horizontal movement across the frame is more convincing if you place the subject entering at the left and traveling toward the right. In this photograph, repeated horizontal lines echo the left to right direction while the diagonal boat pole isolates the point of forward movement, making an arrow shape as it meets the boatman's left hand.

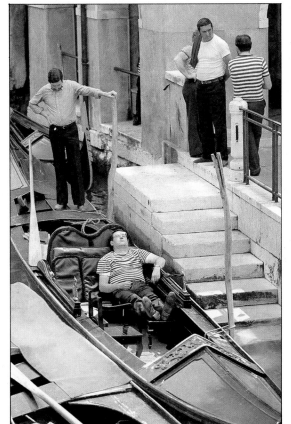

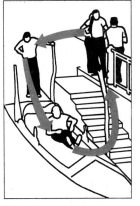

## Complex structure

This picture of a canal in Venice illustrates how lines can lead the eye around a scene. The diagram above analyzes the linear structure: you are led first to study the man lying in the boat; then up the steps, following the vertical post, to the group on the right; then downward, following the line of the columns, to the standing figure; and then downward again. This linear movement links a complex scene.

# USING REPEATING ELEMENTS

Building your pictures around repeating elements gives your compositions structure and unity. In addition, the repetition creates rhythms which the eye enjoys following, holding interest and attention.

Shape is the most commonly found and most powerful repeating element, but repeated color, tone and line can also give unity and rhythm to your pictures. Combinations of any of these can create interesting patterns and textures. The circle, square and triangle are the three basic shapes to look for. Once you begin purposely to seek them out you will realize how often they appear in various forms around you. You will frequently find that a close viewpoint or careful framing are necessary to isolate the repeating shapes or lines and eliminate distracting detail.

Circles, curves and ellipses are particularly pleasing shapes and readily create a powerful rhythm in your pictures. Squares and triangles are more static, but can be juxtaposed to create a dynamic, tension-filled effect. Where a shape is repeated uniformly, as in the chairs and tables, above right, an oblique or unusual angle will create sufficient variation in the shapes to relieve the common structure.

Like other aspects of composition—mass, line and color—repeating shapes, lines or patterns rarely form exciting pictures in themselves. You should rather use them to strengthen an interesting subject, and to give your picture a sense of unity.

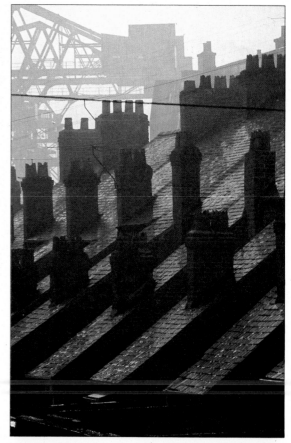

**Repetition and viewpoint**

Unusual viewpoints often help you to bring out simple repetition of shapes and so produce an effective composition. In the picture of the chairs and tables, above, the viewpoint has created an interesting pattern out of their diminishing ellipse shapes. The brightly colored chairs link the two lines of tables.

In contrast, the shot over the rooftops forms a repeating linear pattern running diagonally across the picture frame. Subdued colors offset the strong shapes. Using a long lens from a distant viewpoint caused the apparent massing of the chimneys.

**Repetition and framing** *above and right*

You can use bold repeating elements to create subsidiary frames within the picture area. Repeating rectangles within rectangles form a static symmetrical design in the picture above. Simple shapes provide a balance to the dominant overall color scheme, relieved by the color contrast of the window. The square-on, central viewpoint has incorporated the picture frame itself in the series of rectangles.

Reflections are an obvious source of repeating shapes. The arch and its reflection in this picture provide a strong frame to the center of interest—the two children. Because the two arch shapes are so powerful it was important to frame them symmetrically to balance the composition.

A long focus lens and a distant camera position have brought the two shapes into closer conjunction and the narrow angle of view excluded distracting elements.

## Theme and variations

Even very slight variations in a series of repeating elements add considerable interest to a picture. The strong curving shapes of the horns in the picture above are repeated, with slight differences, not only by each instrument but also in the bright reflections.

In the picture, right, the skull shape is repeated in a multitude of ways. Empty areas of the picture have been used to relieve and balance the complex patterns.

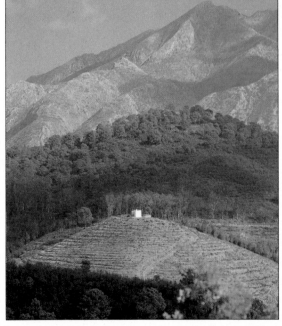

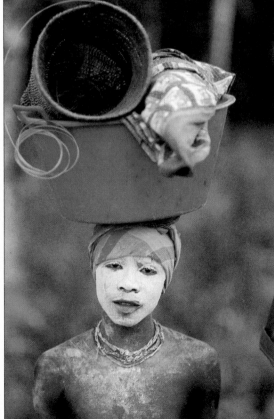

## Hidden structures *left*

Once you have become experienced in looking for repeating elements, you will be able to use them as a subsidiary feature to support your main subject. In the portrait of this girl, repeating circular shapes, analyzed below, have been used in this way. Notice how the arrangement of shapes not only gives the picture unity and balance but is also in agreement with the harmonious color scheme.

## Landscape and repetition

Nature is a good source of similar shapes and patterns which you can make use of in your pictures. A group of flowers, a pile of leaves, or an entire terrain are all likely to have characteristic features repeated within them. In this shot of a terraced landscape, the repetition of conical shapes and shades of green is relieved by asymmetrical framing and the variation of tone and texture.

# 5 THE SUBJECT

This chapter presents some approaches to the major photographic subjects – people and portraits, action, still life, nature and wildlife, the natural elements, landscape, urban settings and buildings. The various types of photography involved differ greatly – in the control you have over the arrangement of your picture, in the amount of specialized equipment, techniques or knowledge you require; and in the interpretive skills demanded.

Still life photography allows you the most complete control over arrangement of your subject, and time to perfect it. You do really need some studio equipment, however, and an undisturbed place to work. Results then depend on your skill with color, composition, and lighting, and your imaginative association of objects – nostalgic, unexpected, bizarre or unique. At the other extreme, action and wildlife photography allow no control over the subject, and demand both patience and the ability to respond very quickly. You must have light, easy-to-use cameras, and probably a range of extra equipment, from long-focus lenses to remote control devices. You may have to travel far afield, and put in advance preparation to set up the shots, and you certainly need specialized knowledge.

Landscape and buildings, while not directly controllable, do at least stay still for you to study them, choose your approach, and wait for the right lighting. In these areas, special equipment is used more to give a variety of images, than out of necessity. In portraiture, you have partial control over picture arrangement (except in candid shots) – and subjects are readily accessible.

Portraits require only a few extra items of equipment – a portrait lens, some filters, some supplementary lighting (such as flash) and reflectors or diffusers. But of all subjects, people are probably the most difficult in terms of interpretive skill – requiring a sensitivity to human type, character, and mood; an eye for style, gesture and the expressive range of the face; and the ability to set people at their ease, and elicit a characteristic response – from laughter, pleasure or flirtation, to sardonic humor, anger, or withdrawn reflection.

Some areas of photography have inherited an existing tradition from painting – notably portraiture, landscape, and still life. Other subjects, however, have only become possible through the camera. The details of fast movement, for example, such as the gallop of a racehorse or the leap of an athlete, were not understood until the camera first froze them on film. The many other types of wholly photographic subjects include images made through a microscope, macro lens or telescope, or with underwater cameras, special films, or the distorting view of special lenses; or those created by multiple exposure, defocusing, or darkroom manipulation.

Much of the pleasure we take in a good picture derives from its interpretation of the subject – we are immediately conscious it has something to say. A striking subject, or elaborate and expensive equipment, cannot in themselves supply this quality. The two things you need most are the ability to simplify – to consider not how many, but how few elements you need to use in a picture, so that it has clarity and impact – and a personal interest in, and knowledge of your subject.

To photograph wildlife, for example, you must become an expert naturalist; to photograph active sports, you must be involved in, and understand sport, and perhaps spend long hours studying different types of movement; to photograph buildings, it helps to have a knowledge of architecture and design. Develop your interest by reading specialist books or joining a class.

This chapter gives you a basic, practical guide to the techniques, equipment and problems relevant to each area, and uses some of the work of contemporary photographers to illustrate the range of images possible. It draws on the equipment, color language, and picture taking skills covered in chapters 2 to 4, and introduces more specialized techniques and equipment where they apply; some of these are covered in detail in chapter 7. When using this chapter, you should take full advantage of the cross references to both earlier and later sections.

**Interpretive power**
Even the simplest subjects can produce a powerful image when handled by a creative photographer. This bungalow, symmetrically framed in its garden, shows a masterful use of color, tone, and mood. The sky is darkened with a graduated gray filter, and the perspective dramatized with a wide-angle lens. Together with the subdued, strange coloring, the whole effect is one of foreboding and unease.

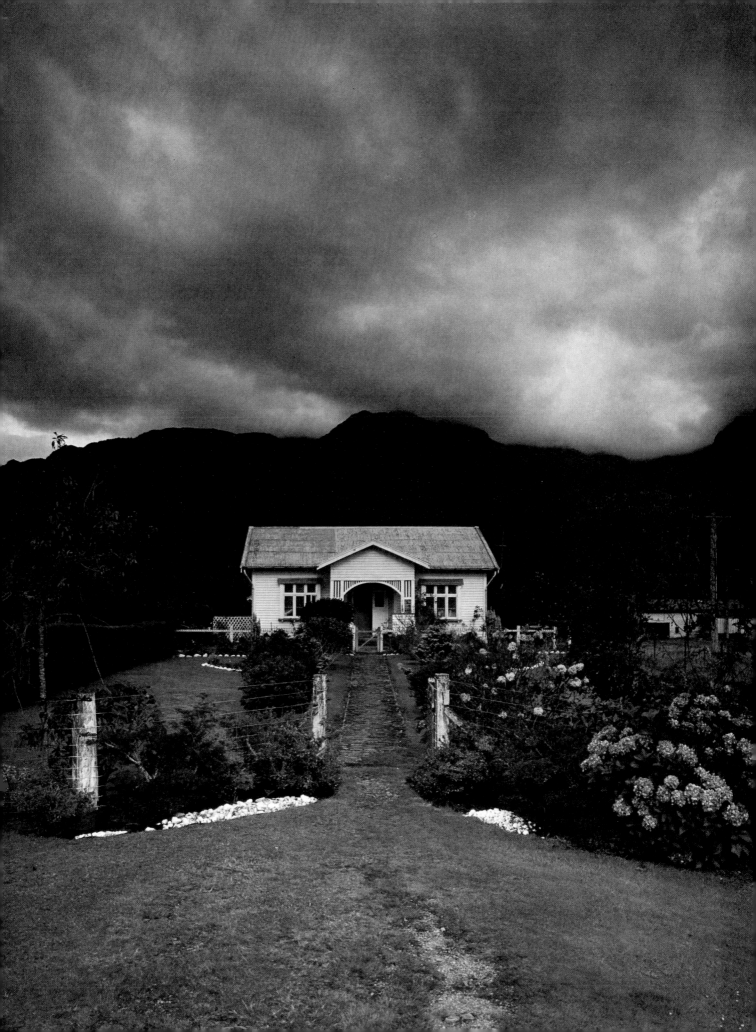

# PEOPLE – THE UNOBSERVED CAMERA

People are the most rewarding subjects for photography, but also the most demanding. Good pictures capture the expressions and gestures that convey character and vitality, without making the subject appear self-conscious. Here we show how you can achieve this directly by photographing people who are unaware of the camera. The following pages present techniques for portraits which require the subject's co-operation.

Candid shots of people involved in their own lives have an attractive intimacy and spontaneity. The skill lies in moving close enough to your subject without being observed, and having your camera ready so you can respond quickly.

### Remaining unobserved

With a long lens you can take candid shots from a distance. However, long lenses restrict depth of field, making quick focusing difficult, and their bulk is conspicuous. Unusual viewpoints may help you approach closer – photograph from the side, rear, or above, or from the cover of doorways or buildings. Try partially concealing your camera, using it at waist-level, or holding it on your lap.

Even if you cannot conceal yourself, you can still take candid shots when people are sufficiently involved in an occasion to ignore you. In the excitement of sports events, parades or fairs you can often take pictures freely. In quieter situations such as family gatherings, try distracting attention by pointing your camera elsewhere for a while until your subjects have relaxed.

### Handling the camera

Light compact cameras with quiet shutters are helpful for candid photography. Some people find direct viewfinders or rangefinders easier for rapid framing and focusing than reflex cameras, and automatic exposure systems can be useful. Even simple 110 and 126 automatic models can give good shots, because they are quick to use. Use a fairly fast film, which will allow small apertures and fast shutter speeds in the light conditions, as your subjects will be moving around.

If you can, preset your focus and exposure in advance, so you can respond quickly, avoid attracting attention, and be free to concentrate on your subject. Estimate the likely subject distance, set it on the lens, and stop down for generous depth of field. Read exposure off an object similarly lit and toned to your subject's face – such as your own hand. With automatic exposure, take care the subject is centered and large enough in the frame to determine the meter reading, and avoid dominating areas of much lighter or darker background.

If you want to include background, watch your framing carefully for distracting detail and try to place your subject against a plain area. Alternatively, you can exclude background by selective focus (pp. 90–1), or by shooting through a frame.

### Gesture and attitude

Characteristic poses and gestures convey personality as much as the face itself. Notice the telling details of the man's raised hand, right, and the girl's feet, below. The couple and child were shot with a 200 mm lens. The girl's bold stance was taken with an 85 mm lens.

**To take the picture** *right*
- reflex
- long
- TTL
- wide aperture, fast shutter

**To take the picture** *below*
- reflex or direct
- standard or medium long
- fast
- small aperture, fast shutter

## Moment of triumph *above*

At times of great excitement you can often take candid shots from quite close up without attracting attention. This dramatic shot of supporters of the winning team at an army football game was taken from a low viewpoint right in front of the crowd, with a wide-angle lens, as a goal was scored.

**To take the picture**
- reflex
- wide-angle
- medium aperture, fast shutter

## Unusual viewpoints
*right and far right*

An unusual camera position not only helps you remain unobserved, but can reveal unexpected relationships between subject and environment. The girl surrounded by cakes, near right, was caught by a quick shot through a window. The man dwarfed by his shadow, far right, was photographed from an overhead bridge.

**To take the picture** *right*
- reflex or direct, prefocused
- preset exposure, read for shade

**To take the picture** *far right*
- reflex or direct
- fast
- low evening sunlight
- TTL

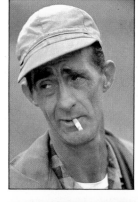

## Candid portraiture *left*

Candid photography often produces the most lively portraits—a subject unaware of the camera uses a wider range of facial expressions than a person aware of being photographed. When you are taking an unposed portrait, try to avoid a cluttered background. Here, the background was thrown out of focus by a long lens, at full aperture.

**To take the picture**
- reflex
- long
- TTL
- wide aperture, medium shutter

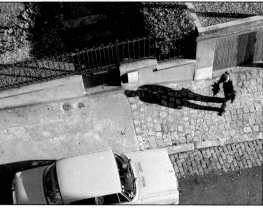

# TAKING PORTRAITS OUTDOORS

Outdoor portraiture is far from easy. It demands a high degree of understanding of your subject's appearance, a relaxed relationship between you and your model, a skill for selecting an appropriate or unobtrusive background, and a knowledge of the effects of different qualities of light (p. 101).

If you could draw a line down the center of most people's faces, you would discover that in general one side is fuller than the other and one eye may be larger or set higher. Few people possess features so regular and well-proportioned that they can be successfully photographed from any angle. So spend some time in finding a viewpoint that makes the most of your model's individual features. Don't ask your subject to change position – move around yourself, trying various viewpoints, as shown right, and looking at your model's profile and three-quarter view from both sides.

Many people "freeze" in front of a camera – much depends on your ability to relax your model so that you can provoke the response you need. Keep talking to your subject while you are deciding on the best viewpoint and background. Verbal instructions may make your subject self-conscious; instead, try to use your own movements to lead him to look the way you want. Moving to the left of the camera will make your subject look to his right; choosing a lower viewpoint will tend to make him look down.

*Taking advantage of daylight*

When taking outdoor portraits, you will generally have to make the best of existing lighting conditions. Strong direct sunlight is harsh and unflattering to all but the youngest complexions, and the shadows it casts lead to problems, see opposite. If you must shoot in bright sunlight, use some kind of reflector to soften shadows; or if the face is largely shadowed, expose for these shadowed areas, leaving the highlights to burn out. When taking portraits, you should generally read exposure from the key areas of your subject's face. The ideal lighting conditions for portraiture are when the sun is diffused by high cloud or haze, which softens shadows and reduces contrast and produces good skin tones. Gray overcast days result in flat even lighting, which lacks both contrast and emphasis.

The direction of the lighting has a strong influence on the character of your portraits. A 45° angle of the sun is the most flattering, giving good modeling and texture. Backlighting your subject can be very effective; it will rim light the hair and emphasize the shape of the head. A lens hood will help to minimize flare when shooting into the light. Avoid front lighting which will flatten your subject's features and, if the sun is bright, cause him to squint, as opposite. Towards the end of the day, you may find your subject's face tinged with red – color casts may add atmosphere to outdoor portraits but they tend to overwhelm skin tones.

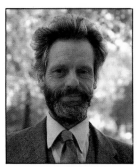
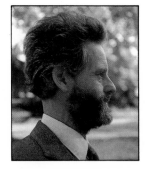

**1  Front view**     **2  Profile**     **3  Three-quarter view**

## Choosing your viewpoint

Move around your model, experimenting with different angles and heights of view before you choose your viewpoint. A front view, **1**, is unflattering to all but the most regular and symmetrical features; it is particularly unsuitable for very broad faces, as it tends to flatten form. A side view, **2**, can be the best choice if your subject has a beautiful or interesting profile, but it generally gives less information than a fuller view. A three-quarter view, **3**, is usually the most flattering and natural-looking angle, and avoids the formal effect of the subject looking into the camera. With a high camera angle, **4**, the neck is rather foreshortened, the forehead is accentuated, and the face tapers. A low viewpoint, **5**, emphasizes the chin and flares the nostrils; it is useful if you want to shorten a long face.

**4  High viewpoint**     **5  Low viewpoint**

## Lenses for portraits

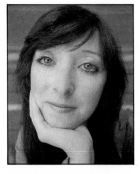

**Wide-angle**
A wide-angle lens magnifies the features nearest to the camera, making the rest of the face recede steeply. Use it when you can exploit this perspective distortion.

**Standard**
Even a standard lens causes some distortion when used at the proximity needed to fill the frame with a subject's face. Use it a little further back to include the subject's shoulders.

**Medium long**
A medium long lens is ideal for close-up portraiture – facial proportions remain unchanged and the subject will be more relaxed due to the more distant camera viewpoint.

## Common faults in outdoor portraits

Both the portraits below were taken in bright sunlight. In the picture below left, the overhead sun has created ugly shadows under the girl's eyes, nose and chin. This could have been avoided by filling in the shadows with flash (see p. 101) or by moving the subject to an area of open shade, where contrast is reduced and lighting softened. The man in the adjacent portrait is squinting into the sun – moving the subject round would have prevented this.

The playground setting of the bottom portrait has no real connection with a teenage boy and it is too sharp and distracting to serve as a neutral background. If you cannot find a suitable background, try selective focusing (see p. 90) or shooting your subject against the sky.

**Shadow on eyes**          **Squinting**

## Choosing backgrounds

In general, you should avoid cluttered backgrounds, unless they are closely associated with your subject. The train in the portrait above provides a busy but supportive setting; attention is drawn to the subject both by the lighting on his face and by his pose. In the portrait right, a plain colored background has been used to isolate the figure. The limited depth of field of a long lens has thrown the background out of focus.

**To take the picture** *above*
📷 reflex or viewfinder
◉ read from face

**To take the picture** *right*
📷 reflex
◎ medium long

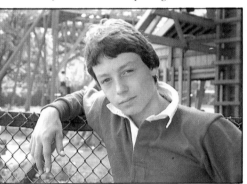

**Confusing background**

## Capturing expressions

The human face is infinitely expressive, reflecting a great range of emotions, from joy and surprise to pain or anger. Mood and character are chiefly expressed through the eyes, the mouth and the tilt of the head, as shown in these informal portraits.

It is up to the photographer to put his subject at ease, so as to capture a characteristic and relaxed expression – any trace of self-consciousness or artificiality will be picked up on film. The mouth in particular tends to tense if the subject is nervous – it is often a good idea to take your subject while he or she is talking, as the face will be more animated, and a half-open mouth looks more natural.

# PORTRAITS BY DAYLIGHT INDOORS

Portraits taken by available light indoors can be very effective – particularly with today's fast daylight color films. Light falling through windows, doors, and archways is softer yet more directional than outdoor light, subtler and more natural than studio lighting. It gives delicate modeling of features, reveals texture, softens and harmonizes colors. Illumination falls off rapidly, giving luminous highlights and contrasting shadows. This expressive tonal contrast is very attractive, but requires careful handling.

You cannot judge by eye how detail will record. Film exaggerates contrast, and is less sensitive than your eyes. A good light meter will help you determine the degree of contrast, and decide whether to expose for mid-tones, skin tones, or highlights only (see Exposure).

*Balancing the light*

The strength and quality of light depend on several variables: light conditions outdoors; the size, height and number of windows; diffusing effects of curtains, dust, or obscured glass; the presence of natural reflectors such as white walls, light-toned drapes or rugs, even an open newspaper.

If you place your sitter in the center of the room, lighting will be dim and color and contrast much reduced. If you place the sitter close to a window admitting direct sunlight, contrast will be great but colors stronger. You can reduce contrast by experimenting with diffusing materials such as gauze or Kodatrace; placing reflectors to "bounce" light back into shadows; or moving the subject back, away from the window.

If outdoor light is weak or diffuse, contrast is softened and you can reveal fine detail. But you will have to place the subject close to the window for enough light. You can control the modeling effects of light by using windows of different height and position, and moving your sitter (see Working with Light).

*Subject and background*

Working with available light allows you to photograph your subject in his own home, free from the distracting clutter of studio lights. So you can more easily establish a relaxed, informal mood – essential for good portraits. Consider how you want to convey the sitter's character and relationship to his environment. To include background detail and some degree of depth, you will certainly have to stop down and use a slower shutter. This may involve using a tripod, and taking careful readings from the sitter's face and background areas (see Exposure). Ask the sitter to keep still, focus on the eyes, and check the background is sharp. Alternatively you can eliminate background, to emphasize the sitter. Use a wide aperture, to reduce depth of field, and perhaps expose for highlights to give a dark background.

### Effects of contrast

Strong outside light creates marked contrast near a window even if diffused by gauze, as above. Scattered light has muted colors and given some shadow detail. The family group, right, was lit by direct sunlight from a high side source – a classic form of portrait lighting. Contrast is extreme. Exposing for highlights has given rich color.

**To take the picture** *above*
- 📷 reflex or viewfinder
- 🎞 fast; daylight
- ☼ diffused daylight
- ◉ read for mid-tones

**To take the picture** *right*
- 📷 reflex or viewfinder
- 🔲 standard or medium long
- 🎞 fast; daylight
- ◉ read for highlights

## Lighting to match mood

When the light outside is weak and diffuse, contrast is reduced to give a gentler, more even lighting. In these conditions you can record fine detail and tone variations, but you must place the subject close to the window to avoid long exposures. An overcast cloudy day provided soft lighting for this expressive portrait. The slight predominance of blue lends a romantic mood to the shot. The photographer used a medium speed film, aiming for fine detail and limited grain. As a result, the subject had to be placed very close to the window, and a rather slow shutter speed (1/30 sec) used. The camera was hand-held.

**To take the picture** *right*
- reflex or viewfinder
- standard or medium long
- diffuse daylight
- read for mid-tones
- medium aperture, slow shutter; hand-held

### Available light to record background *above and below*

The picture above was taken through an open window with a 28 mm lens. In such good light, you can stop down enough to record background sharply without having to use slow shutter speeds, and colors are well saturated. In most interiors however, light levels are low and colors muted and sombre. To record such settings, you must use long exposures and pose the subject. The portrait of the Appalachian couple, below, required a 1/8 sec exposure, with a tripod, to allow the photographer to stop down for depth of field. Light coming from the rear and side windows reveals detail in shadows and softens contrast.

**To take the picture** *above*
- reflex
- medium wide-angle
- fast
- small aperture, medium shutter

**To take the picture** *below*
- reflex or rangefinder
- fast
- medium aperture, slow shutter; tripod

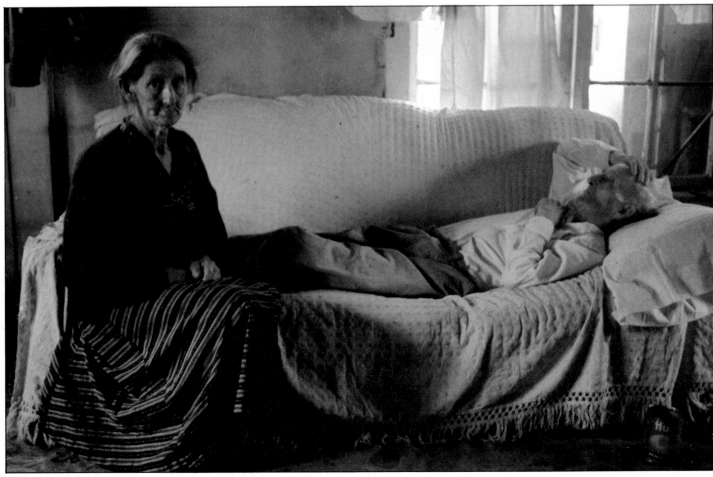

# PORTRAITS BY ARTIFICIAL LIGHT

Photographing people by artificial light allows you an extraordinary degree of technical control over your pictures, compared with the randomness of natural lighting. You can vary not only the direction and height of your lighting but also its quality or intensity, simulating every conceivable form of daylight. In addition, by using more than one light source, you can create a variety of special effects.

*Interpreting your subject*

With artificial lighting, you have enormous scope for interpreting the character and appearance of your chosen model. Experiment with different lighting positions, observing the way you can alter modeling to enhance your subject's appearance. Strong shadows in a portrait will give a more powerful impression of character than soft even lighting. Lines and wrinkles are minimized by soft frontal illumination but brought out by hard, oblique lighting. Sidelighting, with its strong shadows, tends to exaggerate the boniness of a thin face but flatters round or full faces.

The lighting you choose for portraits will not only affect form and texture but will also help to evoke mood and atmosphere. You can create harsh or dramatic lighting with spotlights, flash or desk lamps. (When using the extreme contrasts of direct lighting, remember that exposing for highlights will give you better color saturation.) More often you will want to produce softer, more idealized images, using soft or diffused lighting to harmonize or mute colors. Use a diffuser in front of your light source; bounce light from a neutral or white wall or ceiling to give more even lighting; or use a reflector to reduce tonal contrast (see pp. 102–5).

With any portrait, but especially a head and shoulders, the background should be as plain and uncluttered as possible, distinguished from the subject by tone and color. Selective focus (see p. 90) can be used to soften background color and concentrate attention on the subject. Or you can light the background independently – to counterpoint the lighting contrast on the model, for example, by setting the shadowed side of the model's head against a lighter background, and vice versa.

## Light source moving round the subject

Frontal lighting directly above the camera, **1,** reveals maximum detail but flattens form. At an oblique angle, **2,** the head is given more modeling but an ugly shadow is thrown by the nose. Contrast is exaggerated by sidelighting, **3,** hiding one half of the head in sharp-edged shadow, while emphasizing skin texture on the other side. With the light source at 135° to the camera, **4,** most of the head is obscured and the face is unrecognizable.

**1  From camera**  |  **2  45° to camera**

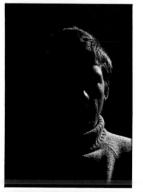

**3  90° to camera**  |  **4  135° to camera**

## Light source moving over the subject

Low frontal lighting, **1,** gives an unnatural, theatrical effect and obscures the shape of the nose in shadow. With the light source 45° above the model, **2,** the forehead and nose are high-lit but cast deep shadows on the eyes and mouth. An overhead light, **3,** dramatically highlights the hair, but may leave the face unlit, without supplementary lighting. Backlighting, **4,** emphasizes shape, reducing the head to a silhouette, with "rim lighting" on the hair. A star effect is produced, **5,** when your light source is just visible behind the subject.

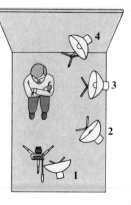

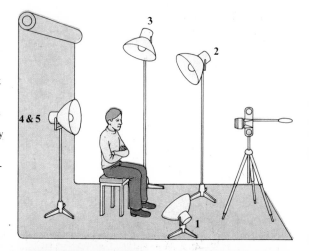

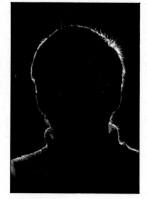
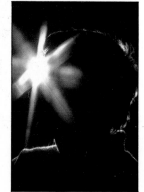

**1  Below**  |  **2  45° above**  |  **3  Directly above**  |  **4  Behind**  |  **5  Star effect**

## Choosing your light source

*Choosing your light source*
Flash is the most popular light source for indoor portraits as it is portable, economical, and conveniently color balanced for use with daylight film. Avoid using it on-camera for pictures of people, however, as besides giving hard unflattering lighting, you run the risk of "red eye", see below right. The main advantage of tungsten lighting is that you can see how the light is modeling the subject. Only studio flash units allow this amount of control as they have modeling lamps fitted to the flash head; with most types of flash you must be able to predict the effect on the subject.

Flash and tungsten are balanced for different color temperatures and will both produce color casts if used with the wrong film types, unless you use a correction filter (see p. 51). When using flash with daylight film indoors, check that any out-of-balance lighting is switched off, or outside the picture area. Be especially careful with fluorescent lighting which will give a greenish cast with either film type, unless a filter is used.

*Using additional lights*
You do not need a large number of lights in order to light a portrait successfully – the best results are often achieved by the simplest means. Practice with one source only before you move on to more complicated lighting set-ups. A single source of light will give you the most natural effect, producing, like the sun, only one set of shadows. And, using a reflector, you can fill in shadow detail as easily as with a second lamp.

Lighting should always be used to interpret or enhance the subject, rather than dominating the picture. Don't use a number of lights indiscriminately just to gain more light – always use a second light source for a specific purpose. And remember that a more sophisticated lighting arrangement may detract from the spontaneity of your picture and tend to make your subject more self-conscious.

## Comparing hard and soft lighting

The portrait right was lit by a spotlight placed at 75° to the camera. This created harsh lighting, reducing the face to two areas, of highlight and sharp-edged shadow. Texture and form are dramatized, but fine detail is obliterated. Two flash units were used to produce a softer, more romantic effect, far right – one diffused source lit the subject from above, the other light was bounced to fill in the shadows.

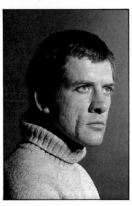
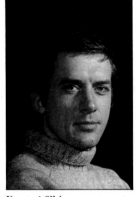

**Hard lighting**        **Soft lighting**

## Using two lights

When using more than one light source, always treat one as the main or "key" light and choose its position and function first. Add a second light for a specific purpose only – to define the background, fill in shadow areas, or add emphasis to one particular feature, such as hair or clothes. The key light is generally used to model the portrait – the nearer it is placed to the subject, the stronger will be the contrast it creates.

The lighting for the pictures, right, is shown below them: For the nearer picture, one source was used to light the subject, from high on the right, giving a strong, three-dimensional effect; the other illuminated the background independently from below, outlining the figure in brilliant blue. The same sidelighting was used for the portrait far right; but, as shown in the diagram, a second lamp was used opposite the first to fill in shadows and create a softer effect.

**Key and background**        **Key and fill-in**

## Common faults with artificial lighting

The overpowering shadow in the picture, right, was caused by rather low side lighting of a subject placed close to the background. Moving the subject further away from the background would have avoided the problem. The greenish cast in the middle picture was caused by bouncing flash off a green ceiling. Red eye, far right, is produced by on-camera flash, used at subject eye-level. Always move flash off camera for portraiture, unless you are using it as a secondary light source to fill in shadows.

**Dominating shadow**        **Color cast**        **Red eye**

# PORTRAITS—MOOD & SETTING

To be a good portrait photographer, you must develop an awareness of individual mood and character, and an eye for characteristic expression or pose. Different types of people demand different photographic treatment. Here we look at four of the most commonly used portrait styles.

A romantic approach is often used for women and children, or for subjects whose appearance you want to enhance—soft lighting, delicate or high key colors, slightly softened focus, a complimentary viewpoint, and a harmonious supportive background all help to flatter your subject. A dramatic treatment on the other hand, with harsher lighting and stronger, or low key colors, is more appropriate to extrovert or theatrical personalities, and subjects with craggy, angular features.

With a romantic or dramatic approach, the background can be plain; but in formal and informal portraiture, setting is of paramount importance. Formal portraiture implies a careful study and preparation of your subject, posing the sitter within a contrived or familiar environment, and perhaps deliberately using props and color to support the statement of the picture. Informal portraiture demands that you work fast and unobtrusively, in order to capture your subject at an unguarded but characteristic moment.

### Romantic and dramatic portraiture *right and below*

For a romantic portrait, the lighting must be soft or diffused so that contrast is reduced, shadows are soft-edged and colors harmonious. The photographer placed his subject in the soft directional light of a window for the portrait right, and used a haze filter over the lens to soften form and detail.

Shape and texture are often exaggerated in dramatic portraits, by using strong directional light from above, below or one side. The man's rugged face in the photograph below is dramatized by a low spotlight from underneath, giving strong modeling and extreme tonal contrast.

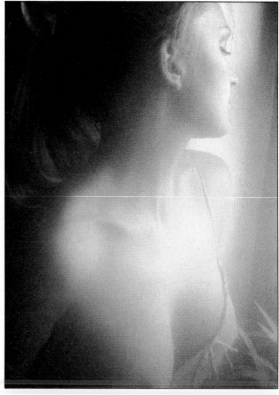

**To take the picture** *right*
- 📷 reflex or viewfinder
- ○ haze
- ☼ daylight through window

**To take the picture** *below*
- 📷 reflex
- ▯ medium long
- ☼ spotlight
- ◉ expose for highlights

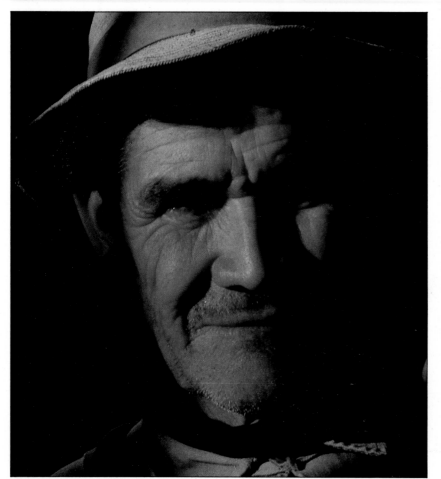

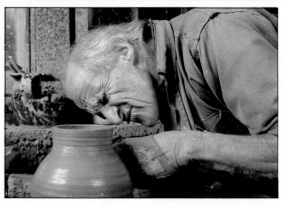

### Creating an informal portrait *above*

For an informal portrait, use any viewpoint that allows you to get close to your subject without intruding—avoid a head-on view which results in stiffer, more formal photographs. You will find it easier to create a relaxed, spontaneous mood if you shoot when your subject is involved in some activity, in his own environment. Tight framing in the picture above emphasizes the concentration and absorption on the potter's face and helps to relate him to his craft.

### Creating a formal portrait *right*

A formal portrait should convey a subject's innate character by concentrating on the pose, expression and surroundings most typical of him. The background can add much information about a sitter and should therefore be well-defined, possibly lit separately. In the portrait right, the head-on viewpoint and classical 45° lighting contribute to the stylized conventional nature of the shot. The formality is relieved by the subject's relaxed pose and expression.

**To take the picture** *above*
- 📷 reflex
- ▯ medium long
- ☼ electronic flash, bounced

**To take the picture** *right*
- 📷 reflex or viewfinder
- ▯ wide-angle
- ☼ daylight, 64 ASA uprated 1 stop
- ◉ full aperture, very slow shutter; tripod

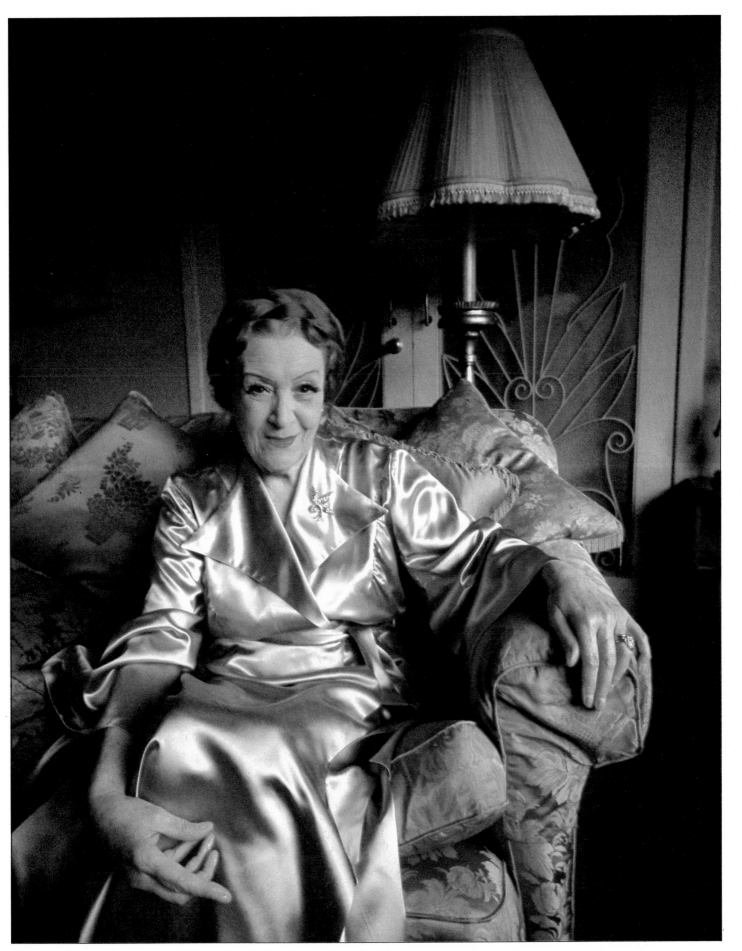

# CHILDREN - THE NATURAL SUBJECT

Young children are willing, active subjects and their rapidly changing, expressive moods provide very good material for the photographer. Few children under the age of six are inhibited by a camera. In fact its very novelty can sometimes arouse the response that makes a lively shot.

But because children are so volatile and unpredictable, they can be frustrating subjects. Some of your best opportunities may pass very quickly, so you must be prepared to work fast. Set the exposure in advance (with a fast shutter to freeze any movement), and prefocus. Even then, much depends on luck. So be generous with film, taking several exposures to allow for the unexpected.

Adult surroundings dwarf a small child, and high viewpoints emphasize this effect, as well as distorting head and body proportions. With toddlers and babies in particular, it is important to bring the camera down to the child's own level, and frame your picture tightly to exclude any out-of-scale elements.

A child's world is one of imagination and adventure – children are natural actors, and live out many different roles. To capture this world, photograph them in their own play areas, where their games absorb their attention, and their toys and dressing-up provide ready-made props and color for your pictures.

### Capturing mood
The open expression of wonder and interest on the child's face, right, illustrates well what rewarding subjects children can be. The child looks out on the world from behind a sheltering fence that serves as a frame. Notice how the long lens isolates the subject.

**To take the picture**
- reflex
- long
- full aperture, fast shutter

### Photographing a growing child

A camera gives you the unique opportunity to make a permanent record of a child's changing personality and experience over the years. At each stage, you can capture their characteristic expressions, whether delighted, curious, or angry. The pictures right show how effective such a record can be, portraying one child from birth to three years.

For several years, you will be dealing with a subject who is completely unaware of the camera. This gives you plenty of freedom to select your viewpoint and wait for strong pictures, but when the moment comes you must be ready to shoot quickly.

Viewpoint and framing are very important when taking small children. All these pictures were taken from fairly low viewpoints, to prevent any distortion of scale, and emphasize the child's eye view of the world. The baby was photographed by daylight through a window; the other ages were all shot by daylight outdoors. All the pictures were taken with a normal lens.

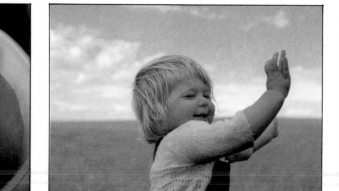

### Children and camera

A child's response to a camera is very different from an adult's. Up until about six years old most children will not be conscious of the camera. After that age children can easily be encouraged to respond in an uninhibited way to the camera, and even dress up or pose for a humorous shot.

It is very much easier to take unobserved pictures of children than of adults, particularly if you use some activity to absorb their attention. If they do notice you, try to distract them.

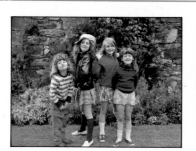

**Reacting to the camera**
Children will eagerly respond to directions. These girls were first posed together, then asked to "make funny faces" for the photograph. They reacted with obvious enthusiasm.

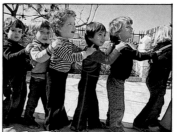

**Involved in play**
A group of children absorbed in play will frequently provide expressive unself-conscious subjects for action pictures, as shown by these children enjoying a school break period.

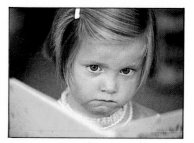

**Unaware of the camera**
A long focus lens has caught the total absorption of this child in her book. Note how the shallow depth of field concentrates interest on the child's face while the book provides a natural frame.

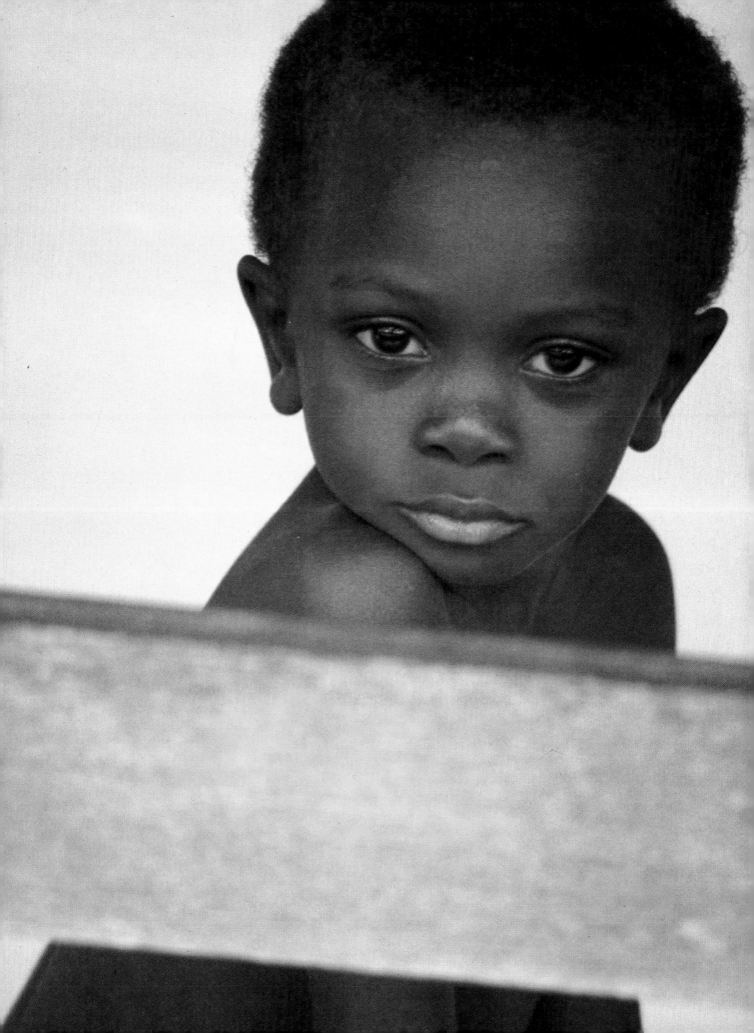

# GROUPS & CROWDS

Gatherings of people can be formal or informal, random or planned, and you should choose your approach accordingly. With posed group photographs taken to record an occasion, your main consideration is to show each face clearly. For less formal gatherings and large crowds, timing and atmosphere may be more important.

You should approach the arrangement of formal groups with as much care and attention to composition, color and lighting as you would use for a still life. Arrange the group so that each face is clearly visible, well lit, and in sharp focus. Place taller people at the back, or sitting, so that heads are at different levels, forming an attractive repeating pattern. Build the group into a simple overall shape which fits the frame compactly, and avoid distracting backgrounds.

Choose your lighting to avoid ugly shadows or people squinting at the camera, and take several shots to be sure of good facial expressions. Try varying your viewpoint and lens too – close framing for impact; a high shot to alter the composition; a wide-angle lens for a large group.

Even for informal pictures, you will have to arrange the group a little, if only to make sure that no one is obscured by deep shadow or another person. You can use props or settings to provide interest and informal structures, as shown below left.

For large groups and crowds where you cannot arrange your subjects, viewpoint, lens and timing are all-important. Look for natural patterns formed by common activities, and for details of color and setting that convey the atmosphere. Large crowds almost inevitably require a high viewpoint.

### Posed family group

Families are perhaps the commonest subjects of group pictures. Even when they are very carefully arranged, as in the picture below, it is still possible for the subjects to look natural and at ease. In this picture the composition has been kept simple so that the family forms a close unit that comfortably fills most of the frame. Notice how the soft, reflected daylight gently models the faces, and reveals subtle colors and textures.

**To take the picture** *below*
- reflex or rangefinder
- medium long
- reflected light

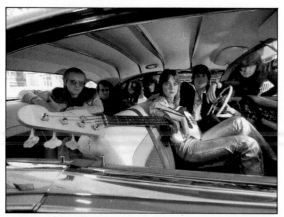

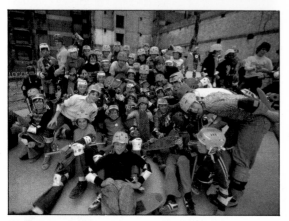

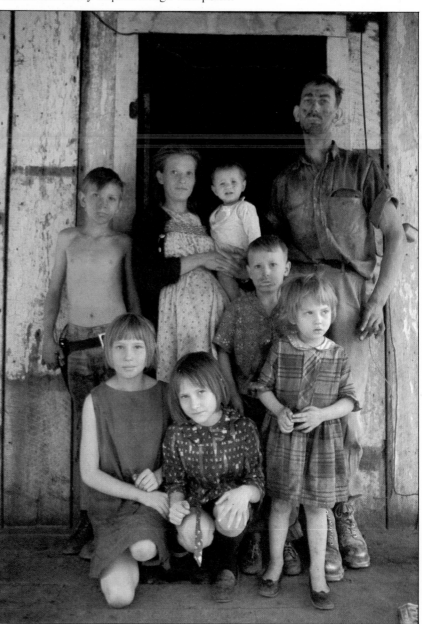

### Using props

The two pictures above show how including relevant objects as props will give a picture natural structure and interest.

In the top picture, the car interior provides an additional frame for the pop group, and the guitar emphasizes their common interest.

In the lower picture, tight framing with a wide-angle lens has produced a powerful composition. The skateboards and helmets give the cheerful, informal group color and interest.

**To take the picture** *top*
- reflex or rangefinder
- medium wide-angle
- reflected daylight
- read from close up

**To take the picture** *above*
- reflex
- extreme wide-angle
- medium aperture, fast shutter

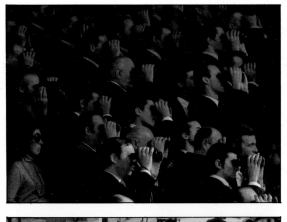

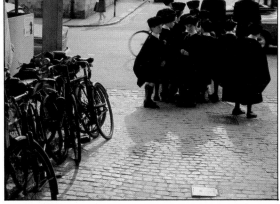

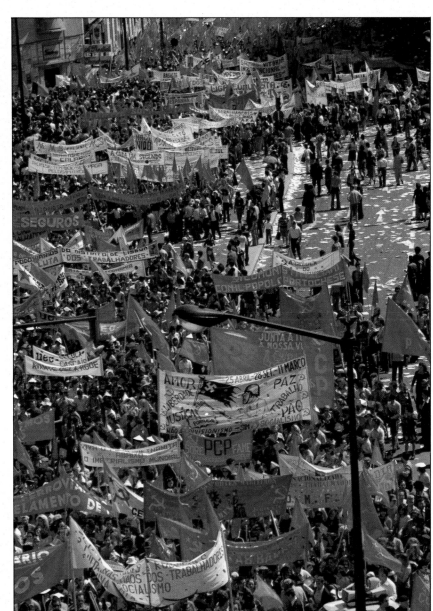

## Natural groupings

By selecting the right view-point and lens you can often bring out the natural patterns that are present even in large crowds, as in the picture of a demonstration parade, right.

The top picture, above, shows a finely observed moment of pattern and rhythm in a crowd of spectators, picked out by a long lens. The picture immediately above has caught the conjunction of the compact group with the intricate pattern of the bicycles.

**To take the picture** *top*
- reflex
- very long
- TTL

**To take the picture** *above*
- reflex or rangefinder
- medium wide-angle
- medium aperture, fast shutter

**To take the picture** *right*
- reflex
- very long
- TTL

## Moods with flash

You can create quite different moods to suit indoor groups by the way you use flash. For the small informal group, right, a single diffused electronic flash gave sufficient illumination, placed to create a soft modeling light. Full detail in the faces was less important than a romantic, intimate mood and overall color effect.

For the bizarre, theatrical shot, far right, two powerful flashes were used above the camera, with a wide-angle lens. The hard light gives sharp detail and plenty of reflections.

**Small informal group** A single diffused flash, low down at almost 90° to the camera, gives a soft light, and intimate mood.

**Large dramatic group** Direct overhead flash gives a harsh effect, here emphasized by mixed temperature lighting.

# STILL LIFE - LIGHT, COLOR & THEME

Setting up a still life requires patience and attention to detail. Selecting the objects and lighting is much easier if you decide on a theme beforehand. It can be a specific idea, such as the arrangement at the top of the opposite page, or a more abstract theme, such as growth, decay or harmony. Choose your objects carefully, considering how they relate to the theme and to each other in color, size, and shape.

You will almost certainly need a tripod to take still life. Depth of field is much shallower when working very close-up (see p. 87) so you will have to use the small apertures on the lens, and consequently a slower shutter speed, and your focusing must be very accurate. To get a fine detailed result you should also use a slow film. A 50 mm macro lens or a zoom lens with a close up facility is particularly useful for close focusing.

A neutral, plain-toned background is generally the best choice. But used carefully, a strong colored or patterned or textured background can enhance your composition without overpowering it.

Once you have chosen your camera position—it need not be a head-on angle—you should arrange your objects, introducing one at a time, constantly checking the effect each has on the composition in the camera viewfinder. The series of four pictures at the bottom of the page show the progressive composition of a finished still life.

This process of checking the viewfinder image is just as essential when it comes to choosing the lighting. Not only will the lighting affect depth, color and form but it will also create an atmosphere or mood. The reflective surfaces and delicate colors in the still life of glass objects, right, highlight the effects of using very different lighting positions. All three pictures were lit by a single electronic flash source, diffused through translucent plastic to reduce reflections.

Use one light as your main light source, considering the variety of effects you can achieve (see pp. 104–5). Only introduce a second source as subsidiary lighting—to bring out the background and reduce shadows or to accent a mood. When using two lights, always watch for double shadows forming; they will overlap and confuse your image and make it seem less realistic.

## Lighting glass

**Top lighting**
With top lighting, bright reflections are reduced. Top surfaces are highlit and some shadows formed – the tonal variation brings out form.

**Background lighting, plus side black cards**
Shapes stand out strongly against the bright background. Opaque objects are silhouetted, colors are richer, surface reflections have been eliminated.

**Lit from below, plus white card**
Highlights define surface shapes and textures, creating form. Colors are desaturated, shadows eliminated. The darker background stands out against the brightly lit base.

## Setting up a still life

Simplicity is the key to a strong still life. Choose your background carefully and make sure it fills your picture frame. Build up your still life gradually, considering the relationships between the objects and the frame. Do not clutter your arrangement with too many objects or competing colors or complicate the lighting unnecessarily.

The sequence of pictures, right, shows the gradual creation of a finished still life. A diffused electronic flash toplit all three pictures.

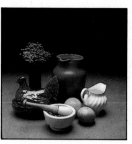

**1** The objects fit comfortably into the frame, but the arrangement lacks unity and lateral lines dominate.

**2** Shapes are more separated but are competing with each other – several of the objects are too similar in height.

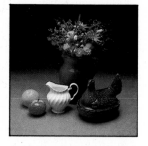

**3** A triangular composition is evolving, but shapes are still too loosely related. The flowers relieve the top of the jug.

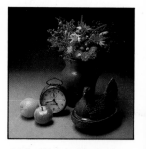

**4** The glaring white jug has been removed and the foreground has been given added depth by the changed angle of the chicken.

## Choosing a theme

If you have a specific subject or theme for your still life it is much easier to select and then arrange your objects. You will have a clearer idea which elements to emphasize and what mood the image should convey. The still life of old cameras and photographs, right, has an obvious unity created by the common associations of its components. Arrangements of shapes and colors are used to support the theme – the subdued harmonious colors, for example, strengthen the nostalgic mood of the image.

The main lighting was given by an electronic flash diffused through a plastic screen to the right of the subject. On the opposite side, a bounced flash reduced deep shadows and brought out detail to the left of the subject.

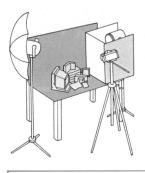

## Found still life

Conjunctions of objects around the house or outside can often make good still-life subjects. You should look for the same qualities – interesting combinations of shapes, colors, textures and so on – that are important in a good studio still life. The shop door, near right top, is a strong linear and graphic image, whereas bright colors and textures predominate in the still life, far right.

Because you are picking out a particular detail or group of objects from their surroundings, framing is very important. The two apples, near right, and the teapot, bottom far right, show how casual arrangements of mundane objects can, with careful framing, create strong still life subjects.

The bizarre or surprising is often evident in found still-life photographs, giving them a sense of life that studio compositions sometimes lack.

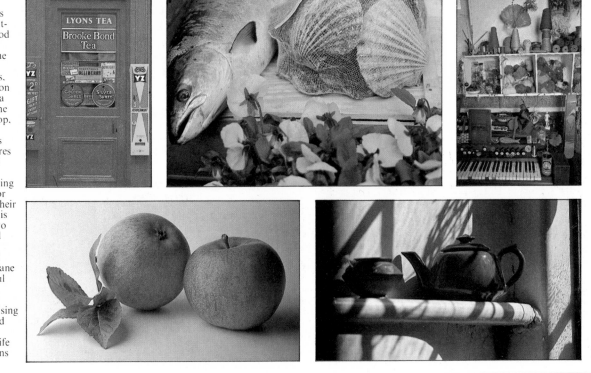

# ACTION-FREEZING MOTION

A still photograph can convey the excitement of action in many ways. You can freeze motion, as shown here, using fast shutter speeds or flash (and fast film). Or you can produce a subjective impression of action by blurring subject or background, or using special techniques, as shown on the following pages.

Freezing the motion may be the best choice when you want to record the particular quality of a type of action–the movements of a dancer or athlete, the expression of a runner near the winning post. The camera can freeze a moment that passes too quickly for the eye to register. But to capture the exact moment that best expresses the drama and effort of the action requires careful planning.

*Viewpoint, timing and focus*

The most convincing moment is often when there is a crisis in the action–the start or finish of a race, the climax of a leap or dive. For such shots you must anticipate where and when the crucial moment will occur, and select the appropriate viewpoint and lens. Preset the exposure, and focus on the zone where the action will enter your frame. Using a small aperture or a wide-angle lens will give you depth of field to allow margin for error.

The subject often presents a fairly complex image–a swimmer obscured by spray for example. So you may have to choose a viewpoint carefully to isolate the subject. Alternatively, you can use shallow focus, perhaps with a long lens–but prefocusing will then require great accuracy.

*Shutter speeds*

The speed required to freeze motion depends on the actual speed of the subject, as shown below, and on its distance and direction relative to the camera. The closer the subject, or the longer your lens, the faster the shutter required. If the subject is moving directly away from or toward the camera, apparent speed is reduced. The same speed of movement across the frame, at 90° to the camera, requires a much faster speed. To minimize shutter speeds, shoot when the subject is head-on, or slowing down at the peak of action–as at the height of an athlete's jump.

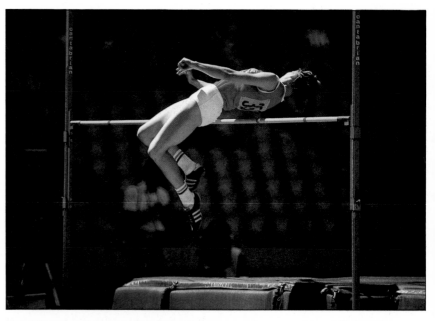

## Using flash to freeze motion

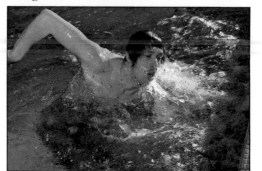

In poor lighting indoors, you can use flash, rather than shutter speed, to freeze action. The speed of movement you can freeze depends on the duration of the flash. Electronic flash gives speeds at least equivalent to 1/250 sec, more likely 1/500 sec. For the shot above, two synchronized flash sources were used–one on camera and one placed beyond the swimmer to light the water. Exposure was read from a flash meter beside the further flash source. See Working with Flash (pp. 102–3).

### The critical moment

Poised between ascent and descent, the highjumper is almost motionless, picked out in brilliant sunlight. Captured with a 600 mm lens at 1/500 sec, this critical moment expresses both grace and tension, leaving the outcome of the jump uncertain.

**To take the picture**
- reflex
- very long, pre-focused
- medium aperture, fast shutter

### Isolating action *right*

A long mirror lens and wide aperture have minimized depth of field in this shot, isolating the leading runner. The photographer pre-focused on a chalk line on the track, and pressed the shutter when the leader ran in to the zone of sharp focus.

**To take the picture**
- reflex
- 500 mm mirror, pre-focused
- fixed aperture, fast shutter

## Shutter speeds to freeze types of motion

**People walking 1/125 sec**
This speed will also freeze everyday human activity and conversation, moving rivers and streams, and trees in light wind.

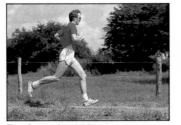

**People running 1/250 sec**
This speed will also freeze running animals, birds in flight, children playing, flying kites, swimmers, and breaking waves

**Car at 30 mph 1/500 sec**
This speed will also freeze a carousel in a fair, cyclists and motorcyclists, and the ball in tennis, football or baseball matches.

**High-speed train 1/1000 sec**
This speed will also freeze skiers and speedboats, aeroplanes taking off, and fast moving automobiles.

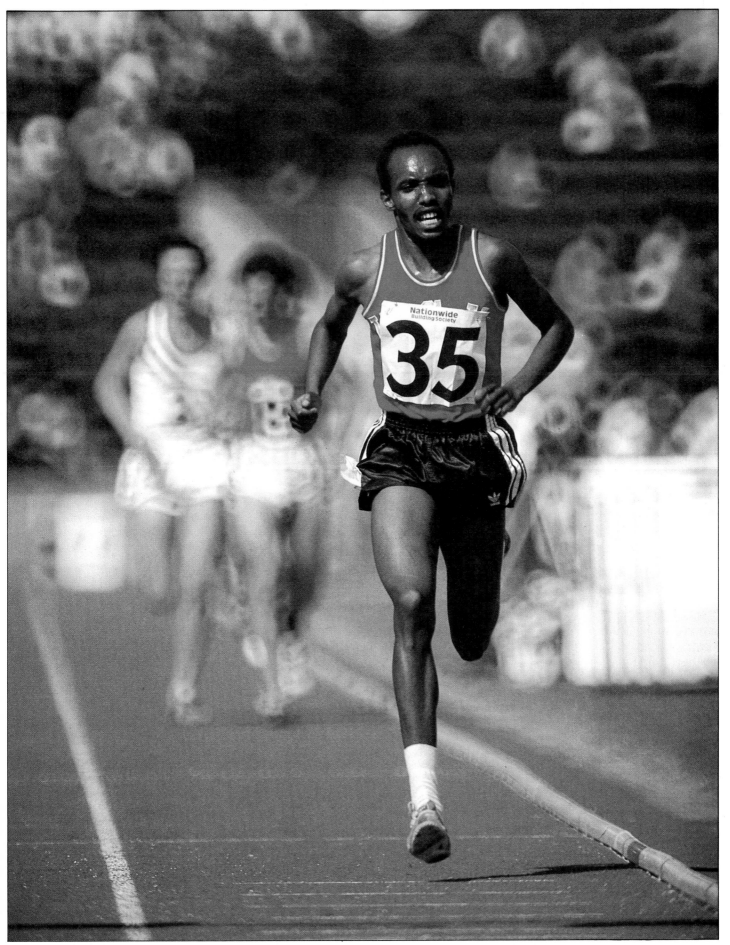

# CONTROLLING BLUR

Some good action pictures depend on a controlled use of blur to suggest movement. You will have to decide for yourself how important image definition is for your subject. Does it matter if details of the image are lost, as in the picture of the Moroccan woman, below, or is it important to keep good detail in the moving subject, as in the race car picture, opposite?

To create and control blur, first consider subject movement in relation to the camera, as shown on the previous page. If you simply use a slower shutter speed than is necessary to "stop" a subject's movement within the frame, the movement will record as blur. The slower the shutter speed, the more the blur, and the greater contrast the blurred sections of movement will make with sharp areas in the photograph. This contrast can be used to isolate a specific static subject if it is surrounded by blurred movement, as in the picture right.

You can deliberately move the camera itself to create blur. If you pan the camera (as shown opposite) in the direction of movement, or shoot from a vehicle moving parallel to a moving subject, you can use a slower shutter speed to render the subject sharp. This will blur the background, giving an effective impression of speed.

Combinations of these techniques give you a whole variety of methods for creating the feel of action. Even deliberate camera shake can be effective as in the tennis shot opposite – blurred subject and background imply speed and effort.

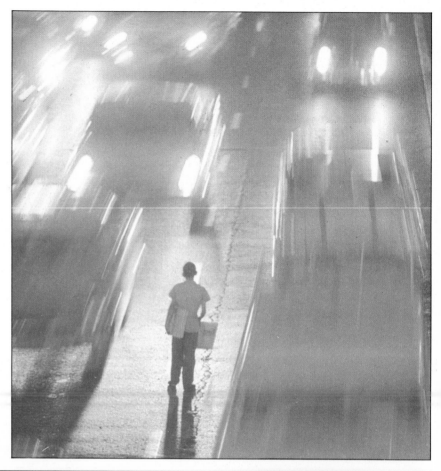

## Blurring background
*above right*
The moving automobiles with their brilliant headlights, in the picture above right, were blurred with a shutter speed of 1/60 sec. They provide a sea of rushing movement that isolates and draws attention to the static figure of the newsboy.

To take the picture
- reflex
- long
- fast daylight
- daylight and automobile lights
- small aperture, slow shutter

## Blurring the subject

The figure in this picture has been deliberately blurred against a sharp, strong color background. The shutter speed of 1/15 sec has only left the rear foot sharp, adding to the contrast between movement and stillness.

To take the picture
- reflex or rangefinder
- medium wide
- slow daylight
- shaded sun
- medium aperture, slow shutter

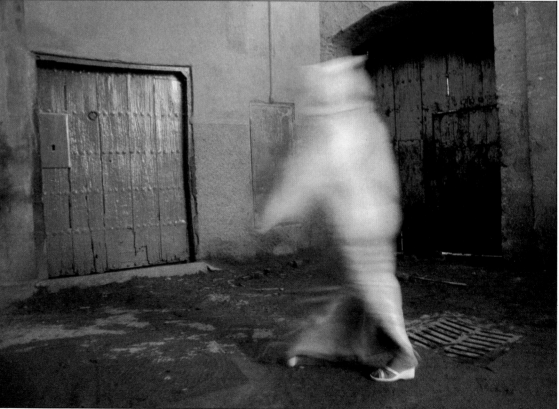

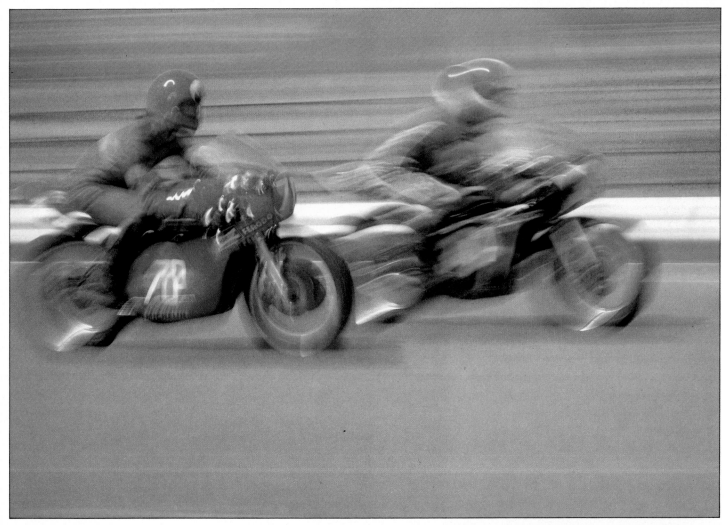

## Panning *below right*

Hold the camera firmly for a horizontal frame shot (see page 82). Pre-focus on the likely path of your subject, then set as small an aperture as shutter speed will allow, to maximize depth of field. Frame your subject as early as you can and use your whole body to swing the camera horizontally, keeping the subject in the frame. Release the shutter as the subject fills the frame, following the movement through. Smooth panning produces shots like the racing car below, where the car has good sharp detail but background blur suggests speed.

**To take the picture** *above*
- reflex
- long
- small aperture, slow shutter from moving vehicle

**To take the picture** *below*
- reflex or rangefinder
- medium long
- small aperture, medium shutter

## Slow shutter and camera movement *above and right*

The picture, above, was taken from a moving car at 1/30 sec. The blurred surroundings, from camera movement, and the blurred motorcycles, from the relatively long exposure and camera shake, give a dramatic sense of action. The speed of a tennis serve has been suggested by jogging the camera during exposure, right.

**To take the picture** *right*
- reflex or rangefinder
- long
- medium aperture, slow shutter with jog

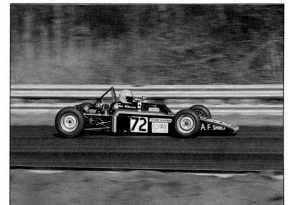

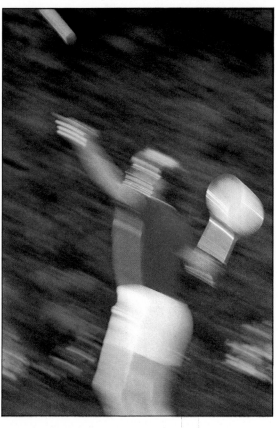

# EXAGGERATING & CREATING MOVEMENT

You can change lens, or use a lens attachment, to give an exaggerated sense of action. Multiple-image prism attachments (see pp. 190–1) fit in front of a standard lens on 35 mm cameras. They split the image, creating an overlapping effect as shown in the motorcycle picture, right. If you use the panning technique shown on page 133 as well as the prism, you can increase the feeling of acceleration and movement still further.

Using a wide-angle lens enlarges detail in the foreground while the rest of the subject diminishes rapidly in size with distance. From close, low viewpoints this exaggerates perspective, making action more dramatic. The wider the lens, the more pronounced these effects are, so for the most spectacular results use a 24 mm lens or wider. If you can get close enough to a moving subject you can even use a fisheye lens (see p. 189) to create an extreme circular image, as shown below.

Zoom lenses (see p. 36) are useful for creating the impression of movement. If you operate the zoom during exposure, blurred streaks of color will radiate from the sharp center of the frame, as in the skateboarding picture, opposite. This picture gives a dynamic effect, even though the subject was posed and stationary. Steady zooming through a slow shutter speed takes practice, but when mastered you can combine it with other techniques. With the camera on a tripod and using a cable release, try panning or tilting the camera while zooming and exposing. This creates both zoom streaks and lateral blur, as shown opposite.

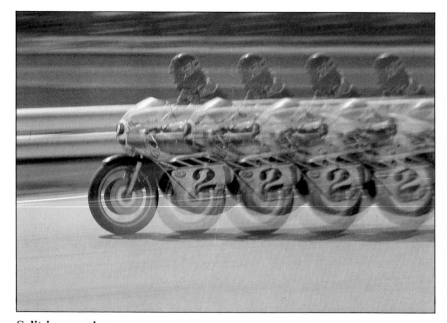

### Split-image prism

When you fit a prism lens attachment, shown right, to your camera your subject will appear repeated and overlapping, as shown in the motorcycle shot, above. This helps you to show fast action while keeping points of sharp detail in the subject. Panning has blurred the background, removing any distracting effect of the multiple image, and further emphasized speed.

**To take the picture**
- reflex
- split-image prism
- small aperture medium shutter, panned

**Prism filters**
These filters may be clear, colored or multifaceted (see pp. 190–1).

### Fisheye lens

For the picture, right, the camera was first set up, with fisheye lens and motor drive (see p. 37), on a small tripod down by the base of the horse jump. The photographer then fired the shutter release by remote control (see p. 189) from a safe vantage point. There is no need to focus a fisheye lens as its very short focal length and small aperture give almost infinite depth of field in your pictures.

**To take the picture**
- reflex, remote control
- fisheye
- fast
- small aperture, fast shutter; tripod

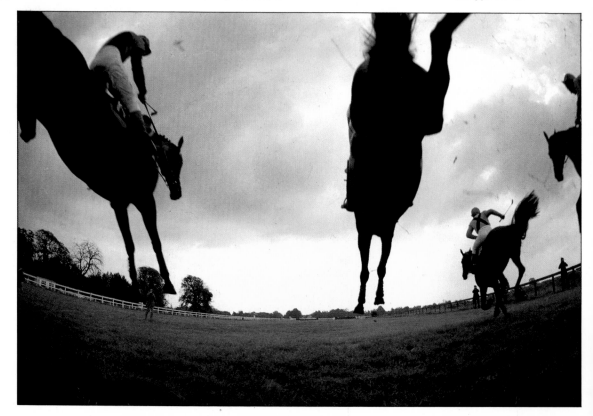

## Using a zoom lens

To simulate movement toward the camera you can use a zoom lens. With the camera on a tripod, focus on a static subject at the lens's longest focal length setting, filling your frame. Set a very slow shutter speed (say 1/15 sec) and as you zoom back to the shortest focal length, fire the shutter. It will take several attempts to find the most effective zooming action.

**To take the picture**
- 📷 reflex
- 🔲 zoom
- ⬚ small aperture, very slow shutter; tripod

## Zoom and pan *below*

If you pan evenly, following the subject, while zooming and firing the shutter, you will get action shots like the one below. You need a tripod and pan head. Control the panning handle and cable release with one hand, and the zoom with the other.

**To take the picture**
- 📷 reflex
- 🔲 zoom
- ⬚ small aperture, slow shutter, panned; tripod

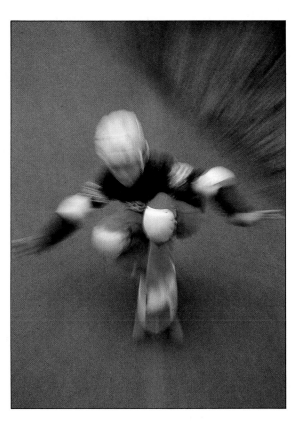

## Zoom and tilt

Zooming combined with tilting the camera can produce dynamic light trail shots from light sources as shown above and right. A long, night time exposure (see p. 136) requires a tripod with a pan and tilt head for close control over the camera movement.

Long exposures of over 5 secs (or sometimes even less) creates reciprocity failure which will distort the color balance in your pictures (see p. 93).

**To take the pictures**
- 📷 reflex
- 🔲 zoom
- ⬚ medium aperture, very slow shutter

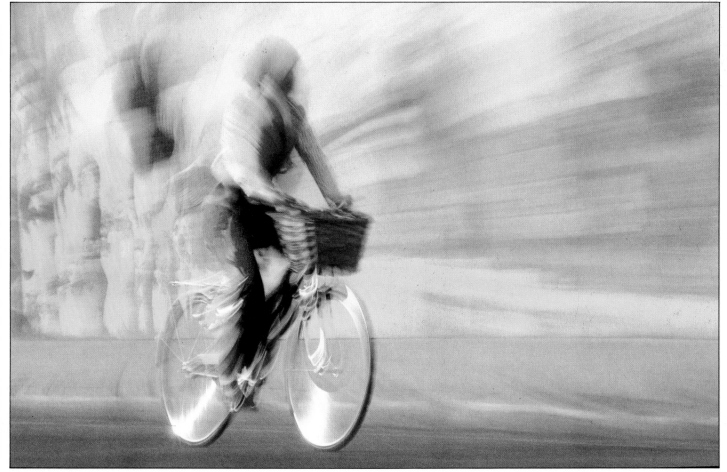

# USING MOVEMENT FOR DESIGN

Colored light sources after dark provide you with many opportunities for extending the techniques you have seen on the previous pages.

Stationary colored lights give you the chance to create abstract designs, like the one below left, by experimenting with slow shutter speeds and various hand-held camera movements. Remember that by moving the camera itself during exposure you will draw points of light into lines of color, mixing and overlapping the colors of the original stationary light sources. Best results come from describing simple arcs and curves with the camera, while visualizing the light path you are creating as you look through the viewfinder.

Moving lights, given even longer exposures, will create trails of color. Mount the camera on a tripod, set a small aperture for good depth of field and leave the shutter open for 20 or 30 seconds. Vehicle lights make fascinating trails if you can find a safe, but exciting viewpoint, as shown opposite. As you can never accurately anticipate the result, good light trail shots are a matter of trial and error – take several shots, at different exposure times.

You can produce interesting designs with many other moving subjects by giving multiple exposures. Results are easier to control in a studio, with a blacked-out background and artificial lighting. A very effective technique is to first light a space for your planned action and, with your camera on a tripod, pre-focus and calculate exposure (see pp. 94–5). Then, making sure the action stays within the viewfinder frame, as with the dancer below, make several exposures on the same frame, varying shutter speed (and aperture) to give both blurred and sharp images. You can use flash to supplement continuous illumination to get harder, more defined images. A fast recycling or stroboscopic flash source used on its own will "chop" movement into several clear, overlapping images, while the shutter remains open.

### Light trails

Night scenes of city streets produce rich and varied color patterns as the film records the movement of lights made by traffic. A small aperture (f11 or f16) is best for sharp definition throughout the scene. This shot of a London street on a winter evening shows a strong blue color cast. Try to avoid bright, static lights in these shots as they will become very overexposed.

**To take the picture** *right*
- 📷 reflex or rangefinder
- 🔲 medium wide
- ☼ daylight, street light and automobile lights
- 🔳 bracketed
- 📷 small aperture, time exposure with tripod

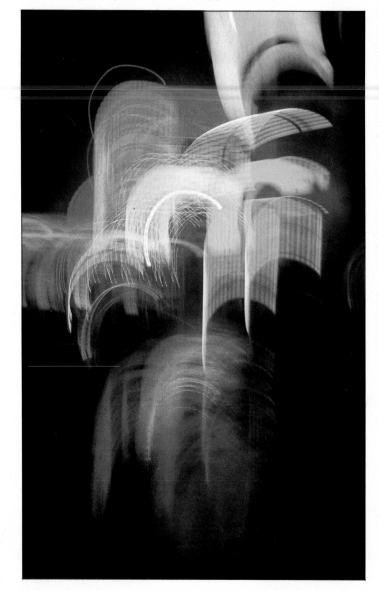

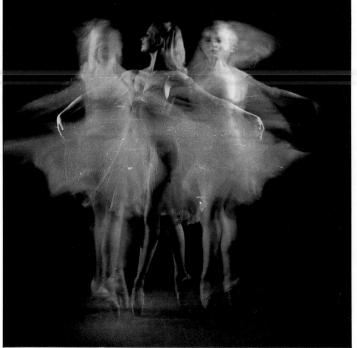

### Creating pattern *left*

The sense of movement and color in the design, left, was made by photographing a cluster of bright colored lights. Shutter speed was set at $\frac{1}{4}$ sec and the photographer deliberately jerked the camera in an upward arc to the right during exposure, taking the lights from top right to low left in the viewfinder.

**To take the picture**
- 📷 reflex or rangefinder
- ☼ night, colored tungsten lights
- 🔳 bracketed ·
- 📷 wide aperture, very slow shutter

### Controlling multiple exposure *above*

A continuous tungsten light source illuminated the dancer, above, as she worked through movements pre-arranged to stay within the limits of the camera frame. Several different exposures were made on the same frame of film to show her at different stages of movement, suggesting pace and rhythm.

**To take the picture**
- 📷 reflex
- ☼ tungsten
- 🔳 highlight reading, bracketing
- 📷 medium aperture, slow shutter

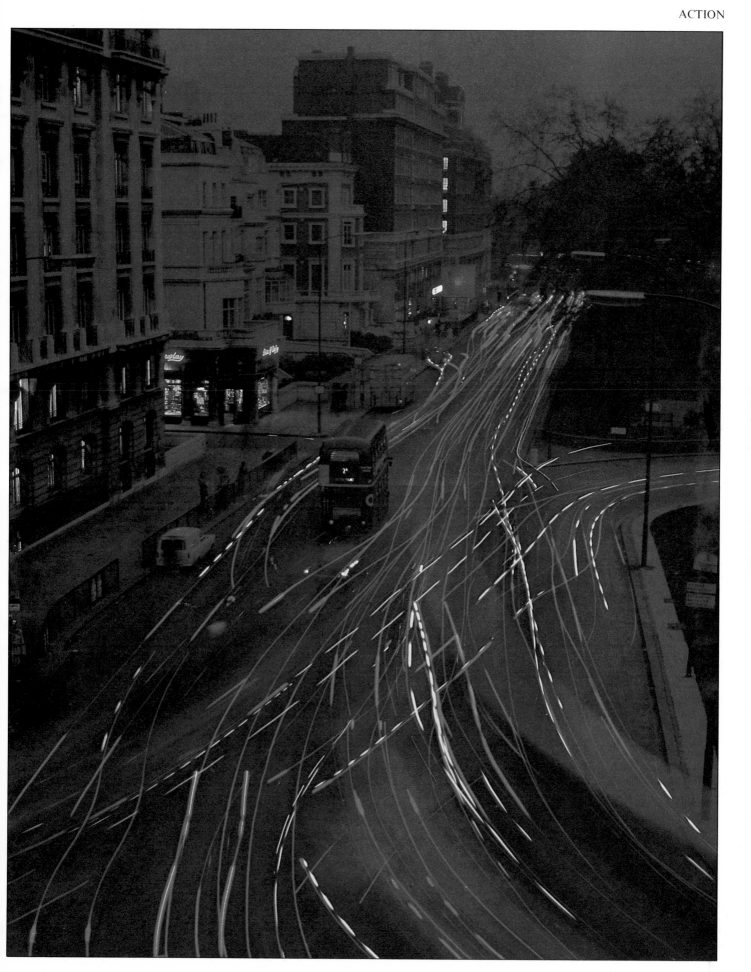

# NATURE - FLOWERS & PLANTS

Most types of plants can be photographed in their natural surroundings by available light. Flowers taken in early morning sunlight, when drops of dew still cling to the petals, have a convincing and realistic appeal. Fairly strong but diffused light is probably best for bringing out the full vibrant color qualities of flowers. Very harsh sunlight can give shadows that destroy the softness and symmetry of a bloom. Move around your subject, changing the fall of shadows so that they have a good modeling effect without being obtrusive. Exposure in diffused lighting is less critical than in bright sunlight, where slight overexposure creates a dramatic loss of color saturation, especially when you are using slide film.

When you can produce good, naturalistic representations of flowers, you can go on to use more unusual lighting conditions, perhaps using flash to supplement daylight (see Working with Flash). You will find that focus is critical and you cannot treat plants as still life – the slightest breeze will set a flower in motion. This means using fairly fast shutter speeds and perhaps a windshield, as shown below, so that you can frame your subject properly. You can get more control still (though less realism) in a studio (see p. 193). The photograph of the dandelion head, below, was taken under studio conditions.

Try to seek out unusual color, pattern and texture in the plant world and you will not be disappointed, as the examples on this page and opposite show. The success of these pictures largely depends on good framing, selective focusing and color contrast. Make sure your framing centers attention on your main subject, and avoid large areas of confusing background that may detract from its prominence. Be careful to avoid competitive background colors that detract from the subject colors, choosing lighting and viewpoint that give a complementary surround. In the picture opposite, top right, the yellow flower is dramatically emphasized by the blue and green of background and foreground. It is often best to blur background altogether when taking pictures of flowers and plants, filling the frame with your subject and using large apertures.

A flower's size will sometimes make it difficult to fill the frame unless you use close-up equipment (see pp. 196–7). A macro lens is useful – its special design allows you to increase the lens-to-film-plane distance sufficiently to get close enough in to most flora. The pink blooms and the dandelion head, below, and the study of moss on bark, opposite, were taken with macro lenses. Alternatively, you can screw on a close-up lens attachment to your standard lens, or use extension tubes or bellows.

**Capturing unusual color**
Prize garden flowers are not the only subject for good plant pictures, as the photographs on the top half of the opposite page show. A mossy tree trunk painted bright green by unusually strong sunshine, or subtle blue toadstool caps can make more interesting subjects than cultivated blooms. Notice how imaginative framing has drawn attention to the lone pink water lily and emphasized the bold purple and white petal design.

**Texture and pattern** *below right*
The pictures on the bottom half of the opposite page show pattern and texture among stems, leaves and moss. Look out for plants that both create pattern with the grouping of their leaves and have designs or texture themselves. Frost often gives the photographer the opportunity to capture texture on leaf patterns. Though diffused lighting gives the best detail for pattern shots, the picture of reeds shows how strong highlights can be used in your designs.

## Choosing complementary lighting

It is especially important to choose the right quality of light for your plant pictures. The diagram, right, shows a typical outdoor set up–notice how the flash and windshield are placed outside the camera view. But you have many lighting options. Below left, careful exposure in bright sunshine has intensified the color contrast between the red and yellow flowers, emphasizing the luminescence of tightly grouped blooms. Conversely, with dull lighting the photographer shows the softness of the pink flowers, below center.

The leaves below right are sunlit from behind, revealing the beauty of their color. Note how overlapping of the leaves progressively darkens the color tone. A dandelion seed head makes a good studio subject, as shown right, since its intricate detail requires special lighting. Here two flash sources were used to give even lighting, leaving the background black.

**Typical outdoor set-up** *above*
For best control outdoors, use a windshield made from stiff cardboard to protect your subject. The windshield here doubles as a fill-in reflector for the supplementary flash.

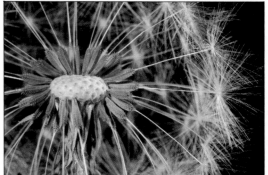

# WILDLIFE OUTDOORS

Most wild animals are photographed in game parks or zoos, where exotic species are in easy reach. It is tempting to photograph everything you see, but the results are often disappointing. In a game reserve you can easily end up with distant rear views of the animals or birds. In zoos, caged animals are more inclined to lie in the shade than run around in strong sun so pictures are often underexposed and obscured by fences.

For better results, use a long lens and move in as close as you can to fill the frame, putting bars and netting out of focus with a wide aperture. Look out for unusual expressions, and interesting animal groupings. Always try to focus on an animal's eyes, as fur especially can appear deceptively sharp on a focusing screen. If you have to shoot into the shade, a tight close-up on an animal head often has strongest impact, so you remove dull background. Alternatively you can use flash (see Working with Flash). If you can get really close to your subjects, consider using a normal lens – or even a wide-angle.

*Animals in their natural habitat*

High quality photographs of undisturbed wild creatures take specialist photographic skill and equipment, extensive knowledge of your subject's haunts and life cycle, ingenuity, and great patience.

Most successful wildlife photography depends on the subject being unaware of your presence. If you are stalking on foot, you will undoubtedly need a telephoto lens with a means of support. Very long lenses (500–1000 mm) give a very narrow depth of field, and this can be used to your advantage to separate your chosen specimen from its surroundings, especially if the subject's camouflaging causes it to blend into the background.

The alternative to stalking is to hide the camera and other equipment close to your subject's predetermined haunt (nest, waterhole, lair, feeding ground, baited area). You then have the option of waiting hidden with the camera for the right shot; firing the shutter from a distance either with a long, bulb shutter release, or by remote control (see p. 189); or using a tripping mechanism that the subject itself sets off.

**Using a tree hide** *above and right*

After days of observation the photographer learned one of the regular flight paths of the kingfisher, above. He set up the hide, right, in tree branches that offered a close view of the passing bird. Three flash heads were linked to the same power pack for illumination. This ensured good modeling of the bird and reduced the overall flash duration by two thirds. In low lighting this duration is critical to freezing motion (see p. 130). It took many attempts to fire the shutter at the right moment.

To take the picture
- ⬛ reflex or rangefinder
- ⬛ medium long
- ⬛ fast
- ⬛ late afternoon shade and flash
- ⬛ for flash; bracketed
- ⬛ wide aperture, x sync.; tripod

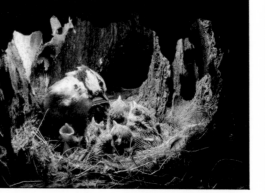

**Nest site pictures** *above*

The photographer was attracted to the hollow tree nest, left, because there were several entrances – not used by the parent bird – that offered clear viewing. He set up flash lighting at one entrance and the camera on a tripod at another, being careful not to disturb the birds. The shutter was fired from a distance with a long release after the parent bird had entered.

The screaming eaglet near its eyrie, right, was caught with a long lens after the photographer had first discovered the site and climbed within shooting distance.

To take the picture *above left*
- ⬛ reflex or rangefinder
- ⬛ fast
- ⬛ flash
- ⬛ for flash
- ⬛ small aperture, x sync.

To take the picture *above right*
- ⬛ reflex
- ⬛ extra long
- ⬛ averaged
- ⬛ wide aperture, fast shutter

**Shooting through enclosure barriers at wide aperture**

When taking pictures of animals, birds and reptiles in zoos, the various barriers that separate you from the specimens pose a photographic problem. Move as close to bars and netting as you can so that, as you focus on your subject, the barrier becomes so out of focus as to be almost invisible, as shown right. To make sure this happens, use a large aperture to limit depth of field. If you have to shoot through glass, avoid smears and distortions.

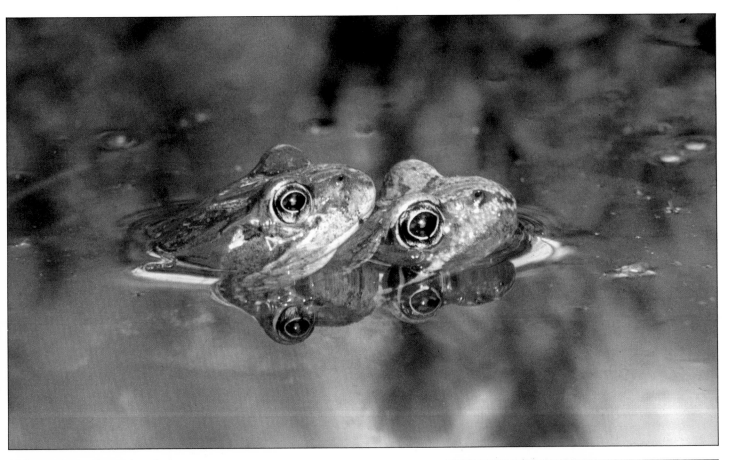

## Using groups, color and setting

The pictures on this page show how the patterns, textures and colors found in pairs and groups of animals in the wild can be used to advantage. The two mating frogs, above, create an unreal duplication. The long lens shot of fallow deer in velvet, right, singles out one head but leaves a criss-crossing pattern of antlers to emphasize their spread and complexity. Local lighting color has matched the hues and texture of the grasses with the lion's manes, below.

**To take the picture** *below*
- reflex
- extra long
- slow
- strong sunlight
- wide aperture, fast shutter

**To take the picture** *above*
- reflex or rangefinder
- medium long
- wide aperture, fast shutter

**To take the picture** *right*
- reflex
- long
- wide aperture, fast shutter

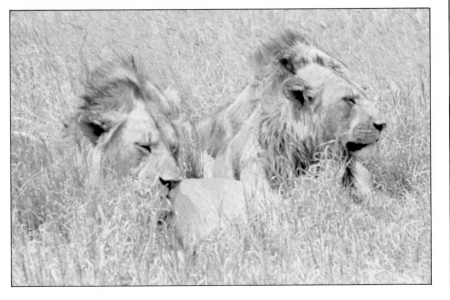

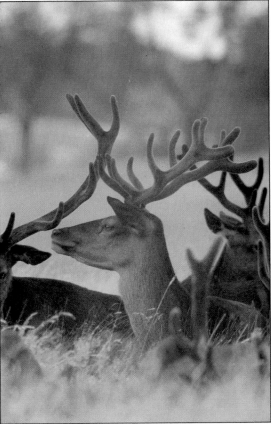

# WILDLIFE IN THE STUDIO

Insects and other small creatures are difficult to photograph in their natural setting, as they are highly mobile, and often camouflaged or dimly lit. Setting up close-up equipment and lighting to improve contrast and detail is often impractical. With patience and skill you may get good shots like the insect, bottom right, with a hand-held camera and macro lens (pp. 194–5). But a more reliable method is to simulate natural settings in the controlled conditions of a studio (p. 193).

Success with studio wildlife work depends on knowing your subject, just as it does outdoors. Creating an accurate, realistic mini-environment takes time and skill. But you can then set up your studio equipment around it and photograph chosen specimens in fine color and detail, as in the red frog

and mayfly pictures below. Aquariums full of brightly colored underwater life provide readily available mini-environments for color photography close up, as shown below.

Using flash only against a dark, unlit studio backdrop will produce a black background. This can help color contrast, as in the frog picture below, where the red/green contrast is strengthened by the area of absolute black. To reveal the intricate detail and subtle hues of translucent wings and bodies, backlighting is more suitable, as in the mayfly picture below right. It is best to use slide film for such detail–if you want prints, best quality will come from a dye-destruction process like Cibachrome (see pp. 178–9). With this process, you can make prints from chosen slides.

## Lighting for detail

Indoors, with artificial lighting, you have the opportunity to arrange the direction and intensity of illumination (see pp. 102–5) to bring out the fine detail of an insect's wing and body structures. Out of the wind, the photographer could take time to arrange backlighting for the mayfly and oakleaves, below. Despite the black background, the artificial lighting does simulate sunlight through the leaves.

**To take the picture**
- reflex
- medium long, with extension
- flash
- for flash
- small aperture, x sync

## Using strong flash

Two electronic flash sources were used to illuminate the red frog on a leaf point, right. Lighting intensity has boldly emphasized the green shape of the leaf against the black background, and created strong highlights on the frog itself, making the red and patches of black and dark blue glisten.

**To take the picture**
- reflex
- standard with extension
- 2 flash heads
- for flash
- small aperture, x sync

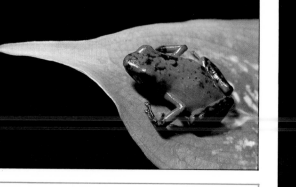

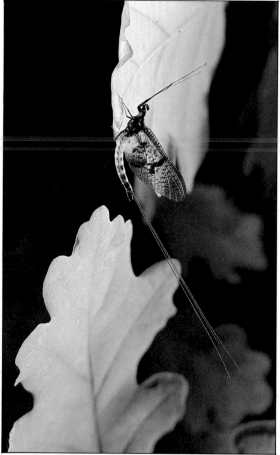

## Photographing aquarium life

If you have access to an interesting home aquarium, you can take pictures of the underwater life using the technique shown in the diagram, below right.

The tank must have flat sides to avoid distorted images. Check glass panels for any flaws that might reduce the quality of your results. Set up the camera on a tripod, as shown, and put a flash source at each side of the tank, angled toward your subject. This will reveal strong color.

To avoid reflections, cut black card to shield the side opposite the camera and to fit over the camera lens as shown.

With a medium wide-angle lens, or using moderate close-up equipment if the fish are small, you can take pictures like the fancy goldfish, right. With more extreme close-up equipment you can take fine detail shots like the open scallop shell, above right. A stationary subject is best for the very limited depth of focus given by close-up attachments.

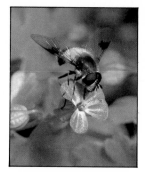

## Daylight for natural color *left*

Outdoors, if you can find a still subject, you can use natural light and backgrounds to produce pictures as good as this shot. Selective focus is useful to isolate subjects from their background.

**To take the picture**
- reflex
- macro
- wide aperture, fast shutter

# UNDERWATER PHOTOGRAPHY

There are various approaches to underwater photography. Small boats are made with glass or plastic observation windows in their hulls which give views of marine life in clear, shallow waters. You can take photographs this way, or even through a glass-bottomed box with which you can carefully wade into the water. You will have to use a polarizing filter or a black card shield behind the camera to remove reflections.

If you are a good swimmer and use a snorkel, there are several flexible waterproof camera housings on the market that allow you to use most 35 mm SLR cameras just below the surface. Here you can use sunlight for your pictures.

Photography at greater depths calls for scuba diving proficiency and elaborate equipment. Some quality camera systems include an underwater housing, or you can buy a specially built camera as shown below, with easy-to-use controls.

In water below 5–6 ft (2–3 m), sunlight is progressively blocked, the red and yellow wavelengths being removed first (see p. 56), causing color casts with any type of color film. You can experiment with color correction filters (see p. 190) to remove unacceptable casts, but it is more effective to carry artificial lighting. Specially protected electronic flash, as shown below, is most convenient and helps to extract the true brilliance of underwater color.

Underwater, images are rapidly degraded with distance, so successful photography depends on getting as close as possible to your subject, using wide-angle lenses or close-up attachments.

## Flash for full color

With depth, light is both reduced and altered in quality as different color wavelengths penetrate deeper than others. To give a sufficient level of illumination for normal exposures, and to retain the full color range, it is best to use flash lighting.

In the picture below, flash was balanced to maintain the blue background and to reveal the reds and pinks of the coral. The same coral, bottom left, and the anemone, bottom right, were taken with different close-up attachments and full flash. This has made the colors bolder still, largely blacking-out backgrounds.

## Equipment for underwater photography

When working below 6–9 ft (2–3 m), you must use hard-cased underwater equipment that is both waterproof and able to stand pressure. It is bulky and heavier than normal, but weight poses no problem underwater. Control knobs and levers are deliberately enlarged.

### An underwater kit

The Nikonos camera and Sea & Sea equipment, right, are made to work to a depth of 165 ft (50 m).

Aperture and focusing controls are on the lens barrel.

The viewfinder (for 28 and 35 mm lenses), **1**, makes framing easier when wearing a face mask. The flash, **2**, gives a 70° angle of lighting, and has a built-in slave unit (see p. 102). On the other side of the camera is a light meter, **3**, on–off and test button, **4**, and film speed control, **5**.

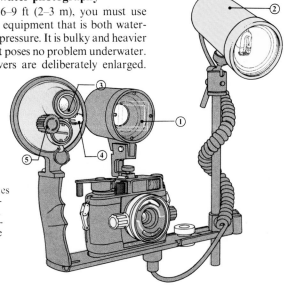

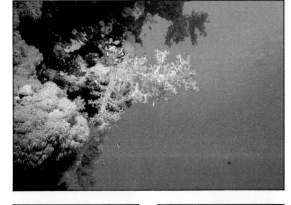

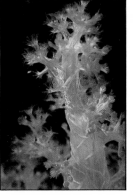

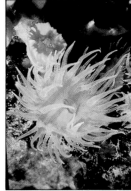

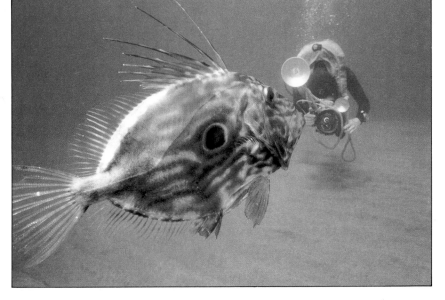

### Moving in close *left*

The fish in the picture, left, appears large because the photographer moved in very close with a 15 mm extreme wide-angle lens. Increased linear perspective and the wide depth of field given by the lens have further exaggerated the size of the fish in comparison with the diver. The strong blue cast shows the way water removes reds and yellows with depth.

**To take the picture** *left*
- underwater reflex
- extreme wide-angle
- daylight, weak flash fill-in

**To take the picture** *top*
- underwater reflex
- medium wide
- daylight and flash
- for fill-in flash

**To take the picture** *above left*
- underwater reflex
- standard; with extension ring
- flash
- for flash

**To take the picture** *above right*
- underwater reflex
- medium long; with close-up lens
- flash
- for flash

# NATURAL ELEMENTS—WEATHER & SKY

There is no such thing as unsuitable weather for photography–often those conditions that seem most hostile and uncomfortable to the photographer, such as rain or snow, produce the most powerful color pictures. The traditional holiday snapshots of blue skies and bright sunlit beaches often look dull and repetitive compared with the dramatic color effects produced by a storm or the muted atmospheric colors created by the diffused light of mist or rain. The sky is so variable in mood that it can become a subject in itself.

Most of the pictures on these pages were taken during unsettled weather conditions–the sunset on the opposite page, below right, was shot during the monsoon in the Bay of Bengal; the storm picture above it was taken in rain in the Gulf of Mexico. (When shooting in moist conditions, remember to dry your lens and keep the camera in its case when you are not using it.)

Bracketing exposure is of crucial importance when photographing under changeable conditions. Try exposing for shadows only, choosing a viewpoint to include a large expanse of shadow, leaving highlights to spread into areas of white. Or expose for highlights only, creating dramatic highlight colors contrasted with dark shadows. Notice how many of the pictures on these pages are composed of highlights and areas of color, balanced by a dark frame or silhouette.

### Exposing for snow

One of the main problems of photographing snow is accurate exposure. Take an incident light reading and over-expose by at least $\frac{1}{2}$ a stop, to get shadow detail. Sunlit snow is best shot in the evening when the sun is low in the sky and shadows are lengthening–oblique lighting brings out its crisp texture, and a reddish sky lessens the blue shadows that usually dominate snow pictures. Using a UV filter, will also help neutralize the blue shadows.

To take the picture
- reflex
- wide-angle
- incident: bracket $\frac{1}{2}$ stop
- medium aperture, fast shutter

### Mist and silhouette

In misty or foggy weather, take an incident light reading, so as to capture color in the mist, leaving midtones and shadows in silhouette as in the picture below. Don't fill your frame with mist–it needs to be offset by dark foreground detail.

To take the picture
- reflex or viewfinder
- medium long
- incident: bracket $\frac{1}{2}$ stop
- medium aperture, fast shutter

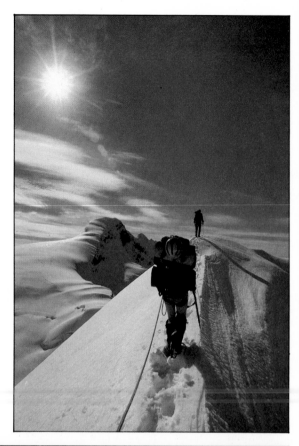

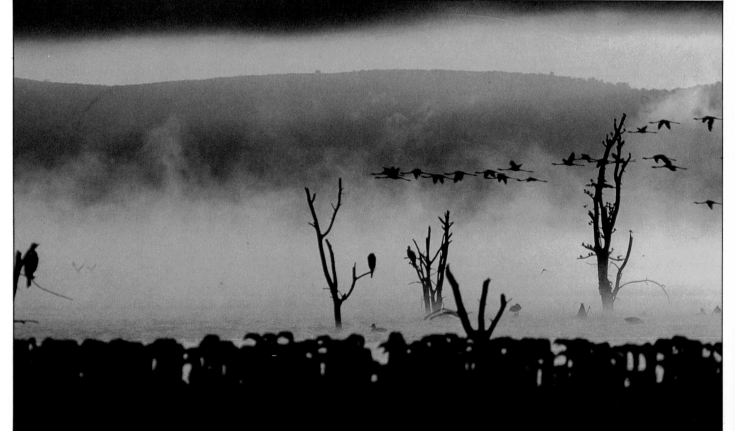

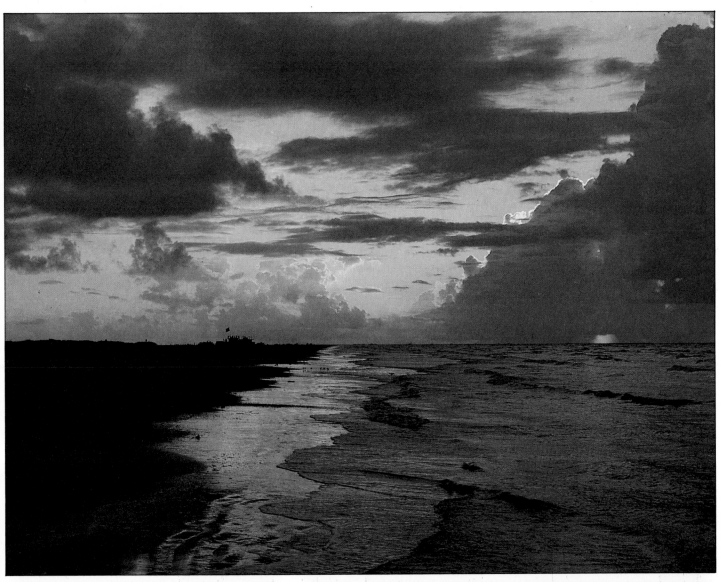

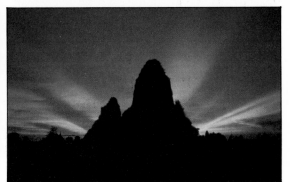

## Dramatic skies

The sky is best photographed during a storm when there is a dramatic build-up of clouds, or an hour before sunset, when there is still a lot of color and the sky is continually changing. To capture the turbulence of a scene, expose for the highlights so that shadow areas remain dark and the clouds stand out from the sky. Use a polarizing filter if you want to darken the blue of the sky or reduce reflections.

**To take the picture** *top*
- reflex or viewfinder
- fast
- bracket 1 stop either side

**To take the picture** *above*
- reflex
- wide-angle
- read for sky

**To take the picture** *right*
- reflex
- wide-angle
- read for clouds

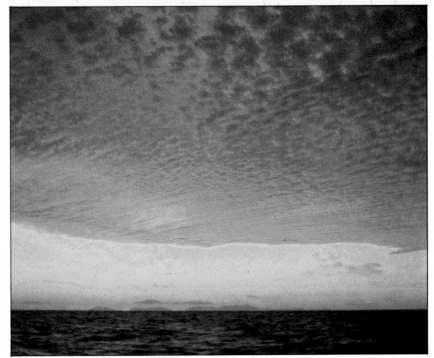

# WATER–MOVEMENT & LIGHT

Water is a sensitive, continually changing subject for the photographer. In motion, it constantly creates new forms, patterns and textures; when still, it mirrors its surroundings. In all its forms, it reflects light, responding readily to the ever-changing moods of weather and sky.

When photographing water–particularly in land- or seascapes with bright surface reflections–you must take care with your exposure reading. Including a large area of pale sky, or specular highlights on the water, may lead you to underexpose darker areas. You can overcome this by taking two readings, from bright and dark areas, and averaging them – or by combining incident and reflected light readings (p. 96) using a hand meter.

Moving water gives you the opportunity to experiment with different shutter speeds. At over 1/250 sec you can freeze almost any movement, capturing the changing forms of drops, streams and breaking waves. Slower speeds produce different blur effects, with long exposures giving dramatic streaks, as shown opposite. Timing the moment of exposure is important. A wave breaking, for ex-

ample, has a peak, and the ripples on a pool, a maximum turbulence. To catch these moments you have to study the movement carefully, and concentrate on releasing your shutter just before the peak.

Broken water–sea rippled by the wind or a still pond broken by raindrops–is best shot against the light. Oblique lighting, particularly if it is low, will highlight the textured surface of the water; with the light behind you, the effect will be calmer.

Brilliant reflections of colors or shapes in water can enliven a picture. A flat expanse of water will be more interesting if you can choose a viewpoint that includes a reflection. Simple shapes are strengthened by being echoed in the clear surface. Alternatively, excluding the subject of the reflection, or waiting for slight surface movement in the water, will produce a more abstract image.

Reflections often record darker than they originally appeared, especially if you are shooting in soft, diffused light. Overexpose by half a stop on slide film, to brighten the colors in your image. A polarizing filter (p. 61) will control reflections, making the surface more transparent, and colors stronger.

### Water in landscape

Water naturally mirrors its environment. It takes on the colors of the sky and surrounding elements. Bright colors, in particular, are readily taken up in reflections, as can be seen by the reflections found at busy harbors or waterfronts.

In the landscape, below, the rhythmic line of the mountains is echoed in the reflection, with the subdued tones enhancing the tranquil mood of the scene.

A powerful impression of the elemental force of moving water has been caught in the waterfall picture below left. The warm glow of the distant sun is picked up on the water.

**To take the picture** *below left*
- reflex
- long
- TTL
- wide aperture, fast shutter

**To take the picture** *below*
- reflex or viewfinder
- medium wide
- read from water

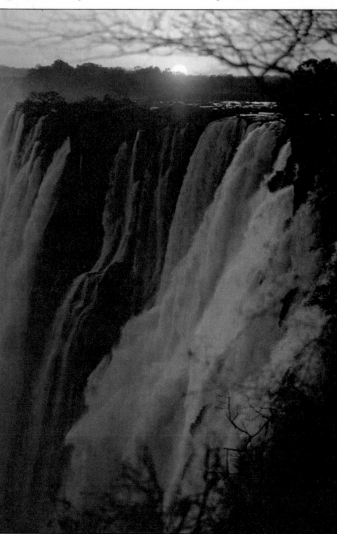

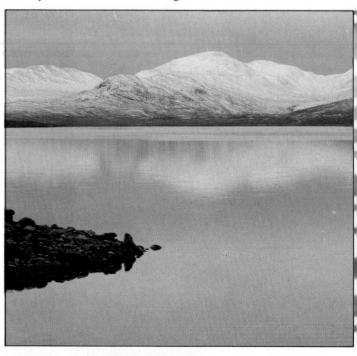

### Water and color

Open expanses of water take on many different colors. You can use them as backgrounds to offset a small isolated subject. In the picture, left, the tiny shape of the sail is emphasized by its dramatic color contrast with the predominant soft blue of the seascape.

**To take the picture** *left*
- reflex
- long
- TTL
- underexpose ½ stop

## Water and movement

Moving water takes an almost limitless variety of forms, and by altering your shutter speed, viewpoint and exposure you can show it in many moods. The waves breaking on rocks, right, were caught by a fast shutter, low viewpoint and good timing. They could look threatening, but shot against the evening light the spray is transformed into a brilliant pattern of delicate shapes.

An exposure of several seconds has blurred the waterfall, below, shot on tungsten film to create a cold, blue scene. The impression of force is increased by the streaks of foam, which stand out against the darker rocks.

**To take the picture** *right*
- reflex or viewfinder
- medium wide
- read from highlights
- wide aperture, fast shutter

**To take the picture** *below*
- reflex or viewfinder
- medium long
- tungsten
- small aperture, time exposure

## Abstract patterns

Gently moving water breaks up bright reflections into changing patterns. For the picture, right, the sun was overhead, and the river bottom is clearly visible. The vertical viewpoint emphasizes the delicate pattern of light playing on the surface ripples.

In the picture, below, strong reflections in a pond have been disturbed by the movement of the ducks. Recognizable elements in the reflection have dissolved into an abstract pattern.

147

# THE SUN

The changing character of sunlight is the single most powerful influence on any scene, especially in terms of mood and atmosphere. But the sun can also be treated as a subject in its own right, as the pictures on these pages show. You will capture it at its best at dawn or just before sunset, when both its color and size are at their most striking and dramatic. Or you can photograph it when it is higher in the sky, as a watery bluish sphere, diffused by haze. A long-focus lens will give you the most dramatic results, enabling you to bring the sun close enough to fill the entire frame. Or, if you have a whole roll of film, try varying viewpoint and framing with a zoom lens, say 80–260 mm.

### Avoiding flare

Flare can be a problem in sun shots. Non-image-forming light is scattered at the surfaces of the lens elements. On reaching the film, this causes either an even haze, or soft light patches around highlights, or iris flare – ghost images of the diaphragm, produced when you shoot with a bright source near or outside the edges of your frame.

Modern lenses are coated to reduce flare (p. 30). Keeping your lens and the internal parts of your camera clean also helps, and you should use a lens hood. To prevent iris flare, keep the sun near the center of the frame, and avoid wide-angle lenses. In some cases, flare may help dramatize sun pictures.

### Exposing for the sun

The sun's very intensity and changeability make it a difficult subject to expose accurately. Don't try to photograph it when it is directly overhead, unless its intensity is weakened by the natural filters of haze or cloud. You can not only hurt your eyes but may also damage your TTL meter, and your image will be spoiled by overexposure. Shoot when the sun is lower in mid-morning or afternoon, using a slow film. You will achieve the most interesting results if you expose for the sun, using the smallest aperture and a very fast shutter speed to create a striking day-into-night effect. Alternatively, use a neutral density filter (see pp. 190–1) to reduce the brightness and allow a wider aperture, or try a starburst filter, as below right.

At dawn or sunset, you can safely use your TTL meter to take a reading. If you expose for the sun, the darker elements in your picture will be reduced to silhouettes – probably the most powerful result. If you expose only for shadow areas, you will lose detail in the sky. It is impossible to obtain detail in both sky and shadows, because of the strong contrast. When light is dim, exposures may be too long to avoid camera shake, unless you use a tripod.

You should bracket exposures at least one stop either side of the recommended reading for all sun pictures, particularly at sunset or sunrise and in stormy weather, when light changes very fast.

### Framing and flare below

The success of your sun pictures will largely depend on viewpoint and framing. At sunrise or sunset, the sun is large enough to dominate your pictures, needing only a range of hills or a sharp silhouette to set it off to its best advantage, as in the picture of the midnight sun in Norway, bottom center. When the sun is low in a glowing sky, it is sometimes more dramatic to photograph its reflection, including a small but recognizable silhouette to give scale and depth, as in the picture below left.

At other times of day, your pictures may lack impact and depth unless you frame the sun with a strong foreground shape, such as a tree, below center. For the photograph below right, a starburst filter was used over the lens to give the effect of the sun beaming down through trees. You can obtain a similar effect by shooting the sun against the hard edge of a building. Or use deliberate iris flare to emphasize its force, as in the picture bottom left.

All the photographs were deliberately underexposed to throw all supporting features into silhouette.

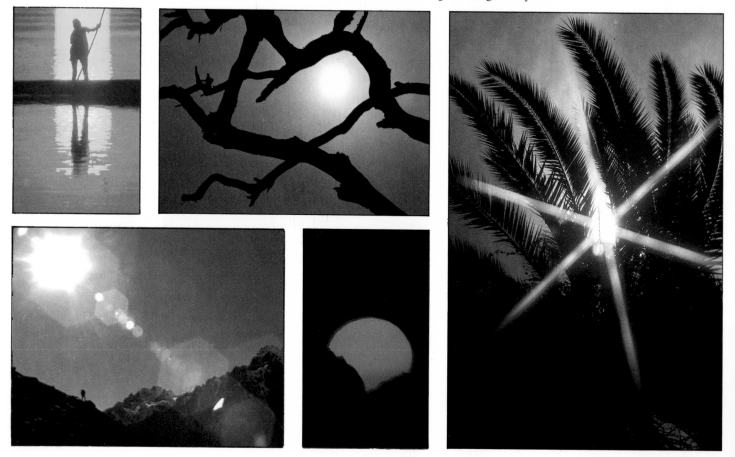

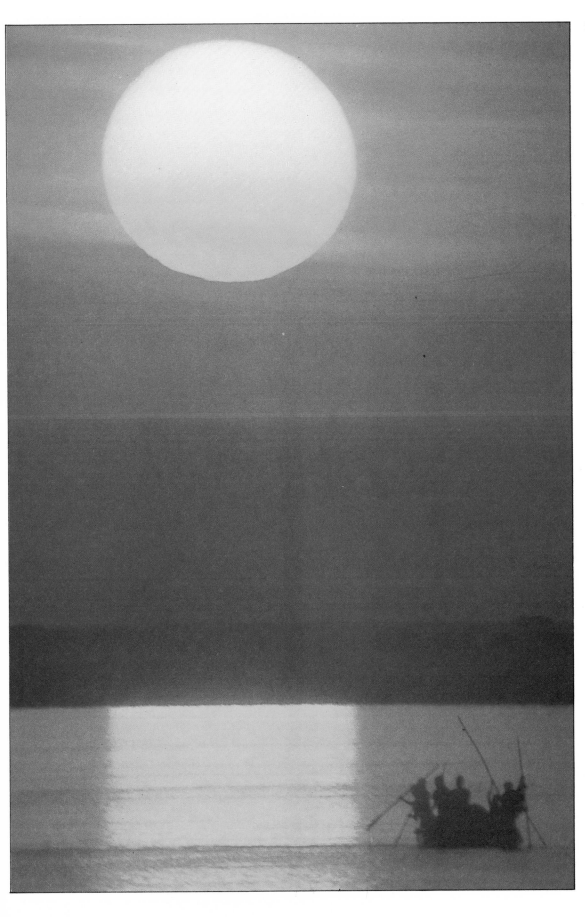

## Lenses for the sun

A long-focus lens is the obvious choice for sun photography, magnifying the sun so that it dominates your whole picture. With a normal lens, the sun will appear no larger than a coin; you will need to include a bold foreground shape to give your shot any impact. A wide-angle lens is useful when you want to encompass a sweeping land- or seascape or a larger area of sky; it is more appropriate for capturing a subject *at* sunset, for example, than for photographing the sun itself.

The picture left was taken at sunset from the banks of the Zambezi River. The photographer used a 1000 mm mirror lens, mounted on a tripod.

**To take the picture**
- reflex
- 1000 mm mirror
- TTL; read for sun
- small aperture, slow shutter, tripod

# NIGHT-USING INCIDENTAL LIGHT

There is a wide choice of subjects for night photography including landscapes by bright moonlight, floodlit buildings, firework displays, bonfires, scenes by candlelight and even the moon and stars. But to achieve good results you must overcome the problems of judging and taking long exposures.

At very low light levels, selenium cell light meters are unreliable. TTL CdS metering can be used for exposures down to the slowest shutter speed on your camera. But a hand-held CdS spot meter (see p. 95) is best, because you can use it to take incident readings from light sources for an averaged exposure (see pp. 92–3). Even so, good night shots most often come from trial and error. The chart, right, gives you estimated exposure combinations for typical night-time subjects. Start with these estimates and bracket exposures so that you are likely to produce an acceptable result.

For very long night-time exposures you must set up the camera on a tripod and connect a cable release to the shutter release button. Set your shutter speed dial to B and make a time exposure as shown on page 93. To focus accurately it may help to place a bright reflector or light at the point of focus, then remove it before taking the shot.

You must expect unpredictable color casts on night shots, as the light you will be working with will often consist of light of more than one color temperature (see pp. 50—1). The new fast films will help you avoid color problems associated with reciprocity failure (see p. 93) caused by excessively long exposures. You can push these fast films one or two stops, and use the enhanced grain appearance to create your own special effects. Use the film that is the most closely linked to the ambient color temperature. For example, if you are shooting by mercury-vapor street lights try daylight films, which will produce greenish results. But when you are including automobile lights in your pictures use tungsten film. If you shoot with color negative stock you can correct local areas of color as you print.

## Exposure guide for color subjects at night

To get accurate exposure readings in very low lighting con ditions you will need expensive CdS metering equipment. It is more practical to use the chart below, which is a guide for 1000 ASA film, and bracket exposure times to get the best result.

| Subject | Time (secs) | f-stop |
| --- | --- | --- |
| Fireworks | Keep shutter open | 32 |
| Neon signs | 1/125 | 8 |
| Street lights | 1/60 | 5.6 |
| Candle light | 1/30 | 2.8 |
| Floodlit buildings | 1/30 | 2.8 |
| Moving traffic | 5 | 32 |
| Lightning | open | 22 |
| Flourescent | 1/60 | 8 |

## Creating atmosphere

A light reading from the children's faces was taken for the shot, left. The torchlight has produced an orange color cast which reinforces the intimate atmosphere. This sort of picture would be ruined by flash.

To capture the atmosphere of a moonlit landscape, above, the photographer chose a 200 mm lens so that the moon sits large in the frame. The wisps of cloud partly covering the face of the moon add to the ultimate mood.

**To take the picture** *above left*
- 📷 reflex or rangefinder
- ☀ daylight
- 🔲 from faces
- 👓 wide aperture, slow shutter

**To take the picture** *above*
- 📷 reflex
- 🔲 long
- ☀ daylight
- 🔲 estimated
- 👓 wide aperture, timed shutter with bracketing

## Firework display *right*

The splendor of a good firework display is a tempting photographic subject. To get good results try to find out when a rapid succession of color will occur. Set up the camera for a time exposure with a lens that covers the expected scope of the display. Simply leave the shutter open for an indefinite period and let the exploding fireworks trace colors across your frame.

**To take the picture**
- 📷 reflex or rangefinder
- 🔲 medium wide
- ☀ daylight
- 🔲 estimated
- 👓 medium aperture, open shutter

## Bracketing exposures

The two pictures of the street scene, right, are separated by two stops. In terms of color and detail, the exposure far right (f5.6, 1/15 sec) gives the more accurate result. Two stops extra exposure (f2.8, 1/15 sec) was given to the picture, near right. This intensified the lights, and produced a slight blue-green cast, making a more evocative image of a busy city at night.

# LANDSCAPE-INTERPRETING SCENERY

Faced with the beauty and grandeur of the natural world, it may seem you have only to press your shutter for a perfect picture. But it is not easy to express the three-dimensional scale and ever-changing mood of landscape. Successful photographs draw on many of the topics in this book – the language of color; the effects of light, weather and season; the elements of form, shape, pattern and texture; use of viewpoint and perspective to convey depth and space; the role of the sky, the sun, and water; and your choice of lens, viewpoint, framing, focus and exposure. These pages show interpretations of different landscapes. The following ones discuss composition, and use of lenses.

Before taking a photograph, study your subject, looking for the elements that make up its essential character and mood. Level plains, for example, offer empty spaces and wide skies; cliffs and mountains show dramatic changes of level and form; woodland can be intricate or bare; hills show rhythm, and man-made landscapes, pattern. Look for the striking color relationships in a scene, too.

Compose your subject, and use camera angle and framing, to express the mood of the scene. You can give landscape strength and emphasis by centering attention on a detail, or one area – a wide-angle lens, for example, can exaggerate foreground, yet still show the full landscape. Most of all, be prepared to wait for the lighting you want.

### Coasts and plains

The pictures right and below show two very different methods of conveying the feel of a landscape. The most striking features of the coastline, right – the imposing cliffs and indented coves – have been captured from the cliff top itself, with a wide-angle lens. The photographer concentrated on one cove, using the strong crescent-shaped shadow in the bay. Extreme depth of field gives detailed foreground, and perspective is exaggerated.

To convey the wide, empty space of an African plain, below, a medium long lens was used to pick out a specific part of the view. The soft colors and carefully balanced shapes of the dirt road, trees, distant hills, and clouds, give the effect of a painting. Distance is compressed, so that the dirt road appears endless.

**To take the picture** *right*
- 📷 reflex
- 🔲 wide
- ☼ low-angled sunlight
- 🔩 small aperture, medium shutter

**To take the picture** *below*
- 📷 reflex or viewfinder
- 🔲 medium long
- 🔩 small aperture, medium shutter

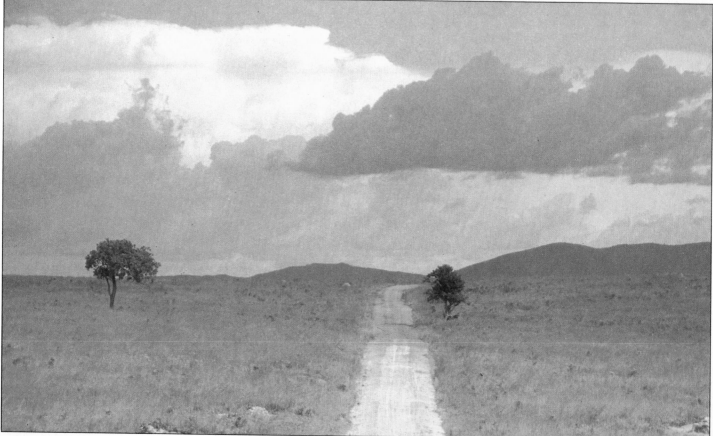

## Prairie and forest

Always look out for unusual weather and lighting conditions that may add to a landscape. After snow on a Kansas plain, right, the sky turned slate-colored with another storm. But lighting remained strong so the snow-capped roofs of the farm buildings made a striking contrast with the storm-heavy sky. Where lighting quality is so unusual it is worth bracketing exposures (see p. 97) so that you are sure of reproducing rare color quality – like the browns of the grasses, wood and trees here.

To convey the atmosphere of a forest in mist, below, the photographer decided to suggest the intricate color and delicacy of the undergrowth by concentrating on one moss-covered tree trunk. A relatively long exposure has made the most of the weak diffused lighting, so that full detail is revealed.

**To take the picture** *right*
- reflex
- long
- wide aperture, slow shutter

**To take the picture** *below*
- reflex or rangefinder
- medium wide
- wide aperture, slow shutter

## Mountain landscape

From experience, the photographer knew that soon after dawn, sunlight brightly illuminated the distant Himalayan peaks, right, while deep shadow still shrouded the foreground mountains. Exposure for highlights only has silhouetted the foreground. The resulting picture accentuates the splendor of mountain ranges.

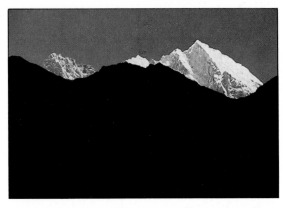

**To take the picture**
- reflex
- long
- dawn or sunset
- highlight
- medium aperture, fast shutter

## Man-made landscapes

Most areas of country now display the marks of man's influence. The path of a new road will carve through hillsides. A hydro-electric dam will stop a river's flow and change valley to lake. Farming creates patterns of fields and boundaries. To record the rhythmic, man-made terraces of the mountain landscape in Nepal, right, the photographer required maximum depth of field. Full detail is clear, from foreground to distant mountain side, so that scale is apparent.

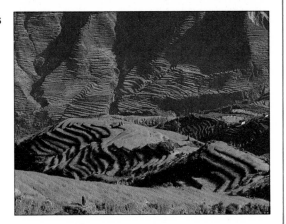

# LANDSCAPE COMPOSITION & SCALE

The impact of your landscape photographs will depend primarily on imaginative composition. Most ineffectual landscapes are cluttered with elements that detract from the significant features. You must be ruthlessly selective, perhaps only using selected details from a scene to suggest the whole.

The position of the horizon in your camera frame can totally change the mood you create. Lowering the camera angle so the horizon is in the top third of your frame, as in the picture right, can give a static effect, with foreground strongly apparent (a wide-angle lens helps to emphasize this). Conversely, adopting a low viewpoint and raising the camera angle, so that the horizon is in the bottom third of the frame, can give a dynamic effect, emphasizing the sky and linear perspective (see p. 108), as shown below right. Controlling the relationship of foreground, midground and sky in this way allows you to emphasize significant details placed at key positions in the frame.

Conveying a sense of scale in your landscapes may help your composition. You can often use the human form to contrast with the size of natural forms around it. Figures will always attract the eye, even when they are very small in the frame. You can use them to create or strengthen a focal point as in the picture at the top of the opposite page, or to balance other elements, as in the picture below it.

Exposure control and focusing techniques can strengthen a composition. Note how extreme depth of field (see pp. 86–7) has been used in the picture, right; whereas shallow depth of field and differential focusing (see pp. 90–1) were used in the small picture, opposite, to contrast the sharp detail and colors of the branch with the shimmering impression of lake and figure. If texture or pattern are the primary features of a landscape, you should wait for lighting conditions that enhance color qualities and give full detail, as shown in the pictures at the foot of the opposite page.

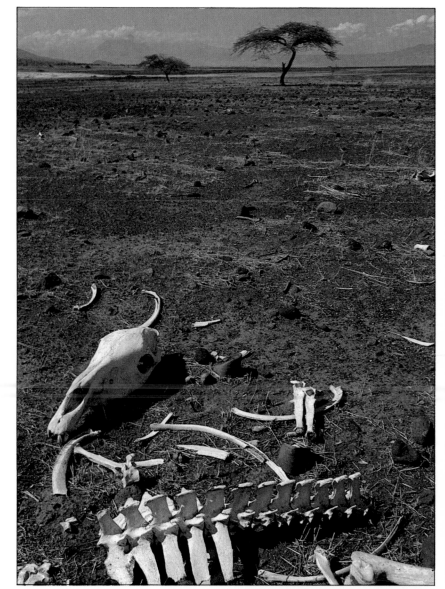

### Strengthening the foreground *above right*

Sun-bleached bones on the floor of an African rift valley epitomize the scorched lifelessness of the terrain. The photographer took up a camera position that featured them boldly in the foreground. Strong lighting allowed a very small aperture, giving great depth of field, so that the mood of the picture is continued into the distance.

The texture of the barren soil stretches away to the two lonely trees and the horizon. The very limited amount of sky directs the eye back, to study the details of the foreground.

**To take the picture**
- 📷 reflex
- 🎞 wide
- ⚙ small aperture, medium shutter

### Using a low horizon *right*

Lighting quality and direction, together with a dramatic cloud formation, encouraged the photographer to move in close and use a low camera angle on this fifteenth-century barn. The horizon is in the lower third of the picture and the sky is a dominant feature. No other distracting elements encroach on the frame. The dynamic effect of the clouds is supported by the exaggerated perspective of the building, and the sunlight that gives harsh shadows and highlights on the walls and the roof.

**To take the picture**
- 📷 reflex
- 🎞 wide
- 💡 highlight
- ⚙ medium aperture, fast shutter

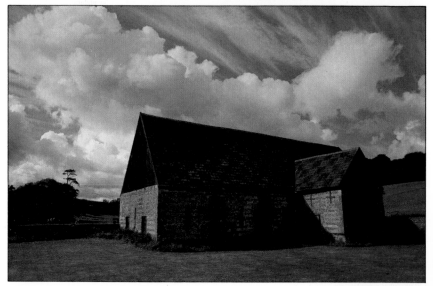

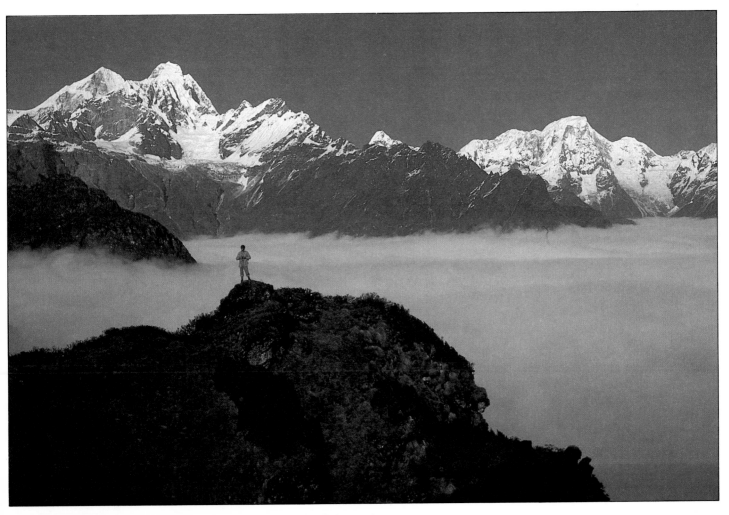

## Implying scale *above and left*

The success of the picture above has much to do with the precise position of the small human figure. Its size suggests scale, emphasizing the magnitude of the surrounding peaks. Its position strengthens the focal point of the picture (at the hub of the composition where background meets foreground), while strengthening the illusion of a "lake" of cloud.

The picture, left, gives an impression of lakeside beauty, although its contents are simple. Its composition depends on balance between the foreground branch and the distant fisherman. As wide an aperture as possible was used to maximize the effects of differential focusing – the branch is sharp, and we can see every subtle color, but the figure and background are impressionistic.

**To take the picture** *left*
- 📷 reflex
- 🔲 long
- 🔄 wide aperture, fast shutter

**To take the picture** *above*
- 📷 reflex or rangefinder
- 🔲 medium long
- ⊙ averaged
- 🔄 small aperture, slow shutter

## Texture in landscape

The two photographs, right, were framed and exposed to use the natural textures of their subjects. The chief feature of the view of a rocky stream, near right, was the combination of textures – on the mossy banks, on the lichen-covered rocks, and on the water. Sun through a leaden sky lent a mysterious glow to the grain stalks, far right. A viewpoint along the stubble lines adds perspective to the texture.

155

# LENSES FOR LANDSCAPE

You will have already seen from the pictures on the previous four pages how choosing a lens of the right focal length will strengthen your compositions, so helping you to reveal the character of a landscape. Sometimes, however, the natural scene particularly lends itself to the use of a more extreme lens (see p. 189), or even a panoramic camera.

Perhaps you are in terrain where the view far ahead is striking, but its various elements are all separated by appreciable distances, along a line from the camera to the horizon. To record the scene effectively, you must use a telephoto lens of 200–300 mm focal length. A lens of this type will make the separate elements of the distant scene appear closer together. So with good, tight framing you can increase the impact of your photograph by bunching all the impressive elements together, as in the picture below.

Where you are faced with an expansive landscape, whose breadth and scale you cannot express with a smaller view, a very wide-angle lens, of 24 mm focal length or less, may give you the angle of view required. Sharp focus from foreground to background (an inherent characteristic of very short focal length lenses, see p. 89) will increase the picture's depth and space, giving you a view of the landscape almost as you saw it. If it is important to record a broad scene in its entirety, you have the option of using a panoramic camera. With this type of camera the fixed lens actually pivots laterally in front of the film plane to increase angle of view in a horizontal plane. The picture of the rainbow, below right, is impressive simply because of the unusual 140° angle of view of the panoramic camera used, which allowed the complete arc of the bow to be included.

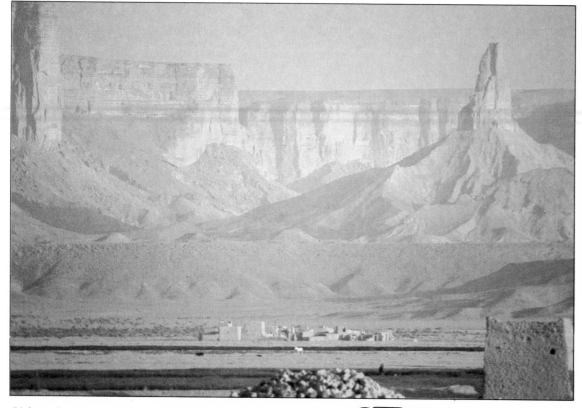

### Using a long lens *above*

The multi-toned background dwarfs the cluster of Arabian buildings, above. The effect has been emphasized by using a 300 mm lens from a distance, to pull all the subject planes together. Shallow depth of field was averted by using a small aperture and focusing on the hyperfocal point (see p. 87).

**To take the picture**
- reflex
- long
- slanting sunlight
- averaged
- small aperture, medium shutter

### Panoramic cameras

The unusual looking 35 mm camera, right, is solely used for panoramic photographs. Its 26 mm, f2.8 lens has fixed focus and it is built to rotate, scanning the subject while the shutter is open. Regular 35 mm film is held in an arc behind the lens path to take the image. You will get 21 panoramic exposures on a 36 exposure reel. As you operate the film wind knob, the lens moves to the extreme left of its arc, and the shutter is cocked. During exposure, the lens swings around to the right, as shown right.

### Scanning a rainbow arc

The unshrouded splendor of a complete rainbow arc is an ideal subject for a panoramic camera because of the wide, flat framing required. Note the bowed horizon, and how it has been used to complement the opposing arc of the rainbow itself. Lines running horizontally, close to the center of photographs made with a panoramic camera, always bend in this way.

**To take the picture**
- panoramic
- highlight
- small aperture, slow shutter, tripod

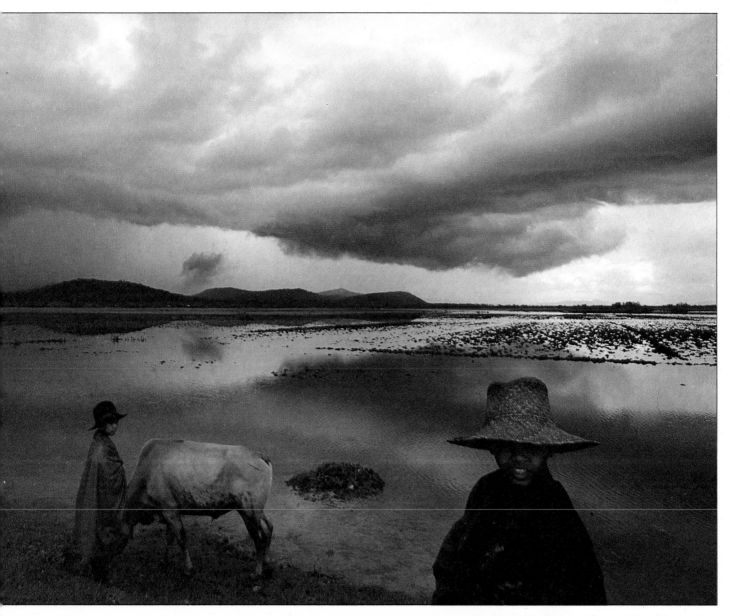

### Scope of a wide-angle lens *above*

The spirit of a landscape often depends on the sense of space and light it gives us. The dramatic feel of boundless space associated with the lake-land area captured above, has been effectively emphasized with a very wide-angle lens. Though the photographer had a very expansive view through the finder, the success of the picture depends on its selective composition. The dynamic lines of sky and land have been carefully framed so they rush to the bisecting horizon, creating strong perspective. The use of backlighting has emphasized the shape of the foreground figures. The reflections about the horizon add to the feel of distance and space.

**To take the picture**
- reflex
- wide
- highlight
- medium aperture, slow shutter

# URBAN LANDSCAPE

In the complex environment of a city, the camera's selective ability is a great asset. The urban landscape offers an endless choice of subjects, but for successful photographs you must simplify, by using viewpoint, camera technique, and the changing effects of light to pick out clear, strong images from the confusion around you. When taking a series of shots, concentrate on expressing the essential flavor of a place – from the bustling canyons of city streets to the sleepy quiet of rural towns. Small details of local color can be as expressive as high panoramas. People are as much a part of cities as buildings, and will give your pictures a sense of scale.

### Selecting images
You can use various techniques to separate subjects from their environment: selective focusing (pp. 90–1), close framing (pp. 60–1), or shooting through a frame (p. 107). To blur out or entirely remove the distracting images of passing people and cars you can use a very long exposure. From a low viewpoint you can outline buildings against the sky; tall buildings allow you to get above the confusion, to take panoramic shots, and exploit the effects of aerial perspective.

City streets present many opportunities to use linear perspective to strengthen composition. Low viewpoints and wide-angle lenses exaggerate the converging lines and emphasize foreground areas, while shooting at street corners creates interesting double perspective (p. 162). Wide-angle lenses are also useful to encompass a scene from across a narrow street. With a long lens, you can pick out distant skylines, or shoot traffic-filled streets head-on, to emphasize their crowded atmosphere.

### Using light
Cities have a wider range of lighting conditions than almost any other subject – from the changing quality of daylight to the different color temperatures of street lighting, neon signs, and automobile lights. Tall buildings in strong light produce abrupt divisions between light and shade. You can use these hard shadows to emphasize geometrical form, especially in modern buildings. But scenes with large areas of deep shadow pose problems of contrast. It is best not to take an average exposure for shadows and highlights – the result will be weak and flat. Either expose for the shadow area and allow highlights to become desaturated; or expose for the highlights, reducing shadows to dark frames, and throwing backlit subjects into silhouette.

Cities often appear at their most uninteresting under midday light. The texture, form and detail of old buildings are enhanced by the oblique light of afternoon or early morning; white or reflective glass and metal walls may look best at sunset or dawn when they pick up color. A panoramic shot can be more atmospheric at dusk; while at night you can create patterns from the lights alone (see pp. 136–7).

### Panoramic city view
When taking a panoramic view, try to convey the atmosphere and color of that particular city by choosing the right time of day. A panoramic view is often more evocative at dusk, when there is a predominant blue cast, as in the picture right. In general, expose for the buildings unless you want to obtain detail in the sky, when you should average your readings. Daylight film used at dusk will give added warmth to the lights in streets and windows.

**To take the picture** *right*
- reflex
- wide-angle
- daylight

### Exposing for contrast
With very tall subjects, you will often find your picture divided by an extreme contrast of light and shade. If you average your exposure readings, both highlights and shadows will be weak and devoid of color. So decide which area you want to expose correctly. In the picture below, exposure was read from the water, throwing the shadow areas into sharp silhouette.

**To take the picture** *below*
- reflex
- long
- read for highlights
- small aperture, medium shutter

### Choosing a viewpoint *left*
When photographing in cities, look for viewpoints that give you the most dramatic effect. From tall buildings, you can photograph the patterns made by streets and rooftops, as in the picture far left. A low viewpoint will make buildings dominate the viewer, as in the picture near left. A wide-angle lens emphasizes the dynamic thrust of tall buildings, making vertical lines converge more steeply. To keep verticals parallel you must use a shift lens (p. 161). At ground level, you can experiment with a variety of camera angles to increase linear perspective, using line to draw the eye into the scene. Low viewpoints create foreground dominance, and an increased sense of space, as in the picture below left.

**To take the picture** *above far left*
- reflex
- medium long

**To take the picture** *above left*
- reflex
- wide-angle
- read for highlights

**To take the picture** *left*
- reflex
- averaged from sky and street

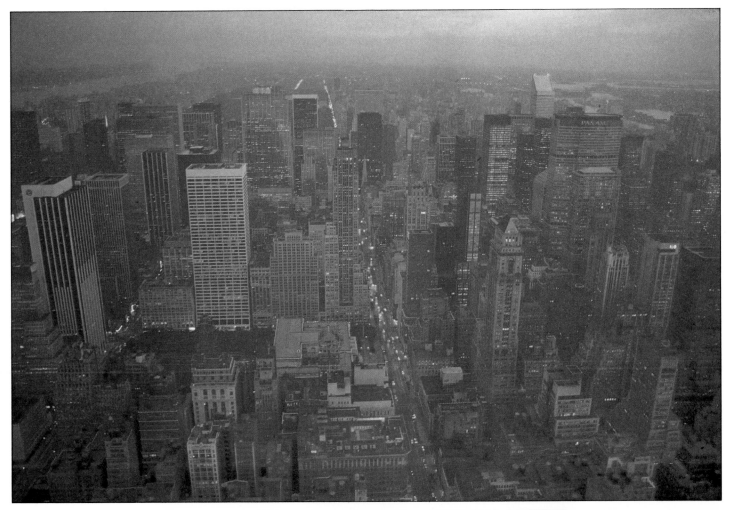

## Urban details *right*

Carefully chosen details can often convey a city's character as effectively as overall views. Signs, store windows, traffic, street stands, characteristic architectural details, even the graffiti on walls, offer a wealth of subjects. Look for unusual color effects, striking designs, patterns or textures, and frame your subject tightly.

*Top row, left to right*
The abstract design of a rear fender, given color and a touch of humor by the drooping tail light, is picked out by selective focus. Soft lighting enhances the harmonious mauve and gray colors of a store front. The red of a closely-framed telephone stand is strongly saturated in bright sunlight.

*Bottom row, left to right*
Neon lights, shot from an unusual angle through a grille, create new patterns and textures. Bright signs and their reflections in a wet street give color to a gray, rainy scene. A long lens turns the front of a truck into a two-dimensional geometric pattern, framing the small figures in the cab.

# INTERIORS–LIGHTING & VIEWPOINT

Interiors range from the ornate magnificence of a cathedral to the simplicity of a firelit room. One of the main problems in shooting them is coping with existing lighting. To capture the atmosphere of an interior lit by weak daylight, you can use a tripod and a long exposure (which may produce reciprocity failure effects, p. 93); or try uprating your film (p. 98). In interiors lit by tungsten lighting only, use tungsten film or correction filters, and avoid adding flash. If the lighting is mixed, match your film to the dominant source.

Excessive lighting contrast is common indoors. You may have to choose whether to expose for highlight or shadow detail, or use supplementary lighting, to fill shadowy areas. Keep added lighting as soft and indirect as possible, to retain the effect of existing light. In daylit interiors, use bounced or diffused flash, off the camera. Take care no extra light spills on brightly lit parts, and watch for color casts from walls used to bounce the flash.

Your viewpoint can convey the special character of an interior, and also control space and perspective. To prevent small rooms looking crowded, keep the foreground clear, or shoot from above. Make sure the floor appears level – sloping floors give a feeling of instability. For tall, extensive interiors, a large format camera with a range of camera movements (p. 192) is useful. For similar controls on a 35 mm camera, use a shift lens – or the shift, swing and tilt lens shown opposite.

### Supplementing daylight
*above right*

In this picture, flash has been added to a largely daylit interior, to fill in detail in the dark corners yet give a natural effect. A wide-angle lens has given sharp definition throughout, and accentuated the perspective lines of the floor.

**To take the picture**
- 2¼ ins² reflex
- wide
- daylight
- electronic flash, daylight
- read for daylight and flash fill
- medium aperture, slow shutter; tripod

### Capturing mood by uprating your film

For this interior scene, the photographer was more interested in capturing mood than in recording detail. Flash would have been intrusive, and changed the shafts of light flooding through the windows. And a time exposure would have blurred the moving figures. So he uprated the film, for a hand-held exposure, creating an evocative, grainy shot.

**To take the picture**
- reflex or viewfinder
- fast daylight; uprated
- read for shadows
- medium aperture, fairly slow shutter

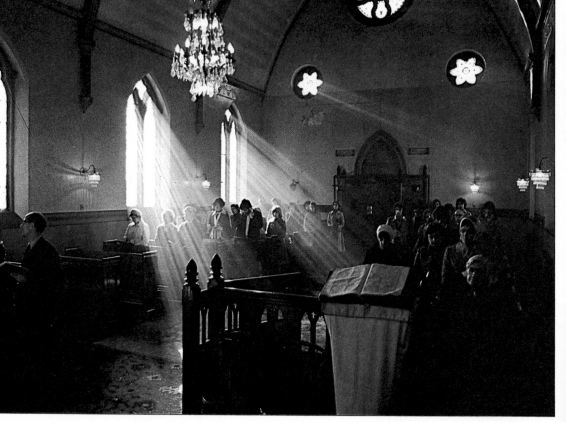

## Using a shift lens

A shift lens is a wide-angle lens on a mount which can be racked up or downward relative to its normal position on the camera. Raising the lens enables you to take in the whole of a tall structure without tilting the camera, avoiding the problem of converging vertical lines. The diagrams, right, show a Canon lens with combined shift and swing and tilt movements.

In the picture below left, taken with a normal 35 mm lens, the uprights of the museum showcase converge toward the top and the Egyptian mummy appears to be falling forward. A 35 mm shift lens was used for the adjacent shot – vertical lines now run parallel.

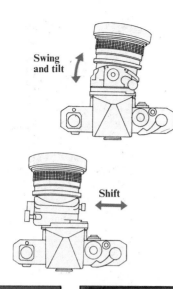

Swing and tilt

Shift

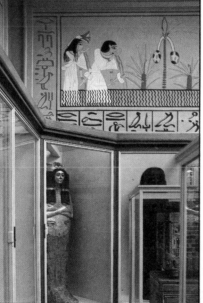

### Using swing and tilt *above and top*

A wide-angle lens with swing and tilt facility can be pivoted sideways, or tilted, while the camera is stationary. Its movements enable you to focus parts of an extensive subject that are at an oblique angle to the film plane. It therefore provides increased depth of field at all apertures. For the picture directly above, an ordinary wide-angle lens was used and the carpet is blurred. In the top picture, a swing and tilt lens gave sharp focus throughout.

## Painting with flash

By firing a flash unit several times during a time exposure, you can light large areas of an interior. Choose flash firing positions at the same distance from the subject surface, as shown right, and wear dark clothes so your own image does not record on the film. With the camera on a tripod, and using the "B" setting, lock the shutter open with the cable release and give the flashes in turn. Do not tilt the flash gun toward the camera – it may create crescents of light. The near picture was taken in available tungsten light, on tungsten film. The far one had a 50 sec exposure on daylight film, while the subject was painted with five flashes.

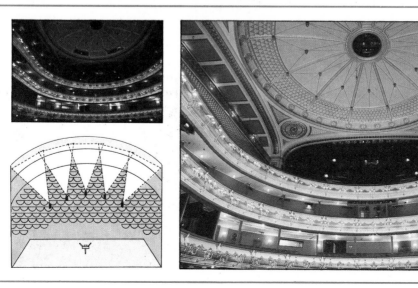

# EXTERIORS-MOOD & SETTING

A building's architecture usually shows its purpose
– domestic, religious, industrial – and a regional,
historical or individual style. To photograph it well,
you must convey both design and atmosphere.

Walk around the building and decide which
feature is most impressive, before choosing a view-
point. A head-on view will reveal pattern in an
ornate facade; an oblique view emphasizes three-
dimensional form by strengthening perspective.
A low, close-up view will exaggerate height.

Lighting direction is equally important. Side-
lighting shows texture and form; front lighting,
color and detail; while shooting into the light will
throw an interesting outline into silhouette. For
the right quality of light, you must wait for weather
and time of day. Classical buildings were designed
for bright light with hard shadows; gray, misty or
stormy days may suit industrial buildings; warm
evening light gives color to brickwork, and to white
walls, metal and glass, which can be glaring at noon.

Changing your viewpoint may place a building
in a new context. With a long lens, you can bring
the background into closer relationship with the
subject. A wide-angle lens can give foreground
context to an exterior that looks best from a
distance. The sky is important as a setting, too,
and can be dramatized with filters (p. 190).

## Lighting quality

By waiting for appropriate
lighting conditions, you
can greatly enhance a build-
ing's structure, setting, or at-
mosphere. The bungalow,
right, was lit by a shaft of
bright sun against an approach-
ing storm. Exposure was read
for the highlights, giving an
unreal floodlit effect to the
house, and underexposing the
background. A haze filter
softened the outline.

**To take the picture** *right*
- 📷 4 × 5 ins view camera
- 🎞 medium long
- ○ haze filter
- ⬛ read for highlights

## Creating double perspective

In order to obtain the double perspective effect
shown right, you must photograph a building from
an oblique angle. When viewed from a corner, two
walls of a building appear to recede toward two
vanishing points. The nearer the corner of the
building is to the center of your frame, the more
depth and distance you will gain. A viewpoint to
the left or right of the corner will tend to flatten one
wall and steepen the converging lines of the other.

**Perspective and symmetry**
In this photograph, the lines
of double perspective have
been exaggerated by using
a wide-angle lens and a low
viewpoint. A wide-angle
lens increases the sense of
depth by making features
in the foreground loom
toward the camera, while
horizontal lines converge
steeply into the distance.
Including the reflected im-
age in the picture has em-
phasized the symmetry of
the facade and the receding
lines of perspective.

## Correcting converging verticals

You will have to tilt your
camera, and perhaps use a
wide-angle lens, if you want
to encompass the whole of a
tall building. This will make
vertical lines converge em-
phasizing soaring height.

A shift lens (p. 161) on a reflex
camera, or a rising front on a
large format camera (p. 192),
will keep verticals straight and
parallel. Alternatively, you
could move to a more distant
viewpoint, and use a long lens.

## Lighting direction

Low oblique lighting brings out the form and texture of the temple, below, and gives the white stonework color. Shot into the light at sunset, the massive chimneys, right, stand silhouetted against the sky.

**To take the picture** *right*
- reflex
- medium long
- read for sky

**To take the picture** *below*
- reflex
- wide-angle

# 6 COLOR PROCESSING & PRINTING

Processing your own slides, or processing and printing your own color negatives, can be as creative and rewarding as working with your camera. The final result becomes totally under your own control. Whereas black and white processing and printing are quite flexible, color work demands very accurate adherence to times and temperatures to produce a naturalistic representation. There is, however, room for considerable experiment with special effects, as shown on pages 182–187.

You will see that processing slides does not necessarily require a darkroom, simply the expense of a suitable daylight developing tank, and the necessary chemicals. But for color printing you will need a temporary or permanent darkroom, and for best results, equipment including a color enlarger, and a print developing drum (see p. 170).

*How color photography works*

Before you start processing and printing it is a good idea to study the principles of color photographic reproduction. On page 57 you were introduced to the color circle, in which the colors of the visible light spectrum are pulled around into a cake with six equal color slices – the three primary colors of light (red, green and blue) opposite their three complementary partners (cyan, magenta and yellow). The relationship between the primary and the complementary colors is shown in the color wheel, top right.

You can match any color by mixing pairs of the three primary colors, in varying intensities, all three giving white (see right). This is the additive synthesis of color. In The Search for Color (p. 18 ) it is explained that additive synthesis produced the first color photograph. It is also used in a color television – any one point of the screen glows with sufficient amounts of red, green and blue to produce the appropriate impression of color for the complete image. Additive synthesis can still be used in color printing, as shown on the opposite page. If you pass white light through a primary colored filter, it will transmit only its own color while absorbing the other two. So to project a full color image using

## How colors form

The color wheel, right, and the paired primary colored lights, below, show how the three primary colors of the visible spectrum, red, green, and blue, can be combined to form their complementary colors, cyan, magenta, and yellow, and so any hue between. This combination of primaries is probably how our eyes interpret color. Color photography splits the color of a scene into its constituent primary colors, recording each separately.

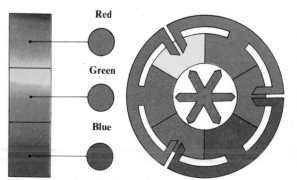

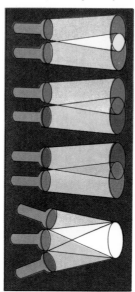

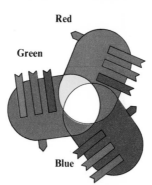

primary colored filters, you have to make three exposures, projecting the red, blue and green components separately.

You can similarly form a full range of colors using the three complementaries, cyan, magenta and yellow. Modern color systems are based on using these three colors as superimposed dyes, inks or filters. You can see below that a complementary colored filter transmits *two* primaries (both its component colors) and absorbs the other, "subtracting" it from white light. Two filters superimposed subtract two primaries and transmit one, while three subtract all the light, appearing black.

But if the filters are only of partial density, they will transmit all three colors in varying proportions. Each filter subtracts *some* of the light of one color, while passing the remainder, and also transmits the other two colors. So by using complementary filters, rather than primary colored ones, you can project a full color image in a single exposure.

## Adding and subtracting colors of light

Primary colored filters against white light transmit their own color only, absorbing the other two primary colors, left. All three projected colors form a "total" of white light. Complementary colored filters, right, "subtract" one primary color each, so superimposition of two allows one primary to pass. All three filters superimposed subtract all colors, giving black.

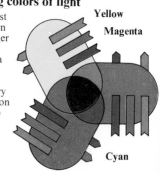

## The principles of color printing

A processed negative has an image formed by three layers of dyes, with complementary color values (for example, red appears cyan) and negative tones. To make a color print, you have to project light through this negative on to color printing paper. This also has three layers, sensitive to red, blue, and green light, and forms an image with complementary dyes, once again reversing the color values and tones. (Cyan, for example, records in the green and blue sensitive layers, where magenta and yellow dyes reproduce the red of the original subject.)

If you project unfiltered white light through a negative, the resulting print will have a browny-red cast and generally unbalanced color. For an accept-able result you must always modify the relative strengths of each color transmitted by the negative, using color filters to create an overall balance of red, blue and green that suits the response of the paper.

In additive printing you have to insert a primary colored filter below the negative, and make three separate, balanced exposures on the same paper. In subtractive printing, you must add graded complementary filters above the negative for a single balanced exposure. (A cyan filter, for example, strengthens the effects of cyan in the negative, thus increasing red in the finished print.) Since all three colors are present in the negative, you need use no more than two filters to get the correct balance so avoiding unnecessary neutral density.

**Original image**

## Using complementary color filters

If you project unmodified white light on to color printing paper, it produces an unbalanced response in all three dyes, giving a browny-red print. To obtain a balanced result, you can use complementary colored filters to control the strength of each primary color in the developed print. A cyan filter will strengthen red in the print, a magenta one will strengthen green, and a yellow one will strengthen blue, as shown below.

Using all three filters together (without a negative) will produce an overall neutral mid-gray on printing material, when color balance has been reached, in terms of the response of the paper you are using.

Modern color printing uses such subtractive, complementary colored filters, in graded strengths, to modify the effect of the color negative (which also subtractively filters the light). By this method, you can achieve the correct response in the paper in only a single exposure, after the appropriate filtration has been determined.

## Subtractive printing

The different densities of complementary colored dyes in a color negative themselves filter the white light projected in an enlarger, but the result would still be browny-red without variable cyan, magenta and yellow filters between the enlarger light source and the negative. As you always require the least filtration necessary, color balance is always set with one of the dyes in the negative left unmodified. Therefore you need never use more than two of the three filters.

In subtractive printing, the negative image subtractively filters white light so transmitting a colored image that activates halides, and ultimately complementary colored dyes, in the printing paper. After development, we see the original colors of the scene against the white paper base.

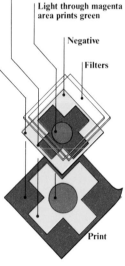

Light through yellow negative area prints blue

Light through blue area prints yellow

Light through magenta area prints green

Negative

Filters

Print

## Reversal printing

Subtractive printing also allows you to make prints from slides. You must use printing paper that works in a similar way to slide film, creating a positive image in one process. You can either use Ektachrome reversal paper, where the complementary color dyes form linked to a reversed black and white developed image of the original slide, and the silver is then bleached away. Or you can use Cibachrome paper (see p. 180) where the dyes are already present in each layer, and the negative silver halide image forms within each dye. The dye and silver negative is then bleached away, leaving a color positive. Finally each color in the slide is duplicated in the finished print.

The profile, left, shows the three complementary colored dye layers in Cibachrome paper.

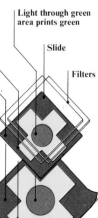

Light through blue slide area prints blue

Light through yellow area prints yellow

Light through green area prints green

Slide

Filters

Print

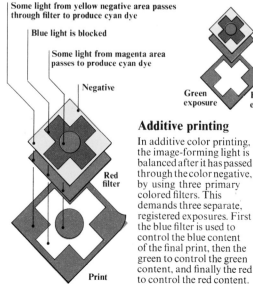

Some light from yellow negative area passes through filter to produce cyan dye

Blue light is blocked

Some light from magenta area passes to produce cyan dye

Negative

Red filter

Print

Green exposure

Blue exposure

## Additive printing

In additive color printing, the image-forming light is balanced after it has passed through the color negative, by using three primary colored filters. This demands three separate, registered exposures. First the blue filter is used to control the blue content of the final print, then the green to control the green content, and finally the red to control the red content.

# COLOR PROCESSING–FILM STRUCTURE

Modern color films (and most color printing papers) have three emulsion layers coated on a base. The top emulsion layer of color film is sensitive to blue light, reacting strongly to primary blue areas of the subject, and proportionally to parts of the subject reflecting some blue light. The second emulsion layer is similarly green-sensitive, and the third one red-sensitive. The second and third layers would also record blue light, so a yellow filter layer prevents blue light reaching them.

The sensitivity of each layer is due to its silver halides, which can be developed to black metallic silver where they have received light of their color sensitivity. The final image, however, is produced by dyes which form coupled to the black silver images during processing. These dyes are in colors complementary to each layer's sensitivity: the blue-sensitive layer forms yellow dye, the green-sensitive one magenta dye, and the red-sensitive one cyan dye.

The diagram below right shows how the colors of a subject affect each layer. Primary colors affect one layer only; complementary colors affect two layers – cyan for example affects the green and the blue-sensitive layers. White affects all three layers, while black has no effect on any layer.

In a slide the dyes form coupled to a "reversed" silver positive. The yellow dye image, for example, correctly corresponds to *absence* of blue in the subject, and subtracts blue light. The blue image is formed by dyes in the other layers – magenta subtracts green, cyan subtracts red, leaving blue. Thus the dyes subtractively produce a correct positive image of the subject.

In a negative, the dye molecules form coupled to the images produced by exposure. The blue light image, for example, is dyed yellow; the cyan one is dyed magenta and yellow, giving red. So a negative shows complementary colors to the subject; it is only a half-way stage to a color print.

The processing sequence given to color film after exposure thus depends on whether it is slide (reversal) or negative film. With slide processing, the first step is to develop the latent images in each layer to black silver negatives, using a monochrome developer. This leaves the undeveloped areas, where the halides were *least* affected by relevant colored light from the image, forming a potential positive image. In reversal materials, it is in these areas that the final color positive is formed. So the next stage starts with "fogging" (usually done chemically), so that the unaffected halides are themselves "exposed".

Now color developer can be introduced. It will convert the newly fogged halides to black silver, and at the same time cause the relevant cyan, magenta and yellow dyes to form in each layer, coupled to these same halides. (The developer either contains the dye-formers, or activates them.) At this point the film looks completely black as the newly formed dyes are still shielded by the developed silver. This black silver is removed by a process of bleach fixing, which changes the dense silver to a soluble chemical compound, leaving the dyes to form the image after washing. A brief rinse in stabilizer makes the dyes more permanent.

With color negative processing, your aim is to create a negative color image corresponding to the initial image formed on exposure, so there is no

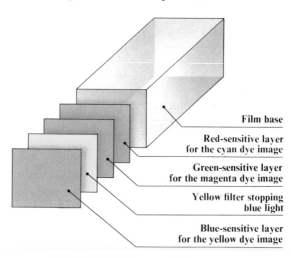

**Film base**

**Red-sensitive layer for the cyan dye image**

**Green-sensitive layer for the magenta dye image**

**Yellow filter stopping blue light**

**Blue-sensitive layer for the yellow dye image**

fogging stage. The first stage of negative processing is color development. The exposed emulsions in each layer are developed to black silver, and it is in these developed areas that the coupled dyes are formed. Bleaching removes the unwanted silver deposits and allows you to see the final negative image. Fixing and washing follow.

The magenta and cyan dye layers formed in color film processing absorb some light wavelengths that they are intended to transmit. As a color negative would otherwise pass on this factor to make a color cast in the print, the green and red-sensitive emulsion layers are given a yellowish and a pink appearance (respectively) at manufacture. This creates the overall orange cast seen in the final color negative.

## Color film structure

If we could magnify a microscopic square of color film to the immense proportions shown left, and separate the emulsion layers, we would see how very thin the sensitive tripack of emulsions is in relation to the film base. The very top emulsion layer is sensitive to blue light, and ultimately forms yellow dye. Below this a yellow layer prevents any blue light from affecting the underlying layers. The middle layer is sensitive to green light, and forms magenta dye; and the bottom layer is sensitive to red light and forms cyan dye. All the layers are bound together on the flexible film base.

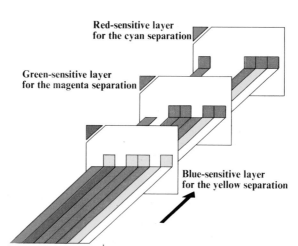

**Red-sensitive layer for the cyan separation**

**Green-sensitive layer for the magenta separation**

**Blue-sensitive layer for the yellow separation**

## Primary color analysis

When light from the various colors in a subject passes through a color film tripack, primary colors in the subject produce an image in their own sensitive layer only. Colors made up of more than one primary create a varying response in each relevant layer. So cyan produces an image in both blue and green-sensitive layers; magenta in both blue and red-sensitive layers; and yellow in both red and green-sensitive layers. With color negative film, these images correspond to the final positions of the complementary colored dyes, as shown left.

# THE PROCESSING SEQUENCE

Slide and negative processing sequences are shown below. Most films contain the dye-forming chemicals in the emulsion, and can be home-processed. But some slide films, such as Kodachrome, cannot – the dye-formers are introduced during processing. In slide processing, you can modify the first development time to compensate for over- or under-exposure (see Uprating). In negative processing this is inadvisable, as first development is dye-linked.

## The subject
The color subject, left, has been specially created to display the range of primary and complementary colors. These colors can be traced through the processing stages, below, for both slide and print film.

## Slide film

**Black and white development**
Black and white developer reveals the latent response of each primary color sensitive layer, converting all exposed silver halide to form a black silver negative.

**Fogging and color development**
After washing, the remaining unexposed halides are fogged chemically. These fogged halides are then developed, along with the coupled complementary dyes.

**Bleach and fix**
Bleaching removes the black silver deposits from all three tripack layers, leaving the complementary colored dyes only. Fixing and washing remove by-products.

**Color slide**
The end result, the color slide, displays a positive image, with correct colors, when viewed in white light. By subtracting appropriate amounts of blue, green and red from white light, the three complementary dye layers give a full range of image colors.

## Print film

**Color development**
First development establishes both the silver negative and the dye positions. The dye-forming chemicals are present in the emulsion, coupled to the halides.

**Bleach and fix**
Bleaching removes the unwanted black silver image. Unexposed areas of the emulsion are then fixed, leaving a three-layered dye image to form the negative.

**Final negative and print**
The three dye layers in the finished color negative, right, combine to give an image in complementary colors and negative tones. Notice how red appears cyan, blue records yellow and white black. A yellowish bias in the unexposed areas of the magenta layer, and a pink bias in the unexposed areas of the cyan layer, combine to give an overall orange cast. This integral dye mask reduces contrast and improves the color balance of the final print, below right. Filtered white light is passed through the negative projecting the image on to color printing paper. Most color printing paper has a similar structure to color film, but with the three emulsion layers sensitive to first red, then green and then blue light. These respond to the projected light from the negative to form the color and tone values of the original subject.

# FILM PROCESSING EQUIPMENT

Slides and negatives require the same color processing equipment. Only the solutions differ between the two processes. If you already do your own black and white processing, you will only have to buy the relevant color processing chemical kit.

## Color processing chemicals

It is essential to purchase a color processing kit that is compatible with the film you are using. The Kodak E6 kit is suitable for using with many brands of color transparency film, although Agfa produce their process AP44, which is E6-compatible. Other manufacturers sell universal or rapid processing kits suitable for either E6 (reversal) or C41 (negative) type films.

Color film processing solutions are available ready-mixed or in powder form. If you do buy them as powders, mix them up in clean dry containers, preferably a few hours beforehand to allow any undissolved solids to precipitate and be separated off. Stored in air-tight bottles, solutions will have a shelf life of about one week. Accordion bottles enable you to expel air (which ages the solution) and improve the storage life to about two weeks. Some color processing chemicals are re-usable. You should check the manufacturer's instructions to find out which. Processing chemicals are toxic, so you should store them all out of reach of children, and wear rubber gloves when using them.

## Processing equipment

The basic equipment for processing color film is shown right. If you use a processing tank you can work without a darkroom – you need only load the tank with the exposed film in darkness. You can do this in a light-tight closet or a black, zip-up changing bag. Once the film is in the tank, solutions can be poured in and out without light getting to the film.

The temperature of each solution and the time it is in the tank are critical to good results with color. Manufacturer's recommendations for timing and temperatures should be strictly followed. At all times, handle film very carefully, by its edges only.

You will need as many graduates as there are processing solutions – before starting, measure out quantities of the solutions into separate graduates. These should stand in warm or hot water to bring the solutions up to the correct temperature. Before using a solution, you should check its temperature and, if necessary, add hot or cold water to the bowl. Only when the solution is at exactly the correct temperature should you pour it into the tank.

For the washing stages, you can use a rubber hose to connect the tank with your water supply; it is also advisable to fit a water filter in order to remove any impurities. After washing and stabilizing, remove the film from the reel, handling it by the edges, and hang it up to dry using film clips. Surface liquid can be removed by running a pair of squeegee tongs down the film.

## Basic equipment

Color film processing equipment, shown below and right, is simple and relatively inexpensive. Wash equipment immediately after use to prevent contamination and reduce the amount of corrosion caused by the processing chemicals. Seal all storage bottles tightly, with their contents clearly marked. Use a deep bowl, preferably insulated, for the water that will keep the chemicals at the correct temperature. A timer and thermometer (accurate to within $\frac{1}{2}°F$, $0.3°C$) are essential.

**Deep plastic bowl, graduates, and stirrer**

**Chemicals and accordion bottle**

**Funnel and thermometer**

**Timer for development stages**

**Squeegee tongs**

**Film clips**

**Rubber gloves**

**Scissors**

**Rubber hose**

**Water filter**

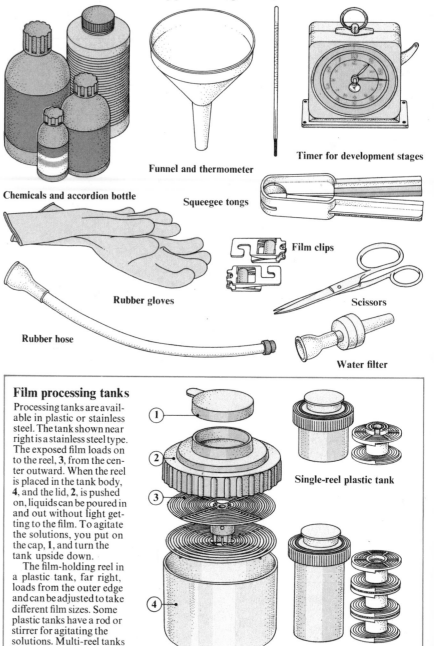

## Film processing tanks

Processing tanks are available in plastic or stainless steel. The tank shown near right is a stainless steel type. The exposed film loads on to the reel, **3**, from the center outward. When the reel is placed in the tank body, **4**, and the lid, **2**, is pushed on, liquids can be poured in and out without light getting to the film. To agitate the solutions, you put on the cap, **1**, and turn the tank upside down.

The film-holding reel in a plastic tank, far right, loads from the outer edge and can be adjusted to take different film sizes. Some plastic tanks have a rod or stirrer for agitating the solutions. Multi-reel tanks are also available.

**Single-reel plastic tank**

**Multi-reel tank**

# STEP-BY-STEP PROCESSING

Until you have loaded the exposed film into the processing tank, you must work in total darkness. With some scrap films, practice removing film from its container and loading it on to your processing tank reel, until you can do it with your eyes closed.

The most important factors for good results are regular agitation, accurate timing and temperature control, and careful film handling. Make sure that the temperature of each solution is exactly 100°F (38°C) before pouring it into the tank. Then start the timer and agitate as recommended by the manufacturer. Stand the tank itself in the water bath between stages. Solutions and times for C41 negative and E6 slide processing are shown right.

## C41 and E6 processing sequences

The two tables, right, show the recommended temperatures, the order of the solutions, and the times of each, for C41 negative and E6 slide films. Slide films take longer to process than negative film, with more stages, because the image has to be reversed.

The temperature of each solution must be as close to 100°F (38°C) as possible. The temperature of the first developer is most critical – even a variation of $\frac{1}{2}$°F (0.4°C) can affect your results.

**Slide film**

| Solution * | Time |
| --- | --- |
| Black and white developer | 6 mins |
| Wash | 2 mins |
| Reversal bath | 2 mins |
| Color developer | 6 mins |
| Conditioner | 2 mins |
| Bleach | 6 mins |
| Fixer | 4 mins |
| Wash | 4 mins |
| Stabilizer | $\frac{1}{2}$ min |

**Negative film**

| Solution | Time |
| --- | --- |
| Color developer | 3 mins 15 secs |
| Bleach | $6\frac{1}{2}$ mins |
| Wash | $3\frac{1}{4}$ mins |
| Fixer | $6\frac{1}{2}$ mins |
| Wash | $3\frac{1}{4}$ mins |
| Stabiliser | $1\frac{1}{2}$ mins |

*All solutions should be at 100°F (38°C).

## Unloading your film

**35 mm cassette film**
In darkness, use a bottle opener to pull off one end of the cassette, and slide out the spool. Trim the film end square.

**120 rollfilm**
In darkness, separate several inches of film from the leading backing paper, before you begin to unroll the film.

**110 film cartridge**
In darkness, break the cartridge in half, remove the film, and separate the leading edge from its backing paper.

## Loading the processing tank reel

You must load the film in total darkness. Stainless steel reels load from the center outward. Attach the leading edge of the film to the clip on the center of the reel, then, bowing the film slightly with your fingers, wind the rest of the film on to the reel. Plastic reels load from the edges inward. Slide the film into the entry slot then rotate the edges of the reel alternately to draw the film on to the reel. Run your finger over the reel surface; if any film protrudes, it is incorrectly loaded.

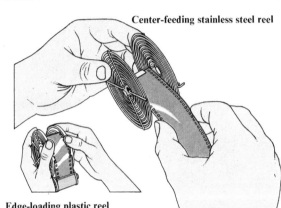
Center-feeding stainless steel reel

Edge-loading plastic reel

## Developing the film

Once the film is loaded and in the tank you can work in room light. Place the tank in the bath of water at 100°F (38°C). Pour out enough of each solution into separate graduates and stand these in the bath. Stir the solutions and check their temperatures regularly throughout processing, and add hot or cold water to the bath as necessary.

The times, temperature latitude, and number of solutions may vary between processing kits. But the procedures shown right should be observed strictly.

**Ensuring correct temperature**

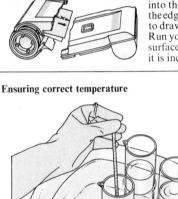

**Using a solution**

**1** Pour the solution at the correct temperature into the tank. Start the timer immediately.

**2** Agitate and tap the tank as recommended by the manufacturer, to remove air bubbles and ensure the solution produces an even effect on the film.

**3** Stand the tank in the water bath between the periods of agitation, and check the water temperature.

**4** About ten seconds before the end of the set time, pour the solution back into its graduate, and allow the tank to drain completely for the remaining time.

## Washing and drying

**Washing**
Removing the tank lid, place the nozzle of the hose into the reel and then let the water (at around 100°F, 38°C) overflow steadily for the correct time.

**Drying**
Remove the film from the processing tank by attaching a film clip to the leading edge, and carefully unwinding the film, handling it by the edges only. Attach another clip to the bottom of the film to hold it taut. Run squeegee tongs down the film. (Beware of grit on the pads of the tongs.) Hang the film up to dry in a warm dust free area.

## Filing and mounting

Once the film is dry you should mount or file it immediately to protect it from dust and grit. At all times the film should be handled by its edges only.

Negatives can be stored in special negative bags. These will hold strips of 35 mm film that are six frames long.

Slides can be cut up into individual frames and mounted in slide holders as shown on pages 198–9.

# COLOR PRINTING–THE ENLARGER

The most expensive and important piece of printing equipment you need is a color enlarger. A good enlarger is as essential to producing a high quality print as a good camera.

There are two main types of color enlargers, which differ in the way that they filter the enlarging light, as shown right. The simpler type has a filter drawer, and you set the filtration by using a pack of acetate filters. The more expensive "dial-in" enlarger has three filtration controls, which progressively move cyan, magenta and yellow filters into the enlarging light.

Most dial-in enlargers include a diffuser which spreads the light to produce an even illumination of the negative. On other enlargers the light is concentrated by a condenser, creating a much harder light and increasing contrast in the image. Every enlarger varies slightly in the quality of the light it gives and you will almost always have to alter the exposure (either the filtration, or aperture, or time) when changing enlargers.

The negative is held flat below the enlarger lamp, in a negative carrier which should be the right size for the film format, see right. Enlarger lenses are available in different focal lengths, to suit the film format you are printing. On the lens, the aperture setting is often shown by a series of f numbers.

The size of your image is controlled by the height of the enlarger head on the column. To obtain a sharp image of the size you want, you adjust the height of the head and the lens focus together.

The printing frame, or easel, holds the light-sensitive printing paper in position, with adjustable masks that determine the size of your print borders. On normal color printing paper these borders will be white; on reversal papers they will be black. A useful accessory is a focus magnifier, which magnifies the projected image, enabling you to adjust the focus more exactly.

## Color filtering systems

### Filter drawer
Some enlargers use a filter drawer to hold the color filtration, positioned just below the lamphouse. To change the filtration you add or remove filters using a pack of 21 color printing filters (seven of each in cyan, magenta and yellow).

### Dial-in enlarger head
A dial-in or dichromatic enlarger head has three dials for cyan, magenta and yellow respectively, which move corresponding internal filters, **1**, into the enlarger light. The degree of filtration is determined by the amount of the filter that is across the light. A mixing chamber, **2**, and a sheet of translucent glass, **3**, ensure that the filter colors are mixed in the light, and that the negative, **4**, is evenly illuminated down through the enlarging lens, **5**.

## Color analyzer

A color analyzer is rather like an exposure meter, but it measures color as well as brightness. Set for a typical negative and your enlarger, the light-sensitive probe will read from the projected image of each negative the correct exposure time and filter settings.

## Timer for exposures

You can use an ordinary timer to time your printing exposure, but an electronic timer, right, is much more convenient. Wired between the electricity supply and your enlarger it will automatically make an exposure for a pre-set time between 1 and 60 seconds.

## Enlarger

A color enlarger is the only essential piece of printing equipment. Accessories, such as a color analyzer or focus magnifier, are optional.

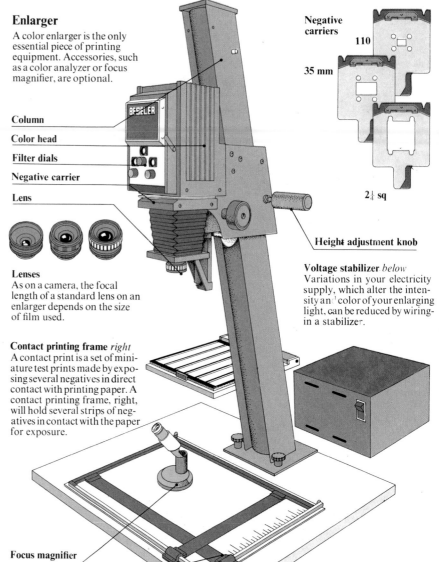

Column

Color head

Filter dials

Negative carrier

Lens

### Lenses
As on a camera, the focal length of a standard lens on an enlarger depends on the size of film used.

### Contact printing frame *right*
A contact print is a set of miniature test prints made by exposing several negatives in direct contact with printing paper. A contact printing frame, right, will hold several strips of negatives in contact with the paper for exposure.

Focus magnifier

Easel

Baseboard

### Negative carriers
110

35 mm

2¼ sq

Height adjustment knob

### Voltage stabilizer *below*
Variations in your electricity supply, which alter the intensity and color of your enlarging light, can be reduced by wiring-in a stabilizer.

# PRINT PROCESSING EQUIPMENT

Following exposure you must process your prints. This requires as much care with temperatures, times and cleanliness as was necessary with film processing. Rubber gloves should be worn whenever you handle chemicals.

A drum processor, rather like a film processing tank, enables you to work in normal light, once it has been loaded. Agitation is again important to producing even results; motorized drums, below, are available as well as hand-operated models, right. You can use a set of trays and tongs to process prints instead, but this method wastes chemicals, is awkward, and reduces temperature control. Furthermore, because prints can only be handled under dark, usually amber safelighting (the color depends on the brand of paper), you will have to work in almost total darkness.

Processed prints should be washed thoroughly to remove chemicals which can discolor a dried print. Use a sprinkler washer, or use a tray and change the water every few minutes. All color printing papers are resin-coated and must be air-dried in a simple rack or a print dryer after using a print squeegee to remove surface moisture.

### More sophisticated processing equipment

A motorized print processing drum will ensure constant, controlled agitation of each chemical through the print processing sequence, and leave you free to check on times and temperatures. A small, table-top automatic print processor may be a worthwhile investment if you intend to process sufficient numbers of color prints.

**Electric processing drum**

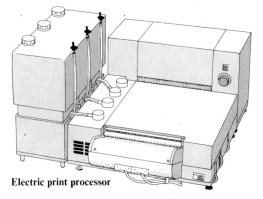

**Electric print processor**

### Processing equipment

A drum processor enables you to work in normal light. The model, right, is hand-operated and rotates in its own water bath, in which bottles and dispensers of the three processing chemicals also stand. The small dispensers hold exactly enough of each chemical for one print, minimizing wastage. Solutions are poured in through a funnel at one end of the drum and can be discarded after use. The temperature of the chemicals and the water bath should be taken regularly with an accurate thermometer. A timer is essential and rubber gloves should be worn to protect your hands from the chemicals.

### Washing equipment

For the final wash before soaking in the stabilizer, the print can be removed from the processing drum. Color papers are resin-coated, which means that the paper does not soak up liquids easily so it needs less washing time and it dries quite quickly. If you have a continuous supply of water at the correct temperature, then the sprinkler tray, below right, is ideal. Otherwise you can use a tray or sink of water and change the water regularly during washing.

### Drying and finishing equipment

Color papers are resin-coated and must be dried either in a special dryer for resin-coated prints, above right, or in a simple rack, above. They will always dry with a gloss finish, so you should never try to glaze them.

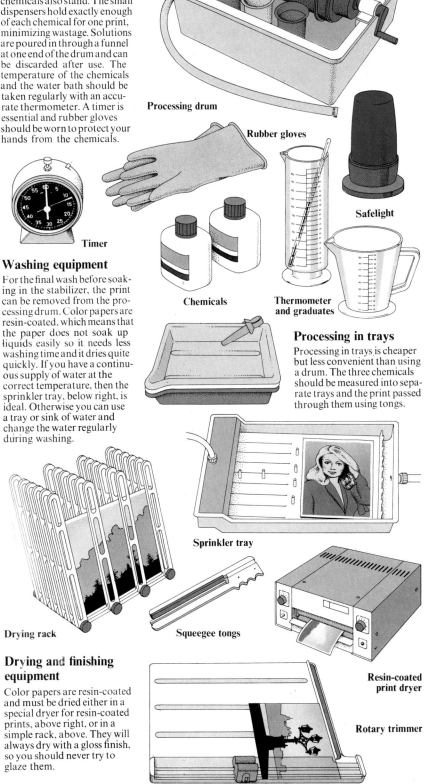

**Processing drum**

**Rubber gloves**

**Safelight**

**Timer**

**Chemicals**

**Thermometer and graduates**

### Processing in trays

Processing in trays is cheaper but less convenient than using a drum. The three chemicals should be measured into separate trays and the print passed through them using tongs.

**Sprinkler tray**

**Drying rack**

**Squeegee tongs**

**Resin-coated print dryer**

**Rotary trimmer**

# ESTABLISHING A COLOR DARKROOM

Whereas you can process color film without a darkroom, you must have a darkroom, however simple, to do any printing. The illustrations, right, show the best way of converting a room and arranging your equipment. Nearly all of the equipment illustrated is shown in use in this section of the book.

The first considerations for any darkroom are darkness and good ventilation. Absolute darkness is essential, since you will be handling unprotected light-sensitive materials. You should fit light-stopping window blinds, and place edging around doorways so that the closed door is light-tight. To test the darkness, stand in the darkened room for several minutes, and then try to spot leaks.

Water and electricity together are very dangerous, so dividing the room into a wet side and a dry side is a safety precaution as well as a practical arrangement. Your running water supply and the processing chemicals should be together on one side; the power sockets for the enlarger and other electrical equipment should be on the other side. Change all light switches to the pull-cord type, which are safer if you are likely to have wet hands. The sink itself should be large enough to hold the water jacket of your print developing drum. Purpose-built PVC types, which are least corroded by the processing chemicals, are probably the best. Flooring should be waterproof and easily cleaned; heavy duty plastics are ideal because they are resistant to minor corrosive chemical spillages.

Your work tops and storage units should be easy to clean and as simple as possible, to reduce the chances of dust collecting in corners. Cleanliness is essential to any darkroom. Film and photographic papers are easily damaged by dust or grit, particularly when wet, and your enlarger lenses are also very sensitive. On either side of the sink make the bench slope for easy drainage. You should have a dark amber safelight, timer and towel rack on the wet side of the room and, since processing chemicals will be used along the wet bench, provide storage, and position the extractor fan close by.

Your drying and viewing area should be butted on to the wet bench, as shown right. A light box and a magnifier are best for studying your slides and negatives. To check your print colors accurately, a proof light balanced to 5000°K is desirable to provide a consistent white light source. If you are likely to want to see your results before drying, use a pin board with a drip tray beneath for your tests, and a smaller tray with a glass sheet to support the paper to view larger prints.

Your enlarger, with a timer and other printing accessories such as a contact printing frame and any dodgers or shaders (see p. 177), should be at the center of the dry bench. Any other space on the dry side can be devoted to print mounting and finishing equipment.

Light-sensitive materials are best stored in a refrigerator to prolong the life of the emulsions.

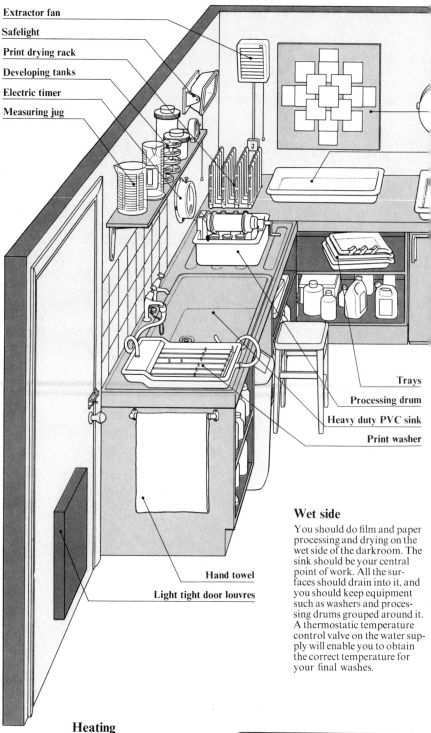

Extractor fan
Safelight
Print drying rack
Developing tanks
Electric timer
Measuring jug

Trays
Processing drum
Heavy duty PVC sink
Print washer

Hand towel
Light tight door louvres

## Wet side

You should do film and paper processing and drying on the wet side of the darkroom. The sink should be your central point of work. All the surfaces should drain into it, and you should keep equipment such as washers and processing drums grouped around it. A thermostatic temperature control valve on the water supply will enable you to obtain the correct temperature for your final washes.

## Heating

Ideally your darkroom should be kept at about 70°F (21°C). At this temperature there will be almost no risk of condensation forming on cold equipment surfaces, and the processing chemicals will not be inconveniently far from their working temperatures.

## Dry side

The enlarger is the central point on the dry side. Your papers should be stored near it and you should have nearby, perhaps on the wall, a chart for recording details of filtrations and exposures. Most other electrical equipment, such as a dry mounter and a light box for viewing negatives and transparencies, should also be on the dry side for safety reasons. Always dry your hands thoroughly before touching the equipment on the dry side of the darkroom.

Dust is your chief enemy so do not allow benches, shelves and empty containers to become dust traps. If possible, put your equipment under cover when not in use.

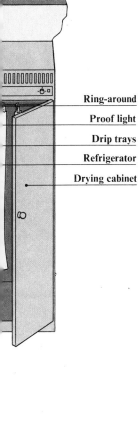

**Ring-around**
**Proof light**
**Drip trays**
**Refrigerator**
**Drying cabinet**

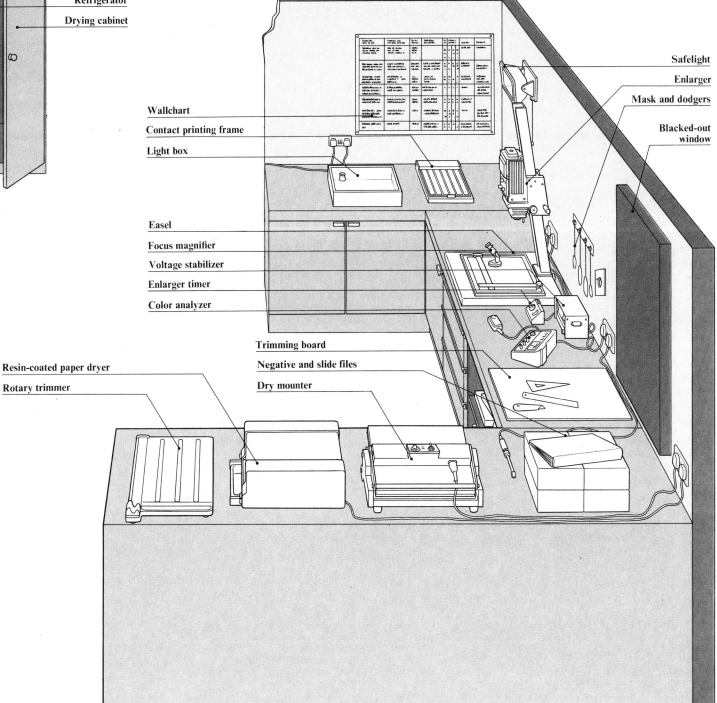

**Wallchart**
**Contact printing frame**
**Light box**

**Easel**
**Focus magnifier**
**Voltage stabilizer**
**Enlarger timer**
**Color analyzer**

**Safelight**
**Enlarger**
**Mask and dodgers**
**Blacked-out window**

**Trimming board**
**Negative and slide files**
**Dry mounter**

**Resin-coated paper dryer**
**Rotary trimmer**

# JUDGING EXPOSURE & FILTRATION

Color printing involves exposing an image, usually a negative, on to light-sensitive color printing paper. The two main variables by which you control how the image appears in your print are exposure and filtration. Learning to assess these two factors, in particular filtration, is one of the most important skills in color printing.

*Exposure*

To choose the best exposure for your image, you must make a series of test exposures (altering either the enlarger lens aperture, or the time) until you get the tone, saturation and fine detail you want. Very simply, the more exposure you give, the darker (denser) and more saturated the image will be, as shown on the opposite page. You can make important adjustments to your image by giving increased or decreased exposure to selected areas (by burning-in or shading, p. 177).

*Filtration*

If you expose a color negative on to color paper without any filtration, the image will be brownish in color, as explained on page 165. Some filtration is necessary for every color negative to allow for their orange cast, and this will differ to suit differences in enlarger lamps, film brands, paper batches, and most of all your subjective judgment of the acceptable color balance for the image. As with exposure, the filtration you choose depends greatly on what you judge to be correct.

In subtractive, or white light printing, which we use in this section, cyan (C), magenta (M), and yellow (Y) filters are used, two at a time, in one exposure. These will subtract red, green and blue respectively from the white light source, in varying degrees according to their strength. Filter strength is coded in standard numbers, from 00 to 150 or 160. Additive, or tricolor printing, uses three primary filters and three separate exposures; this takes longer, and makes local adjustment of the print more difficult.

With all color printing, you have to make a test to determine the filtration necessary for each image. If you have a color analyzer, you can measure the required filtration from the image

**Color balance**

Achieving the best color balance in your print requires skill and practice but ultimately it is up to you to decide what is correct. The series below shows just how fine your judgement of the print must be. From the normal filtration at the far left, doubling amounts of magenta have been added, producing a progressively visible green cast. But it is not until as much as 20M has been added that the cast is clearly identifiable. (In some lights it may be even harder to see.) In practice, because you are dealing with permutations of up to six colors, a color cast will not be as easily identifiable as this and judging prints is a more difficult task.

projected on the baseboard, but you may still want to make a test. With experience, you will be able to judge a required filtration quite accurately, with or without an analyzer. But to begin with, you should make your tests around the filtration values recommended by the paper manufacturer.

The essential rule to remember in subtractive printing is that to remove a color cast from a print you must *increase* that color in your filtration. For example, if your print is too yellow, you should increase the yellow filtration; if it is too blue, you should increase cyan and magenta (which make blue) in the filtration.

Each time you change the filter values, you will have to recalculate your exposure time, as explained on page 176. You should never filter all three colors; this lengthens your exposures unnecessarily, and as explained opposite, can be eliminated.

*Color printing paper*

Color printing paper is most commonly sold in 10 ×8 ins size. It is available only as a resin-coated, paper, special finishes can be added during mounting (p. 198). The side toward which the paper curls is its emulsion-coated, light-sensitive side, and should be placed uppermost for printing. You should store the paper in its light-tight box when it is not in use. Each pack has filtration recommendations, an exposure factor number, and a paper batch number.

The color response of each paper batch is slightly different; batch numbers remind you to calculate a new exposure and filtration when changing batches. To calculate the new filtration for a different paper batch, you must first subtract the values recommended on the old batch from your actual filtration values, then add the result to the values recommended on the new batch. Suppose, for example, you are using a filtration of 55Y 20M, with a paper that has a recommended filtration of 20Y, 05M. If the new batch values were 00Y, 10M, the new filtration for your image would be 35Y 25M. Finally, you must recalculate the exposure. To obtain the new time, divide the exposure factor number on the new label by the old one, and multiply the result by the existing exposure time.

Normal filtration      ×5M      ×10M      ×20M      ×40M

## Filtration ring-around

A ring-around test chart, shown right, is an essential aid to color printing. It will help you to judge the color and strength of a color cast and establishes a standard from which you can work. The chart should show six color variations – for the three primaries and three complementaries – away from the normal filtration. Each color is in the same position as on the color circle (see p. 164) – opposite its complementary – and increases in strength away from the neutral filtration.

Ring-around charts are produced for sale by paper manufacturers; you can also make one yourself. To do this, use a well-exposed image that includes a good range of tones and colors (in particular neutrals and skin tones).

### Judging print color

When you are judging print color make sure that you do so in daylight or in fluorescent light balanced to 5000K. You may find that they have a strong cast in other lighting. Look at the neutral and skin tones on a print; these more readily show up casts (watch for warm casts, which tend to be overlooked, particularly in skin tones).

By matching your print's cast to a particular position on the ring-around, you can determine a correct, neutral filtering – simply add that color and strength of filter to the values in your filtration.

### Neutral density

You may find that by adding filters to your pack you end up with three filter values. Since one will tend to partly cancel out the other two – neutral density – you will have to use an over-long exposure. You can eliminate one value and reduce the exposure time by subtracting the lowest filter value from the other two. (For example, a filtration of 10Y 70M 30C will become 00Y 60M 20C.) This will give you the same color result.

**Red**

×20      **Yellow**      **Green**

×20      ×10      ×20

×10      ×10

**Correct filtration**

×10      ×·10

×20      ×20

×10

**Magenta**      ×20      **Blue**      **Cyan**

## Exposure

You must assess exposure separately for each print. A standard exposure series, such as the one shown right, is a useful accompaniment to a ring-around. Choose an image that has a good range of tones and was well exposed in the camera. Images with an extreme range of tones are difficult to print because you will lose detail either in highlights or shadows.

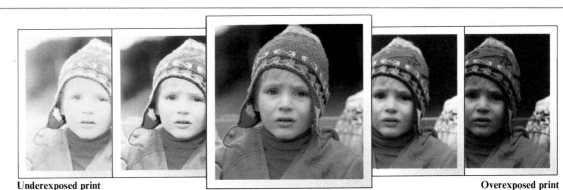

**Underexposed print**      **Overexposed print**

# MAKING PRINTING TESTS

For each image, you must make at least two tests, to determine the exposure and filtration. With experience you will be able to estimate these two values quite accurately, and any subsequent tests you make will establish them more exactly. (Even if you use a color analyzer you should make some tests around the recommended values.) For any test, you should select a section which is representative of the complete image (in color and tone).

Two tests are shown on this page. The first, made at the recommended filtration values for the film, shows a series of different exposures across a section of the image. This processed test was then compared for color and exposure against a ring-around. As a result, the filtration was adjusted slightly for a second test, which used more closely related exposures around one chosen time.

If you are uncertain about the best filtration for your negative, you can make a separate test for the filter values. Alter the exposure each time to compensate for filter changes, using the table, right.

## Making contact prints

Contact printing produces same-size positive prints from your negatives. These will help you to decide which frames are worth enlarging.

In darkness place a sheet of paper in the frame, emulsion side up (the side toward which the paper curls). Place your negatives on the paper emulsion side (dull side) down. At the recommended filtration, expose for 10–15 secs at f8.

### Exposure filter factors

Each time you change your filtration you alter the strength of the exposing light, so you must compensate for this in exposure. If you remove a filter, you should divide the exposure time by its factor; if you add a filter, multiply the exposure time by the relevant factor. The table right shows Kodak filter factors.

| Yellow | Factor | Magenta | Factor | Cyan | Factor |
|--------|--------|---------|--------|------|--------|
| 025 | 1.1 | 025 | 1.2 | 025 | 1.1 |
| 05 | 1.1 | 05 | 1.2 | 05 | 1.1 |
| 10 | 1.1 | 10 | 1.3 | 10 | 1.2 |
| 20 | 1.1 | 20 | 1.5 | 20 | 1.3 |
| 30 | 1.1 | 30 | 1.7 | 30 | 1.4 |
| 40 | 1.1 | 40 | 1.9 | 40 | 1.5 |
| 50 | 1.1 | 50 | 2.1 | 50 | 1.6 |

## Making the tests

Once you have selected the image you want to enlarge, make sure it is free of dust or grit before inserting it in the negative carrier. With the carrier in the enlarger and the enlarger on, compose and focus the image on the baseboard. For the purposes of the tests you need only expose a representative section (in tone and color) of the complete image.

When you are first starting color printing, it is best to use a correctly exposed negative – perhaps one you already have a good print from – which is not too contrasty, and has a good range of colors. This should not require too many tests and will enable you to learn the routine of color printing.

**Making an exposure test**
Dial-in (or make up in your filter pack) the recommended filtration for your film. In this case, a filtration of 80Y 90M was used. Then, in total darkness, place a strip of printing paper under the masking easel, emulsion side up. Using a piece of black card as a mask,

make a series of bands of increasing exposure across the paper by moving the card at regular intervals (perhaps 5 or 10 seconds) to uncover a further band. On a second test you can make the intervals shorter around a particular exposure time.

**First exposure test** *below*
The processed test strip below shows four different exposures – 5, 10, 20 and 40 secs – (all at the same filtration of 80Y 90M). To select the best exposure, you should judge each band by its range of tones rather than its color. Highlights should not be too burned out and shadows not too dense. In this example the best exposure lies between 10 and 20 secs. The end bands are either too dark or too light.

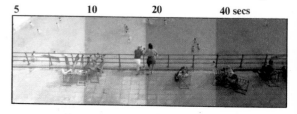

| 5 | 10 | 20 | 40 secs |

## Using your ring-around

When your processed test is dry (when wet it may have a slight magenta color cast), hold it up against your ring-around to judge in what way you should alter your initial filtration. Make your assessment from the best exposed band, where tones are most accurate. Flesh tones and neutrals show up color casts most readily. Study these areas first to determine any color bias. You should make all color comparisons in daylight or in light matched to 5000K.

If you have to make very large changes in the filter values of the first test, you may need to make an extra test (like the test for exposure) for filtration only.

**Second exposure test** *below*
Again, wait until your test is dry before assessing it. On this second test you should find that one of the bands is very close to neutral on your ring-around. (If you still have to adjust the color very much, you should make a third test strip before exposing the complete image.)

For the test below, the filtration was adjusted to 60Y.

70M and seems to be accurate. Again, the best exposure seems to be in the 20 secs band.

You may find that casts on your tests contain elements of two colors in the ring-around and you will have to alter more than one of the filter values. In this case, be careful to avoid creating neutral density and remember to recalculate your exposure from the filter factors.

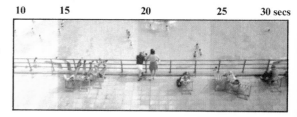

| 10 | 15 | 20 | 25 | 30 secs |

# STEP-BY-STEP PRINTING

Before you can make any exposures – for tests or full prints – you must set your image up in the enlarger. Select and clean your negative before carefully placing it in the negative carrier (only handle the film by its edges). With the carrier in the enlarger and the enlarger switched on, you can adjust the height of the head to get the magnification and cropping of the image you want. Increasing the height of the head from the paper increases the size of the image on the baseboard. Adjust the focus at full aperture, then reduce the aperture two stops and set the timer before turning out room lights and making the exposure.

## Keeping a notebook

When printing, make a habit of writing down all your exposure details. This is essential when making tests, or if you decide to make extra prints later. Under subject list film format, enlarger lens used, enlarger height, filtration, exposure time, and aperture. You should also note details of any local controls used.

## Making an enlargement

Select and clean your negative, and insert it in the enlarger carrier. With the carrier in position, turn on the enlarger and adjust the height of the enlarger head. At full aperture, adjust the focus using a focus magnifier if necessary, then stop down for exposure. Finally, dial-in or make up the filtration.

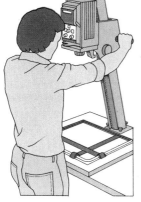

**Making an exposure**
In darkness or under the correct safelighting, position the paper on the baseboard and make the exposure.

## Local controls of print quality

When making your own prints the simplest form of control you have is composing your image so that unwanted details at the edges of the picture are not printed ("cropped out").

Apart from filtration, the most important control you have is over the darkness or lightness of your print, to increase or reduce contrast, bring out detail, and so on. You do this by increasing the exposure to selected areas (burning-in) or reducing the exposure selectively (shading).

To darken (give extra exposure to) a particular area, use a card with a hole cut to match the shape of the area (a "dodger"). After exposing the whole print, give extra exposure through

**Dodger**

**Shader**

this hole to the chosen area, keeping the card moving slightly.

You can lighten an area (reduce the exposure) by shading it for part of the exposure with a piece of card attached to thin wire (a "shader"). Again, keep the card moving slightly.

## Processing the print

Still in darkness, load the exposed paper emulsion side inward into the processing drum. Put on the drum lid and turn on the room lights. With rubber gloves on, pour out the three solutions from their containers into their dispensers. Fill the water bath with water at around 100°F (35°C) and fit the tank into the bath. Add hot or cold water until the temperature of all three solutions is within the recommended range.

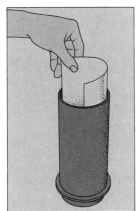

## Adding the solutions

When the temperature of the first solution – the color developer – is within the recommended range, pour it into the drum and start the timer. Revolve the drum steadily as directed during the recommended time. About 15 secs before the end of the set time, begin to drain the drum. Return the drum to its water bath and repeat this procedure with the other solutions, taking care to follow the temperatures, times and agitation recommended.

At the end of the process, take off your rubber gloves before removing the print.

## Washing

Wash the print for the recommended time in a continuous flow of water at the correct temperature. The most convenient washer is a sprinkler tray, shown right. You can, however, use trays or a sink and change the water regularly throughout the time.

After the final wash, add the print stabilizer and let the print soak for the full time.

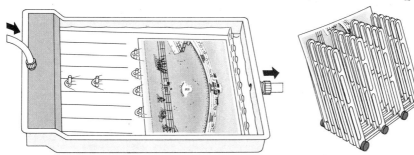

## Drying

Blot off any surface moisture then dry the print in an air-drying rack, such as shown left and below.

# MAKING PRINTS FROM SLIDES

Because transparencies are finished positive images, unlike negatives, you must use a special paper to make prints directly from them – either a dye-destruct paper like Cibachrome, or a reversal paper such as Ektachrome. Your controls over exposure will work in reverse. More exposure gives a *lighter*, not darker, image, and to remove a cast from the print you *remove* that color in the filtration.

Slides lack the orange mask which compensates for inadequacies in the negative/positive system and, as a result, some subtleties of tone and color may be lost in a reversal print. To begin with, use a well exposed slide that is not too contrasty.

*The Cibachrome process*
Cibachrome materials follow a different, shorter processing sequence from normal papers, because the dyes are present in the emulsion layers of the paper (and are selectively bleached out), instead of being formed in processing. You use only three processing solutions – a black and white developer, which develops exposed areas in each layer; a bleach, which removes black silver and dye from the exposed areas; and a fixer. Cibachrome materials are usually sold in complete kits, with full instructions for all stages. Other equipment is as for normal negative/positive printing.

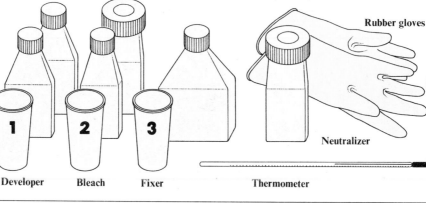

**Drum**

## Cibachrome chemicals and equipment

Once mixed, the developer, bleach and fixer should be stored in sealed bottles. Always wear rubber gloves when you handle these solutions; the bleach in particular is highly acidic, and kits include a neutralizing chemical to add to the solutions before you throw them away. Because the processing temperatures are lower, you can more easily use a simple drum such as shown right, which does not have its own water bath.

**Developer** **Bleach** **Fixer** **Thermometer** **Rubber gloves** **Neutralizer** **Timer**

## Exposing the slide

Remove the slide from its mount and clean off any dust or hairs, before inserting it into the negative carrier. Compose and focus the image on the baseboard, set your timer, and dial-in a filtration. Kits usually include recommendations of likely filter values for most film brands. Variations from these values arise largely from differences in image contrast, enlarger lights, and so on. You must make comparatively large changes in exposure and filtration values when making your tests, as shown opposite.

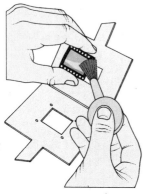

**Using the processing drum**
After the exposure, load your print into the drum, emulsion side inward, and put on the drum lid before turning on room lights. You can then pour the three solutions in and out of the drum without fogging the paper. The same rules apply to Cibachrome as to other processing procedures – clean, dry equipment is essential; even agitation (simply by rolling the drum back and forth) is important; chemicals must be the correct temperatures and free from contamination; and so on.

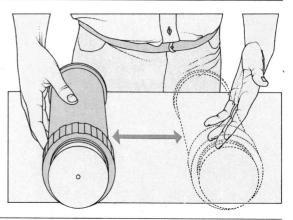

## Processing the print

Pour out the three solutions into their respective dispensers and stand them in warm water until they reach the recommended temperature range. This is usually 72–78°F (22–25°C). To avoid contamination always use the same dispensers and storage bottles for the same solutions. Before starting, prepare a container with the neutralizer to pour all the used solutions into.

Each time, check the temperature of the solution before pouring it into the drum. Total processing time is usually 12 minutes; and you can dry the print as any other resin-coated paper (see p. 171).

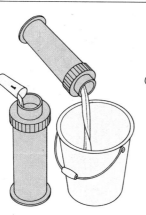

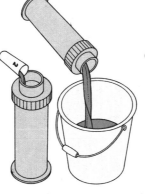

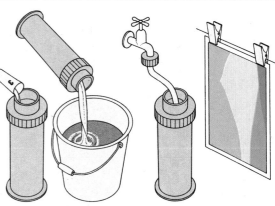

**1** Pour in the developer, agitate for the full time, drain the drum for 15 secs.

**2** Pour in the bleach, agitate, drain the drum for 15 secs into the neutralizing solution.

**3** Pour in the fixer, agitate for the recommended time, drain the drum for 15 secs.

**4** Wash for 3 mins in running water at around 75°C (24°C). Dry in a dust-free room.

## Exposure tests

Before exposing a full print on reversal paper you should make exposure and filtration tests (as in normal color printing). But, as you can see from the test, right, you have to make much greater changes in exposure (and filtration) to affect the print to the same extent. Consequently, correcting the exposure or filtration requires large changes with reversal papers.

## Ring-around

If you intend to use reversal materials regularly, you should make a ring-around, such as shown right, using a well-exposed slide. Again, choose a subject with good neutrals and skin tones, but avoid high contrast images as these will become even more contrasty in a reversal print.

Because you are printing from a positive, filters, like exposure, work in reverse with reversal materials. For example, to reduce a cyan cast in your print you must remove cyan from the pack.

Always wait until your print is dry before assessing its color; when wet, reversal prints often have a slight red cast. As in normal color printing, make sure that you eliminate neutral density from your final filtration (see p. 176–7).

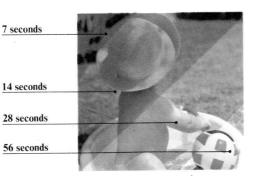

7 seconds
14 seconds
28 seconds
56 seconds

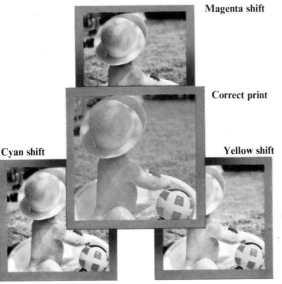

**Magenta shift**

**Correct print**

**Cyan shift**

**Yellow shift**

| Color cast | Neg/positive | Reversal |
|---|---|---|
| Print too yellow | add yellow filters | reduce yellow filters |
| Print too magenta | add magenta filters | reduce magenta filters |
| Print too cyan | add cyan filters | reduce cyan filters |
| Print too blue | reduce yellow filters | reduce magenta and cyan |
| Print too green | reduce magenta filters | reduce yellow and cyan |
| Print too red | reduce cyan filters | reduce yellow and magenta |

## Correcting color casts

In reversal printing the normal principles of filtration and exposure work in reverse. More exposure (printing-in) makes the print lighter, less exposure (shading) makes it darker. You reduce a color in the filtration in order to reduce that color in the print, and vice versa. The table left summarizes the differences in filtration between the two processes.

## Ektachrome reversal paper

With Ektachrome paper, the dyes are formed in processing as with normal paper, but the paper is given reversal processing (similar to slide film). You can do the reversal chemically, or by exposing the print to light during development, see below.

The number of solutions and the temperatures are greater than for Cibachrome. All the solutions should be at 86°F (30°C); the color developer temperature is most critical, with a latitude of only $\frac{1}{2}$°F (0.3°C). The principles of filtration and exposure, however, are the same as for Cibachrome. Begin by making exposure and filtration tests for each image, around the values the kit recommends for your film brand.

Type 22, process R 3000

**Step-by-step**
Load the exposed print into the drum, turn on room lights, and replace the drum in its water bath. Check the temperatures of the solutions — they should be 86°F (30°C) when they are poured into the drum. If necessary, add hot or cold water to the bath until they are correct. Before starting, warm up the drum and print by pouring in water at around 86°F (30°C) and rotate the drum. Drain it, add the black and white developer, and agitate every 30 secs for $2\frac{1}{4}$ mins. Drain the drum and pour in a wash at 86°F (30°C), agitate for 2 mins 20 sec. Drain and repeat for a second wash, and drain and repeat for a third. Pour in the color developer and agitate for 5 mins 15 sec. Reversal occurs in the color developer where unexposed silver halides are developed to make a positive silver image, and dyes are formed in the emulsion layers chromogenically. Drain the color developer and wash twice more for sequences of 5

mins 20 sec at 86°F (30°C). Then pour in the bleach/fix and agitate for 4 mins 20 secs. Finally wash the print for 2 mins 15 secs in running water, and dry. You can use the same equipment for Ektachrome processing — developing drug, graduates, trays, thermometer and gloves — as are used for normal print processing.

## Ektaflex PCT

Ektaflex uses the "peel-apart" system — you expose your slide or negative on to the correct film and then, using a special printmaking machine, soak the film in activator before laminating it on to a receiving paper. The dyes migrate from the film to the paper, leaving chemical residue and the silver image behind on the film.

**Loading**
After exposure, place your sheet of Ektaflex PCT film on the film ramp of the printmaking machine and a sheet of PCT paper on the paper shelf.

**Soaking**
Slide the exposed film into the activator solution contained in the base of the printmaker. Wait 20 secs.

**Laminating**
Turn the handle on the printmaker to laminate the film and paper together. You can now turn the room light on while the "sandwich" processes itself.

**Peeling**
After the recommended time you can peel the paper and film apart. Do not wash the finished print.

# PROCESSING FAULTS

It is only when you have finished processing your film that you will discover any errors, even those made in the camera. Unsharpness and similar faults will obviously have occurred in the camera. But some apparent exposure faults are, in fact, caused in development. Because negatives are an intermediate stage, whereas slides have been reversed in processing, errors in processing will produce opposite faults in prints and slides.

Density is one of the main factors in judging a good image. On a thin negative, shadow areas will appear weak and pale, lacking detail. When printed, these areas will be dark and flat (as on a dense slide, which also has muddy highlights)

and altering the printing exposure will not help. An overdense negative will be very dark, and therefore difficult to focus in the enlarger. On the print, highlights will be bleached out (as they are on a thin slide). The critical factor with a negative is sufficient density in shadow areas; with a slide, good highlights are important for projection.

A thin negative may be caused by underexposure, low first developer temperature, reduced development time, or insufficient agitation – factors which produce a dense slide image. A dense negative may be caused by overexposure, by having the first developer too warm, or by leaving the film in the tank too long – factors that produce a thin slide.

### Assessing a negative
When judging the quality of a color negative, do not be misled by its orange mask and reversed colors and tones.

The negative, right, has been correctly exposed and processed. Detail and color are present in important areas and there is a wide range of tones in the image. Shadow areas are dense enough, while highlights are not too dark.

### Assessing a slide
A slide is much easier to assess for quality than a negative, because it is a finished image with correct tones, colors, and so on. There should be a good range of tones, with some detail and color in both shadow and general highlight areas, and bright highlights should be clean, not bleached. Main areas of interest should not be too dark or too light.

### Exhausted developer
A developer which has been exhausted either by use or ageing will produce a weak, pale image on the film, lacking in detail.

### Uneven drying
Brown streaks running across the whole width of the film are caused by uneven drying. Rewash the film immediately to remove these.

### Contaminated developer
Bleach contamination of the developer will create a very weak, flat image with little detail in the processed image.

### First developer contaminated by bleach
Contamination of the first developer produces a strong blue color cast overall, and increases contrast in the slide.

### Exhausted reversal bath
An old, weak or exhausted reversal solution produces a pale, weak image with an overall green cast.

### Touch marks
Black blotches result if the film is in contact with itself in the developing tank spiral. (On a negative the blotches are clear.)

### Negative film developed as slide film
Negative film processed using E6 slide procedure and chemicals instead of C41 produced the image right. There is a strong red cast overall and the image has been reversed by the process so that highlights are pale (and would print dark) and shadows are dark (and would print pale). Contrast has increased, as mid-tones have almost been eliminated.

### Slide film developed as negative film
If you mistakenly process slide film using C41 procedure and chemicals your image will have an overall purple cast, such as shown right. Tones are reversed, as in a processed negative, and contrast is greatly increased. If you then expose this slide on to reversal color paper, subject colors will be distorted.

# PRINTING FAULTS

Although you can make alterations to an image during printing, the quality of your negative (or, with reversal printing, transparency) largely determines the quality of your final print. If adequate detail or good contrast do not exist on the film, you can only make limited improvements during printing. In addition, printing may bring out defects in your image, because it is a process of enlarging — scratches and dust are magnified indiscriminately alongside subject detail. You can, however, make general corrections (by exposure or filtration), or local contrast or density corrections (by burning-in or shading, see p. 177). You can also retouch very small marks or blemishes on

a print, using a fine brush and watercolors or inks which match the adjacent print colors.

To assess the quality of your print, compare it against the image from which it was taken, in daylight or light balanced to 5000 K.

As explained on page 179, Cibachrome materials work in the reverse way to ordinary color printing papers. If an ordinary print is too dark, the cause could be overexposure or too warm developer. If it is too pale, the cause could be underexposure or the developer being too cold. On a Cibachrome print underexposure or too cool developer may cause a dark print, overexposure or too warm developer a pale one.

## Assessing a color print

Even a well-exposed print from a good quality negative, such as shown right, should be analyzed. Look carefully at the color to see if you have used the best filtration, and at the density to judge the exposure. Both highlights and shadows should contain detail and color. Small areas can be brought out if necessary by burning-in or shading (p. 177).

## Assessing Cibachrome

Exposure and filtration principles for Cibachrome are the reverse of those for normal prints. But the same criteria apply to judging a good quality Cibachrome print, such as shown right, as a normal print. With reversal printing you have the advantage of a positive – the transparency – against which to judge the processed print.

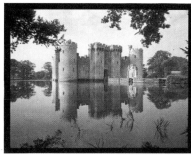

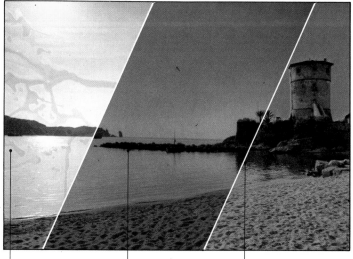

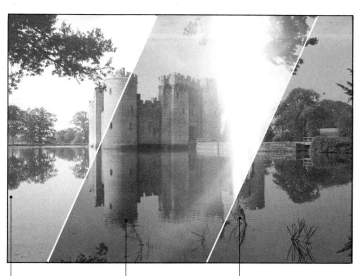

**Water stains**
Water on an unprocessed print, perhaps from the inside of a developing drum, produces dark blotches on the print.

**No filtration**
Printing a negative without any color filtration at all produces a result with an overall reddish-brown cast.

**Developer contaminated by bleach**
Contaminated or exhausted developer produces a blue, magenta or pink cast (even in the print borders).

**Developer contaminated by fixer solution**
A dull print with an overall pink or muddy yellow cast results if your equipment is contaminated with fixer.

**Fogging in the drum**
Light getting to an unfixed print in the drum desaturates colors and destroys the image in certain areas.

**Exhausted bleach**
Too short bleaching time or an exhausted bleach solution produces a dull final print with flat muddy color.

## Paper upside down

A common error is to place your paper upside down on the easel, thus enlarging on to the back of the paper. This gives you a reversed unsharp image that has an overall cyan cast. Printing papers are normally packed emulsion side up in their light-tight box. The emulsion surface of printing paper is that toward which it naturally curls.

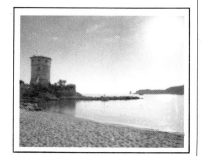

## Print processed back to front

The Cibachrome print, right, was loaded into the processing drum back to front. The processing solutions reached only parts of the print, leaving unprocessed solid black areas elsewhere. You can identify the back of Cibachrome paper by gently rubbing it with your fingers – it should faintly rustle, whereas rubbing the emulsion surface will produce no sound at all.

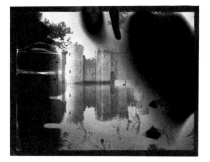

# DARKROOM EFFECTS—COLOR FROM BLACK & WHITE

In the darkroom you can achieve many special effects quite simply, using variations of the standard procedures for color printing and processing. Many of the effects are by their nature experimental – this is half of their interest. The following pages give general recommendations; you must experiment yourself to discover the particular requirements for your negative and print.

*Printing black and white negatives on color paper*
One simple way of producing a special effect is by printing black and white negatives on to color paper, as in the sequence shown on this page. The first step is to establish a neutral filtration; since black and white negatives do not have a compensating orange mask, you will have to use a fairly high yellow and magenta (orange) filtration for this. Then you can add or subtract filters, in a second test, to obtain the colors you want.

Even at a neutral filtration, unusual color effects will appear on the print, because the color paper does not respond uniformly to black and white negatives. You can control the colors selectively by burning-in or shading.

### Color filtration of a black and white image

The negative of the black and white print above was chosen for printing on to color paper because it was not too contrasty, but had a good tonal range. This brings out color that you add in the filtration, and also encourages a variety of color casts to form. You can get extreme results from an under- or overexposed negative, as the highlights and shadows may produce different colors. You can see this in the green/yellow end of the test strip, right. The print below was produced by the filtering sequence, explained right.

**Filtration**
Insert the negative, in the carrier, into the enlarger. Compose the image, then dial-in an estimated neutral filtration. Because the negative does not have an orange mask, use a high yellow and magenta filtration – 100Y 60M 0C was used for the print below.

**Test strips**
Before you can expose the complete image you must make two tests. The first, above, at the neutral filtration, shows bands of exposure of 5, 10, 15 secs, and so on.

The test below is for color; again, each step is at five second intervals. On the left, the filtrations is 0Y 120M 0C, producing yellow; on the right, a filtration of 60Y 20M 0C produced red.

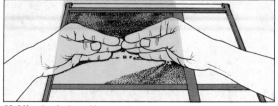

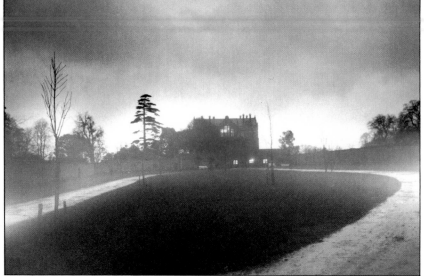

**Final print**

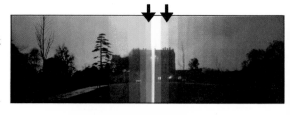

**Holding back the mid-ground**
At the neutral filtration the middle section of the print was held back, by shading, for the 15 second exposure. Only the foreground and sky printed as neutral. (Keeping your hands moving slightly will avoid creating a hard edge.)

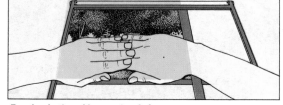

**Burning-in the mid-ground and sky**
For the next stage, the mid-ground and sky were burned-in for ten seconds. The filtration, of 60Y 20M 0C, printed the mid-ground as red and the sky as a degraded red color (because of its previous neutral exposure).

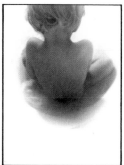

**Burning-in the foreground**
Finally, the sky and mid-ground were shaded and a filtration of 0Y 120M 0C was used for five seconds.

This produced a yellow color in the foreground, degraded by the blacks of the first, neutral exposure.

### Selective exposure

You can achieve very subtle effects by using a subject with closely matched tones and overlapping the color filtrations.

The subject, right, was first printed at its neutral filtration. Then, for the near right picture, a blue filtration was made, followed by a cyan filtration, holding back some areas and burning-in others. For the far right picture, a green filtration was followed by a yellow filtration.

**Blue result**

**Green result**

# COMPOSITE PRINTING

Double printing two negatives (color or black and white) to obtain composite images is very simple. Each negative should be exposed separately, at its own filtration and exposure, masking off areas to obtain a composite print. Choose two images which counterbalance each other in areas of interest – a negative with an interesting foreground combined with one that has an interesting background, for example. Prints and tests for neutral filtration and color variations have to be made as usual. But before you begin making any tests, put each negative in the enlarger in turn and trace on to a sheet of paper the detail from each you want printed. This will help you determine the respective enlargements and cropping necessary, and the masking for the second negative.

## Using two originals

For the composite color print below left, the negatives of the two prints, right (one color, one black and white) were used. They are both strong simple images that will print well together. When you are combining the two negatives, relative position and size of the images is almost as important to your final result as the filtrations and exposure you choose. For the composite image you can alter the enlargements and positioning as you wish, to create, for example, strange distortions of perspective and scale.

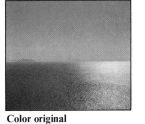
**Color original**

**Black add white original**

### Tracing off the combined images

With the color negative of the sea in the enlarger, the enlargement and cropping were chosen and critical details of the image were traced on to a sheet of paper. The exposure and filtration tests were made at this enlargement and processed. The position and size of the second negative was marked on the same sheet of paper. Tests for exposure and filtration (first neutral, then color) were then made.

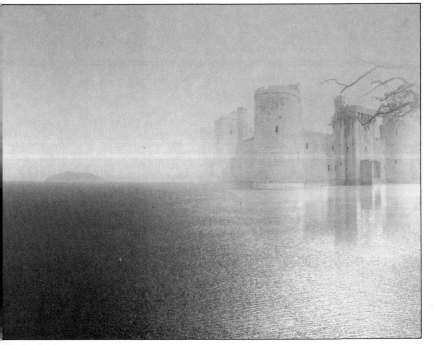
**Final print**

### Exposing the two negatives

The first negative was positioned and exposed at an exposure reduced by one stop. For the second exposure, the rest of the image was masked off with card. Again, filtration and exposure (about one stop lighter) were taken from the tests. In the final print, left, the sea filtration was 70Y 30M 0C and the castle 88Y 65M 0C, both were given ten second exposures.

## Printing from two color negatives

Printing black and white negatives on to color paper restricts your color range to the filtrations you use. Combining two color negatives enables you to get a full range of hues. The two prints right are the result of combining a color negative of the castle with a color negative of the sky at sunset (giving the "misty" foreground). The far right print was exposed at the neutral filtration. Yellow and magenta filter values were reduced for the near right print to produce the burnt orange color.

**Orange print**

**Neutral print**

# SOLARIZATION

**Original color print**

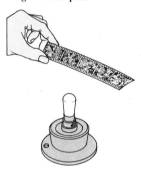

**Exposing the negative**

Strictly speaking, solarization is the reversal of the image on film by extreme overexposure. On the emulsion, the intense light would produce a black image, instead of white. In the darkroom, however, the term solarization is commonly applied to an effect, similar in appearance, known as Sabattier. This is produced by briefly exposing a partly developed negative to light, and then continuing development. The result is part negative, part positive. (The extent of the reversal depends on the duration, intensity, and moment of exposure.)

A further change in the image is also created by solarization – the Mackie line effect. On the final negative or print, a black line forms separating different tones from each other, so that principal areas of the image are clearly outlined.

You can produce a solarized print most simply by exposing a color negative to light during processing, and then printing it. But a stronger separation of tones is achieved by making a black and white copy negative of a normal color print, solarizing this, and then printing it in register with the original color negative. (At the copying stage you can use color filters to further strengthen the contrast in the black and white negative.) Use a copying stand (p. 200) to copy your color print.

### Making a solarized print

Select a strong colored, simple image, and copy the print on to black and white film. (In this example the image was copied through a red filter to increase contrast.) Begin to process the film normally. About two-thirds through the developing time, remove the film from the solution, rinse it in water, and expose it about 18 ins (46 cm) away from a white light for about 10 secs. Complete the development, fix, then wash.

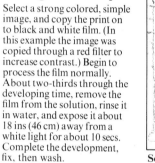

**Solarized copy negative**

### Solarizing the black and white copy negative

Until you have made a test strip to produce a neutral color, the effect of the solarized black and white negative on the color is difficult to predict and control. To obtain the filtration for the two negatives printed together, you add the neutral filtration and exposure of the copy to the filtration and exposure for the original print. Sandwiched together in the negative carrier, the two negatives at this combined filtration produced the print, below left. Notice how the red subject areas are emphasized in the print – a result of using the red filter in copying.

You can experiment further with the colors by, for example, emphasizing the red in the printing, below. This is done

by decreasing the yellow and magenta in the filtration.

When printed, the two negatives should be in register – any points that are out-of-register will create a three-dimensional effect known as bas-relief, with an increase in line and texture.

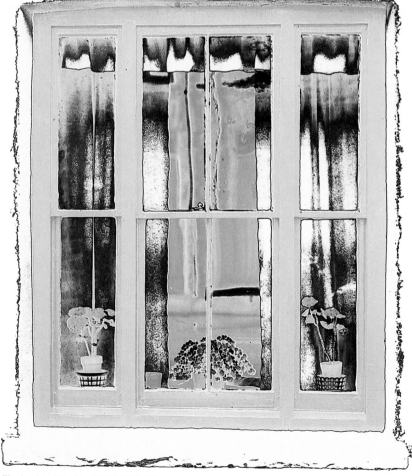

**Final print: filtration 110Y 64M 0C**

**Final print: 15Y 54M 0C**

# POSTERIZATION

Color posterization simplifies a normal variable tone image into separate areas of flat tone, producing a poster-like image on the print. The process involves separating the colors in a normal color image into their component three primaries, and then printing these three separated negatives additively through their respective primary colored filters. This is done by copying the image on to black and white film (or high contrast, pan lith film) separately through three primary colored filters. (You can adjust texture, tone and contrast by varying the exposure and development given to each separation.) When processed, the copies give you three black and white negatives, each corresponding to one of the primary colors.

Printing these negatives in turn through their primary colored filters gives you the posterized result. Keep the three filters constant throughout; you can alter the color balance in the print by varying the exposure given through each filter. To remove a color cast, increase the exposure through the same color filter, or combination of filters.

**Posterizing a print**
The cottage, above, is an ideal subject for posterization. It contains areas of different bold colors that will produce three strong, sharply defined separations. The red roof, for example, will record as a solid dark area in the red separation and as a light area in the green and blue. Since posterization simplifies and "flattens" the image, shapes in the subject are emphasized.

**Copying**
Use ordinary black and white film to produce your separations. Set up your print on a stand, then take three exposures through a red, green and, finally, blue filter, all of equal density.

**Filtration**
Make separate tests through each appropriate filter to determine the exposure for the density of color you want. You must reduce the exposure times suggested by the tests by about a third to obtain the same density on the print.

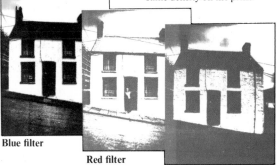

**Blue filter**

**Red filter**

**Green filter**

**Final print**
The three prints above were each printed from one of the separations. A standard combination of the three separations produced the posterized print, left. To produce the more detailed variation below, the exposures for the green and blue separations were reduced by two thirds.

**Final print: R 15 secs G 15 secs B 15 secs**

**Final print: R 15 secs G 5 secs B 5 secs**

# SPECIAL EFFECTS WITH CONTOUR FILM

"Equidensity" or contour film, produced by Agfa, is one of the many specialized films you can use, with experience, to achieve unusual effects. It is a black and white sheet film which produces high contrast line images that look rather like black and white solarized negatives. The film has a mixed emulsion, of slow and fast halides, that produces a half negative, half positive image. During processing the combined emulsion of the film undergoes two types of development – physical and chemical – to produce this image. In physical development, the silver image is formed directly by the developer's action on the emulsion (rather than by normal exposure and development). As a result, on the processed film highlights have been blackened by normal chemical development, while shadows have also been blackened, by physical development. In the intermediate tones only the most sensitive of the two halides has received enough exposure and this may appear as clear white lines.

You can select the band of equidensity (and therefore the arrangement of lines in the image) by your exposure and filtration. Reducing the exposure will move the equidensity band towards the shadow tones; increasing the exposure moves it towards the highlights, or paler tones. You can also alter the width of the lines by filtration. A yellow filter will reduce the thickness of the lines, a magenta filter increases the line thickness. Recopying the image on contour film will eliminate all tone areas and also improve the line quality.

You will have to make all your exposures on contour film under the enlarger, not in the camera. In addition, you will need a special (red) safelight, and developer and stop bath.

## Making orders of equidensities

You can use almost any image, black and white or color, negative or positive, for contour printing.

Copying an image on contour film produces "orders" of equidensities which are successively more refined. The negative, right, was contact printed on to contour film for the "first order" image, right. In this image tones from the equidensity band have reproduced as gray areas. Thin white lines have been formed between adjacent highlight and shadow areas (which are both black).

When this image is contact printed on to another piece of contour film, a "second order" image is produced. Contrast has been increased, sharpening the line effect. Areas of gray have been eliminated and are now bordered by fine lines.

A "third order" copy, bottom right, strengthens the image still further. The lines have been sharpened and are now very fine double lines.

Most exposures on contour film need several seconds; you can judge from the color of the emulsion surface of the film whether you have over- or underexposed. When the exposure is too short, only the blue-black silver formed by physical development will be visible. If the film is overexposed, the emulsion will appear silvery brown. When both colors are in evidence, exposure is correct.

**Original color print**

**First order density**

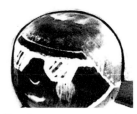

**Detail**

**Second order density**

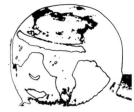

**Detail**

**Third order density**

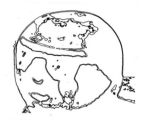

**Detail**

## Making composite contour prints

The print below was made from three different second order images, produced by three different yellow filtrations. These were then printed in succession with magenta, cyan and yellow filtrations respectively. Notice how additional equidensities are formed where the images overlap.

The print, right, was made using a second order negative and a copy of this on line film. (The high contrast copy, being a negative, prints in all areas but the equidensity lines.)

**Composite contour film print**

**Contour and line film combination print**

# PHOTOGRAMS & SCREENS

**Unusua**

Photograms are images produced without a camera by exposing objects in contact with printing paper (or even projected from the negative carrier). The result is a very simple image, showing the shapes of solid objects in white against the black background of the paper. However, you can experiment by altering sharpness, contrast or color.

You can alter sharpness and contrast by changing the distance of the objects from the paper, or by using objects with a different opacity (with the objects in the negative carrier you can also adjust focus). The result of altering sharpness or contrast is to produce a limited three-dimensional effect in what is otherwise a flat image. The filtration and the varying amounts of light falling on the paper (caused by the different opacities of the objects) also result in various color effects. Generally, pastel colors predominate; fully saturated colors are harder to obtain. Experimenting and producing tests to obtain a neutral filtration will help you to control the colors in your print.

Enlarging through a screen (either placed in the negative carrier or laid over the paper on the baseboard) can produce a range of finishes on your print, from abstract – where the screen breaks up the image entirely – to more subtle effects.

**Fisheye l**
This 7.5 n
cords eve
giving a f
The imag

### Making photograms

For all photograms it is advisable to make exposure and filtration tests as you would do in normal color printing.

Three of the very different effects you can achieve with photograms are shown right. For the near, top print, silver foil was placed in contact with the paper, and two exposures were made. The first was at neutral filtration (shading the areas to be printed red); the second was used to burn-in red areas only, with a red filtration.

In the near bottom print a strong three-dimensional effect was achieved by placing the objects – pins – in the negative carrier itself.

Tiny dried flowers were placed in the negative carrier for the first exposure in the photogram, far right. The stalks were held back during the exposure (to soften their outline). For the second exposure a piece of acetate, colored with felt marker pens, was placed on the paper. The top part of the paper was held back to reduce the montage effect.

**Silver foil on printing paper**

**Pins in negative carrier**

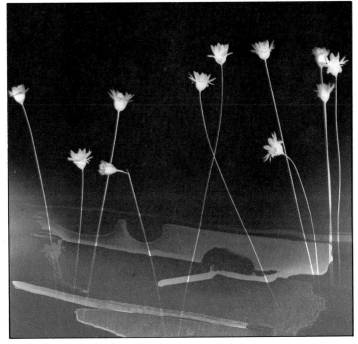

**Flowers in negative carrier, colored acetate on printing paper**

**Mirror le**
Mirror, o
offer a lor
relatively
struction.
a focal ler
front elen
is very wic
portion o
mirror ho
right, ligh
passes into
the edges
ing, is refl
portions c
to the fror
back thro

### Screens

You can use almost any non-opaque material as a screen to add a pattern to your print. However, the coarser the pattern of the screen, the more your image will be broken up. The three prints, right, were produced either by exposing a screen and negative together in the enlarger, or by placing a screen on the paper.

Various patterned screens can be bought commercially, but you can make your own. Find a suitable textured or patterned surface and take a slightly underexposed shot of it in even lighting. If you then slightly underdevelop the negative, you will have a patterned image, pale enough to act as a screen.

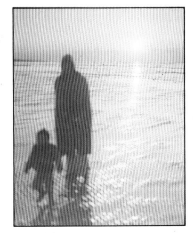

**Wavy line screen**
This print was produced by exposing with a wavy line screen in the enlarger.

**Fine cloth screen**
A colored open weave cloth was placed over the paper for this result.

**Coarse screen**
A coarse patterned neutral screen was exposed with the negative for this print.

# CAMERA FILTERS

Although some extreme focal length lenses have built-in filters, or a special filter slot in the lens body, most filters are mounted so that they can be screwed in front of the lens. Some manufacturers offer a universal filter holder, as shown below, but filters are mostly sold in their own threaded mount.

The table, right, divides the different types of camera lens filters available into five groups. They are listed against their availability among the major manufacturers, with useful cross references to other areas of the book where applications of the filter are discussed, or illustrated. The fourth column shows whether a particular filter affects exposure. If it does, use the filter factor given by the manufacturer, unless you have a TTL meter.

The first two groups contain commonly used filters that help to keep a color image true. Ultra-violet (UV) and polarizing filters reduce the effects of ultra-violet and scattered light where haze and glare are undesirable. (Skylight filters, not on the chart, also eliminate ultra-violet light, and some blue light too.) A neutral density filter reduces the intensity of light without affecting color or tonal range, so you can alter the required exposure to manipulate depth of field or use fast film in strong light. Conversion filters (p. 51) are colored and are designed to re-balance the response of your film for unsuitable lighting. For example, there are filters to correct the effects of tungsten lighting on film balanced for daylight and vice versa.

The remaining groups contain filters used to achieve false color, multiple or distorted images, or various kinds of frame division so you can treat different areas of the frame separately. These filters are either densely colored to produce a predominant color cast, or they are clear, but ground or treated to manipulate the subject light.

Filters are made of gelatin, acetate, or glass. All but glass filters may be ruined by thumb marks.

## Using a filter kit

The filter kit, right, consists of a universal holder and many different color and density acetate squares. You buy the holder threaded to fit the lens you choose to use, and it opens to take any of the squares. You can combine the available colors, overlapping them or cutting them to divide the frame, but be sure to consider their combined density for exposure calculation.

You need not be bound by the filter materials provided by the manufacturer – you may be able to achieve similar effects by your own ingenuity. You can certainly cut or treat the acetate to make frame, spot, or diffusing filters.

**Filter chart**

| | | Cokin | Hoya | Vivitar | Filter factor | Page reference | Effect |
|---|---|:---:|:---:|:---:|:---:|:---:|---|
| **Standard** | | | | | | | |
| | Ultra-violet | | ● | ● | Yes | 144 | Haze decreased, and so distant colors stronger. |
| | Polarizing | ● | ● | ● | Yes | 61 | Non-metallic reflective glare reduced. Contrast increased. |
| | Neutral density | | ● | ● | Yes | 90, 148 | Light intensity reduced by a constant factor. |
| **Correction** | | | | | | | |
| | Conversion | ● | ● | ● | Yes | 51 | Color cast prevented. |
| **Strong color** | | | | | | | |
| | Center spot | ● | ● | | No | 79 | Diffuse, colored surround leaving center clear for main subject. |
| | Dual color | | ● | ● | Yes | 79 | Each half of the frame receives a different color cast. |
| | Single color | ● | ● | ● | Yes | 73, 76 | Whole frame receives a cast to match the filter color. |
| **Distortion** | | | | | | | |
| | Diffraction | ● | | | No | 191 | Strong highlights split into spectral color bursts. |
| | Diffusing | ● | ● | ● | No | 162 | Colors muted, focus softened. |
| | Cross screen | ● | ● | | No | 148 | Highlights exaggerated into star shape. |
| | Prism (multi-image) | ● | ● | ● | No | 134 | Image repeated and overlapped within the frame. |
| | Prism (colored) | | ● | | Yes | 191 | Casts of the spectrum colors imposed in a pattern. |
| | Double exposure | ● | | | No | 191 | Frame masked half at a time. |
| | Framing | ● | | | No | | Edge of frame masked to form a black or colored surround. |
| **Special** | | | | | | | |
| | Infra-red | ● | ● | ● | Yes | 49, 78 | Short wavelength light (up to blue/green) absorbed when using IR film. |
| | Underwater | | | ● | Yes | 143 | Removes cyan cast from underwater shots at more than ten feet. |
| | Split-field | ● | ● | ● | No | 191 | Allows differential focus within the frame. |
| | Close-up | ● | ● | | No | 194 | Increases image size without changing lens. |

## Effective filtering

The pictures on this page show how special effect filters can be used to strengthen an image. The multi-colored prism filter, used near right, produces multiple images with spectrum-colored casts across the frame. The diffraction filter used at a carnival, far right, has also produced a false color result. The filter is, however, clear glass with a multi-faceted surface that diffracts strong rays of light striking it, splitting them into rainbow bursts of color. Clear prism filters are also made, with fewer distinctly ground faces. These cause the image to repeat itself within the frame, as in the racing car shot, center right.

The star-shaped highlights in the fishing shot below, were produced by a criss-cross grid in a clear filter: a cross-screen or "starburst" filter. The colors of a hamburger stand, below right, have been muted by a diffusing filter. This is another clear type, but has concentric etched circles which scatter the light from the subject, softening the image.

To reduce glare from reflective non-metallic surfaces and from clear blue skies, you can use a polarizing filter, as shown bottom left and right. You first focus, then turn the filter mount until glare decreases and colors appear richer, before taking the shot.

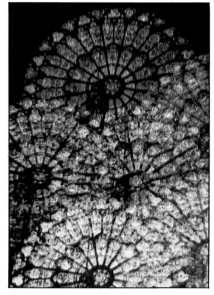
**Spectrum colored prism filter**

**Diffraction filter**

**Multi-image prism filter**

**Cross-screen filter**

**Diffusing filter**

**Without polarizing filter**

**With polarizing filter**

## Filters that divide the frame

The robot pictures, below, illustrate the use of a split-field filter where the lower half of the filter only is given over to a converging lens that gives additional close-up sharpness. The filter used for the illusion, bottom, totally masks one side of the frame so you can rotate it 180° between exposures.

**Without split-field filter**

**With split-field filter**

**Double exposure mask**

# VIEW CAMERAS

View cameras mostly use 5 ×4 ins or 10 ×8 ins sheet film, and also accept Polaroid or rollfilm backs. The monorail, or technical camera, shown right, is a highly developed view camera.

The camera is focused by moving the lens panel (or "standard"), the image being formed upside down on the viewing screen. Fit the focusing hood, shown right, and the image appears right way up. When the subject is sharp and you are ready to expose, you remove the viewing screen and replace it with the film (you can load two sheets back-to-back in a typical sheet film holder).

This lengthy exposure process, and the camera's size and need for a heavy tripod, are disadvantages; but the quality of large-format color negatives and slides is unbeatable. The modern view camera also allows remarkable adjustment of the lens plane in relation to the film plane, for fine image control. There are two sorts of these camera movements: cross and rising front, where the lens and viewing screen remain parallel but are moved independently from side to side or up and down; and swing and tilt, the turning of either film or lens plane through their center axes, from side to side or up and down. Cross and rising front control subject framing. Swing and tilt control the extent and position of sharp focus in the frame, and perspective.

## Monorail camera

The large format camera right, is fully adjustable. The focusing hood, below, and the row of film backs, bottom, are all compatible. A film plane spot meter is shown bottom, far right.

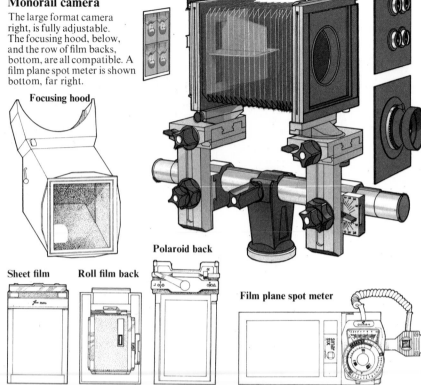

**Focusing hood**

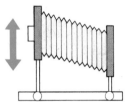

**Polaroid back**

**Sheet film**          **Roll film back**

**Film plane spot meter**

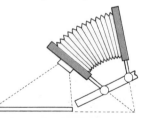

---

## Camera movements

### Rising front
Moving the lens panel up or down, parallel to the viewing screen, alters the subject area recorded. This can be useful if an obstruction, like the wall below, obscures the scene even with the tripod at full extension.

### Swing
Turning the lens panel in relation to the viewing screen alters the angle of the plane of sharp focus in the subject. The two butterflies, below, are at different distances from the camera, so one would normally be out-of-focus (top). With swing, the plane of sharp focus has been twisted to include both butterflies (bottom).

### Correcting vertical perspective
Simply raising the camera rail produces the top picture. By using the movements indicated, the converging verticals are corrected, and the roof is included.

### Tilt
Tilting the lens and viewing screen panels together in a vertical plane, as shown in the diagram below, increases depth of field to a maximum when the subject plane, lens plane, and film plane converge on one point.

**Without movement**

**Without movement**

**Without movements**

**Without movements**

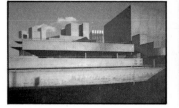
**With movement**

**With movement**

**With movements**

**With movements**

# STUDIO EQUIPMENT

Building up a temporary or permanent studio requires extra equipment if you want absolute control of your results. Once you have established sufficient space for the lens and camera angle you will be using, your two main considerations will be background and lighting.

Mat white painted walls make a good neutral background; for a wider choice, you can use colored-paper backdrops. Various sizes of roll are available. You can cut lengths and attach them to the wall, or better still, support a selection of rolls on bars and stands, as shown, so that you can roll down the backdrop of your choice easily. For smaller subjects, especially still life, a high-backed table frame in wood or angle-iron is invaluable. You can put opaque or translucent surfaces on to the table, or hang colored paper or material from the top of the table back. Drops that curve down under the subject itself will create a sense of infinite space in the background.

Once you have subdued any daylight entering your studio area, you can control subject lighting completely with the artificial lighting you introduce. Studio lights are either floods or spots: floods have reflectors or diffusers to spread the light, so the illumination is soft; in spots, the light source shines a well defined beam, that gives harsh lighting. Spotlights can be further narrowed by barn door shades or a snoot attachment. Whereas you can add a diffuser to a spotlight, you cannot re-focus a flood light to give a spot effect.

You have the choice of tungsten lighting, or studio flash units. Tungsten lights plug straight into your power supply (always check that your total lighting will not overload the power circuit); but mains-powered flash units have a control box from which you can usually run up to four flash heads. Flash units sometimes have a small, built-in modeling lamp, for previewing the flash effect. Flash lighting allows a greater choice of films than tungsten lighting (see pp. 50–3).

A variety of stands is available to support your lamp heads. Clamp connectors are also useful, as is a G clamp converted to support lights or cameras.

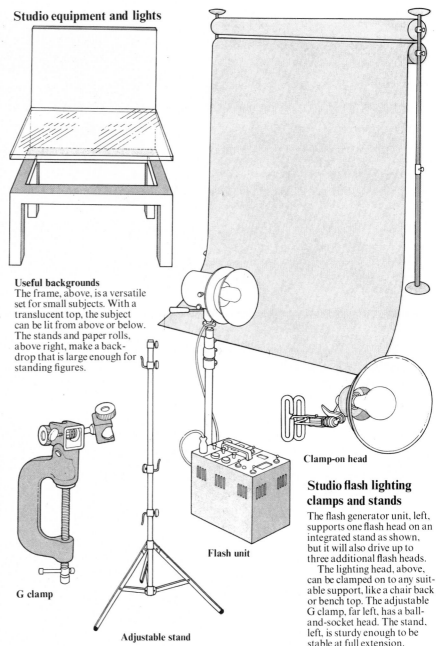

**Studio equipment and lights**

**Useful backgrounds**
The frame, above, is a versatile set for small subjects. With a translucent top, the subject can be lit from above or below. The stands and paper rolls, above right, make a backdrop that is large enough for standing figures.

**G clamp**

**Adjustable stand**

**Flash unit**

**Clamp-on head**

**Studio flash lighting clamps and stands**
The flash generator unit, left, supports one flash head on an integrated stand as shown, but it will also drive up to three additional flash heads.

The lighting head, above, can be clamped on to any suitable support, like a chair back or bench top. The adjustable G clamp, far left, has a ball-and-socket head. The stand, left, is sturdy enough to be stable at full extension.

**Tungsten lighting**
The tungsten lighting heads that you see in a studio will either give a narrow beam, or a wide arc of light. The first three lights shown right give a wide flood effect because the beam is diffused with a reflector or diffuser. The spotlight, far right, is fitted with barn doors which can be adjusted, where a snoot attachment cannot. Note that a spotlight can be directed into an umbrella reflector to give a diffused, flood effect.

**Flood with diffuser**

**Mushroom reflector**

**Umbrella diffuser**

**Spotlight and barn doors**

**Snoot**

# MACROPHOTOGRAPHY

Even set at its closest focusing distance (say 2.5 feet, 0.75 m), your standard lens will show very small subjects disappointingly small in your frame. Pictures like those shown here require the equipment and skills of macrophotography – close-up photography up to ×10 magnification.

You can buy close-up lens attachments that fit in front of your camera lens like a filter (p. 190). These converge image light rays before they reach the camera lens, allowing closer subject distances. (They are graded in diopters: units that express the light-bending power of a simple lens, where + indicates converging, and −, diverging.) Adding a close-up lens may reduce sharpness and color quality, and magnification is limited.

With interchangeable lens cameras you have other choices. Some manufacturers produce an additional lens mount that allows you to reverse your standard lens, so you get sharp focus with very close subjects. You can also get lenses with a "macro" facility, which allows you to adjust the focusing ring down to very short subject distances. Macro lenses are usually of standard focal length, or medium telephoto; but some zoom lenses offer a "macro" switch.

A popular way of providing the extra space between lens and film needed for close-up work is to add an extension ring or tube between lens and camera. With your standard lens, this will enable you to record subjects at up to half life size. If you use a macro lens with an extension tube, or fit a set of tubes, life-size pictures are possible. But for increased flexibility and further lens extension it is best to use extension bellows. Shorter focal length lenses give most dramatic magnification, although slightly longer lenses allow you to work further from the subject.

Depth of field becomes increasingly shallow as you go in closer, so you must have a firm tripod to prevent camera shake during the long exposures necessary at small apertures. Doubling the lens-to-film distance quarters the light that reaches the film, so non TTL exposure readings must be adjusted accordingly.

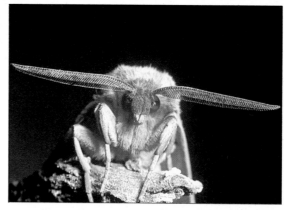

### Close-up equipment

The close-up lens attachment, right, screws in front of the lens. A reversing ring screws into the filter thread at the front of your normal lens. Its other end duplicates the normal lens mount. Extension bellows usually adjust along a rail to give you between ×1 and perhaps ×10 magnification. Fine focusing is controlled by the focusing ring.

### Enhancing your subject

Industrial photography often requires close-up techniques, and today's precision components can make graphic subjects. The highly detailed shot, right, of gas turbine blades, is at ½ life-size on the original slide. The complex differential subject planes required a small aperture for maximum depth of field, so powerful, diffused flash was used. Strong highlights, and a blue filter, dramatize the metal surfaces, but the diffuse flash prevents hard shadows which would detract from the modeling of the blade shapes.

### Using bellows, macro lens and reversing ring *left and opposite*

You can use several close-up techniques in combination. For these two pictures of a moth, the set-up included extension bellows and a macro lens, but the magnification was still insufficient. With a reversing ring, the macro lens was then turned around, to give a range of greater magnification including the picture left, where the moth is ×2½ life size on the original slide, and opposite, where it is ×4 life size on the slide.

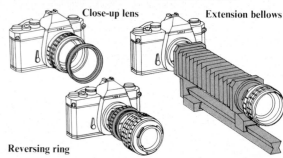

Close-up lens

Extension bellows

Reversing ring

### Time-lapse sequence

The life-cycles of winged insects can present fascinating close-up time-lapse subjects, especially if you can catch a relatively fast metamorphosis, like the emergence of a wanderer butterfly from its chrysalis, right. (See pp. 138–142 for outdoor and indoor wild-life techniques.) Release the shutter at every likely point of action and choose the best sequence after processing. Note that the blurred background frames the subject.

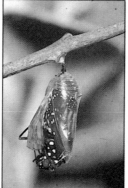
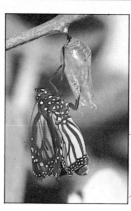
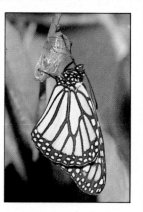

# PHOTOMICROGRAPHY

To take pictures at more than ×10 magnification, you have to use a microscope in conjunction with your camera. This is a specialized field: you should really be familiar with a microscope, know how to prepare specimens, and be acquainted with the various forms of microscope lighting, before you begin. Your subjects can then range from everyday minutiae to rare samples. The quality of pictures depends on the quality of the objective lens in the microscope. To calculate image magnification at the film, you multiply the eyepiece magnification by the objective lens magnification and the distance from eyepiece to film (in mm), and divide by a constant, 250.

A 35 mm SLR camera with TTL metering is easiest to attach to a microscope and use. (Other types of metering are laborious.) You will require a convertor attachment to join the camera body to the microscope eyepiece, as in the set-up shown right. If your TTL meter works only with a lens in position, you require a convertor that screws into the filter thread of your standard lens (set to infinity and its widest aperture). To focus the image, you use the microscope controls, not the camera lens.

The whole set-up must be vibration free, as any shake will be magnified with the image. Even with a cable release, shutter speeds slower than ½ sec may cause blur, while the shutter mechanism itself can cause vibration at speeds faster than 1/30 sec. Select a shutter speed within these limits, and then arrange your lighting strength to suit. You will also have to consider film speed: Kodak's micrography film, for example, is rated at 16 ASA. Slow speed films give good resolution, and help maintain color saturation at magnifications above ×25.

You can also use a view camera for photomicrography, by converting an enlarger stand to support the camera rail and fitting a special light-trapping lens panel. This panel links with the eyepiece.

## Photomicro equipment

The 35 mm SLR body right, is shown with connector attachment suitable for the quite sophisticated microscope below it. The microscope has a variety of objective lenses for different magnifications. A prism in the monocular head bends (refracts) the image light to give an easier viewing angle. The analyzer and compensator work in conjunction with the sub-stage polarizing filter which is an integral part of this microscope. It also has a sub-stage condenser with its own focusing control.

The microscope, below, connected to a view camera with focusing hood, has its own viewing system separate from the camera connection. This is vital if you intend to use a camera without through-the-lens viewing.

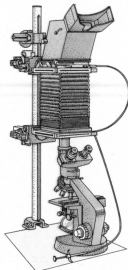

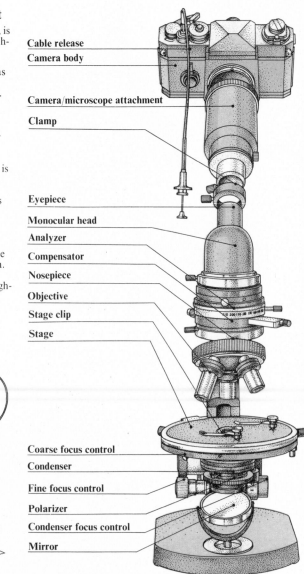

Cable release
Camera body

Camera/microscope attachment

Clamp

Eyepiece
Monocular head
Analyzer
Compensator
Nosepiece
Objective
Stage clip
Stage

Coarse focus control
Condenser
Fine focus control
Polarizer
Condenser focus control
Mirror

## The problems of magnification

**Same-size**
The picture above shows the surface texture and colors of semi-precious stones in their bedrock at life-size. Detail is sharp, but you cannot detect the individual textures of the different colored minerals. The contrasted crystal line structure of each mineral remains indistinct.

**×3 magnification**
The ×3 magnification, above, was photographed using a bellows extension tube. Now the individual colors and textures of each mineral crystal are visible, with good color contrast and definition. Focus is sharp throughout the image.

**×10 magnification**
This magnification reaches the limit possible with macro equipment. Color contrast is poor compared with the potential suggested by the life-size result. Focus is not constant even through these limited subject planes as depth of field has become too slight for macro-photographic techniques.

**×25 magnification**
The multicolor result above shows the same subject but magnified 25 times using a microscope. Polarizing filters were used to reveal detail and produce the colors shown. The overall shape of crystals has been lost, in favor of showing the striking internal structure, using dark field lighting for maximum contrast.

## *Lighting*

Using a simple tungsten lamp, there are two ways you can illuminate microscopic subjects. For magnification to ×60, remove the sub-stage condensers from the microscope and simply direct the light toward the sub-stage mirror, adjusting it to give even illumination of the subject. (For magnifications of more than ×60, the sub-stage condensers must be focused before exposure.) Using the mirror in this way will give *bright field* illumination – the background will appear light. Translucent subjects are best for bright field work. If you re-arrange the lamp to shine obliquely on to the microscope stage itself, you will get a black background – *dark field illumination.* (Angle the sub-stage mirror to prevent it transmitting any light from below.)

For moving microscopic subjects, you can consider using flash, for bright or dark field results. The flash unit must be powerful enough to give a very brief, but intense flash. The adjustable-head type is best and you will find it useful to incorporate a tungsten filament bulb to shine along the flash axis, so you can align the unit before exposure.

Many specimens only reveal their full structure and detail in polarized light. Some microscopes have a built-in polarizing filter for normal viewing. For photomicrography, you have to use two polarizing filters, one between the light source and the stage, and one between eyepiece and film.

## Lighting techniques

You can use tungsten or flash lighting for microscopic subjects. The soft bodied rotifer, right ( ×250 on the slide), shows bright field illumination. As shown far right, flash was directed straight on to the sub-stage mirror, reflected up through the translucent subject, and the objective lens, and on toward the film. The water flea, below right ( ×15 on the slide) is highlit against a black background, showing dark field illumination. The lighting was played directly on to the stage, see below.

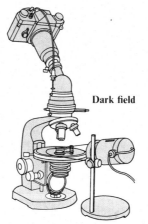

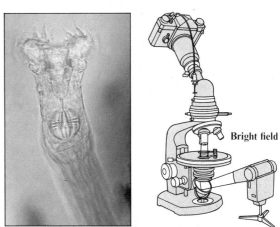

**Bright field**

**Dark field**

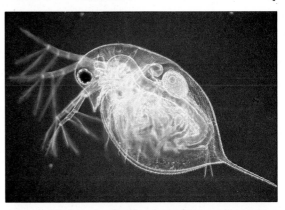

## Using polarized light *right*

Polarized light can enhance detail and contrast, and add color, in subjects that would otherwise appear neutral and indistinct, like the granite chip at ×40, left. One polarizing filter is put between eyepiece and film, and another between the light source and the subject. Using a bright field set-up, turn one of the filters until the field of view darkens. You can now change to a dark field set-up if desired.

## Revealing microscopic detail *left*

This picture of a section of the leg of a cat flea, showing the air supply tube (trachea) passing through the front socket, required ×100 magnification. The quality of your results at extreme magnification depends on the resolving power of the objective lens you use. A ×40 water-immersion achromatic objective was used in this case.

At magnifications of more than ×60 you must use the microscope condensers to focus the illumination for even coverage. Hold a pencil point above the condenser so you can see its silhouette on the viewing screen. Use the condenser focusing control to render the silhouette sharp before exposure.

# PRESENTING PRINTS

The same care and skill you devote to your picture-taking should be extended to the storage, mounting and framing of your prints.

Negatives need protection from damp, heat, dust and fumes so keep them in transparent sleeves or envelopes. 35 mm and roll films can be cut into strips six or four negatives long respectively and stored in sleeves; large format negatives need individual sleeves. As sleeves are easily crumpled, keep them in boxes, drawers or filing cabinets or, for most efficient retrieval, file them in an album.

To present your prints, you can mount them either in an album or singly on blockboard, hardboard or stiff cardboard. Some quick and simple mounts are illustrated below center, but the neatest and most permanent method is dry mounting. This entails sandwiching a layer of shellac tissue between print and mount and bonding them in a dry mounting press, as shown below left.

Rubber cement is the best alternative to dry mounting. Trim your print and position it on the mount, marking round the corners in pencil. Spread a thin layer of cement evenly over the back of the whole print and the marked area of the mount. When both surfaces are almost dry, align the print on the mount and smooth it down gently to get rid of air bubbles. Finally, rub off any excess cement. Don't use ordinary domestic adhesives for mounting – they may damage your print; and avoid spray adhesives if you want a permanent seal.

A cardboard mat surround protects a mounted print as well as providing a border. Choose a neutral color and consider the proportions carefully so as to display your print to its best advantage. Mark out the area of your image on the center of a piece of card. Then, using a sharp trimming knife and a metal straight edge, cut out the marked area. Attach the print under the mat with adhesive tape.

### Storing negatives *below*

Storing your negatives next to their contact sheets in an album or ring binder keeps them flat and allows you to locate them quickly. Some albums contain plastic sleeves for negatives; in others you will have to stick your negative sleeves to the page with adhesive tape. It is a good idea to give each film a reference number and include some technical details, such as the date, film speed, developer used, and film brand.

### Dry mounting press *left*

This electrically-heated press can be used either for dry mounting your prints, as shown below left, or for giving them a variety of surface finishes. It guarantees uniform bonding, by giving even pressure at a controlled temperature. If you want to give your print a textured finish, you should buy an embossing kit. You can then invent other textures, using materials such as canvas or wallpaper.

### Dry mounting a print

Attach a piece of shellac tissue to the center of the back of your print with the tacking iron, left. Then trim off the excess tissue with a sharp knife and carefully position the print face up on the mount. Lift each corner of the print in turn and tack the tissue underneath to the mount. Put the print face up in the press and leave it under pressure for 5–10 seconds at the recommended temperature.

### Mounting in an album

There are several ways of mounting your prints in an album – you can use rubber cement or dry mounting, slip-in plastic sleeves, cling plastic overlay, self-adhesive corner mounts, double-sided tape, or slit corners. Small prints can be arranged in groups on a page; larger ones may require a page to themselves. To dry mount your album prints, use a loose-leaf binder.

### Framing your prints

Framing adds the finishing touch to your presentation, enabling you to display your prints on the wall. You can make a simple frame by clamping your mounted photograph between a piece of plywood and a sheet of glass or plastic, cut to the right size and held together with clips. Or you can buy a frame kit consisting of a metal or wood frame with mitered corners. Glass is not vital to a frame (though it does protect the print) but you must have a rigid backing in addition to your card mount or mat.

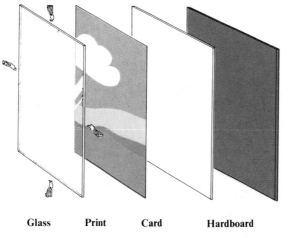

**Glass          Print          Card          Hardboard**

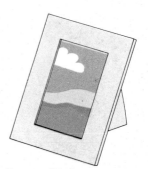

### Free-standing frames

It is better to buy free-standing frames from an artists' supply store, as they are hard to make successfully. Some take mounted prints,

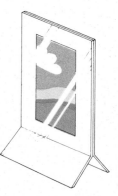

others require unmounted print. Varieties include plastic slip-in frames and metal-rimmed, glass-faced frames, as shown above.

# PRESENTING SLIDES

To do full justice to your slides, careful mounting, selectivity in preparing a slide sequence and a good quality projector are vital.

When mounting slides, make sure the transparency is dust-free and be careful not to touch the film surface. Position the film carefully in the mount so that no white edge shows during projection. The simplest mounts, made of self-adhesive card, are liable to buckle and jam the projector. Glass-faced plastic mounts are slower to assemble but protect slides from scratches and finger marks. You can also buy black presentation mounts.

Preparations for a slide show will be made quicker if you mark a spot in the bottom left hand corner of the front of your mount and keep the spot at the top right, facing the back of the magazine, when loading the projector. To keep a sequence of slides in the right order, draw a diagonal line across the mounts (as shown below).

### Slide mounts

Card mounts (top) are cheap and quick to assemble but offer little protection. Glass-faced plastic mounts (above) cost more but are durable.

There are many different projectors on the market, including simple hand-operated push-pull models into which slides are fed individually; straight and circular magazine projectors (illustrated below) both of which allow you to change slide automatically by remote control; and dissolve projectors which allow continuous viewing instead of the usual blank screen between pictures.

Projector lenses of different focal length are available to suit different viewing conditions. The longer the focal length of the lens, the further the screen must be from the projector. You can find the approximate screen distance by dividing the lens focal length by 10. A standard 85 mm lens for example fills a screen 3 feet wide from a distance of about 8 feet. When projecting your slides, always check that the screen is parallel to the projector lens and the room dark—even a little light will weaken blacks and desaturate color.

## Rollei projector *below*

This projector uses straight magazines holding 36 or 50 slides and takes five interchangeable lenses, from 50–150 mm. It has an automatic focus mechanism which brings each slide to focus automatically once the first slide has been accurately focused. Like the Kodak projector shown right, this model has an interval timer, allowing slides to be changed automatically at pre-selected intervals, from about 3 to 30 secs, when showing a sequence.

### Projector lenses

Interchangeable projector lenses range from 28–250 mm, plus a 70–120 mm zoom. Fixed focal length lenses give the best performance.

## Kodak carousel projector *right*

This model is supplied with a circular slide tray taking 80 slides, as shown right. It is of higher quality, and so more expensive than the Rollei projector. A thermal safety cut-out switches off the projector automatically if the machine overheats. It takes a wide range of lenses, from 28 to 250 mm. As with the Rollei, slides can be moved forward or backward and both models can be synchronized with tape or cassette recorders.

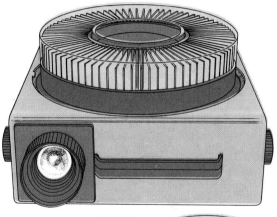

## Slide storage *right*

Careful storage will not only protect your slides from dust and damp but also simplify retrieval, if you label your boxes or viewpacks. Plastic viewpacks take twenty or more transparencies and can be filed in a ring binder or hung in filing cabinets. Slide boxes or drawers with lids take the greatest number of slides. To keep a projection sequence of slides in order, you can draw a diagonal line across the mounts in their box, as shown right.

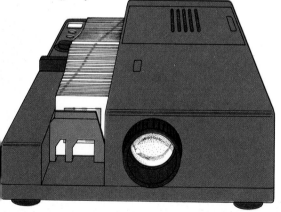

### Slide box

Plastic slide boxes often have numbered slots coupled with an index card in the lid where details can be entered.

### Circular slide tray

Storing slides in circular projector trays protects them from dust but proves expensive for a large number.

## Projection screens

There are two main types of screen surface—mat and beaded. Mat white screens, emulsion painted walls, or white cardboard provide an even reflection of the image over a wide viewing area. Beaded white screens are more reflective, giving a brighter image, but their viewing angle is more restricted, as shown right.

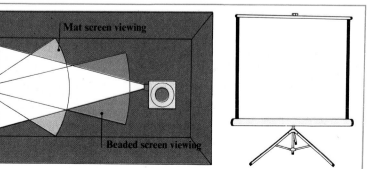

Mat screen viewing

Beaded screen viewing

## Hand viewer

A hand viewer is useful for previewing and selecting slides for projection.

# COPYING

Photographic copying techniques are sometimes required to reproduce color prints and other original material, or slides. As making any copy reduces the quality of the original, you must use precision equipment. Two basic rules apply to all copying. First, the original, the camera lens and the camera body must be parallel, to avoid distortion and help with overall sharp focus. Second, lighting must be even across the face of the original.

To copy prints of normal size and other opaque originals you should use a copying stand, so you can clamp the camera firmly over a baseboard. You can sometimes use an enlarger stand for this. You will also require two diffused lights, to give even illumination. To check that neither light is dominant, stand a pencil as shown below left, so that the two shadows it will make can be compared. If the shadows are uneven, move one of the lights until both shadows match. Larger originals can be copied against a matt wall, but you will have to shield the camera with black card to guard against reflection if the original has a high-gloss finish or is framed behind glass.

You can get various slide-copying devices. These either hold the slide in front of your camera lens, at the end of light-tight bellows or a tube extension or, with some sophisticated units, hold it on a stage with a diffuser and a flash source beneath. The slide must always be backlit, and separated from the illuminating light source (daylight, flash or tungsten) by a diffuser.

Exposure is critical when copying color material, so bracket one half stop each side of the estimate. Some units include an exposure meter so that you can adjust exposures to suit the densities of different slides. Contrast is usually increased in the copy, so overexpose contrasty originals by one stop and underdevelop the film by one stop.

## Copying flat originals

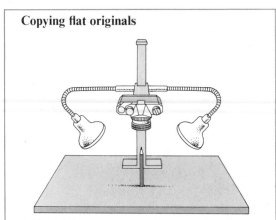

### Lighting balance
To copy prints and other flat originals you must have two light sources, set up as shown below. To ensure that both sources give equal lighting, stand a pencil upright on the base-board in line with the camera lens axis. Two shadows will be created, and can be compared for length and intensity. Move one of the light sources until the shadows match.

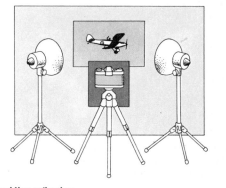

### Avoiding reflection
When copying paintings behind glass, or other originals where surface sheen will cause a camera reflection, use a square of black card as a shield. Cut a hole for the camera lens and set up the camera and shield on a tripod as shown above. Polarizing filters over the light sources and the camera lens will also help to reduce reflection.

## Copying slides
Copying slides is straightforward using an interchangeable lens camera. If you have two sets of close-up bellows, you can use them with your standard lens and a slide holder arranged as shown right. Or use a slide copying tube with integral lens as shown below. Point the bellows or tube copier at the light source, using diffused daylight with daylight film, or tungsten light with type B film. You can lessen contrast by overexposing one stop at the copying stage and reducing development time.

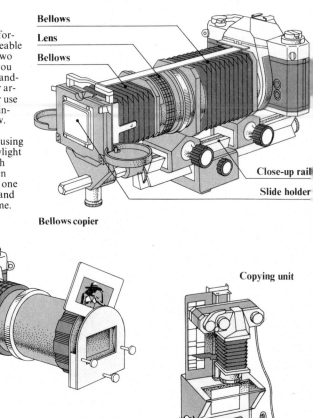

**Bellows**
**Lens**
**Bellows**
**Close-up rail**
**Slide holder**

**Bellows copier**

**Tube copier**

**Copying unit**

### Slide copying unit *right*
A copying unit, like the one shown right, uses flash illumination from below the copying stage to expose the original slide. The copying stage is a light box; it allows you to view the original before exposure, and use the swing-over exposure meter. The unit also contains a second, smaller flash unit that is reflected into the camera lens. This is used to reduce contrast by "flashing" – slightly fogging the image during exposure. Low contrast originals will copy well without use of the flashing control, but high contrast originals will reproduce too harshly unless you dial-in the degree of fogging required. You can bracket exposures and fogging levels if you are in any doubt.

# GLOSSARY

*Italics indicate Glossary entry*

## A

**Aberration** The inability of a lens to produce a perfect, sharp *image* especially at the edge of the lens field. Such faults can be reduced by *compound lens* constructions and by *stopping down*.

**Absorption** The process by which light falling upon a surface is partly absorbed by that surface and converted to heat.

**Accelerator** General term applied to any chemical in a developing solution that increases the activity of the *reducing agents* and thus speeds up *development*.

**Achromat** A *compound lens* system which is able to bring two *primary colors* of the *spectrum* to a common point of focus.

**Acid** A chemical substance with a pH below 7 which neutralizes *alkali*. It is often used in photographic *processing* to stop the action of an alkaline bath.

**Actinic** (Of light) having the ability to cause a chemical or physical change in a material.

**Additive color synthesis** A method of producing images containing a full range of colors by mixing light of the three primary color wavelengths, blue, green and red. Mixed in equal proportions they produce white. Mixed in varying proportions they can produce all the colors of the *spectrum*.

**Aerial perspective** The feeling of depth created in a landscape photograph by the tonal changes that occur with increasing distance and haze. It can be emphasized by using a *long focus lens* or reduced by using a haze or *polarizing filter*.

**Agitation** The method used to keep fresh solution in contact with the surface of the *emulsion* during photographic *processing*.

**Alkali** A chemical substance with a pH above 7. Most color developing solutions contain alkali to increase the rate of *color development*.

**Ambrotype** An early type of photograph, created by a process using a thin wet collodion *negative* that was bleached and then backed by a coating of black dye to form a *positive*. Such photographs were sometimes selectively hand colored for a more realistic effect.

**Ammonium thiocyanate** Chemical used as a silver solvent. One of its main applications is to control the growth of exposed *silver halides* during the first *development* of *slide films*. This reduces *grain*.

**Ammonium thiosulfate** Silver solvent used in some *bleach-fix* solutions to convert the unwanted *silver halides* (including the black silver *rehalogenized* by the bleach) to a soluble complex, so they can be removed from the *image*.

**Anamorphic lens** Lens capable of squeezing an image either horizontally or vertically. Distortion occurs in the recorded *image*, but a similar lens can be used to project the image in its correct proportions.

**Anastigmat** A *compound lens* that reduces the effect of *astigmatism*.

**Angle of incidence** The angle created between an incoming (*incident*) ray of light striking a surface and an imaginary line perpendicular to the surface.

**Angle of reflection** The angle formed between a ray of light reflected from a surface and an imaginary line perpendicular to the surface.

**Angle of view** The widest angle through which a lens can accept light and still give a full *format*, good quality *image* on the film. Hence, the widest arc of a scene covered by a lens.

**Angstrom** Unit used to measure the *wavelengths* of light within the electromagnetic *spectrum*.

**Anhydrous** Free of water.

**Anti-halation backing** Light-absorbing dye coated on the back of the *film* base to absorb light which passes through the *emulsion* layer. It prevents this extraneous light being reflected back through the film layers.

**Aperture** Opening in front of, or within, the camera *lens system* which controls the amount of light passing through the lens. Except on the simplest cameras the size of aperture is variable and calibrated in *f numbers*.

**Aperture preference** Term used to describe the *automatic exposure* system used on some cameras, in which the *aperture* is selected, but the *shutter speed* then adjusts automatically to expose the film to the correct amount of light.

**Aplanat** Lens corrected for *spherical aberration*.

**Apochromat** Lens corrected for *chromatic aberration* in all three additive *primary colors*.

**Artificial light film** Color film balanced for use in tungsten artificial light, usually of 3200 *Kelvins*. Packs are usually marked "Tungsten" or "*Type-B*". Such films will only render color correctly in daylight if used with a *color conversion* or *CC filter* over the camera lens, to alter the *color temperature* of the light. See also *Type A color film*.

**ASA** Denotes American Standards Association, the organization that devised a system by which manufacturers rate the sensitivity of their films. Films are classified by ASA number: the higher the number, the higher the *speed* of the film. Values are based on a simple arithmetical progression, so that a film marked 400ASA is twice as fast as one marked 200ASA.

**Aspherical surface** Surface with more than one radius of curvature, i.e. the surface does not form part of a sphere. Many lenses are constructed with such surfaces to overcome *aberrations*.

**Astigmatism** Lens *aberration* where parallel rays of light passing through the lens obliquely come to *focus* as a line rather than a point.

**Autochrome** Early commercial system of color photography using the principle of *additive color synthesis*.

**Automatic exposure control** System of *exposure* setting in a camera in which the electric current produced or inhibited by the action of light on a *photo-electric cell* operates a mechanism that adjusts the *aperture* and/or *shutter* speed automatically.

**Automatic focusing** Any of various devices used on cameras or projectors to focus the image automatically. No manual adjustment is necessary to achieve sharp *focus*.

## B

**Back focus** The distance between the rear of the lens and the *focal plane*. This distance is not always equal to the lens *focal length*, particularly in *telephoto lenses* and in *wide-angle lenses* given *inverted telephoto* (retro-focus) construction to gain more space behind the lens.

**Backlighting** Lighting coming from behind the subject, and consequently toward the camera.

**Back projection** Method of projecting images on the back of a translucent screen to make a background for subjects placed in front.

**Barn doors** Accessory for studio lamps with hinged flaps that can be moved across the light beam to control its direction and width.

**Barrel distortion** Lens *aberration* where straight lines in the subject are formed as curved lines in the image. These barrel-shaped lines are most noticeable along the edges of the frame.

**Baryta** Coating of barium sulfate used as a foundation layer in fiber-based photographic papers to give a smooth base for the *emulsion* and a chemically inert barrier.

**Base** Support for the photographic *emulsion*. It is usually made from glass, paper or plastic.

**Bas-relief** A technique where a contact *positive* (on sheet film) and its negative are sandwiched slightly off register in the *negative carrier* of the *enlarger*. Resulting prints look like side-lit embossed images.

**Batch numbers** Set of numbers printed on the side of film and photographic paper boxes to indicate the production batch of

*emulsion* with which they are coated. With color printing paper, *filtration* recommendations are also given and are of particular importance when changing from one pack of paper to another during a print session. To keep printing results constant, a new filtration pack must be prepared for a new batch of paper.

**Bellows** Light-tight folding sleeve which can be fitted between the lens and the film plane. Bellows used on *large format cameras* are of two types. The accordion type allows a range of lens-image distances. Bag bellows replace the accordion type when they will not compress sufficiently for use with *wide-angle lenses*. Bellows are used on smaller format cameras for close-up work.

**Between-the-lens shutter** Shutter located within the components of a *compound lens;* either a leaf-type shutter close to the *aperture*, or a *diaphragm shutter*.

**Bi-concave lens** Simple lens element whose surfaces curve inward toward the optical center. Light rays passing through the lens are caused to diverge.

**Bi-convex lens** Simple lens element whose surfaces curve outward away from the optical center. Light rays passing through the lens converge and can be brought to *focus*.

**Bleach** Chemical bath used in the processing of color photographs. It converts the black silver image formed in the *tripack* into a colorless silver complex.

**Bleach/Fix** Chemical bath in which the bleach and fixer have been combined. Such a bath is only used in some color processes.

**Bleed off** To print a photograph so that one or more of its sides is flush to the edge of the paper.

**Blooming** Putting a transparent coating on to the surface of a *lens* so that surface *reflection* is eliminated, through destructive interference of the waves of light.

**Blur** Unsharp areas of the *image* caused by camera or subject movement, or by selective or inaccurate *focusing*, or deliberate defocusing.

**Bounced light** Light directed on to a reflective surface so that it "bounces" back to illuminate the subject. A diffusely reflective surface scatters the light, so softening the nature of the original light from the source.

**Bracketing** In *exposure*, taking a series of pictures of the same subject that vary only in the exposure given. For example, correct, half, and double estimated correct exposure time.

**Brightfield** Method of illumination used in *photomicrography* which shows a specimen against a white or bright ground.

**Bright line viewfinder** *Viewfinder* in which the subject area is outlined by a white line frame. It may similarly show *parallax* correction marks within the frame.

**Brightness** Subjective description of the strength of *luminance*.

**Brightness range** Term used to describe the range of *luminance* found between the brightest and darkest parts of the subject or the image.

**B setting** Setting on the shutter ring indicating that the *shutter* will stay open as long as the shutter release button is depressed.

**BSI** Abbreviation for British Standards Institute.

**Burning-in** Method of increasing printing *exposure* in specific areas of an image.

# C

**Cable release** Flexible cable for releasing the camera *shutter* remotely without touching the camera body. Used with a tripod, it reduces the risk of camera shake during long *exposures*.

**Cadmium sulfide cell (CdS)** Cell used in some *exposure meters*. A small electric current is passed through the cell which offers a resistance directly proportional to the amount of light received. The degree of resistance recorded can be used as a measurement of light intensity falling on the cell.

**Callier effect** A *contrast* effect found on *prints* produced with condenser *enlargers*. The effect, named after W. H. O. Callier, is caused by the scattering of light from the *condenser* system by dense areas of the *negative*. These contrast greatly with the less dense shadow areas. In *diffuser* enlargers the light is scattered at source, so the effect on contrast is much less.

**Camera movements** Mechanical systems found primarily on *large format cameras* which enable the lens and film plane to be moved from their standard positions. Such movements allow extended *depth of field* and correction or distortion of image shape.

**Canada balsam** Liquid resin sometimes used for cementing together the elements in *compound lens* construction.

**Carrier** Metal or plastic hinged frame that holds the *negative* or slide flat in the *enlarger* during the printing process.

**Cartridge** Pre-packed, sealed film container for 110 or 126 films designed for drop-in loading. It contains both feed and take-up spools and is light-tight.

**Cassette** Cylindrical metal film container holding 35 mm *format* film. It is supplied ready to load into the camera, but the film must be engaged with the take-up spool on the opposite side of the camera.

**CC filter** Abbreviation for color compensating filter. CC filters are designed primarily for correcting color bias in *subtractive color* printing processes. CC20Y for example indicates a yellow *filtration* of 0.2 density. They are sometimes called CP (color printing) filters.

**CdS cell** A *cadmium sulfide* cell.

**Celsius (or centigrade) scale** Scale of temperature on which 0° equals the freezing point of water, 100° its boiling point.

**Characteristic curve** Graphical representation of the performance of color film or paper under known *processing* conditions. It shows the relationship between *exposure* and *density* of each dye.

**Chromatic aberration** The inability of a *lens* to bring different colors of light reflected from the same plane in the subject to a common point of *focus* in the *image*. The *aberration* appears as a color fringe at the edge of the picture frame.

**Chromogenic materials** Color photographic materials which form dyes during processing (from the *oxidation products* of *development* and *color couplers*).

**Circles of confusion** Disks of light in the *image* formed by a *lens* as it reproduces rays of light from points in the subject. The smaller these disks, the sharper the image.

**Clearing agent** A chemical solution used to destroy fixing agent in an emulsion, to reduce washing time.

**Close-up attachment** Specially designed attachments which allow the lens to be *focused* on subjects closer than normal. The attachments can be *extension tubes, bellows* or *supplementary lenses*.

**Coated lens** *Lens* whose air-to-glass surfaces have been coated in magnesium or sodium fluoride to reduce *flare*.

**Cold cathode illumination** Fluorescent light source used in some sheet film *enlargers*. Such a light softens *contrast* and reduces the appearance of grain.

**Cold colors** Colors associated with the sensation of coldness, e.g. blue.

**Color balance** Adjustment in color photographic processes ensuring that a neutral scale of gray tones is reproduced accurately, i.e. a gray subject will have no color bias.

**Color circle** Chart of *spectrum hues* presented as a circle. It is often divided into sectors with the three *primary colors*, red, blue and green, opposite their *complementaries*.

**Color contrast** Subjective judgment on the apparent luminous difference or intensity of two colors close to one another.

**Color conversion filters** Filters capable of converting the *color temperature* of a light source to suit the *color balance* of film.

**Color coupler** A compound which links with the *oxidation products* of a *developer* to form dye. Such compounds form the dye image in all *chromogenic* color materials.

**Color developer** A *developer* whose *oxidation products* can combine with *color couplers* to form specific dyes, allowing *color development*.

**Color development** Chemical treatment in the color *processing* cycle that produces the colored dye image. *Oxidation products* from the developing silver image link with *color couplers* to form dye at a rate related to the amount of silver image reduced. Hence a heavy deposit of silver, produced by exposure in negatives, or by reversal development in slides, gives a heavy deposit of dye.

**Color masking** Orange color mask built into color *negative* film to improve reproduction on the *print*.

**Color mixing** A general term used to describe the practical application of either *additive color synthesis* or *subtractive color synthesis*.

**Color sensitivity** Response of *sensitive material* to the colors of the *spectrum*.

**Color temperature** Scale usually measured in *Kelvins* that can be used to express the color quality (content) of a light source.

**Coma** Lens *aberration* which causes circular patches and comet-like images at the edge of the frame

**Complementary colors** Two colors which, when added together in suitable proportions, make white light. The term is also used to describe the colors magenta, yellow, and cyan, because each is complementary to one of the primaries.

**Composite printing** Printing two *negatives* as one, or separately, onto a single sheet of printing paper.

**Compound lens** *Lens system* constructed of two or more elements.

**Condenser** Simple *lens system* which concentrates light from a source into a beam. Condensers are used in equipment such as *spotlights* and *enlargers*.

**Contact printing frame** Hinged glass cover attached to a firm base for keeping printing paper and *negatives* in firm contact with one another while contact printing.

**Contrast** Difference in apparent brightness and density between shadow and highlight areas in the subject, negative, slide or print.

**Contre jour** See *Backlighting*.

**Converging lens** See *Convex lens*.

**Convertible lens** *Compound lens* whose elements can be unscrewed and rearranged to make lenses of different *focal lengths*.

**Convex lens** Lens which causes rays of light passing through it to converge.

**Coupled exposure meter** *Exposure meter* built into the camera and linked with the *aperture* or *shutter speed* controls, or both.

**Coupled rangefinder** System which links the *rangefinder* and the focusing mechanism of a lens, so that the lens is automatically *focused* as the rangefinder is adjusted.

**Covering power** The maximum diameter of good quality *image* that can be formed by a *lens* at the *focal plane* when it is focused for a given distance.

**Crossed polarization** Technique of using two *polarizing filters*, one over the light source, one between subject and *lens*. The method removes specular *reflections* from shiny objects, and intensifies color under certain conditions. It is also used to identify stress zones in bi-refringent (double refracting) materials, such as certain crystalline mineral structures.

**Curvature of field** Lens *aberration* causing the plane of sharp focus to be curved.

**Cut film** *Film* obtainable as flat, single sheets rather than in a roll. Cut film is usually available in large *formats* only.

**Cyan** Color composed of a mixture of blue and green light. It is a subtractive primary, and the *complementary color* to red.

# D

**Daguerreotype** The first commercial photographic process, introduced in Paris on August 19th 1839. Many daguerreotypes were selectively hand colored.

**Darkcloth** Dark material placed over the camera back and head of the photographer to allow viewing and *focusing* on cameras with *ground glass screens*.

**Darkfield** Method of illumination used in *photomicrography* which shows a specimen against a dark or black background.

**Darkroom** Light-tight room used for handling, *processing* and printing *sensitive materials*, often under *safelights* to which the materials do not react.

**Darkslide** *Cut film* holder used on *large format cameras*.

**Daylight color film** Color film designed to be used with daylight or a light source of equivalent *color temperature*, which includes blue *flashbulbs* and *electronic flash*. The film is balanced to 5400K.

**Definition** Subjective term used to describe the clarity of an *image*. *Focusing*, lens quality, *graininess, contrast* and *tone* all affect the definition of an image.

**Density** General descriptive term for the amount of photographic deposit (silver or dye) produced by *exposure* and *development*. Strictly, measurement is based on light-stopping ability (*opacity*) and is usually expressed as the logarithm of this opacity.

**Depth of field** The distance between the nearest point and the furthest point in the subject which can be brought to relatively sharp *focus* at any one focus setting.

**Depth of field scale.** Scale on a lens showing the near and far limits of *depth of field* possible with a lens at any particular *aperture*.

**Depth of focus** The distance the film plane can be moved from an exact point of *focus* while keeping the *image* acceptably sharp.

**Developer** Chemical bath which converts the invisible *latent image* on exposed *sensitive material* to a black silver image. Other chemicals in the form of *accelerators, preservatives, restrainers* and *color couplers* may be present in the developer to modify its action. See also *Color development*.

**Development** The chemical or physical treatment that converts a photographic, invisible *latent image* into a visible form.

**Diaphragm** The device within, behind or in front of the lens which uses a set of interleaving blades to control the size of the *aperture*.

**Diaphragm shutter** *Between-the-lens shutter* which is also the *diaphragm* of the lens. Its interleaving blades open for a predetermined time at the selected aperture when a picture is taken.

**Diffraction** The way in which light waves are caused to change direction or become scattered when they pass through a small aperture or come close to the edge of an opaque surface.

**Diffuser** Any substance capable of scattering light.

**DIN** Abbreviation for Deutsche Industrie Norm (German standards organization), the organisation which devised a system by which manufacturers rate the sensitivity of their films. Films are classified by DIN number: the higher the number, the higher the *speed* of the film. Values are based on a logarithmic progression so that a change of + 3° indicates a doubling of speed. Hence a 21° DIN film is twice as fast as one of 18° DIN.

**Diopter** Unit used in optics to express the light-bending power of a *lens*. The diopter value of a lens is calculated by taking the reciprocal of the *focal length* expressed in meters. The power of a *convex lens* is prefixed by a positive sign, that of a *concave lens* by a negative sign.

**Direct vision viewfinder** A *viewfinder* which gives you a direct view of the subject through a separate window in the camera body, unconnected with the taking lens' view of the subject.

**Dish development** See *Tray development*.

**Dispersion** The ability of glass to bend light rays of different wavelengths to different degrees. The degree of dispersion depends on the type and refractive index of the glass and the angle at which the light strikes the glass.

**Diverging lens** See *Concave lens*.

**Dodging** Local control over *density* on a photographic *print* achieved by reducing *exposure* to specific areas of the paper.

**Double extension** The extension (by *bellows* or *extension tubes* or by special design) of a lens to twice its *focal length* from the film plane.

**Drying marks** Marks left on the *emulsion* side of processed films through uneven drying. Unlike scum marks on the film *base* which can be removed, marks on the emulsion are permanent and can show up on prints.

**Dry mounting** Method of attaching *prints* to mounts by melting *shellac* tissue between the two substances.

**Dye destruction process** System of color reproduction which depends on the selective removal of dyes already existing in a photographic material, rather than the chemical formation of dyes during *color development*.

**Dye sensitizing** Method of sensitizing *silver halides* to all colors of the *spectrum*. Without this extra sensitivity, the halides only respond to *ultra-violet* and blue light.

**Dye transfer process** Method of producing color *prints*. Color *separation negatives* are made, either from the original subject or from color transparencies or prints, and positive matrixes produced from these separations are dyed in the subtractive colors. Printed in register they produce color prints.

# E

**Electronic flash** Discontinuous artificial light source balanced for use with *daylight color film*. The flash is created when an electric

current is released across two electrodes contained within a gas-filled glass or quartz tube. A single tube gives thousands of flashes.

**Electronic shutter** *Shutter* where the mechanism used to control the period between opening and closing, is replaced by an electronic timing circuit.

**Emulsion** The *sensitive material* that is coated on different *bases* to make photographic film, or paper. It always consists of *silver halides* suspended in *gelatin*, but with emulsion for color photography *color couplers* are often added.

**Emulsion speed** See *Speed*.

**Enlargement** *Print* larger than the *negative* or *slide* used to produce it. It is sometimes referred to as a projection print.

**Enlarger** Device containing a light source, a lens and a means of varying *filtration* for color, to project and *focus* a film-based image on to photographic printing paper. Prints of different sizes can be produced by altering the distance between the enlarger head and the paper. An enlarger is sometimes called a projection printer.

**Exposure** In photographic terms, the product of light intensity and the time that light is allowed to act on the *sensitive material*. Intensity is controlled by the size of the *aperture*, time by the *shutter speed*.

**Exposure latitude** The amount by which *exposure* can be varied on *sensitive materials* and with standard *processing* still give acceptable results. Greatest latitude is found in negative material, the least in printing paper.

**Exposure meter** Device for measuring the amount of light falling on or being reflected by the subject. Most meters convert the measurement into meaningful terms by indicating the *shutter speed* and *aperture* settings that would give correct *exposure*.

**Extension tube or ring** Metal tube used on smaller format cameras between the lens and camera body to extend the range of focusing for close-up photography.

# F

**Fahrenheit scale** Scale of temperature named after its originator G. D. Fahrenheit. On this scale the freezing point of water is 32°F and the boiling point 212°F.

**Fill-in light** Direct or reflected light used to illuminate shadows cast on the subject by the main light source.

**Film** Photographic material in which light-sensitive *emulsion* is coated on a transparent plastic base. Black and white film has one emulsion layer, while color film has at least three, each sensitive to a different color of light.

**Film plane** The plane of a camera across which the film lies, at or close to the *focal plane*.

**Film speed** See *Speed*.

**Filter** Transparent material such as glass or *gelatin*, which alters the nature, color or quality of the light passing through it.

**Filter factor** Number by which an unfiltered *exposure* reading must be multiplied to give the same effective exposure through a filter. This compensates for the absorption of light by the filter.

**Filtration** In color printing, the use of color filters to control the *color balance* of the enlarged image, and so of the resulting print. See also *CC filter*.

**Fish-eye lens** Extreme *wide-angle lens* with an *angle of view* in excess of 100°. Such lenses distort the *image* because they are not corrected for *barrel distortion*.

**Fix** (or **Fixer**) Chemical solution used for *fixation*.

**Fixation** Stage in film and print *processing* during which the image is rendered no longer sensitive to light. *Silver halides* that have not been converted to black metallic silver are converted to a soluble silver complex.

**Fixed focal length** (or **Fixed lens**) Refers to a camera whose lens cannot be interchanged for one of a different *focal length*.

**Fixed focus** Camera that has no method of adjusting *focus*. The lens is usually set for the *hyperfocal distance* which, in conjunction with a small *aperture*, usually also pre-set, gives a sharp image of subjects from a few feet away to *infinity*.

**Flare** Non-image-forming light scattered by *reflection* within the *lens, lens hood* or the interior of the camera. When allowed to affect the film it reduces *contrast* and shadow detail. The problem is offset in many modern lenses by a coating technique – *blooming*.

**Flash** See *Electronic flash*.

**Flashbulb** Expendable glass bulb containing zirconium wire in oxygen. It burns out in a brilliant flash when ignited by a low voltage current. Bulbs are usually grouped four to a flash cube or ten/twelve to a bar. Flashbulb light is balanced for use with *daylight color film*.

**Flash synchronization** Method of synchronizing the maximum light output of a flash source with the fully open period of the *shutter*. There are usually two settings on a camera, X and M. X is for *electronic flash* and M for *flashbulbs*.

**Flood** An artificial light source with a 125–500 watt bulb and a dish-shaped *reflector* to give diffused, even illumination over the subject. Floods are balanced to 3200K (or sometimes 3400K), for use with *artificial light film*.

**f numbers** Number sequence on the *lens barrel* which is equivalent to the *focal length* divided by the effective diameter of the *aperture*, giving a scale of aperture settings which is constant for all lenses.

**Focal length** The distance between the rear *nodal point* of the *lens* and the *focal plane* when the *focus* is set at *infinity*.

**Focal plane** The plane at right angles to the *optical axis* of a *lens* and passing through the *focal point* on which a sharp *image* is formed when the *focus* is set at *infinity*.

**Focal plane shutter** *Shutter* system using paired blinds which lie just in front of the *focal plane*. *Exposure* is made as the gap between the two

blinds passes across the *film.* By altering the width of the gap, exposure can be regulated.

**Focal point** Point where the *optical axis* of a lens is intersected by the *focal plane.* It is the point at which rays of light from distant subjects, transmitted by the *lens,* intersect to give an *image* in sharp *focus* when the lens is set at infinity.

**Focus** The condition in which rays of light from the subject, transmitted by a *lens,* converge to form a sharp *image* on the film. Hence, the lens adjustment necessary for sharp focus of a subject.

**Focusing** Method of moving the *lens* forward or backward relative to the *film plane* so that rays of light from the subject are brought to sharp *focus* as an *image* on the *film.*

**Focusing scale** Subject distance scale marked on the focusing mechanism of a camera.

**Focusing screen** *Ground glass screen* mounted in a camera to allow viewing and precise focusing of the *image* formed by the *lens.*

**Fogging** Veil of *density* on processed photographic materials which does not form part of the *image.* It can be caused by *exposure* to light or by chemicals.

**Format** Size and shape of *negative, slide,* photographic *print* or camera viewing area.

**Freezing motion** Technique which allows a moving subject to be photographed as a sharply focused, unblurred *image* either by use of fast *shutter speed* or by lighting the subject with *electronic flash.*

# G

**Gelatin** Transparent medium in which the light-sensitive *silver halides* of a photographic *emulsion* are suspended. It is coated onto the film *base* or printing paper. It is also used for making *filters.*

**Glare** Intense light reflected off highly reflective surfaces such as water, glass and very light toned subjects. It can be minimized by using a *polarizing filter.*

**Glaze** Shiny surface produced on some photographic printing papers by placing the *emulsion* side of a wet *print* in contact with a heated drum. The process darkens blacks and brightens color.

**Glossy paper** Printing paper with a smooth, shiny surface.

**GOST** *Gosudarstvenny f Standart,* the official standardizing organization of the USSR, which has devised a system for rating the *speed* of films, using an arithmetical progression of speed numbers: the higher the number, the faster the film's response to light.

**Gradation** The range of tonal *contrast* found in an image. Descriptive terms of gradation are used: soft indicates a short gradation where contrast is minimal, hard or contrasty a long gradation where contrast is great.

**Graininess** Term used to describe the grainy appearance of a photograph caused by the clumping together of exposed and developed *silver halides,* and of dye molecules in color photographs. This effect is visible on photographic *enlargements,* and is more prominent on higher *speed* films.

**Grains** The minute particles of black metallic silver formed by exposed and developed *silver halides* in an emulsion.

**Granularity** Objective physical measurement of the amount of *grain* clumping that has occurred within an *emulsion.*

**Ground glass screen** Translucent glass sheet used for viewing and focusing the image in most *reflex* and *large format cameras.*

**Guide numbers** Numbers given to *flashbulbs* and *electronic flash* units to express their power. The guide number is used to calculate the *aperture* required for given subject-to-light source distances when flash is being used.

# H

**Halation** Secondary image usually formed around bright highlights in the subject. It can be caused when

light passing through the *emulsion* is reflected back from the *film* base onto the light sensitive layer again but slightly out of register with the original recorded *image.*

**Halogen** Any element that with silver forms *silver halides,* the light-sensitive crystals used in photographic *emulsion* e.g. bromine, chlorine, or iodine.

**Hard** Term used to describe a quality of harsh *contrast* in a photograph. Also used to describe a light source which produces this quality in the subject.

**Hardener** Chemical used in film manufacture and as a bath in some *processing* cycles to strengthen the physical characteristics of *gelatin.* This is especially important with high-temperature processing.

**High key** Describes a photograph dominated by pale tones, giving light, desaturated color in color *prints* and *slides.*

**Highlights** Brightest, lightest areas in the subject or photograph. They may be general – such as pale-toned, brightly lit surfaces – or locally extreme, such as points of reflected light from glass or water.

**Holography** System of photography, not requiring a camera or lens, in which laser beams are used to create a three-dimensional image on fine-grained photographic plates.

**Hot shoe** Fitting on top of a camera body to hold a flash unit. It contains electrical connections which automatically make contact between the flash unit and the *shutter* synchronization circuit when the shutter release is fired, operating the flash.

**Hue** Title of a color. The property (color wavelength) that distinguishes one pure *saturated color* from any other, i.e. red as distinct from purple.

**Hydroquinone** A *reducing agent* with strong developing action (to give high *contrast*) when used in conjunction with a vigorous *alkali.* It can also form a balanced normal contrast solution when used with metol. These two chemicals mixed in roughly equal proportions

form the basis of most first *developers* in slide *processing.*

**Hyperfocal distance** The distance between the camera and the nearest plane of the subject which is sharp when the *lens* is *focused* on *infinity,* at a given aperture.

**Hypo** Abbreviation of hyposulfite of soda, the original chemical name of *sodium thiosulfate.* Often used as a general term for fixing solutions.

**Hypo-eliminator (Clearing agent)** Chemical bath used to destroy fixing agent from an *emulsion,* and so reduce washing time.

# I

**Image** Two-dimensional representation of a real object produced by *focusing* rays of light.

**Image plane** The plane behind the lens, commonly at right angles to the *optical axis,* at which a sharp *image* of the subject is formed. The nearer the subject is to the camera, the greater the image plane-to-lens distance. To bring closer subjects to focus on the *film plane,* the lens must be racked forward to accomodate this greater distance.

**Incident light** Light falling onto a surface from a source.

**Incident light attachment** Accessory for an *exposure meter* which allows it to give *incident light readings.*

**Incident light reading** The measurement by *exposure meter* of the amount of *incident light* reaching a subject. The meter is held close to the subject, pointing toward the main light source.

**Infinity** In photography, the focusing position (marked ∞) at which distant objects are in *focus.*

**Infra-red** Invisible band of *wavelengths* on the electromagnetic *spectrum* beyond visible red. Infra-red film is sensitized to a range of these invisible radiations and records colors not normally associated with a subject.

**Integral tripack** Light-*sensitive material* used for color photography consisting of three *emulsion*

layers, usually of different color response, coated onto a common *base*. The emulsion layers contain *color couplers*. Some color materials are so constructed that the color couplers must be introduced during *processing*. These are referred to simply as tripack or *non-substantive* color materials.

**Intensification** Chemical method of increasing the *density* or *contrast* of the *image*. It is normally used for improving black and white *negatives*.

**Interchangeable lens system** Facility on a camera that allows a *lens* to be removed from the camera body and exchanged for another of a different *focal length*.

**Interference** The interaction of meeting light waves in which they reinforce or cancel each other. It can produce colors, and also create a photographic image, as in *holography*.

**Internegative color film** Color *negative* film manufactured with a built-in mask to control color and contrast, designed for making precise copy negatives from color slides, so that prints can be produced from them.

**Inverse square law** The intensity of light reaching a surface is quartered each time the distance from the light source is doubled. This law applies to all forms of artificial lighting, and is used to calculate flash *guide numbers*.

**Inverted telephoto lens** Lens constructed to provide a short *focal length* with a long *back focus*, or lens-to-film distance. Most *wide-angle lenses* built for small format cameras are constructed in this way to allow space for the mirror, shutter, and so on.

**Irradiation** In photography, the scattering of light within the *emulsion layer*. It causes loss of *definition*, color *brightness* and color saturation.

**ISO** International Standards Organization, which has devised an international system of film *speed* rating control, based on the *ASA* arithmetical or *DIN* logarithmic scales.

## J

**Joule** Unit of measurement (watt/sec). Applied to the ouput of *electronic flash*, it is used to compare the output of different flash systems. The higher the number of joules, the greater the light output.

## K

**Kelvin (K)** Unit of measurement on the Absolute scale of temperature (calculated by adding 273 to degrees centigrade) used to measure the *color temperature* of light.

**Keyed emulsion sensitivity** Of an *emulsion* used in color photography, sensitivity to a narrow range of color. For example, color printing paper emulsions are only sensitive or keyed to the dye characteristics of the color *negative* and not to the full visible *spectrum*. This precise keying of sensitivity allows *safelighting* to be used with *sensitive materials* and helps control *contrast* and *color balance* in the *print*.

**Key light** Term used to describe the main light source illuminating the subject of a picture.

## L

**Lamp** General term used to describe an artificial light source.

**Lamphouse** Ventilated light-tight housing which contains the light source on an *enlarger* or *projector*.

**Large format camera** General term for cameras taking pictures 4 × 5 ins and larger.

**Latent image** The invisible *image* produced on the *emulsion* by *exposure* to light and subsequently made visible by *processing*.

**Latitude** In photography, the amount *exposure* level can be varied and still produce an acceptable result. Generally black and white film has greater latitude than color film, and color *negative* film has greater latitude than slide film.

**Lens** Optical device made of glass or plastic, capable of bending light. In photography, lenses are used to gather together light rays reflected by an object to form an *image* on the *focal plane*. There are two types of simple lens: convex (positive), which cause rays to converge to a point, and concave (negative), which cause rays to diverge. Both are used in *compound lens* constructions in which several elements are combined to give an overall converging effect.

**Lens barrel** Housing for all the elements of the *lens*.

**Lens hood** Accessory opaque tube made of metal, wood, rubber or plastic, shaped to suit the *angle of view* of a lens, that prevents unwanted light falling upon the *lens* surface and creating *flare*.

**Lens system** The interchangeable lenses available for use with a particular camera. This term is also used to describe the optical construction of a *compound lens*.

**Light** Form of energy that makes up the visible part of the electromagnetic *spectrum*. *Wavelengths* between 4000 and 7000A (400–700 nm) are visible to the human eye and are seen as all the colors between violet and dark red.

**Light meter** An alternative term for *exposure meter*.

**Light-sensitive material** See *Sensitive material*.

**Linear perspective** In a two-dimensional image such as a photograph, the apparent convergence of parallel lines with distance. Different viewpoints and lenses of different *focal lengths* can be used to make the lines converge more or less sharply to increase or reduce the illusion of depth in a picture. See *Perspective*.

**Lith film** Black and white film which produces very high *contrast* images when used in conjunction with a special lith developer. It is used as an intermediate process in creating a number of photographic color effects in the darkroom.

**Local control** The method used to add or subtract *exposure* and/or *filtration* to selected areas of a photographic *print*. For example, *burning-in*, *dodging*.

**Long-focus lens** Lens with a *focal length* that exceeds the length of the diagonal of the film *format* with with it is used.

**Low key** Dominated by dark *tones*, giving degraded color with few highlights in prints and slides.

**Lumen** Unit of measurement describing light intensity.

**Luminance** Measurable amount of light which is emitted by a source or *reflected* from a surface. See also *Brightness*.

## M

**Macro lens** Lens specially designed for use in *macrophotography*. Manufacturers also use the prefix "micro" to describe a lens that has this close-up focusing ability.

**Macrophotography** Extreme close-up photography in which images larger than the original subject are recorded without the use of a microscope. To achieve this *magnification*, the camera is usually fitted with *extension tubes*, *bellows* or a *macro lens*. Typically, *image* size does not exceed about × 10 magnification.

**Mackie line effect** On a negative or print, an effect in which a black line forms separating areas of different tone. It can be caused during processing by *solarization*.

**Magenta** Purple-red color composed of a mixture of blue and red light. It is the *complementary color* to the primary color green.

**Magnification** Ratio of the height of the image to the height of the subject; or the ratio of the lens-to-image distance to the subject-to-lens distance. When a subject and its image are the same size magnification is × 1.

**Mask** 1) Opaque material used to cover the edges of printing paper and so produce borders; 2) Weak *positive* image on *film*, which when registered with a *negative*, adds *density* to the shadow areas and so reduces *contrast*; 3) Dyes incorporated in the non-image areas of color negatives to improve color accuracy when printed.

**Mat** 1) Term used to describe the surface finish of printing paper that is non-reflective; 2) Cardboard surround used to frame a print.

**Metol** A reducing agent with mild developing action (to give medium/low contrast) when used in conjunction with a soft working *alkali*. It can form a balanced normal contrast solution when used with *hydroquinone*. These two reducing agents form the basis of most first developers in slide processing.

**Microphotograph** Miniature photograph made through a special camera on ultrafine-grain film. It is enlarged for viewing through a microfilm reader. Often used as a space-saving method of recording books and documents.

**Midtone** Area of *brightness* midway between shadows and highlights.

**Mired** Abbreviation of *micro-reciprocal degrees*, a scale of measurement of *color temperature*. To calculate the mired value of a light source, divide one million by its color temperature in *Kelvins*. *Color conversion filters* are often given mired shift values.

**Mirror lens** *Compound lens* that uses mirrors within its construction. This allows an extremely long *focal length* lens to fit within a short barrel. Mirror lens design requires a fixed aperture.

**Monochromatic** Strictly, light rays of one *wavelength*, i.e. a single, pure color. Also used loosely when talking of a range of *tones* of one hue, or of a black and white image.

**Montage** Composite *image* formed from a number of photographs either overlaid or set side by side.

# N

**Nanometer** (nm) Unit of measurement of *wavelengths*. A nanometer is one millionth of a millimeter.

**Negative** Developed photographic *image* where subject *tones* are reversed and each subject color, in color photography, is represented by its complementary hue. It is the product of *exposure* and *processing*, usually made on a transparent base so that it can be used to make a *positive* image.

**Negative carrier** See *Carrier*.

**Neutral density filter** A gray *filter* used to reduce the amount of light entering the camera when *aperture* and *speed* settings cannot be altered. It has equal effect on all colors of the *spectrum* and so does not affect the color of the final photograph.

**Neutral filtration** In color printing, the *filtration* at which *color balance* is achieved, rendering a neutral gray in the negative or slide accurately on the print.

**Newton's rings** Concentric rings of colored light produced by *interference* when two flat, transparent surfaces are in partial contact. Often seen in glass transparency mounts and in glass *negative carriers*.

**Nodal plane** An imaginary line passing through a *nodal point* perpendicular to the *optical axis*.

**Nodal points** Points in a *compound lens* where rays of light entering the lens appear to aim (front nodal point) or where the rays of light appear to have come from when they have passed through the lens (rear nodal point). Nodal points are used in optical measurement, for example in calculating the *focal length* of a lens.

**Non-substantive film** Name given to color film in which the *color couplers* are not contained within the *emulsion*. Instead they are introduced during *processing*. Such films cannot be user processed.

**Normal lens** See *Standard lens*.

# O

**Objective** Term which describes a lens used in microscopes, telescopes or on an optical bench.

**Opacity** The light-stopping power of a material.

**Open flash** Method of using *flash* where the *shutter* is opened, the flash is fired and then the shutter is closed. It is used when the shutter speed is unimportant because existing lighting is poor.

**Optical axis** Imaginary line passing horizontally through the center of a *compound lens* system.

**Orthochromatic** Photographic *emulsion* sensitive to blue and green light but insensitive to red.

**Overdevelopment** The result of exceeding the degree of *development* recommended by the manufacturer. It can be caused by prolonged development time, increased temperature or agitation. In color photography, it results in an increase of color *density* and *grain*. On color slides there is a loss of *contrast* and *color balance*. On color *negatives* contrast is increased, but color may be out of balance to such a degree that it cannot be corrected at the print stage. It can be used intentionally to *uprate* film.

**Overexposure** The result of giving a light-*sensitive material* excessive *exposure*, either by subjecting it to too bright a light source or by allowing light to act upon the film for too long. The result on color *negatives* and prints is an increase in overall *density* giving degraded color. On slides the effect is to lighten the result, weakening color to a point where it can be totally absent in the *highlight* areas.

**Oxidation product** Chemical produced by a *color developer* during the conversion of exposed *silver halides* to black metallic silver. It is capable of creating a dye to allow primary *color development*. With modern color materials it is common for the *oxidation product* to be coupled with another chemical compound known as a *color coupler* so that a dye of precise and known character is formed. This procedure is known as *chromogenic* development.

# P

**Panchromatic** A photographic *emulsion* sensitive to all the colors of the visible *spectrum*, including red, although it does not react uniformly to all colors.

**Panning** In still photography, the technique of swinging the camera to follow movement of a subject so that the recorded *image* is of a sharp main subject with a blurred background.

**Panoramic camera** Camera with a special type of scanning lens which rotates about its rear *nodal point*. It produces an *image* on a curved plate or film and can cover a very large *angle of view*.

**Parallax error** The difference between the *image* area seen through the camera's *viewfinder* and that recorded by the film. Through-the-lens viewing systems avoid the error.

**Paraminophenol** *Reducing agent* used in some *color developers* whose *oxidation products* combine with phenol and amines (*color couplers*) to form dye.

**Paraphenylenediamine** *Reducing agent* used in some *color developers* whose *oxidation products* combine with phenol and amines (*color couplers*) to form dye.

**Pentaprism** In *single lens reflex* cameras, a five-sided silvered prism used to give correct left-to-right viewing of the image and reflect it on to the *focusing screen*.

**Perspective** System of representing three-dimensional objects on a two-dimensional surface to give a realistic impression of depth. Achieved mostly by *linear perspective*, scale, overlapping elements and *aerial perspective*.

**Photo-electric cell** Light sensitive cell that either generates electricity when light falls upon it (*selenium cell*) or offers a resistance to a small electric current produced by a battery according to the light received (for example, a *cadmium sulfide cell*). The response of either type relates to the strength of light falling upon it, and thus becomes a means of measuring light intensity. Both types of cell are used in *exposure meters*.

**Photoflood** Photographic lamp with a *tungsten filament* bulb giving light of 3400K.

**Photolamp** Photographic lamp with a *tungsten filament* bulb giving light of 3200K.

**Photomicrography** Photography of magnified objects by means of a camera attached to a microscope. The *image magnification* is usually greater than × 10.

**Polarized light** Rays of light that have been restricted to vibrate in one plane only.

**Polarizing filter** Colorless *filter* able to absorb *polarized light*. It is used over a camera lens or light source to reduce or remove *reflections* and to strengthen color.

**Positive** Photographic *image* (on paper or film) in which light and dark correspond to the highlights and shadows of the original subject, and, in a color image, subject colors are represented truly.

**Posterization** Technique of using a number of tone-separated *negatives* printed on a high *contrast* material to produce a photograph containing selected areas of flat tone instead of continuous graduated tones.

**Potassium bromide** Chemical used as a *restrainer* in some *developers*.

**Potassium carbonate** *Alkali* used to increase the activity of *reducing agents* in developing solutions.

**Preservative** Chemical (often *sodium sulfite*) used in developing solutions to control oxidation.

**Primary colors** In light, the three primary colors of the *spectrum* are blue, green, and red. Each comprises about one third of the visible spectrum and they can be blended to produce white light or any other *hue* (NB in painter's pigments, the primaries are considered to be yellow, blue and red, and in *subtractive color synthesis*, they are yellow, magenta and cyan.

**Print** In photography, usually a *positive* image, which has been produced by the action of light, passed through a *negative* or *slide*, on paper coated with a light-sensitive *emulsion*.

**Printing-in** See *Burning-in.*

**Prism** Transparent medium with flat, polished surfaces inclined to one another. A prism is capable of

bending light of different *wavelengths* to varying degrees.

**Process control** Controls exercised by manufacturers and processors of photographic materials to ensure that quality is maintained during bulk *processing*. Sample strips of pre-exposed film are processed regularly and compared with a "standard", to make sure that solutions are working accurately.

**Processing** General term used to describe the sequence of steps by which a *latent image* is converted into a visible, permanent image.

**Process lens** Lens corrected for the seven basic *aberrations*, and able to render colors of different *wavelengths* with extreme accuracy. It is used for high quality copying of full color and line originals.

**Processing tank** See *Tank.*

**Projector** Apparatus for displaying enlarged images of color slides and movie film on a screen.

# R

**Rangefinder** A camera *focusing* system that determines the distance between camera and subject. The subject is viewed simultaneously from two positions a short distance apart. Two *images* are seen which can be superimposed by adjusting a mirror or similar device. This adjustment may be linked to the focusing movement of the camera lens, to give a *coupled rangefinder*.

**Reciprocity law** States that *exposure* equals intensity × time, where intensity is equal to the amount of light and time is equal to the time the light is allowed to act upon the *emulsion*.

**Reducing agent** Chemical in a *developer* which converts exposed *silver halides* to black metallic silver. In some *color developers* the *oxidation products* of the reducing agent combine with *color couplers* to produce color dye.

**Reflected light reading** *Exposure* reading taken with the *exposure meter* pointing toward the subject so that it measures the light reflected from subject surfaces.

**Reflection** The bouncing back of rays of light striking a surface. Specular (mirror-like) reflection occurs where light rays are reflected from an even smooth surface such as glass or water; diffuse reflection occurs where they are reflected from rough, uneven surfaces which cause the light to scatter.

**Reflector** Any surface from which light is reflected. Generally, the whiter the surface the greater the amount of *incident light* reflected. If reflectors are used in color photography they should be neutral in color to avoid color casts.

**Reflex camera** Camera with a viewing and focusing system that uses a mirror to reflect the image rays, after they have passed through the lens, on to a *focusing screen* where the image can be viewed.

**Refraction** The change in direction of light rays as they pass obliquely from one transparent medium to another of different density, e.g. from air to glass.

**Rehalogenization** Process by which black metallic silver formed during processing is converted back to *silver halides*, so that they can be redeveloped in a different form or be made soluble by the action of *fixer* in the *bleach/fix* solution.

**Relative aperture** Diameter of the *aperture* divided by the *focal length* of the *lens* in use. The result is expressed as an *f number*, and is marked on the lens barrel.

**Replenishment** The addition of extra chemicals to a *processing* solution to compensate for its repeated use and prevent chemical exhaustion.

**Resin-coated** (or **RC**) **paper** Printing paper with a water-repellent base. RC papers process faster, need less washing and dry more quickly than regular fiber types.

**Resolving power** The ability of the eye, a lens or a photographic emulsion to resolve fine detail.

**Restrainer** Chemical used in developing solutions to prevent *reducing agents* from converting unexposed *silver halides* to black metallic silver.

**Reticulation** Minute net-like pattern on the *emulsion* surface giving a cracked appearance to *film*. It is caused during *processing* by extreme changes in temperature or acidity/alkalinity.

**Retouching** After-treatment carried out on negatives, slides, or prints to remove blemishes and/or change tonal values.

**Reversal material** Photographic materials designed to give a direct *positive* after only one *exposure* (i.e. without producing a separate negative), by reversing the image during processing.

**Ring flash** *Electronic flash* tube in the form of a ring surrounding the camera lens. Used when shadowless lighting is required.

**Rinse** Brief wash in water given to photographic materials between *processing* steps to remove residual chemicals and prevent carry-over from one solution to another.

# S

**Sabattier effect** Term commonly applied to the partial reversal effect achieved by re-exposing photographic *emulsion* to white light during *development*.

**Safelighting** Darkroom lighting to which the particular photographic materials being handled are virtually insensitive.

**Saturated color** Pure color *hue*, undiluted by black or white.

**Selective focusing** Method of setting the camera controls for minimum *depth of field* to limit picture sharpness to a particular area of the subject, isolating it against an unsharp background and/or foreground.

**Selenium cell** *Photo-electric cell* used in many older type *exposure meters*. It generates electricity in direct proportion to the amount of light falling upon its surface.

**Sensitive materials** In photography, the term applied to the film or paper *emulsions* that react to light, by changing chemically where they are exposed.

**Separation negatives** Black and white *negatives*, usually prepared in lots of three, made by photographing a full color original through primary color *filters* which analyze the original in terms of blue, green and red. The three negatives can be synthesized in primary or subtractive color dyes to produce a copy of the original.

**Shading** See *Dodging*.

**Shadowless lighting** Lighting arranged so that there are no obtrusive shadows cast on the subject, obscuring detail.

**Sheet film** Alternative name for large format *cut film*.

**Shellac** Natural resin with a low melting point, used for *dry mounting* photographic *prints*.

**Shutter** Mechanical system used to control the time that light is allowed to act on a sensitive *emulsion*. The two most common types are the *between-the-lens* (or *diaphragm*) *shutter*, and the *focal plane shutter*.

**Shutter preference** Term used to describe the *automatic exposure* system on some cameras, in which *shutter speed* may be selected, but the *aperture* then adjusts automatically to give correct exposure.

**Shutter speed** The action of the shutter which controls the duration of an *exposure* – the faster the speed, the shorter the exposure. Shutter speed settings are given in fractions of a second, each half the duration of the preceding one in a constant scale, marked on the shutter speed dial.

**Silver halides** Compounds formed between silver and alkali salts of *halogen* chemicals such as bromine, chlorine and iodine. Silver bromide, silver chloride and silver iodide are the light-sensitive silver halides used in photographic *emulsions* to record the *image*.

**Single lens reflex (SLR)** Camera which allows the user to see the exact *image* formed by the picture-taking lens, by means of a hinged mirror between the lens and film (and usually a *pentaprism* to correct the image from left to right).

**Skylight filter** A pale pink correction filter used on the camera when taking color slides, to eliminate blue casts found in dull weather or when subjects are lit only by reflected blue sky light.

**Slave unit** Relay mechanism which fires additional flash sources simultaneously when a *photo-electric cell* is activated by the light from a flash source on the camera.

**Slide** General term for a *positive* image on film, usually mounted in a frame ready for projection.

**Slide film** Direct reversal, normally color film used in cameras for full color projection *positives*. Sometimes called color transparency film.

**Snoot** Cone-shaped shield used on *spotlights* to limit the illumination to a small area.

**Sodium carbonate** Chemical used as an *accelerator* in some black and white developing solutions.

**Sodium hexametasulfate** Chemical used as a water softener.

**Sodium sulfite** Multipurpose chemical sometimes used in a *developer*. It can act as an *accelerator*, a *restrainer*, and a silver solvent.

**Sodium thiocyanate** Chemical used as a *fixer* and a silver solvent.

**Sodium thiosulfate** The chemical most commonly used in *fixation* to convert unused *silver halides* into a soluble form.

**Solarization** Reversal or partial reversal of a photographic image achieved by extreme overexposure. It is similar to the *Sabattier effect*.

**Spectral sensitivity** Relative response of a photographic *emulsion* to the colors of the *spectrum*. The natural response of an emulsion can be altered by the introduction of *dye sensitizers* during manufacture. In color films, dye sensitizers are used to achieve the required spectral sensitivity in each of the three emulsion layers.

**Spectrum** Commonly, part of the electromagnetic spectrum, between wavelengths of 4000 and 7000 A

(400–700 nm), to which the human eye is sensitive. It appears as the colored bands, arranged according to wavelength, which are produced when white light is refracted by a *prism* into its separate *hues*.

**Speed** Sensitivity of a photographic *emulsion* to light. Films are given *ASA/ISO* or *DIN* (or *GOST*) numbers to indicate their relative *speed* characteristics. The higher the number, the faster the film reacts to light.

**Spherical aberration** Lens fault which causes loss of *definition* particularly at the edge of the frame.

**Spotlight** Artificial (usually tungsten-filament) light source that uses a fresnel lens and a simple focusing system to produce a beam of *hard* light of controllable width and intensity.

**Stabilizer** *Processing* solution used in color photography which makes the dyes produced by chemical development more stable and fade-resistant.

**Standard lens** Lens whose focal length is approximately equal to the diagonal of the film *format* with which it is used. It is also referred to as the prime or normal lens.

**Stock solution** Chemical stored in concentrated form and diluted just before use.

**Stop bath** Chemical bath used in *processing* to stop *development* by neutralizing the developer. This prevents active developer from contaminating other baths.

**Stopping down** Reducing the size of the lens *aperture*.

**Studio camera** A *large format camera* allowing *camera movements*, for studio work.

**Subtractive color synthesis** Way of producing color *images* by subtracting appropriate amounts of unwanted *primary colors* from white light by means of yellow, magenta, and cyan dyes.

**Supplementary lenses** Additional lens elements used in conjunction with the prime lens to provide a *lens system* of different *focal length*.

**T**

**Tank** Plastic or stainless steel container used to hold chemicals in which films or photographic papers are processed.

**Telephoto lens** A *long-focus* lens which has a compact internal construction to give a relatively short *back focus*.

**Test strip** In color photography, a strip of printing paper or film which is given a range of *exposures* (using different *filtrations*) to test for correct *density* and *color balance*.

**Tone** The strength of the grays between white and black contained within a color. When a pure *hue* is lightened because of the introduction of white the color is said to be desaturated. When a pure hue is darkened because of the introduction of black the color is said to be degraded.

**Transmitted light** Light which is passed through a transparent or translucent medium. The amount of light transmitted depends on the density of the medium through which it passes and the brightness of the original light source.

**Transparency** A color *slide*.

**Tray development** Method of *development* used in the *processing* of *prints* and occasionally *cut color film*. Chemicals are used in shallow trays to allow immersion of the photographic paper or film.

**Tripack** See *Integral tripack*.

**T setting** Shutter speed setting found on some cameras, denoting "time". The *shutter* remains open after the shutter release is pressed and released; it is closed by again pressing the shutter release or, in some cases, by winding on the film.

**TTL exposure meter** Through-the-lens *exposure meter*. A system of "in-camera" metering, using a *photo-electric cell* within the camera. It measures the image-forming light that has passed through the camera lens.

**Tungsten-filament lamp** Artificial light source using a tungsten

filament contained within a glass envelope. The tungsten produces an intense light when an electric current is passed through it. This is the basic artificial light source used in photography.

**Tungsten halogen lamp** Compact *tungsten-filament lamp*. It contains halogen traces to reduce lamp discoloration with age.

**Tungsten light film** Usually, a color film balanced to light sources with a color temperature of 3200K, i.e. *type B color film*. Sometimes, also refers to *type A color film*, now seldom used.

**Twin-lens reflex (TLR)** Camera with two lenses of identical *focal length*. One forms the *image* on a *focusing screen*; the other forms the focused image on the *film plane*.

**Type-A color film** Color film balanced to artificial light sources with a *color temperature* of 3400K. Such films are rarely used now.

**Type-B color film** Color film balanced to artificial light sources with a *color temperature* of 3200K.

# U

**Ultra-violet** *Wavelengths* of the electromagnetic *spectrum* between about 5 and 400 nm. Ultra-violet light is invisible, but records on photographic materials, and is one of the causes of *aerial perspective*. An ultra-violet (UV) filter can be used in front of the camera lens to reduce the hazy effect of UV light.

**Underdevelopment** This is the result of too little *development* time or a lowering of the development temperature. Underdevelopment reduces *density* and *contrast* on color *negatives* and *prints* but increases density on color transparencies.

**Underexposure** This is the result of too little *exposure* in the camera or at the *enlargement* stage. Underexposure reduces *density* and *contrast* in negatives and prints.

**Uprating** Term used when the manufacturer's recommended film *speed* is deliberately exceeded, by setting a higher speed rating on the camera, so causing *underexposure*, and then compensating by *over-development*. Reversal color films react reasonably well to this method, but color casts can occur.

# V

**Variable focus lens** Alternative term for a *zoom lens*.

**View camera** *Large format camera* with *camera movements*.

**Viewfinder** System for viewing the subject, showing the field of view of the camera lens. There are several types including the direct vision frame, optical frame, *ground glass screen* and reflex mirror.

**Viewpoint** Position of the camera relative to the subject. When viewpoint is altered *perspective* changes.

**Vignetting** Printing technique where the picture edges are gradually faded out to black or white.

# W

**Warm colors** Colors which by association suggest warmth, namely red, orange and yellow.

**Washing** Part of the *processing* cycle that removes residual chemicals and soluble silver compounds from the *emulsion*.

**Wavelength** Method of identifying a particular electromagnetic radiation, considered as rays progressing in wave-like form. Wavelength is the distance between one wave crest and the next. Different electromagnetic radiations have different wavelengths. In the case of light, wavelength is measured in *nanometers* (nm) or *Angstroms* (A). Different wavelengths of radiation in the visible spectrum are seen as colors.

**White light color printing** Technique using an *enlarger* with a facility for placing color *filters* between the light source and the *condenser* to control the *color balance* of the final *print*.

**Wide-angle lens** Lens whose *focal length* is less than the diagonal of the film *format* with which it is used.

# X

**Xerography** System of document copying in which the light-*sensitive material* used is an electronically charged metal plate. Exposure to light destroys the charge leaving a *latent image* in which shadows are represented by charged areas. A powdered pigment dusted over the plate is attracted to the charged areas and so produces a visible image. Colored xerography is also possible, using *separation images*.

**Xography** Photography which produces prints and transparencies with a three-dimensional effect.

**X-ray** Electromagnetic radiations (like light waves) which form a shadow image of certain internal structures when allowed to pass through opaque objects and act upon a light-sensitive *emulsion*. X-rays cannot be refracted by lenses to form images.

# Z

**Zoom lens** Lens which is constructed to allow continuously variable *focal length* without disturbing *focus* or *f number*.

# INDEX

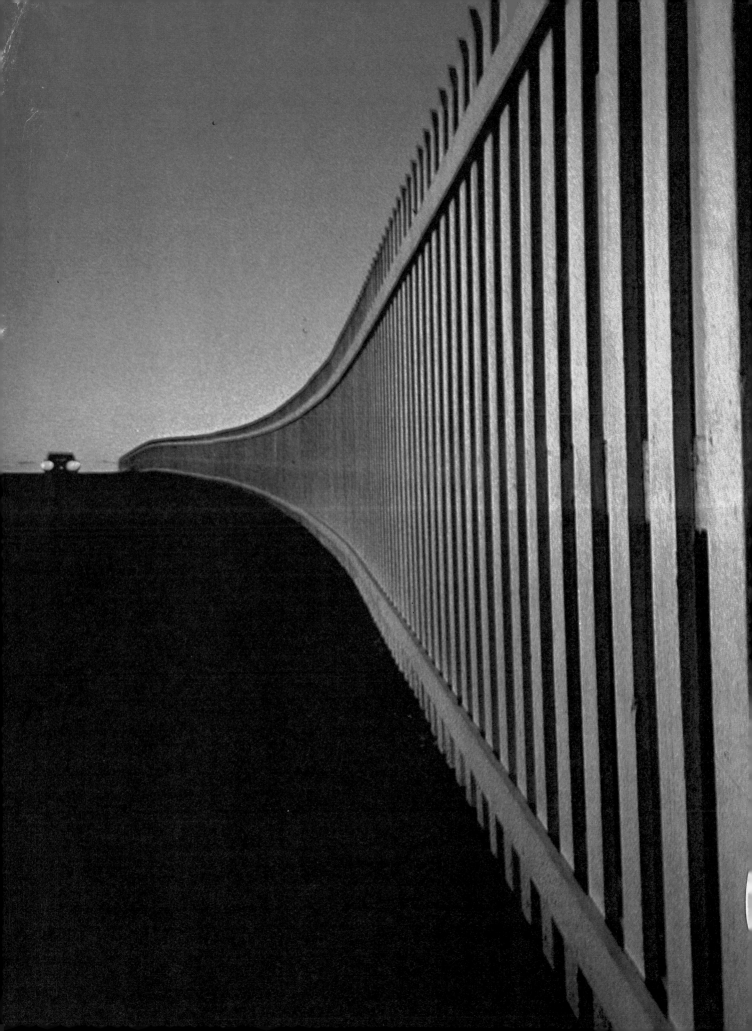

# THE BOOK OF
# COLOR
# PHOTOGRAPHY